Brutal Beauty

performance works

SERIES EDITORS This series publishes books in theater and performance studies,
Patrick Anderson and focused in particular on the material conditions in which
Nicholas Ridout performance acts are staged, and to which performance itself
might contribute. We define "performance" in the broadest sense,
including traditional theatrical productions and performance art,
but also cultural ritual, political demonstration, social practice,
and other forms of interpersonal, social, and political interaction
that may fruitfully be understood in terms of performance.

Brutal Beauty

Aesthetics and Aspiration in Urban India

✦

Jisha Menon

NORTHWESTERN UNIVERSITY PRESS
EVANSTON, ILLINOIS

Northwestern University Press
www.nupress.northwestern.edu

Copyright © 2022 by Northwestern University Press.
Published 2022. All rights reserved.

Printed in the United States of America

10 9 8 7 6 5 4 3 2 1

Library of Congress Cataloging-in-Publication Data

Names: Menon, Jisha, 1972– author.
Title: Brutal beauty : aesthetics and aspiration in urban India / Jisha Menon.
Description: Evanston, Illinois : Northwestern University Press, 2022. |
 Series: Performance works | Includes bibliographical references and index.
Identifiers: LCCN 2021014092 | ISBN 9780810144057 (paper) |
 ISBN 9780810144064 (cloth) | ISBN 9780810144071 (ebook)
Subjects: LCSH: Arts and society—India. | Performing arts—India. | Art and
 cities—India. | Neoliberalism—India.
Classification: LCC NX180.S6 M46 2022 | DDC 700.1030954—dc23
LC record available at https://lccn.loc.gov/2021014092

To Rahil

CONTENTS

ACKNOWLEDGMENTS

The seed for this book was planted in those heady days when I returned to Bangalore in 2008, following a prolonged convalescence. I felt renewed by the exuberance of the city, and I was exhilarated to be back in India. With a core team of about ten actors and crew, I set about chronicling the changed social dynamics of Bangalore through an adaptation of Anton Chekhov's *The Cherry Orchard*, which explored the city's emergent social formations. I was eager to rediscover this city I had left over fifteen years ago but still had always imagined as home. Working with my cast and crew, I learned anew how to inhabit and navigate Bangalore, which was at once familiar and strange. My thanks to Janani Ambikapathy, Prakash Belawadi, Rudy David, Himanshu Dimri, Anuja Ghosalkar, Pritham Kumar, Abhishek Majumdar, Hemaa Narayan, Vinod Ravindran, Arshia Sattar, Sonali Sattar, and Vivek VK for their enthusiasm, candor, and persistence as we worked on the production, *City of Gardens*, which we staged at Ranga Shankara and Grasshopper in Bangalore in September 2008.

During my sabbatical in Bangalore in 2012–2013 I studied how artists grappled with urban transformations, which sought to remake postcolonial cities into idealized versions of a "world-class city." I am grateful to those who took the time to talk to me about their impressions of the shifting, kaleidoscopic arrangements of urban life: Aditi De, Ranita Hirji, and Anmol and Sarita Vellani. I am especially grateful to the artists who were generous with their time, provided materials, and/or gave me permissions to reprint images: Ayisha Abraham, Krishnaraj Chonat, Mahesh Dattani, Sheela Gowda, Suresh Jayaram, Ram Ganesh Kamatham, Ravikumar Kashi, Preetam Koilpillai, Shantamani Muddaiah, Pushpamala N., Archana Prasad, Rimini Protokoll, Cop Shiva, Vidhu Singh, Christoph Storz, Vivan Sundaram, Surekha, Living Smile Vidya, and Michael Walling.

My colleagues at Stanford and beyond are an unending source of insight and support: thanks to Samer al-Saber, Shahzad Bashir, Anna Bigelow, Robert Crews, Lalita Du Perron, Milija Gluhovic, Aleta Hayes, Leslie Hill, Kate Kuhns, Aishwary Kumar, Young Jean Lee, Nayanika Mookherjee, Debbie Mukamal, Daniel Murray, Helen Paris, Peggy Phelan, Michael Rau, Aileen Robinson, Anna Schultz, Margaret Sena, Parna Sengupta, David Sklansky, Matt Smith, and Jeremy Weinstein. For their intelligent and generous feedback on this manuscript in its many iterations, I thank Amita Baviskar, Akhil Gupta, Usha Iyer, Bakirathi Mani, Purnima Mankekar, Ato Quayson, and

Patricia Ybarra. I am grateful to Jennifer Brody, Harry and Michele Elam, Lata Mani, Ania Loomba, and Suvir Kaul not only for their intellectual rigor but also for their courage, compassion, and integrity. My students inspire me with their brilliance and creativity. For research assistance, I thank Kari Barclay and Matthew Stone, and especially Rishika Mehrishi, who helped me through the final push to publication. Thanks also to friends and family who have sustained me with their cheer: Deepa Chikermane, Maya Dodd, Gauri Gill, Priya Krishnamurthy, Pushpa Menon, Angeles Pawar, Sanjay Rajagopalan, Sonali Sattar, and Nirada Vijay.

I am grateful for the opportunity to work with Northwestern University Press not least because I benefited from the formidable intelligence of my series editors: Patrick Anderson's attention to the micro, evanescent, and ephemeral details of artworks, and Nicholas Ridout's focus on the larger structural, political, and institutional dimensions of art practice, enriched my analysis. I'm grateful to the careful and incisive feedback provided by the anonymous reviewers. Thanks also to my editorial team at Northwestern University Press: Olivia Aguilar, Anne Gendler, Trevor Perri, Patrick Samuel, Anne Strother, and JD Wilson supported this project with meticulousness and professionalism.

I presented portions of this book at various conferences and universities, including Association for Asian American Studies, American Comparative Literature Association, American Society for Theatre Research, Brown University, Jawaharlal Nehru University, New Delhi, Performance Studies International, Stanford Humanities Center, University of California, Berkeley, University of California, Los Angeles, the University of Chicago, and the University of Warwick. I thank all my interlocutors who helped me refine my ideas. Although significantly revised, some portions of this manuscript have been published in other venues, and I thank the following for permissions: John Wiley and Sons for "Queer Selfhoods" in *Journal of Historical Sociology* (2013); Springer Nature for "Palimpsestic City" in Patricia Ybarra and Lara Nielson, eds., *Neoliberalism and Global Theatres: Performance Permutations* (Palgrave Macmillan, 2012); Taylor and Francis for "Toxic Colonialism" in *Performance Research* (2018) and "Calling Local / Talking Global" in *Women and Performance* (2013).

The loving care and nurture of my parents, Haridas and Chandrika Menon, has been a blessing, and their unwavering love has steadied me through rough weather. The love and loyalty of my siblings, Jyothi, Roji, and Manoj Menon, is a gift beyond measure. This book is dedicated to my son, Rahil Menon, who lives up to his name and illumines my path with his joy, verve, and resilience. Through all our travels across the globe, he remains my home in the world.

Brutal Beauty

For the sculptural installation *Stopover*, Bangalore artists Sheela Gowda and Christoph Storz dispersed 170 grinding stones along the floor of a veranda in Aspinwall House in Kochi, a city in the southern state of Kerala. A large sea-facing heritage property, Aspinwall House opens out to the Arabian Sea.[1] In the emergent consumer capitalism in urban India, the aspiration to accumulate ever more efficient kitchen appliances has rendered the grinding stones obsolete. Framing these stones as art, Gowda and Storz make vivid the sensuous connection to ancient spice routes across the Arabian Sea. The heavy, roughly square-shaped slabs of granite are sculpted to contain a womb-like cavity, a gently sloped openness, in front of which women squatted and pounded rice, spices, and herbs into paste. The square stone itself is roughly hewn except for the circular cavity; the bulk of the stone was interred under the kitchen floor, with only the open cavity exposed. The artists' excavation of the material strata of urban memory recovers layered histories of the city.

The displaced granite stones carry the memory of their former home in Bangalore, while also accumulating resonances from their current location in Kochi. Wary of their sacral charge, Bangalore real estate developers left the grinding stones intact. In their artists' statement, Gowda and Storz explain, "With the escalated value of real estate, property changes hands and the old house is demolished or renovated for modern living. The grinding stone has to go, like the rubble of the old walls. But unlike the rubble that is transported away as debris, no one dares to take this final step with the grinding stone. No one dares to willfully destroy it either. It is too charged an object, too full of memory of its use and meaning. Its destruction may be read as an act of irreverence."[2] No longer consigned to their role as obsolete domestic objects, the stones exude an animating force that transcends their utilitarian function.

Each four-hundred-pound grinding stone captures a range of unruly affects: the aspiration to upgrade to modern lifestyles is layered over with a sense of nostalgia and obsolescence. The stones connote an unhurried mode of life, radiating sensuous materiality that evokes a slower time, eclipsed in the frenzied pulse of the world-class city. The emergent urban rationalities of convenience, expediency, and speed have produced a new range of kitchen appliances that chop, grind, and mix efficiently, briskly, and automatically. These replicable, standardized electric mixers replace the sensuous particularity of the grinding stones, eliminating the tactilic labor of women who

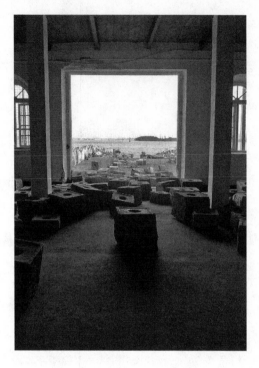

Figure 1. Sheela Gowda and
Christoph Storz, *Stopover*, Kochi,
2012. Courtesy of the artists.

pound, grind, moisten, and crush spices. The constant accumulation of newer
models appears to concurrently upgrade the consuming subject, transform-
ing her relationship to time, opening up new opportunities for leisure, and
consequently encouraging her to discard the obsolete grinding stone.

However, even in urban India, many traditional Brahmanical and "upper-
caste" households forbid "lower-caste" people and Muslims from entering
the kitchen, let alone polluting food with their touch. These appliances
reshape domestic relations between middle-class women and their domestic
servants. The nostalgia that the stone evokes simultaneously represses the
ways this sacral and charged object animated contests around caste, class,
religious, and gender hierarchies. The grinding stones serve as placeholders
for emergent social forms within the home and beyond.

The grinding stones traveled from their erstwhile homes in Bangalore in
the southern state of Karnataka to their renewed life as found art objects in
Gowda and Storz's installation for the 2012 Kochi-Muziris Biennale. India's
Biennale exhibition opened on December 12, 2012, in Kochi, a port city that
evokes bustling trading ports, ancient spice routes, and languid backwaters.[3]
One of the largest natural harbors in India, Kochi summons tales of pirates
and shipwrecks and was home to precolonial cosmopolitanism when China,
Africa, Southeast Asia, West Asia, and Europe met, traded, and commingled

on its shores.⁴ Kochi is a layered city: beneath it lies the spectral presence of Muziris, the ancient trading port buried after a great deluge in the fourteenth century. In the words of the artist-curators of the Biennale, Bose Krishnamachari and Riyaz Komu, "Kochi's cosmopolitanism is one that has been worn by generations in Kerala as a badge of honor even as it has led to a series of struggles, time and again, generating a curiosity about current realities, a complex one."⁵ At the very outset, Bose and Komu sought out the "struggle" and the sense of dissensus in artistic and cultural encounters; they were circumspect about models of relational aesthetics that swept under the rug contradictions and tensions in cosmopolitan encounters.⁶

Strewn across the veranda all the way to the edge of the water, the grinding stones appear huddled together, displaced, a little anxious. As the viewer's line of vision approaches the sea line, the claustrophobia and crowded proximity of the stones turns spare, as if each stone inhales deeply the salty sea-fragrance and contemplates an exilic and solitary journey to the sea. The stones under the shade were cool to the touch, unlike the scorching ones that blazed beneath the afternoon sky. The talismanic force of these stones seems to release the vigor of the heaving and dazzling Arabian Sea. Illuminating the vitality of discarded grinding stones, the installation sets the obsolescence of the weighty grinding stones against the panorama of the ancient Arabian Sea, frothing and foaming, rising and ebbing, weightless waves carrying specters of ancient pasts. The scene at Aspinwall House evokes a sense of nostalgia, hovering between substance and specter, matter and memory.

Such a tableau of nostalgia is also evoked in the final scene of Anton Chekhov's *The Cherry Orchard*, when the aristocratic Ranevskaya and her daughter stand bereft and huddled amid weighty suitcases and empty furniture as they depart their beloved orchard. *The Cherry Orchard* captures a moment of transition from feudal landed aristocracy to robust bourgeoisie at the turn of the century in Russia. Aglow with warm nostalgia, and buoyed up with lighthearted comedy, the play tenderly ushers out the doomed Ranevskaya, desolate after the drowning death of her son, and makes way for the entrepreneurial Lopakhin. This final, bittersweet scene captures the contradictoriness of aspiration and nostalgia, enterprise and obsolescence. Like Gowda and Storz's installation, it is an image of leave-taking, one that captures both the material heft of memories neatly packaged into suitcases and the tenacious hauntings of spectral pasts.

The Cherry Orchard offered me a passage to India. In September 2008, I returned to my home city, Bangalore, to direct *City of Gardens*, an adaptation of *The Cherry Orchard*.⁷ The adaptation mapped Bangalore's emergent urban politics onto Chekhov's classic realist play. Using a Chekhovian frame allowed us to grapple with questions that were particularly germane to Bangalore's residents: How do rhetorics of development and paradigms of the "world-class city" justify redevelopment projects that make way for wider roads, larger buildings, a new airport, and other megacity ventures? Who and

what is ushered out, left behind, or reinvented in these scenes of leave-taking? Chekhov's *The Cherry Orchard* offered an apposite framework within which to narrate this historical moment of urban transformation. Yet my own slide into a nostalgia for a former "garden city" was promptly rebuked by my spirited cast and crew members, many of whom were newcomers to the city. They pointed out that my wistful sentimentalism positioned them as unwanted outsiders, new migrants with only a tenuous claim to their current hometown, and that frustrations with infrastructural dysfunctions are frequently directed toward incoming migrants. This sentiment manifests itself while walking down the streets of the city, where one is accosted by bumper stickers that exhort "outsiders" to "Go back!" Their lighthearted censure made me aware of the ways nostalgia could indeed foster exclusionary narratives of belonging.

Various critics discuss the current suspicion surrounding nostalgia: Tim Reiss argues that nostalgia "breeds regression"; Susan Stewart refers to it as a "social disease" that arouses an inauthentic longing, disconnected from lived experience; and Fredric Jameson has warned that nostalgia supplies "a formal compensation for the enfeeblement of historicity in our own time."[8] Still, perhaps, as Linda Hutcheon has suggested, "*some* nostalgia we are seeing today . . . is of a different order, an ironized order."[9]

The experience of mounting a production offered a mode of returning to and engaging with the city's affective geographies. Returning to direct a play in the city I had left over fifteen years before unsettled me; it was a place that was simultaneously familiar and strange. Traveling through the city was full of surprises: spectacular billboards loomed over large swaths of informal settlements; gleaming shopping malls and high-rise buildings stood beside congested roads; the city where the urban poor eked out a precarious living was dotted with island-like gated communities. The aural city impressed itself on the traveler—the cacophony and turbulent variety of traffic sounds insistently jolted one from any anodyne recourse to the past. The sidewalks, often in various states of disrepair, prevented any leisurely strolling; thanks to potholes, traffic, and other surprises along the way, a walk required a full-bodied awareness. Still, despite its radical transformations, the city was a profoundly haunted place, teeming with memories of demolished buildings, of vanished neighborhoods, of the disappearing tree cover that once gave Bangalore its moniker, "the garden city." The trace of these ghosted memories continues to linger in the new city, evoking nostalgic yearnings for times past.

As Janaki Nair has cautioned, however, the discourse of nostalgia is tied to particular ideologies of beauty, which are rearticulated through recourse to environmental concerns.[10] Indeed, as she points out, aesthetic and environmental arguments were routinely conflated to legitimate and police the commons in ways that have systematically denied nonelite citizens free and fair access to the city's public spaces. The burgeoning nonelite populations, newly arrived in the city, signify a growing democracy, itself deemed

unaesthetic. There is a sharp contrast between these nonelite migrants and the restrained middle-class urban citizenry. Nair argues that behind the nostalgic discourses around Bangalore's disappearing natural beauty lurks an anxiety around the emergence of unruly democratic subjects.

But nostalgia draws on multiple sources, is layered and complex, and generates unpredictable effects. Derived from the Greek *nostos*, "homecoming," and *algia*, "ache" or "longing," nostalgia is a longing for a home that oscillates between memory and imagination. Svetlana Boym reminds us that nostalgia could emerge in restorative or reflective registers: restorative nostalgia focuses on *nostos*, or the home, and proposes to rebuild the lost home, whereas reflective nostalgia dwells in *algia*, in longing and loss, the imperfect process of remembrance. Restorative nostalgics "believe their project is the truth," while reflective nostalgia "lingers on ruins, the patina of time and history, in the dreams of another place and another time."[11] Nostalgia emerges in these discussions not only as longing for a place but also as yearning for a different time, for the slower rhythms of an imagined past, which resists the brisk forward march of development and the linear temporality of progessivist modern time. Some of the environmental activism could indeed be precipitated by middle-class reflexive nostalgia for greener spaces and cannot be easily labeled as "bourgeois environmentalism."[12] For example, festivals such as Neeralu, Bangalore's annual tree festival, and the important work done by organizations such as Environment Support Group advocate for social and environmental justice, arguing for more rather than less support for democratic inclusion of marginalized communities in their vision for greener cities.

Nostalgia appears in the discourses of urban planners as a longing for a prior time with fewer people and less demands on urban infrastructure.[13] "It is not so much redevelopment, or even reconstruction," Nair reminds us, "but beauty that is emphasized frequently in the writings of those concerned about the festering slums of the city."[14] Urban beautification projects undertaken for the city unleashed authoritarian spatial regimes on the urban underclass in the city, evacuating them from their sources of livelihood and their places to live. The elite city dweller's lament about the death of the city mourns a lost Bangalore of gardens and parks set in compounds and homes, rather than in the flower markets in the City area, which were systematically usurped and transformed into real estate properties. The disorienting transitions for the elite include not only the newly arrived "populations" of migrant labor in the city but also the subsequent pressures on the resources and infrastructure of the city.

In what ways can restorative nostalgics deploy spatial strategies to counter emergent social dynamics? How do rhetorics of the "risk society" perpetuate the creation and demarcation of spatial enclosures? For example, gated communities delineate affluent islands untarnished by the presence of those who literally construct these buildings and make such lifestyles possible. In

addition, mass transit systems provide transportation to laborers who are encouraged to live in periurban centers and commute daily to their places of work, enabling the city to remain less congested and the province of the wealthy. At other times, restorative nostalgics take recourse to violent acts of regional and religious self-definition. The wave of attacks on churches in Bangalore and other cities in Karnataka in September and October 2008 by right-wing Hindu organizations further demonstrate the violent tactics deployed by restorative nostalgics, eager to restore a mythical notion of a Hindu-ized Karnataka.[15]

The liberalization of the Indian economy radically altered the social, cultural, and political phenomenology of inhabiting the city. The shift to a liberalized culture of consumption emerged in policy discourses during the political tenure of Prime Minister Rajiv Gandhi in the 1980s. These policy discussions provided the political-discursive environment for the formal moment of transition in July 1991 when India embraced economic reforms under its finance minister, Manmohan Singh. India had suffered a major economic setback: the devaluation of its currency, a sharp plunge in its foreign exchange reserves, and was forced to sell forty-seven tons of gold to the Bank of England as collateral for a loan, while it waited for more help from the International Monetary Fund. Singh's way out of this dire economic predicament was to initiate large-scale economic restructuring and fiscal adjustment in a manner that aimed to protect the poor.[16] Singh devalued the rupee, abolished most of the quotas and licenses that dictated who could produce what, and opened industries to foreign capital. In the years since, India's economy has almost quadrupled in size, growing by about 7 percent a year on average over the past two decades and by over 9 percent from 2005 to 2007. Contrary to dominant models of neoliberal policies in the North that have been characterized as waging war on the poor, liberalization in India presented a more complex picture: in terms of numbers, it reduced the percentage of people living below the poverty line from a bit more than 50 percent in 1977 to less than 23 percent in 2004. Furthermore, unlike its counterparts in Latin America and East Asia, India, until recently, took pride in its transition from a socialist style economy to a liberalized one without damaging its democratic institutions.[17] The more recent assault on democratic institutions presents a dire picture of the new turn in Indian politics.

The economic restructuring and deregulation of financial flows profoundly impacted the cultural imaginaries of urban India. Once imagined as metonym for the nation, the city, in the wake of neoliberal globalization, reimagined its relationship to the nation. The circulation of newly available commodities, mediascapes, and lifestyles precipitated a shift from a post-Independence ethic inspired by values derived from Nehruvian socialism and Gandhian renunciation that emphasized restraint and sober planning to urban aspirations to wealth, excess, and profligacy induced by liberalization. Moving away from a conception of a bounded and insular space, the city now exerts

a vertiginous force field of encounters with other cities, within and beyond the nation, mediated through migration, commerce, media, and commodities.

The rapid changes in urban life in the wake of liberalization generated powerful social force fields. Formative notions of self, tied to labor, work, consumption, gender, sexuality, and class, shifted in the new political economy of the city and gave rise to new selfhood narratives. Citizens navigated the sensory overload—the noise of traffic, the smell of pollution, overcrowding, bombardment with images, and other hyperstimuli of India's growing metropolises—through a range of affective techniques that help manage the urban sensorium. The rise in commodity capitalism encouraged a shift in the subjective formation of the city dweller from a political citizen to an economic consumer.

The aspiration to remake the city into a world-class destination simultaneously galvanized a range of entrepreneurial and enterprising actors, while also inciting its dark side. This book turns to artworks, performances, and aesthetics produced at a transformative moment of social ferment to examine the aspirations and anxieties generated in the wake of liberalization. "Aspiration" derives from the Latin *aspirare*, "breathing spirit into," panting with desire, craving to rise above one's station: a longing for social and economic elevation above one's current position. If representational politics in preliberalized India stressed horizontal equality and social justice as the normative political ideal, postliberalized India has witnessed a reconfiguration of values, normalizing aspiration as the vertical striving to remake oneself in the images offered up by consumer capitalism. This emergent entrepreneurial subject is mediated by discourses and institutions of mass media and popular culture, which encourage the cultivation of aspiration as the affective corollary to self-interest in order to participate in the economic opportunities available in neoliberal cities.

How did the global flows that permeate Indian cities reshape the values of its urban citizens? How does one come to value a new set of dispositions and discard a prior set of affective attachments? What is the relationship between aspiration, personal responsibility, and social normativity? Aspiration suggests not only personal striving but also a calculated project of renovating one's value system.[18] Aspiration conjoins feeling and instrumentality and is embedded within a field of social norms. Rather than pitting desire against reason or feeling against calculation, aspiration evinces its own deep structure of rationality. It suggests yearnings that are not merely superficial or transient; instead these yearnings are instilled with a new set of values derived from a reasoned desire. Aspiration is not autogenetic but mimetic. The striving urban subject does not simply invent a new self; rather, aspiration is mimetically generated through attachments to images and ideals that circulate as social goods. Aspiration draws from that tension between who one is and what one desires to become: it is central to practices of identification as one moves toward inhabiting more fully the values of those one emulates. Acquiring a

new set of values necessitates psychic rearrangement as prior values are attenuated and gradually released to remake the self to suit a brave, new world.

Brutal Beauty demonstrates that aspirations to remake the city and the self in the idealized image of a "world-class" template can have unpredictable effects, from entrenching existing hierarchies to generating new solidarities. Considering cultural narratives through the lens of aesthetics moves us beyond the urban exigencies of planning and development. The artworks I discuss delineate the libidinal contours of the precarious city, sketching out scenes of aspiration and its affective repercussions. The everyday civic and social problems registered in these artworks illuminate the political economy of aspiration and its ripples on social and cultural formations.

By considering a range of artworks—from visual art, installations, paintings, and photography to documentary film, theater, and confessional and live performances—*Brutal Beauty* argues that neoliberalism exceeds its descriptors as an economic, social, and political phenomenon; neoliberalism is also a profoundly aesthetic project. "Aesthetics" derives from the Greek *aisthetikos*, for "sentience" and "sense perception." While city planners, architects, and development officials cite given templates of "world-class cities" as aesthetic models to aspire to, the artists I discuss critically intervene into prevailing discourses of urban beauty. The aesthetic rearrangement of sense experience in these artworks augurs a mode of dissensus. This enhanced understanding of aesthetics encompasses phenomenological habitation, dwelling, and movement in the city; it renews the capacity to be receptive and responsive to urban transformations. The artworks discussed here critically engage *anesthetized*, routinized, and celebratory discourses of the world-class city and explore the promise and perils of such urban transformations.

What can the nostalgia and obsolescence captured in Gowda and Storz's *Stopover* tell us about urban aspirations of the consuming subject? The discarded grinding stones cannot be easily dismissed as obsolete objects: their sacral aura inspires a sense of reverence, while also intimating frictions across registers of class, caste, and gender. This affective contradictoriness marks scenes of urban aspiration: they are simultaneously imbued with consumer desire and accumulation while also evoking a range of unruly affective intensities, such as nostalgia, panic, defiance, narcissism, and obsolescence. Considering the political economy of nostalgia allows us to take seriously the heterogeneous and supple forms of aspirational politics, and the ways they foster creative and negative effects.

The turn to artworks as dense registers of affective intensities makes visible the key ways emotion is mobilized in urban politics, enabling both political engineering and progressive action. Restorative nostalgia is ripe for political manipulation, as I discussed earlier. Yet Gowda and Storz's *Stopover* recovers a nostalgic critical reflexivity that contemplates the preoccupation with speed and efficiency, which devalues the sensuous handling of spices and slower modes of preparing food. Nostalgia cannot be dismissed as bourgeois

indulgence; it manifests a particular value system that incorporates a world-view, which could be deployed, as in the case of cultural nationalists, to invoke a vision of the past as either ordered in rigid class, caste, and gender hierarchies or, as the artwork of Gowda and Storz suggests, holding the potential for articulating a form of critical reflexivity around discourses of national progress, urban development, and social frictions.

Brutal Beauty turns to artworks to trace urban aspiration and its affective afterworlds. As embodied cognition, affect is a kind of intelligence that can be engineered, manipulated, and stoked by political and market forces but also, as this book demonstrates, offers the possibility of activating critical reflexivity. How do artists express the transformations of subjectivity and social relations in the wake of contemporary capitalism? What horizons of personhood and sociality are enabled or disabled in its wake? How do artworks vivify nostalgia, aspiration, shame, defiance, narcissism, panic, and obsolescence within urban dreamscapes? In these artworks, the city exceeds the rationalities of urban planning and policy discourses and reveals the affective and social life of aspiration and its discontents.

While many of the artists and performances I write about are located in Bangalore, the insights of this study are not limited to Bangalore. Indeed, I discuss works from a range of other cities: Delhi, Kolkata, Chennai, Mumbai, Kochi, New York, San Francisco, and London. These aesthetic projects, which range from city- to self-making, can be extrapolated to speak to any number of world cities that are in the process of remaking themselves. However, situating and describing the urban texture of a particular city allows the reader to imagine the lived contradictions of inhabiting cities with world-class aspirations. To this extent, I contextualize urban transformations within their larger historical, political, and social frameworks. Moreover, this study imagines the city not only as a territorial unit but also as a "global" category. Locating cities within transnational networks allows us to contend with how cultural imaginaries exceed the territorial jurisdictions of the city-space and nation-state. *Brutal Beauty* opens the canvas to a broad consideration of themes within and beyond Bangalore that pertain to the larger theoretical questions of this book. The effort is not to draw a narrow referential relationship between artwork and city; rather, the city provides an analytical, rather than territorial, paradigm through which to consider questions about urban aspiration and emergent affects, socialities, and subjectivities.

Urban Imaginaries

Global cities have emerged as crucial nodes within transnational networks of markets.[19] Saskia Sassen refines the idea of "the global city" not simply as a transnational hub of finance but as an urban center that practices global control.[20] In a recent anthology, *Performance and the Global City*, D. J. Hopkins

and Kim Solga take their cue from Sassen and, looking at a range of international cities, identify the "global city" as "the geo-social condition of this century."[21] However, simply extending the category "global city" continues to privilege the epistemological frameworks set up by Sassen and discounts the discursive paradigms emerging from urban networks in the global South. Moreover, their dismissal of "outmoded, unproductive national identities" disregards the creative and manipulative ways national and local governments often act in concert with multinational corporations to facilitate neoliberal corporatist agendas within city-spaces.[22] Such universalizing accounts of the flattening effects of global capitalism culminate in Mike Davis's apocalyptic characterization of megacities in the global South as a "planet of slums."[23]

Several recent theorists of urbanism have noted that the "global city" paradigm overlooks heterogeneous formations of urban life in the global South. Gyan Prakash warns against diffusionist models of urban theory which suggest that urban modernity emerged first in Europe and then gradually spread to the peripheries.[24] In *Mumbai Fables*, Prakash turns his sharp yet lyrical analysis to the glittering, cosmopolitan metropolis of Mumbai and its cultural history. Mumbai emerges not as a container of modernity but as a spatial form of social life.[25] Likewise writing against the global city paradigm, Ananya Roy and Aihwa Ong argue that the concept assumes that all metropolitan life across the world is subject to the identical universal force of global capitalism.[26] Achille Mbembe and Sarah Nuttall contend that the global city paradigm privileges the role of financial flows and techno-scapes in the making of the global city and thereby neglects crucial *cultural* narratives through which citizens imagine themselves and their cities.[27] The normative and schematic accounts of the homogenizing drive of global capitalism found in the urban theories flatten the affective and libidinal dimensions of cities and their subjects.

Performance studies offers a rich analytical framework for studying the unruly, imaginative city, which thrives beyond the functionalist imaginaries and bureaucratic precincts of the planned city. Loren Kruger reminds us that all cities are "world cities" because their "citizens aspire in unequal but nonetheless significant measure to inhabit the world and to imagine and reimagine that habitation as their right to the city."[28] Drawing on Charles Baudelaire and Walter Benjamin's notion of the flaneur and Guy Debord's notion of the *dérive*, Jen Harvie reminds us that walking in the city is a way of creating it anew "by rejecting the types of priorities the city dominated by capital and spectacle might try to impose."[29] Likewise, SanSan Kwan pursues a choreographic approach to reading "urban Chineseness" across a range of metropolitan cities, including Shanghai, Taipei, Hong Kong, New York, and Los Angeles, to trace kinesthetic experiences of moving through cities and identities.[30] Nicholas Whybrow generatively sketches out the analytical category of performance in understanding the nonlegal, nonofficial city.[31] While he concurs that the city is built around the operation of certain agreements,

a functional order that strives to be moral as well as pragmatic, he argues that the city is also irrefutably anarchic, and its radical play can challenge the planned city's authority. Ato Quayson retells the life of Accra, Ghana, through the performative streetscapes on the singular Oxford Street, which is a "demarcated spatial theatre yet one that is also extraordinarily permeable in terms of the intersection of variant dramaturgies."[32] Moving away from a focus on a social geography of needs, questions of policy and services, and functionalist accounts preoccupied with social justice, equity, and efficiency, these scholars offer a more processual and libidinal understanding of the relationships between bodies and buildings, actors and networks, pedestrian movements and urban structures.

Building on this scholarship, *Brutal Beauty* turns to the kaleidoscopic arrangements of new subjects, socialities, and affects in the rapidly changing liberalized Indian cities. How do radical economic and spatial changes shape value systems, giving rise to new urban subjectivities and social relations, and how are these rendered through artworks? Offering a more labile account of the city, this book turns to cultural imaginaries and urban dreamscapes and demonstrates that the city is more than its sum total of structures and infrastructures, legalities and technologies. The economistic vocabulary of markets, labor, and consumption does not capture the affective intensities that pulse through the city's libidinal, unruly, and imaginative life.

The cultural productions I examine in this book respond to the ongoing social and cultural upheavals in the city by exploring the undercurrents of urban aspiration. Recuperating the dark side of the "world-class" city—urban poverty, ecological crises, precarious migrant labor—these artists foreground the impact of the neoliberalizing agendas of contemporary capitalism. These creative interventions disclose a range of concerns, from gender, regional, and sexual identity politics to civic problems of the precipitous costs of living, migrant labor, electronic waste, media-generated panics, and the precarity of dwelling and traveling within the city's "rapidly changing" environments. In the process, *Brutal Beauty* traces the cultural life of neoliberal urbanism by departing from dominant representations that swing from triumphalist discourses of the "world-class city" to their apocalyptic obverse, the third world "planet of slums."[33] While the interlocutors of the global city paradigm have generatively enriched our understanding of the unruly, complex, and manifold dimensions of urban histories, geographies, and lifeworlds emerging from the global South, my project turns specifically to aesthetics as the mode to reimagine the self and the city in liberalized India.

Aestheticizing the Self

Theories of performance provide particularly rich tools to consider the formation of subject positions in liberalized India. Erving Goffman and Michel

Foucault have contributed to our understanding of the micro- and macro-level factors in the constitution of subjects. While Goffman studied face-to-face interactions within institutional settings to examine how normality and deviance are constituted and resisted by individual agents, Foucault examined technologies of power, domination, and discipline in the production of docile subjects. Goffman's analysis of the management of self is especially generative for a consideration of the development of a professional persona, which I take up in chapter 2.[34] Focusing on the minutiae of daily interactions rather than large-scale social systems, Goffman's social actor attempts to "manage impressions" by persuading his audience of the reality of the interactional situation.[35] Goffman draws from a performance vocabulary to attest the significance of the "role" not as that which conceals the inner self but, rather, as the iterative performance that constitutes the person. Building on Goffman, Pierre Bourdieu develops his concept of "habitus," where the self internalizes and incorporates social roles in the form of enduring dispositions and inculcated capacities, and subsequently manifests this behavior through embodied practice.[36]

Foucault's oeuvre is especially generative in understanding the role of aesthetics in the formation of human capital. The Foucauldian move to self-governance builds on his earlier work; he recuperates an older conception of governmentality, which extends well beyond a narrow understanding of political government to include technologies of self-governance. Foucault points out that in post-Nazi Germany, ordoliberal schema regarded the market and the principle of competition as antinaturalistic and as something that had to be instituted through active government intervention. Departing from orthodox classical liberal theory pitting individual liberty against state intervention, ordoliberals consider instead what type of government would best enable the market to flourish. The subsequent state/capital chiasmus anchors enterprise as not merely an economic but an individual horizon in capitalist societies.

Foucault distinguishes the ordoliberal approach from that of the Chicago School economists, who identify human capital as a significant way of understanding the problem of labor in emergent neoliberal formations. While the ordoliberals deployed the state to stimulate the market, thus retaining a distinction between the functions of the two, the approach of the Chicago School economists attenuated that distinction by ensuring that the economic form saturates all spheres of social life. Inculcating the self as capital draws not only on genetic traits but also on social, familial, and pedagogical "investments," which instill enterprise at the heart of human capital. The subject is now held responsible for her own choices about future investments in the shaping and development of her human capital. Bringing together theories of performance and formation of subjectivity allows us to see that the enterprising actor braids together techniques of external management as well as techniques of the self, combining micro- and macropolitical arts of self-governance.

Wendy Brown returns to the Chicago School's conception of human capital when she contends that "persons and states are expected to comport themselves in ways that maximize their capital value in the present and enhance their future value, and both persons and states do so through practices of entrepreneurialism, self-investment, and/or attracting investors."[37] In a relentless pursuit of self-enhancement, human capital seeks to improve its portfolio value. By pointing out how the democratic horizon of equality and social justice begin to diminish, Brown cautions against a political rationality that obsessively focuses on projects of self-investment. In her words, "When we are figured as human capital in all that we do and in every venue, equality ceases to be our presumed natural relation with one another. Inequality becomes normal, even normative. A democracy composed of human capital features winners and losers, not equal treatment or equal protection."[38]

It is now commonplace to assert that there is no singular or univocal "neoliberalism." While it is a global phenomenon, it is also constantly differentiated, unsystematic, and impure, inflected by existing arrangements of culture and society. It is not only diverse geographically and historically; it also has remarkable plasticity to reinvent itself in shifting guises as it manifests in discursive formulations, economic policies, modes of governance, and material and cultural practices.[39]

Akhil Gupta has cautioned us that neoliberal reforms in India did not replicate economic patterns in the West. In India, welfare programs were not eviscerated in order to usher in market reforms. Rather, social programs that focused on increased self-reliance and self-empowerment aided the ability of working classes to access the benefits of already existing welfare programs. The growth in government revenues made more resources available for redistributive purposes. In fact, liberalization facilitated the implementation of the government's welfare interventions. Unpacking the tangled and contradictory forces at the conjuncture between neoliberal policies and welfare, Gupta demonstrates that while the ideology of neoliberal governmentality supports cutting back welfare programs, "the pressures of securing legitimacy in a democratic politics and the growing economic resources that allow for this possibility have resulted in an expansion of welfare programs. A simplistic understanding of neoliberalism's impact on the poor would miss the multiple ironies at play here, ironies that demand us to pay close attention to social processes rather than rehearsing well-intentioned political slogans."[40]

Tariq Thachil demonstrates that where India's government machinery was failing to provide social services to marginalized citizens, nonelectoral organizations saw an opportunity and seized it.[41] In his analysis, the party of the Hindu Right, the Bharatiya Janata Party (BJP), has effectively deployed a network of nonparty organizations that have spread their tentacles and supplied a range of social services in remote areas, thus using social programs rather than overt Hindutva ideology to bring new constituents into its fold. Instead of insisting on clientelistic exchange, the distribution of social

services works as an insidious performance of charity and goodwill, gradually building trust rather than pressuring recipients to vote for the BJP. When the BJP won the 2014 national elections, the marginalized electoral groups of Scheduled Tribes (Adivasis) and the Scheduled Castes (Dalits) and the economically marginalized poor voted in their favor rather than for the Indian National Congress party, which has ideologically and historically represented marginalized groups.

The landslide victory of the BJP in 2019 further accentuates the ways that the hydra-headed Hindu Right party wears multiple guises and speaks in many tongues and appeals to sentiments as well as material needs in order to recruit diverse constituents. The "Modi wave" cannot be explained only through a religious vector; we need to also consider the permeation of a neoliberal calculus in all sections of society, where voting and democratic politics are seen as transactional tokens in exchange for services, jobs, and other material and economic benefits. Moreover, Narendra Modi himself evokes the "rags to riches" narrative of aspiration, mobility, and resilience to serve as a role model to striving citizens.[42] In a poor democracy such as India, marginalized citizens are also substantial vote banks, so political parties deploy social programs and proffer aspirational narratives to compete for the vote of the poor. We can see that in India, while neoliberal policies do not decimate social programs as in the West, parties like the BJP deploy neoliberal rationalities, bringing the principle of competition into noneconomic areas of social services and thus infusing it within a neoliberal political-economic calculus.

Building on the work of these scholars, this book invokes "the neoliberal" not only as the historical launch of economic reforms in 1991, when the Indian government opened its doors to foreign trade and investment, deregulation, privatization, tax reforms, and inflation-controlling measures that shifted from a developmental state to a more capitalist economy.[43] *Brutal Beauty* argues that the neoliberal involves more than a descriptive and analytical category of political economy; it functions as a prescriptive and normative horizon, disseminating market values beyond the market, or, as David Harvey puts it, "bring[ing] all human action into the domain of the market."[44] By using artworks to explore the braiding of political and affective economy, this book examines the neoliberal as a "structure of feeling" that naturalizes market logic as the dominant mode of engaging with the self and the world.[45]

Neoliberalism is not merely an economic or social phenomenon; it is also an aesthetic project. Its aesthetics are not circumscribed to urban beautification but also extend to acts of *poiesis*, or crafting the self as an economic actor. While the concept of human capital is central to the shaping of subjectivity in liberalized India, it is also imperative for us to situate these transformations within wider circuits of urban culture.[46]

How do artworks explore the human and social costs for the transformation of cities? A city like Bangalore, once imagined as an idyll and a site for

repose, has grown to an incessant nonstop 24/7 work milieu that normalizes productivity without pause and labor without rest.[47] The cultural productions discussed here grapple with the spatialization of time by considering the conflation of temporal notions of progress with spatial plans for growth. In these artworks, the past persists as a spectral force in the "future city," disarticulating the rigid chronology of developmental time. Contemporary cultural productions complicate progressivist teleologies and evoke the kaleidoscopic city, one that provides shifting and illusory configurations of desire and power, selfhood and sociality in the layered and porous city.

Departing from accounts that reinforce the "death of the city" narrative, *Brutal Beauty* explores the vitality, energy, and creativity of urban entrepreneurs as they grapple with radical social and spatial transformations. In cityscapes where advertising images saturate public spheres, where urban beautification projects are fostered through the nexus of private-public partnerships, where "the commons" are rapidly privatized, it becomes increasingly difficult to recuperate artistic interventions that are not subsumed by forces of consumer capitalism. While the artworks described in this book serve as the occasion to explore the ramifications of rampant urbanization, the globalization of the Indian art market also partakes in the discursive production of creative cities. The "city" serves not only as resource for several art projects but also as talisman: nonprofit cultural institutions regularly curate events around the theme of "the city" and invite local, national, and international artists to collaborate and create works. The proliferation of art galleries, theater spaces, and art and design institutes demonstrate the emergence of the creative class as mainstream and alternative, established and emergent artists and entrepreneurs both perpetuate and critique discourses of the "world-class city."

The public-minded artists I discuss in the following pages demonstrate their receptivity to and responsibility toward the city through artworks and performances that give aesthetic form to social confusions. If the neoliberal project of city and self-making acquire a renewed impetus, then these artists rearrange our aesthetic sensibilities by pointing to some of what is lost or at stake in these projects of urban reimagining. The various artworks and performances I consider in this book uncover the dark side of rhetorics around "India Shining."

Drawing on the city as inspiration and resource, these artists belie dominant debates that pit artistic autonomy against the social instrumentality of art. Their entanglement with the city challenges conceptions of liberal individualism that construe persons as autonomous, insular, and self-sufficient. These artists foreground the relational attachments across theater, artist, and civic collectives as the enduring infrastructures of urban life. Their artworks remind us of the porousness and vulnerability of our physical, social, and affective worlds. By heightening perceptiveness and illuminating a sense of civic attentiveness, these artists highlight the shifting affective and social dynamics in the city. This deep sense of attunement between person and place

manifests in a dialectic of receptivity to and responsibility toward the cities in which they are enmeshed.

Artworks amplify alternate modes of cognition: through their sensorial address, they expand our fields of attention and allow us to critically reflect on urban transformations. Looking specifically at urban artscapes in liberalized India, this book examines how economic transformations remake existing value systems and prompt new imaginaries of selfhood and the world-class city.[48] I turn to the creative workers of urban India who grapple with volatile conditions of the rapidly globalizing city. The theater and performance artists I consider here include playwrights Mahesh Dattani and Ram Ganesh Kamatham, artistic directors of New York–based Builders Association and London-based motiroti; Berlin-based Rimini Protokoll; performance makers such as Pushpamala N., Surekha, A. Revathi, and Living Smile Vidya; directors such as Preetam Koilpillai, Vidhu Singh, and the transgender group Panmai; filmmakers like Ashim Ahluwalia; and performative sculptors and installation artists such as Sheela Gowda, M. Shantamani, Vivan Sundaram, and Krishnaraj Chonat. These creative interventions raise a range of concerns from gender, caste, regional, and sexual identity politics to civic problems around the precipitous costs of real estate, migrant labor, electronic waste, media-generated panics, and the precarity of dwelling and traveling within the city. While recognizing that commodity cultures impinge on urban subjectivities, I turn to critical performance makers to consider their creative interventions in the cityscapes of India.

Each chapter takes up specific affective orientations that offer urban subjects strategies of psychic management in the face of radical cultural, social, spatial, and economic transformations. Chapter 1 turns to urban panic as a heightened emotional response to the reterritorialization of space, and the frenzy of construction and building projects currently underway in Bangalore. I explore particular social and cultural ramifications of pervasive construction projects that attempt to remake Bangalore into a "world-class city." The numerous building projects, in particular, manifest the tumult of development in the city. How do these spatial and material manifestations of urban aspiration produce panic as an affective experience of territorial dispossession? Considering panic in relation to questions of property and real estate brings into sharp relief the spatial strategies for negotiating social hierarchies.

The artists I consider in chapter 1—Surekha, Sheela Gowda, Krishnaraj Chonat, and M. Shantamani—examine panic from multiple viewpoints: the insulation of elite enclaves and gated communities from slum dwellings, the precarious homes of migrant laborers, and the pervasive sense of exile for religious minorities in India. The chapter considers how panic is spatialized, managed, exacerbated, or overcome through spatial reconfigurations. Taking up the question of dwellings—elite enclaves, makeshift tin sheds, incinerated homes—these artists probe how social relations between communities are configured through spatial arrangements and move us from a habituated and

routinized sense of panic to a greater openness and responsibility toward class inequalities and cultural difference.

Taking the call center industry as its point of departure, chapter 2 examines the aspirations of urban youth as they navigate nightly regimes of labor. Dramatic performances of cosmopolitan encounters within the transnational framework of the call center industry in India offer crucial insights into questions of aspiration, cosmopolitan subjects, and emerging regimes of labor. How do the virtual intimacies generated by new media and market technologies usher in aspirations toward a new cosmopolitan subjectivity? Discourses of cosmopolitanism evoke ways of being and acting beyond the local, of having affective attachments in multiple spaces beyond the boundaries of the resident nation-state. By invoking cosmopolitanism here, however, I consider its deep entrenchment within circuits of capital. Considering call center agents and the actors who portray them as exemplary of new cosmopolitan subjects, I explore the labor of impersonation in their aspiration to perform within a transnational economy.[49]

Precarious conditions of labor undergird the professional aspirations of Bangalore's young call center workers. Artistic representations of the practices of impersonation within the outsourcing industry puncture a hole in the gleaming facade of Brand Bangalore, touted as India's Silicon Valley. Through a process that simultaneously disavows the material implications of their virtual identities and actively encourages them to imagine, if not identify with, the lifestyles of the white American middle class, impersonation offers the modality through which call center employees aspire to a better life. Practices of impersonation are not disembodied but occur at a complex conjuncture in which material city, global capital, neoliberal state, urban cultural production, social relations, and spatial alignments intersect and shape one another. I argue that impersonation becomes a key means through which citizens remake themselves into consumers who aspire to an imagined cosmopolitan community.

Chapter 3 considers the dramatic shift from discourses of shame to pride in representations of same-sex desire in urban India over the past two decades. From a mere dozen people who assembled at India's first gay pride march, in the eastern city of Kolkata in 1999, now thousands throng urban gay pride marches in Delhi, Mumbai, Bangalore, and other urban centers.[50] Concurrently, discourses around same-sex representation and politics have shifted from shame to the growing aspiration of queer subjects to belong to a horizontal, global community.[51] In December 2013 the Supreme Court overruled the 2009 decision of the Delhi High Court, which declared that Section 377 of the Indian Penal Code (IPC) from 1860, which criminalized "carnal intercourse against the order of nature," should be read down to exclude consensual sex between adults in private. Subsequently, in 2013, the Supreme Court ruling reinstated the 153-year-old colonial law passed under British rule, in the process further igniting and intensifying a mounting experience of queer defiance that taps into a global sense of outrage against injustice

toward queer and LGBT subjects. In September 2018, the Supreme Court decriminalized homosexuality in India.

I situate the affective shift from shame to self-assertion in the context of the booming NGO industries in urban India.[52] The medical and social institutions and discourses that surround AIDS play a crucial role in the globalization of same-sex identity politics and the emergence of queer self-hoods in India. Are LGBT and queer rights struggles in India caught within a progress narrative that rehearse developmental accounts of the liberation from stultifying tradition to an imagined cosmopolitan community of global queers? Through a consideration of Mahesh Dattani's plays, chapter 3 charts the emergence of an identitarian model of expressive same-sex politics that draws on transnational AIDS activism, queer pride parades, and queer film festivals, in addition to the increased visibility of same-sex desire in mass media and public culture at large. The chapter concludes with a consideration of the nonelite transgender performers A. Revathi and Living Smile Vidya and the first transgender theater group, Panmai. I discuss their confessional performances, which chart the trajectory from the sense of stigma of caste identity and nonconforming gender identities to their aspiration for freedom from humiliation and a life with dignity.

While the first three chapters examine the crucial role of performance in the formation of an aspirational selfhood, whether as a high-tech worker, a homeowner, or as a queer activist, chapter 4 explores narcissism as a technology of self-dissolution. How may a subject resist discourses that urge a sense of Promethean striving? What may a politics of refusal to the incessant entrepreneurialism of the self look like? In an environment that routinely indoctrinates "self-reliance" and "self-empowerment" into citizen-consumers, how might a counterintuitive reading of narcissism illustrate the unmaking of the self? This chapter examines the work of visual and performance artist Pushpamala N., whose *Phantom Lady* series illustrates that narcissism develops not only as an emergent culture of self-absorption and entitlement but also as a libidinal intervention in an environment increasingly organized and rationalized under "the performance principle," where competitive economic performances of its workers are closely managed and scrutinized. Pushpamala N.'s *Phantom Lady* series illustrates that the libidinal economies of media urbanism are a primal and primary sensuous mode of experiencing India's expanding metropolises. The chapter ponders whether narcissism can trigger a different reality principle and playfully defy cultures of toil, industry, and domination. The modernist imaginary of the administered, planned city gives way to the vertiginous repertoire of an urban sensorium that exposes a chiasmic and libidinal economy.

Brutal Beauty charts the itineraries of the aspirational subject as she traverses a journey from entrepreneurial self-making to the detritus of spent desire. Chapter 5 explores artistic engagements with obsolescence to examine the systematized human degradation that becomes part of the market

calculus of value and waste. Turning specifically to artworks by Vivan Sundaram, Surekha, and Krishnaraj Chonat, this final chapter asks, What are the human, social, ecological consequences of the current valorization of innovation, speed, and enhancement? In particular, what are the material effects of technological and human obsolescence in relation to the looming transnational problem of international electronic waste being dumped on Asian shores? How do we understand the pervasiveness of obsolescence, the feeling of pastness, of having outlived one's utility, in cultures that celebrate youth and newness? How do persons become the collateral damage of consumer capitalism? Turning to obsolescence as an affective corollary to cultures of waste and disposal, and considering the performance of waste, I discuss the highly exclusionary social worlds that are engendered through spatial and social demarcations of hygiene and filth, privilege and poverty, technology and tradition. The material life of discarded things and, by extension, the obsolescence of persons, professions, and lifeworlds makes vivid the spectral histories of innovation and technology in the city. Examining these works of art reveals the relational dynamics and porous borders between persons and things, and allows us to see how contemporary capitalism produces cultures of obsolescence that not only render commodities as waste but also mark people as having outlived their value and utility.

While the liberalization of the Indian economy in the late 1980s and early 1990s propelled the much-touted Indian "art boom," it simultaneously produced a host of critical artists who draw from and détourn the pervasive entrepreneurial exuberance in the city. By considering the dispersion of innovation, dynamism, and artistic creativity into cultural terrains, this book avoids pitting corporate domination against creative insubordination. These artworks neither transcend nor subvert market forces; they are buoyed up by the very global market circulations that they seek to critique. Yet this does not evacuate their work of critical resonance. These artworks exert an aesthetic force by activating a sense of aesthetic and critical judgment that presses back against the vigorous tide of neoliberal rationality. *Brutal Beauty* illuminates this complex agonistic encounter between capital and culture by considering how emergent capitalist norms are variously imbibed, inhabited, contested, and negotiated on the ground.

As postcolonial cities are integrated into new transnational geographies of markets and labor through networks of communication and capital, the older model of insular, internally coherent modernist cities, subordinate to national planning, gives way to transnational urbanized networks of culture-scapes. Confounding the earlier center/periphery, city/country spatial binaries, exceeding the jurisdictional boundaries of the nation-state, the Indian city eludes coherent and predictable grids for comprehending and containing city politics. Considering the dynamic and dialectical relationship between affective and political economies, this book argues that modern urban life is not only composed of the architectures of its built environments

or the infrastructures of its formal and informal services; it is also shaped by libidinal forces not reducible to a flattened discourse of urban planning.

Brutal Beauty traces urban aspiration in the wake of neoliberal economic reforms and delineates the affective undercurrents that pulse through the city and shape its social contours and psychic life. In the pages that follow, we see the emergence of new dramatis personae unlike Baudelaire's strolling flaneur of nineteenth-century Paris. On the streets and sidewalks of the city and in railway stations, shopping malls, call center offices, pride parades, theaters, and underground cultural productions, we encounter a host of newer urban subjects: the urban planner, the call center worker, the technocrat, the road-maker, the construction worker, the queer activist, the Dalit transgender, the enervated action hero, the displaced farmer, the migrant laborer, the waste picker. While caught in the ebb and flow of urban life, these protagonists of a new India allow us to glimpse their aspirational dreamscapes, the passions and actions that drive their performances of survival in the city.

Chapter 1

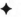

Urban Striving

Panic, Property, and Precarity

A simple line drawing of a "modern home" is superimposed against a series of photographic images of a demolished residence in Seshadiripuram in Bangalore. Within the precise and clean boundary of the simple line drawing of a house, we see chaotic scenes of upheaval and disorder: colorful articles of strewn clothing, a suitcase, an abandoned shoe, jagged pieces of crumbling concrete. Broken, erect stone pillars jut out from the gutted foundation, a thin plaster of pale green paint clings to the underlying red brick wall recalcitrantly, the walls pockmarked with rusted iron nails now bereft of their adornments. On a solitary rusted nail against a barren wall hangs a bunch of silver, red, and yellow glass bangles. Rear shots of bare, calloused feet on wooden slats, the legs covered in a modest sari, suggest the impoverished class of the subjects. Another picture shows a man seated on a chair, a middle-aged woman bending over her daughter, an elderly woman surveying the scene—their belongings scattered everywhere.

Surekha, a conceptual and performance artist from Bangalore, created these images and the subsequent installation, *They had their home here*, in 2008–2009. In each composition, Surekha visually superimposes, with clinical precision, the line drawing of a simple house against these frantic photographic scenes. Capturing scenes of eviction, Surekha's photos document the impact of demolition and dispossession: the evicted sit listlessly on the rubble with their belongings strewn on the ground where their homes once stood. The smoking concrete, calloused bare feet, and scattered belongings convey the ways urban development projects disorder homes and lives of these dwellers.

In a related series, *Skin Home*, Surekha uses the same line drawing but this time fills the outline with close-up shots of the grain of the skin of those evicted. The outlines now consist of the fleshly materiality of those evicted: pink and brown skin, palms of laborers, their children and family—skin that is soft, calloused, aged, youthful, brown, displaying veins, moles, hair. Arranged in kaleidoscopic patterns, the granularity of the skin reminds us of the nonfungibility, the singularity of each inhabitant. The lines on the

Figure 2. Surekha, *They had their home here*, Travancore House, Delhi, 2009. Photograph by Surekha, courtesy of the artist.

palms connote an alternative mode of conceiving of futural temporality than the developmental narratives of urban planning. These particular sensuous details fill in and engulf the outline drawings of standardized houses.

Surekha cuts out these images in the shape of identical standardized homes, the replicable form belying the affective and disorderly excess of its content. Pasting these images on a large tarpaulin sheet affixed to the floor, this site-specific installation invites viewers to walk and trample on these images as they survey the art installation. In a dark, defunct fireplace of the gallery, a film screening flickered neon light. The *Skin Home* series of six images was framed and mounted on the wall. This scene of eviction, Surekha reminds us, lays the foundation for the emergent aspirational homes in the metropolis. There's a coarse, unfinished quality to the work, which seems to capture some of the frantic disarray, a sense of quiet foreboding and mounting panic of sudden dislocation from one's home.

The superimposition of the line drawing on the photographs starkly illustrates how a particular sensuous experience of habitation is transformed into replicable and standardized property. The seemingly banal operation of property development turns real estate into tradable commodity through a process of abstracting, systematizing, and transforming the messy particularities of informal settlements into identical and replicable homes. Juxtaposing the sterile, standardized pattern against the nonfungible materiality of the

evicted reinforces the structural violence of forcibly detaching people from their social enmeshment and human attachments.

These images flicker between promise and despair: the aspiration for a modern home sits uneasily with the rubble of their current residence. In Surekha's words, "Bangalore has been my city. I was born and brought up here. I was born into a peasant's family and my ancestors must have stayed here for at least two hundred years. Actually over the years I have seen the transformation of Bangalore, particularly its rural areas. I have witnessed the city taking over the village. My parents lost their land and had to adapt to new ways of living and working."[1] All that remains standing are abandoned belongings, fragments of posters, colorful bangles, and other material things that cling tenaciously to crumbled concrete.

The demolition of informal settlements that make way for development projects is a routine spectacle in urban India. During my sabbatical research year, I witnessed the demolition of informal settlements in Ejipura in East Bangalore between January 19 and 20, 2013, that led to evictions of a community of eight thousand people: children, elderly, Dalits, religious minorities, and other disenfranchised communities.[2] In contravention of the Karnataka Municipal Corporations Act, which does not provide for transfer of land to a private party, plans are afoot to redevelop Ejipura into a shopping mall under a public-private partnership.[3] Such a partnership will divert seventeen of the twenty-two acres of land originally allocated for housing the urban poor to Maverick Holdings and Investments Ltd. (a private developer) to construct a shopping mall, while the remaining five acres will ostensibly be developed into quarters for the original slum dwellers.[4]

As an aggressive tactic in beautification programs, the evictions in Ejipura appeared not only to purge the city of its ugly elements but also to drive its residents to the outskirts of Bangalore. The diversion of public land for private profit resulted in extreme uncertainty for the evicted slum dwellers who grapple with urgent immediate concerns, such as keeping warm and safe while out on the streets in the cold January weather, as well as concerns about leaving their meager possessions behind when they leave for work, the disruption of their precarious employment (mostly as garbage cleaners, construction workers, and domestic workers), and their children's education (even as they prepare for their examinations) as they are pushed toward the city's peripheries. As Sanjay Srivastava reminds us, these urban settlements constitute "parallel histories" that sit uneasily along with the spatial histories of national monuments and middle-class housing.[5] In the name of beauty and progress, then, the destruction of these parallel histories attempts to coercively erase not only habitations but also people by the diktat of the neoliberal state.

The evictions and ravages at Ejipura did not go unnoticed by the citizens of the city. There were impressive protests of solidarity by citizens who came together to provide food, medicines, and blankets to assist the evictees. In addition, protestors thronged Garuda Mall to oppose the predatory acts of

destruction in Ejipura. By making visible that which is deemed unsightly, these acts of protest insist that the inhabitants of informal settlements be recognized as citizens of the nation.

The sheer brutality of urban beautification programs, slum evictions, and the destruction of urban settlements reveals the fervor with which the neoliberal state pursues capital accumulation. Ananya Roy reminds us that "public purpose" and "consent-based compensation" lie at the heart of civic governmentality.[6] However, with the rapacity of the coercive state, poorer citizens are evicted unscrupulously, while governments take recourse in neutralizing rhetorics of consent and compensation. As Roy points out, the irony of deploying the notion of "consent" is especially stark in a context where the poor are subjected to extreme inequality. How does a slum dweller consent to being displaced from her home in order for a government to acquire properties allocated to the Economically Weaker Section? Evicting the poor from property allocated to them in order to reap profits from private partnerships reveals how the state wields the ambiguous discourse of "territorialized flexibility" to effect its insidious designs on its own disenfranchised citizens.[7] The absence of effective governance is itself a strategy so that the informalized state can elude accountability.

The liberalization of the Indian economy drove policies that enabled foreign direct investment in Indian real estate, which has reconfigured encounters between Indian real estate developers and investors, prior tenants and potential customers, establishing new encounters and practices in the real estate market. Given the frenzied pace of India's real estate market, property development in India has become a potential site for capital accumulation both within the country and abroad. Investors, developers, consultants, and government officials are players in a global network that transforms real estate for local uses into an international financial resource.[8]

This chapter examines the dark side of aspiration. While acquiring property indexes a key means for exerting a sense of aspiration and freedom in one's life, this chapter considers the panics that are generated in spatial struggles over home and belonging. Property is not simply territory; it is also a social relation that mediates transactions between city dwellers. As the object that makes subjects, property traffics in a sign system not reducible to an inert conception of neutral space. Taking up the question of dwellings— demolished homes, makeshift tin sheds, incinerated dwellings, apartments, and elite enclaves—the artworks discussed below probe the ways urban precarity incites feelings of suspicion and anxiety and produces panic that reshapes social relations and reconfigures spatial arrangements. Moving beyond discussions of panic as a response to a particular stimulus or as a generalized condition of neoliberal society, these artworks make visible the particular social forms generated by these urban affects. Before I turn to a closer analysis of these artworks, I sketch out below the cultural and historical environment within which these artworks emerged.

Heteronomous Art Practice in the Neoliberal City

Unlike New Delhi or Mumbai, Bangalore is not renowned for its gallery system or a state- or privately owned museum culture. While it does boast some innovative and established gallery spaces (e.g., SKE, Sumukha, Tasveer, the National Gallery of Modern Art, and Venkatappa Art Gallery) that exhibit experimental and renowned artists, the vast majority of galleries cater to Bangalore's increasingly affluent consumer market. Key artists such as K. Venkatappa (1886–1965), who studied with Abanindranath Tagore of the Bengal School, Paranje (1882–1965), who studied at the Sir J. J. School; his student Hebbar (1911–1996), who also studied at the J. J. School; and Hanumaiah (1909–1991), who studied at Chamarajendra Institute in Mysore made an impact on generations of artists in Bangalore. In addition to influences from the art schools in Bombay, Bengal, and Baroda, the Madras Art Movement (1950–1980) and Cholamandalam (1966) and the significance of K. C. S. Paniker (1911–1977) and his son, other prominent voices within the artistic community in Bangalore included sculptor Nandagopal (1946–2017) and S. G. Vasudev (1941–). As a result of these cultural confluences, the arts scene in Bangalore retains a healthy aesthetic cosmopolitanism and innovative spirit where multiple artistic styles and practices came to flourish.

Moreover, the city is unique in its artist-initiated cooperatives, where artists come together through jointly owned and democratically run alliances.[9] Such cooperatives bring alternative aesthetic and ethical values to our understandings of autonomy and heteronomy and exemplify what Shannon Jackson calls "infrastructural politics of performance" that conjoins aesthetic and social dimensions, and emphasizes "sustenance, coordination, and rematerialization."[10] In addition to its experimentalism, the contemporary art scene in Bangalore is distinctive for its lateralized system of peer support through associations, residencies, and more informal channels of feedback and critical nurture.

The discourse of aesthetic autonomy follows a complex itinerary in India. The "autonomous" and austere character of Karnataka's preeminent artist, K. Venkatappa, of the princely state of Mysore, draws from the mystical and spiritual aesthetics that were promulgated in the Bengal School, where he studied under Abanindranath Tagore.[11] Venkatappa's autonomy is grounded in his practice of *aparigriha*, a yogic vow he undertook in 1913 when he formally renounced any service from others. His subsequent vow of *brahmacharya*, or celibacy, further suggests his disdain for sensual pleasures and his yearning to channel his creative energies toward "spiritual" aesthetics. Here we see that autonomy derives not from a conception of liberal individualism or radical avant-garde subversion but, rather, from an ethic of renunciation and nonattachment.[12]

If Venkatappa insisted on cultivating an austere autonomy in his aesthetic pursuits, the artist and teacher Rudrappa Mallapa Hadapad maintained the

importance of heteronomy in the formation of aesthetic sensibility. Born in 1932 in Badami and trained in Bombay's J. J. School of Art, Hadapad was a pivotal figure in the formation of a collaborative and associational civil society of artists in Bangalore. In 1968, Hadapad founded Ken School and espoused a philosophy of art as a way of life rather than as an object-based practice. He encouraged the use of art as a means of remaking society through deliberate pedagogical, social, and political interventions. Along with a group of dynamic young artists including Yusuf Arakkal, S. G. Vasudev, Balan Nambiar, Milind Naik, and G. S. Shenoy (known as the Karnataka Painters), Hadapad energized the arts scene in Bangalore by taking on institutional positions, fostering associational ties among artists, and promoting pedagogical and mentoring practices between generations. Hadapad, like K. K. Hebbar, served as chairman of the Karnataka Lalit Kala Akademi (1987–1990). Hadapad's influence on artists such as Sheela Gowda, Surekha, and others I discuss in the following pages is hard to underestimate.[13] He insisted on an attitude of artistic humility, an acknowledgment of the power of the things we make to remake us. Moreover, he advocated an ethic of interconnectedness that cuts across institutional and class hierarchies and inspired his students to follow in his footsteps and conceive of artworks as relational aesthetic experiences.

Here the focus on "relational aesthetics" derives not merely from a harmonic conception of social relations, as Nicolas Bourriaud delineates in his well-known endorsement of the concept, which emphasizes the ways contemporary artists resist aesthetic commodification or social alienation by avowing the heteronomous dimensions of art practice.[14] While for Bourriaud the artist produces "relations between people and the world, by way of aesthetic objects," for Hadapad the relational dimension of art practice is engendered from a range of exigencies that include government budget freezes, lack of state support, and diminished resources from nongovernmental agencies, which prompt artists to reach out and support each other through voluntary efforts to raise funds.[15] The relational aesthetics are not circumscribed to their artworks; rather, social relations across artists takes on aesthetic qualities, inspired by a sense of care, nurture, and support. This is evident even in contemporary art practice in the city where artists organize lecture series such as Somberikatte (curated by Pushpamala N.) and Ananya Drishya (curated by S. G. Vasudev) to observe and comment on their colleagues' work. These gatherings not only supply a professional environment where artists receive careful critical feedback; they also provide communities of conviviality and care.

Contemporary residencies offered by groups such as Samuha, BAR 1, 1 Shanti Road, Jaaga, Maraa, among others, exemplify the convergence of creative practice, public goods, and civic conscience in the networks of artist collaborative endeavors. Artist residencies mushroomed as alternative venues to the gallery system to allow a slower pace and more collaborative

environment that fosters self-reflexivity and risk-taking in the creation of art-works. For example, Samuha, an artist collective initiated by artists Archana Prasad, Suresh Kumar G., and Shivaprasad S., facilitated a space where artists could come together and showcase, collaborate, and curate works of their peers.[16] Among the more established residencies, Bengaluru Artist Residency One (BAR1), initiated by Swiss artist Christoph Storz, serves as a nonprofit exchange program by artists for artists to foster the regional, national, and international exchange of ideas. Akin to Khoj in New Delhi, BAR1 was conceptualized from within the local Bangalore artist community. Another example is 1 Shanti Road, the residence of Suresh Jayaram, artist and art historian and former dean at Chitrakala Parishad, one of Bangalore's premier art schools. Since its inception in 2003, 1 Shanti Road has functioned as a venue for artist residencies and exhibitions as well as performances, lectures, and arts events. This warm and hospitable environment fosters relationships between artists, curators, scholars, writers, and young students in the city and beyond. Jaaga is another brainchild of the dynamic artist-entrepreneur Archana Prasad, who combines visual art, technology, and urban community performance to create public art projects.[17] She collaborated with technology evangelist Freeman Murray to create a living building space, Jaaga, a unique architectural experiment using pallet rack shelving material to construct a large-scale, multistory inhabitable space. Jaaga brings DIY improvisational and design thinking to repurpose flexible workspaces for a range of "creative capitalists," from start-up entrepreneurs to activist queer groups. Maraa is a media and arts collective, founded as a charitable public trust, that uses a range of arts and performance events to foster greater civic consciousness around issues pertaining to urban public space, sexual violence, and community media activism.[18] Undertaking curatorial projects, Maraa supports artists and encourages the use of performances in nontraditional public spaces including parks, playgrounds, sidewalks, bars, and bookshops. Its annual festival, October Jam, provides urban residents with opportunities to sensuously explore the city through a variety of forms, including walks, projections, installations, and performances, to probe questions of urban commons, access, privilege, and exclusion. These collectives bring together critical and creative practice to dwell on the usurpation of "the commons" with the increasing privatization of public resources in the city.[19]

Poetics of Dwelling

Bangalore-based artists Sheela Gowda, Krishnaraj Chonat, and Shantamani Muddaiah explore social and cultural ramifications of pervasive construction projects that attempt to remake idyllic Bangalore into a world-class city. The numerous building projects, in particular, manifest the frenzy of development in the city. The artworks critically comment on affective geographies of

dwellings and raise crucial themes in the wake of unbridled world-city-making projects: the increasing insulation of elite enclaves of gated communities, the resultant "active economies of dispossession," and the usurpation and remaking of the "dead capital" of rural hinterlands into the high-value liquid capital of speculative property.[20] These artistic interventions into the question of property illuminate struggles over competing claims to the city and articulate alternative imaginaries of belonging in the city.

The question of property in the liberal imagination is deeply enmeshed in conceptions of personhood, ownership, and liberty. For Kant, autonomous persons are ends in themselves, possess free will, and deserve respect and dignity, whereas objects, as heteronomous entities, are not ends in themselves, do not possess free will, and are manipulable at the will of persons. Property, in Kant's political philosophy, enabled persons to extend the realm in which they exert their free will by manipulating objects to their own ends. Property was necessary to give full scope to the free will of persons: they must have control over objects in order to fully constitute themselves as persons.[21] In the liberal imagination, property tethers person to place providing order, security, and certitude in a disorderly and fluctuating world.

The artists I discuss here move beyond liberal understandings of property and personhood; they recuperate a more labile and multivalent conception of property. They make it clear that the question of urban property and the ownership model it espouses are more ambiguous and politically contested. From state evictions of dwellers of informal settlements to development-driven displacement of the urban poor and subsequent gentrification, these artists shine a light on a variety of spatial struggles. By exploring the many socioeconomic tensions and legal frictions enmeshed in spatial struggles, their artworks probe the ethics of property.

Aggressive economic reforms trigger a sense of structural vulnerability and evoke a range of affects, from anxiety and fear to panic. Rebecca Schneider and Nicholas Ridout remind us, "Precarity is life lived in relation to a future that cannot be propped securely upon the past. Precarity undoes a linear streamline of temporal progression and challenges 'progress' and 'development' narratives on all levels."[22] In the ubiquitous "state of emergency" post-9/11 global society that we now inhabit, panic erupts as a response to conditions of precarity that characterize contemporary urban life and subsequent ontological insecurity. In *Liquid Fear*, Zygmunt Bauman observes that fear is the defining trait of our post-9/11 world. As he puts it, "Fear is the name we give to our *uncertainty*: to our *ignorance* of the threat and of what is to be *done*—what can and can't be—to stop it in its tracks—or to fight back if stopping it is beyond our power."[23] Ulrich Beck describes our contemporary world as a "risk society" and argues that risk is omnipresent, "an inescapable structural condition," and being at risk is the way of being in the world of modernity. Brian Massumi warns of an "ever-present threat" that possesses and modulates individuals through bodily and affective reactions

that produce "fear-based collective individuation."[24] Ernst Bloch delineates the futural temporality of anxiety as an "expectation emotion," which "aim less at some specific object as the fetish of their desire than at the configuration of the world in general or (what amounts to the same thing) as the future disposition of the self."[25] Bloch is attentive to the ways that affects lubricate the interstices between the world and the self. And according to Keith Tester, panic is an unusual but typical experience of contemporary social relations that rely on extremely complex and fragile networks of interdependency.[26]

While Bauman discusses "liquid fear" as characteristic of contemporary life, and Beck discusses "the irrepressible ubiquity of radical uncertainty in the modern world," Tester identifies panic as an adaptive response such as "irrational flight" from a stimulus where one perceives threat or danger. Here panic functions as a means of social control and as a form of collective flight response in relation to questions of property and real estate. These ways of conceiving of panic either dissolve and disperse it into an ambient, pervasive, and inescapable condition of modernity or narrow its compass by reducing it to a discrete response to an environmental stimulus.

The sense of precarity produces ambient anxiety, which when exacerbated erupts into immobilizing scenes of panic. While anxiety, a temporal affect, acquires its energy from projections into and about the future, from scenes of worrying about how the future may unfold, panic is often conceptualized through temporal paralysis. The state of emergency induced by panic collapses temporal horizons into a compacted and vertiginous "now." Panic provides a chronotope to think of the arrest of movement on both temporal and spatial registers. Unable to escape its stranglehold, panic evokes a sense of entrapment that goes beyond physical confinement to a feeling of inescapability, even desperation. One is seized by panic, the affective agent that transforms the perceiver into a thing. Panic is contagious: circular, incited by rumor, yet an affect that incites self-interested desperation and a resolve to survive at all costs.

In the precarious city, panic is normalized across class and social strata. Panic is neither an aberration that departs from routine nor so dispersed and inescapable that it loses its social form. The lens of property and development enables a reconsideration of urban panic, produced under conditions of social and economic precarity. An increasingly prevalent affect, panic exacerbates suspicion and anxiety and drives a wedge between communities and individuals in the city. Rather than a diffusive and pervasive conception of "liquid fear," as the dominant condition of contemporary life, artworks reveal the particular social forms that panic takes in ways that delineate the contours of this urban affect. They depict how panic is routinized and spatialized in scenes of evictions from informal settlements, habitations of minority and migrant subjects, and elite escapes into gated communities insulated from the gathering menace of the world. A temporal affect, panic deterritorializes urban subjects and geographies of dwelling. This chapter looks at a range of

sites of panic, from evictions from homes to insulated gated communities to minority and migrant dwellings.

Sheela Gowda: Choreographies of Viewing

Sheela Gowda's ash installation, *Collateral*, was first produced for Kassel's Documenta 12 in 2007. *Collateral* (2007) was made by rolling, arranging, and burning incense on mesh frames to produce intricate patterns. Extremely fragile, the sculpture enables us to witness the transformation of material as it passes from life through death and leaves behind its residue.

The installation evoked for me the devastation wreaked on the urban slums in Ejipura and viscerally brought back numerous stories I had heard of slum settlements and squatter colonies that mysteriously "catch fire" and burn down, conveniently paving the way for new constructions and megacity projects. Despite its serene beauty, *Collateral* brought to my mind scenes of panic, the devastation of homes and lives that are victim to, indeed collateral damage of, the unchecked ambitions of frenzied urbanization in the city. Is this the burnt-out residue of houses or the entrails of its dwellers? The aerial view of burnt remains allows one a God's-eye view of urban planning and of the real estate that could be redeveloped. The smoking residue evokes the notorious practice of setting fire to the slums and hut settlements of the urban poor to evict them from their homes to usurp the land for commercial and housing development.

When shown in Rivington Place, United Kingdom, in 2011, *Collateral* occupied the entire upstairs gallery space: eight wooden frames of various sizes were raised thirty-five centimeters above the ground. Myriad shapes of incense sculptures adorn the underlying mesh metal: some oval and spherical, resembling Indian rotis, others winding like long entrails of a charred snake across the mesh floor, several smaller broken fragments in rectangular and square shapes. Discernible on the incense ash beds are gently drawn patterns, like the netlike veins of a leaf, or the filigreed outline of veins on skin. Others reveal enlarged protuberant pores. The colors wash across the sculpture evocatively: monochromatic shades of soft gray and brown, muted tones bring a contemplative serenity to the installation. A large glass jar in one corner of the room holds the ash from the earlier 2007 Kassel installation, inadvertently accentuating the mystical dimensions of the piece.

In *Collateral* Gowda combines charcoal, tree bark powder, and water to make dough, which she kneads into incense for burning. The very act of working the dough is reminiscent of how roti, Indian bread, is made—a typically feminine gesture of making food and giving sustenance. She rolls the meticulously made incense, then arranges it on mesh frames and sets the mixture alight. What viewers see is an arrangement of intricate patterns of muted colors, pale gray-brown ash, the residue of a burning, breathing life.

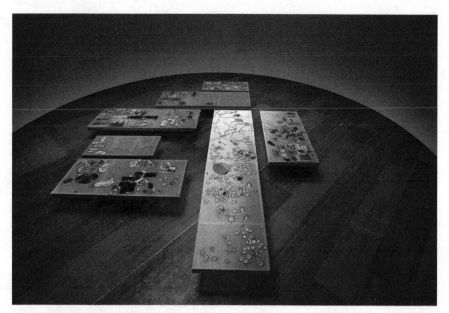

Figure 3. Sheela Gowda, *Collateral*, Documenta 12, Kassel, Germany, 2007. Courtesy of the artist and GALLERYSKE.

The incense also resembles flattened bread that is then set on fire. We watch as sustenance turns to a scene of expiration. The incense burns and turns to ash on stretcher frames covered in stainless steel mesh. The drama is as much of the slowly dying incense as it is of the steel mesh that holds the incense without suffocating it. Incense needs air to breathe—it will die out if it is laid on a flat surface. The mesh is both pragmatic and symbolic: it brings air to the incense to allow it to breathe, in addition to holding the incense. The extreme economy of the work is typical of Sheela Gowda's method. As she puts it, "I feel challenged when I limit myself—I want to be frugal—it makes the result intense. . . . If I am using a material because of its associative meanings then using other materials alongside it dilutes the reading."[27] It is a fragile scene of holding—a lesson in how to hold, without smothering the other person of the very air she needs to live. *Collateral* offers a glimpse into life support. A detailed and careful composition of broken circles, irregular squares, coiled spirals, supported on rectangular wire meshes, bears witness to scenes of proximity, holding, and togetherness.

A crucial element of Hindu rituals, incense conveys the smoldering remains of material life. Gowda arranges the incense in imperfect circles, deformed squares, twisted spirals atop rectangular wire meshes that appear to hover above the cool concrete floor. Gowda is selective in her use of materials. Her conscious decision to turn away from media and more fully embrace the

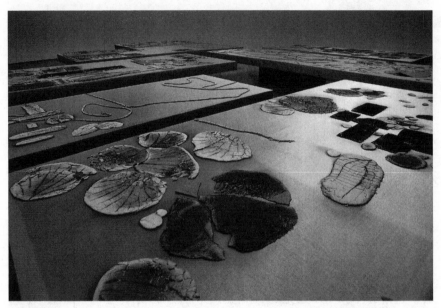

Figure 4. Sheela Gowda, *Collateral*, Documenta 12, Kassel, Germany, 2007. Courtesy of
the artist and GALLERYSKE.

challenges of the particular materials she works with was derived in part as a
response to the rampant social transformations in India in the 1990s. The rise
of the Hindu Right and the concurrent intensification of economic liberaliza-
tion deployed media to stream incessant political and market ideologies. Her
turn to the texture and materiality of things was a response to an unrelenting
stream of discursive and mediatized accounts of crises that produced a gen-
eralized nervousness and jumpiness in the populace. Rather than rehearsing
the confining affective surround produced by panic, Gowda's contemplative
artwork offers her viewer a somatic release from such fretfulness, and the
opportunity to dwell on the afterlife of panic and devastation.

Sheela Gowda's sculptural installations are marked by a certain tenacious
tenderness that derives from her growing sense that her abstract watercolors
were materially divorced from and unable to incisively address the social
and political transformations she witnessed around her. Painting offered no
points of resistance—its easy canvas allowed one to paint in an effortless
sweep; it did not offer the friction of sculpture, which Gowda felt she needed
in order to make art. Resistance is an important facet both in her conceptual
and methodological engagement with art practice.

Eschewing the path of least resistance, Gowda builds challenges into her
own work. Gowda acknowledges that it is sometimes important to travel
through more circuitous routes that defamiliarize the patently visible everyday

life that she takes as her source of inspiration. Taking the more arduous path disallows the viewer to witness the artwork as ready, finished, prepared for immediate consumption and gratification. It provides a window into the far more labored processes of production, which are both intensely experienced in the act of viewing and also on occasion made visible to the viewer.

The urban enters Gowda's work not as conscious ideological commentary or as strident politics. But the work registers the transformations: civic, political, social, cultural changes that are produced as a result of the rapidly urbanizing society that she inhabits. It enters into this work as a sensibility of the maker and through the sensuous trace of the materials she uses in her work. As Gowda puts it,

> Any material that you choose to work with, because it will have its own resistance, it will have its own will, it will have its own history but at the same time it can be quite passive and allow you to do things with it. How do you use it or misuse it, respect or disrespect its character? In my case, I have always wanted to let the material speak for itself and not supersede it completely, yet it is the material that I have chosen amongst thousands of other materials. . . . There is a reason, a purpose and something that I want to say to it, with it, which is why I have come to using varied but specific materials for a long time and continue to do so. You can take a material and break it up or cut it up, make it seem like something else altogether, give it another identity, so much so that the material itself does not matter and what appears finally becomes its new identity. I am not interested in using material this way. I've always been interested in the material itself and what it represents.[28]

In so saying, Gowda cognizes that what the artist chooses to do with the material is in her hands, suggesting both the manual dimensions of this sensuous labor and the sense of responsibility that she bears to the particularity and historicity of the material she uses. She does not set out to make a statement about the material—she will simply get out of its way. Her method suggests an ethic of yielding to the material rather than attempting to mold it according to her willful artistic vision—of respecting sensuous materials as bearers of their own stories that urban audiences need to learn to listen to.

The installation evokes the precarity of life, of dwelling, and of support.[29] In the words of Gowda,

> The ash rests on differently proportioned grey "beds" made of stretched metal mesh on frames, which are positioned 30 cm above the ground giving it a floating quality. This gives the work a constructivist presence. The steel mesh allows air to flow beneath the incense for it to burn. It is a practical need, which I have made an essential component

in the reading of the work. For me, this aspect of combining practical issues to the conceptual is very important. Conventional sculpture tends to subscribe a passive role to the pedestal that it is placed upon. But for me the "pedestal" is an integral part of the work. A pointing finger is not a tool to look elsewhere but in itself of interest.[30]

The term "collateral," the title of Gowda's installation, connotes a range of meanings: in its more modern usage of the term it suggests exchange value, something given as security in exchange for something. Etymologically, it signifies genus, of familial (lateral) genealogy; it also derives from the medieval Latin *collaterālis*, for "coming together," and *laterālis*, or "of the side," referring to parallel or lateral organization. Collateral brings together temporal ideas of genus with spatial ideas of proximate togetherness. Gowda's title for the installation evokes a sense of togetherness, familial and spatial, conjuring communities of kin and proximity.

Gowda implies these relationships of kinship when she speaks about the different frames she uses in the piece, "There are three sizes, two that I call 'man-size' and two which are 'child-size.' I kind of play around to imagine relationships between father and son, mother and son. There is a pairing that happens but on the whole [the mesh pieces] are together. They have silence, I see silence there."[31] Encouraging her viewers to "see silence," Gowda evokes the sensorium in ways that stimulate her viewers to bring a full-body attention to scenes of expiration.

The title of the piece, *Collateral*, troubles the viewer's aerial perspective, one typically associated with an imperious God's-eye view of urban planning. The aerial perspective not only connotes objectivity and impartiality but also enables surveillance and control. So why call an installation of aerial aesthetics *Collateral*, a term that emphasizes lateral relationality? This scene of remote sensing does not imply instrumental alienation; rather, an affective charge suffuses and surrounds the aerial perception of encountering these landscapes of ruin and bereavement.[32] Highlighting the affective excess of aerial aesthetics, Caren Kaplan reminds us of the ambiguities of aerial imagery, noting that even if the designs for aerial surveys are tied to clinical military designs, their experience provokes unruly intensities.[33] She argues that remote sensing is too easily conflated with imperial visual regimes, and she recuperates it as a set of complex and mobile techniques of apprehension, which generates productive ambiguities between abstract and lived knowledges. Complicating distance and proximity, vertical abstraction and horizontal proximity, *Collateral* proffers a new mode of urban perception, a way of grasping the "big picture" through the ethics of lateral relationality. Gowda demonstrates how intimacy and affective excess imbue aerial modes of perceiving collateral afterworlds.

Therein and Besides, the exhibition's title, points to both "therein"—the very substance of life, its material, its irreducible, nonfungible thingness—and

"besides"—its lateral relationships, which are arranged to evoke kinship and offer a sense of comfort (i.e., having someone beside you) but also, like the simultaneously resilient and sheer mesh, offers you the support to breathe. *Collateral* dramatizes a scene of expiring and suggests a way to stand beside, and to hold, someone you love. But the viewer does not witness the death of a singular figure—she witnesses how the death of one we love also makes something in us die. The pairs here suggest that we do not die alone, indeed kinship promises togetherness even in the very process of death. It is a commitment to be with the loved one, to hold her, even in the very process of losing her. The smoldering remains of *Collateral* convey the devastation of lifeworlds in the pursuit of an international game of capital accumulation, speculation, and financialization. Moving away from vertical and hierarchical relationships between persons and things and toward lateral relations between persons and other materialities allows us to take a step toward a more ecological sensibility.[34]

Gowda returns to the question of habitation in the rapidly globalizing city in works such as *Darkroom, Private Gallery, Someplace, Sakshi Guddi, And Tell Him of My Pain*. Gowda's material meditations move the audience from passive consumer of art to an embodied sharer of experience. The artworks do not allow the viewer to stand at a distance, observe, and admire them; rather, they solicit, summon, and rouse the viewer through their sensuous address. Gowda's works make certain bodily demands on the viewer. Often the viewer has to take the risk and enter into the work, obliterating modern aesthetic dichotomies separating spectating subject and inert object. The installations insist that you reexperience your bodily habitus, reconfigure yourself in relation to the new spatial demands of the sensuous artwork. In rejecting the ways the commodity market and the art market have colluded to position the viewer as consumer, Gowda's work forces the audience to enter into a very precarious space. The tenuousness and frailty of the artwork provides a clue to the qualities that the viewer must bring to bear on her experience of the artwork—an attentiveness, openness, humility, and respect for the spatial and psychic worlds that we are invited to momentarily share. Gowda's work invites us to lose our bearings and sense of control, rescale our self-importance, and approach the artwork with a sense of responsibility.

Private Gallery *(1999–2000)*

Private Gallery, which first appeared in SKE Gallery, Bangalore, in 1999, enables viewers to ponder the ways interior spaces shape the interiority of their dwellers. The installation consists of a structure composed of two door-sized "walls" of pink Formica sheets attached to make a corner. Each gleaming Formica wall evokes the standardized, reproducible plasticity of urban material life in Bangalore. The Formica very simply and effectively

indexes the increasingly generic and standardized exterior surface life of the city. The homogeneous global modern marks its ubiquitous presence in the fake textures of plastic, particle, and laminate wood. Such laminate surfaces are perceived not as cheap, low-quality material but, rather, the very stuff that is hailed as the sign of the global and marks middle-class aspiration to global urbanity.

Walking around the corner, the viewer encounters the "private gallery," where she is confronted with a complex and heterogeneous textural world—numerous cow dung pats dot the interior walls. A row of vertical watercolors of portraits adorns the interior corner of one wall. A shorter sequence of watercolors of the generic city—empty spaces—almost like architectural drawings line the upper right frame away from the corner. Creating this material sensorium in the private gallery allows the viewer to experience the mosaic of textures, smells, images, and affects that constitute the experience of urban living.

In the private gallery, the viewer confronts the recalcitrant material presence of the rural within the landscape of the architectural piece. Here thumb-sized cow dung pats adorn one wall and part of the other wall. Pressed into an uncomfortable proximity with the artwork, *Private Gallery* constrains the viewer to recalibrate her size in relation to the thumb-sized cow dung pats.[35] The compressed space brings the viewer into an enforced proximity with the materiality on the inside of the cubicle. The miniaturized cow dung pats make the viewer, who has some familiarity of the customary size of such pats, experience herself as magnified. This proximity forces the viewer to smell the cow dung pats and to experience the effects and affects of this vital material course through her own body. Gowda plays with scale to comment on how the human gets inflated in relation to natural matter. Her work installs the viewer's body as giant-sized, too large for this space. *Private Gallery* suggests that such an enlarged anthropocentric human occupation threatens to subsume and displace other ways of living.

Gowda's deployment of enchanted materials suggests that matter is never inert or instrumental—it connotes both symbolically and sensuously. Gowda uses cow dung as material extensively, first in her paintings, and subsequently in her installation work. The rich multivalent associations of cow dung appeals to Gowda. In her own words, "Cow dung is used in India as a sacred material in religious rituals, as cow dung pats for fuel, as a cover for the floor and the walls, and as a material for folk sculpture and toys. The cow is also a symbol of nonviolence. I liked the range of its meanings."[36] Her work draws on the evocative associations of other material such as *kum kum*, a red dye powder made of turmeric and limestone that women wear on their forehead to symbolize their marital status; it is associated with feminine adornment. In addition to *kum kum*, she also uses ritual hair in sculptural installations that also speak in multiple tongues. The intimate proximity with evocative material brings the viewer to the sensuous fullness of these scenes of mediated

presence. As she puts it, "To begin with I was using dung more as pigment as texture rather than as sculpture. Using it in the way that dung is used in India as pats—letting the material be itself rather than transforming it. . . . Arriving at the purity of the material without mixing it with anything else was already a big deal."[37] Here again we see Sheela Gowda's artworks distill the substance and heart of the material itself, yielding to its sensuous vitality rather than redeploying it, transforming it, or instrumentalizing it to serve another agenda.

The interior space also displayed muted brown watercolors of portraits and landscapes that resonate with the chromatic scheme of the pats. Gowda quotes the genres of landscape and portraiture painting through sepia-toned watercolors, their pigments made from diluted dung and red *kum kum*. The turn to the picturesque landscape through the sensuous ritual material mediates anxieties regarding the urban. The topoi for the picturesque are unusual subjects: migrant laborers, domestic wares, and landscape provide the inspiration. The panic that one encounters beyond the home is managed through domesticating images portrayed through sensuous ritual materials.

The picturesque serves not only as aesthetic object but also as a technology of social control; it offers the means for aristocrats to neutralize pressing social problems and view distressing or threatening aspects of the country as pictorial themes rather than as practical or ethical problems.[38] Domesticating aesthetic commodities, the picturesque mode thus transforms and restrains unruly urban subjects. Less a matter of asserting control than of ameliorating urban anxiety, enjoying the urban from one's private gallery, as pictorial spectacle, enables the city dweller to manage urban anxieties through recourse to the picturesque, which perpetuates a fiction of a regulated society.[39] *Private Gallery* cites the picturesque as mimetic ornament, one that emulates middle-class aesthetics and aspires to bourgeois distinction but does so through the materials and means that retains hetero-temporal associations of auspiciousness, ritual, and home.

Gowda's installation demonstrates the interior as a complex spatial arrangement of desires and aspirations. Her focus on smaller, more intimate and private spaces as crucibles for self-transformation echoes Sanjay Srivastava's argument that in liberalized India, spatial imaginaries shift from focusing on the nation as the primary spatial locus of affective belonging to more intimate, privatized, and banal spaces as locales of identity.[40] *Private Gallery* represents a doubled hetero-temporal space, where the reproducible, standardized exterior chafes against the material sensuousness and textures we find inside. The coexistence of the rural and the urban holds together seemingly incommensurable cultural logics within the space of the home. Here the rural and the urban do not collide; rather, they layer and overlap in hetero-temporal intimacy. The doubleness suggests that rural-to-urban migrants might chart their way in the new city through a complex psychic repertoire that involves both an ongoing aspiration to urban modernity and

a sense of attachment to rural lives. The commingling of watercolors and cow dung pats indexes the rural in the urban and points to the intermingling of aesthetics and aspirations.

Vaastu / Some Place

Private Gallery preempts Gowda's later work, *Vaastu* (2005), a painting which is sometimes part of a triptych installation (*Some Place*). *Vaastu* consists of a faux marble wall, dotted with lines that guide the eye to inscriptions associated with Vaastu Shastra, derived from *vāstu*, Sanskrit for "dwelling," and *shastra*, which means "set of principles." Vaastu Shastra is an ancient doctrine devoted to the understanding of architecture and its relationship to people, nature, and dwellings. Here Gowda ironically alludes to the recent revival in the practice of consulting ancient texts before making decisions regarding property purchase. The intertwining of dwelling and fortune was reinforced through markers from Vaastu Shastra—such as Moola Sthana (place of origin), Kuberana Sthana (place of wealth), and Sthana Mana (social status)—that predicted one's fortune relative to the geography of home and spatial positioning. Gowda adds to this more ambiguous scribbles that appear almost like graffiti—"You are here," "Are you there?," comments and questions that both situate and dislocate the reader. Gowda's installation indexes the fake marble facades of lower-middle-class homes in the periphery of the city. The fake marble reveals the aesthetic mode through which the rural and urban residents of these homes register their aspirations for class mobility.

Vaastu also appears in Gowda's triptych installation, *Some Place* (2005), which juxtaposes three pieces of work: *Vaastu*, *Portraits*, and *Someplace*. Two perpendicular "walls" frame the installation—a flat wall surface with the Vaastu etchings that evoke a faux marble exterior wall, while the other surface displayed a row of four large windows. In the center of the room stood a grid of interconnected metal plumbing pipes. At various points the pipes open up and transmit sounds, which, if the viewer listens carefully, transmit radio waves, emitting the voice of erstwhile radio commentator A. S. Murthy layered with audio intensities emitted from varying frequencies.

Modern capitalism began, Richard Sennett reminds us, in systematically colonizing the ground.[41] The technology of tunneling enabled infrastructures such as modern sanitation systems; underground pipes diminished the scourge of plague, and increased the population. Tunnels now house fiber-optic cables that provide resources of digital communication. The sonic installation disemboweled the plumbing networks and turned them into auditory instruments from which we strain to catch the feisty former radio commentator popularly known as Akashvani Eranna. Bringing news in a style of casual conversation through the radio during the 1970s, Eranna

was a well-known street theater actor and intellectual, founder of Abhinaya Tharanga.[42] In the program, the popular Kannada social commentator A. S. Murthy takes on the persona of Heeranna, and his monologue registers multiple dialects of nonurban Kannada and evokes the many voices heard in the streets and bazaars of Kannada public spheres.[43] Another audio stream emanated sounds, at once distinct but melded, by layering outputs of different radio stations at varying intensities. Reinforcing the shared commons of infrastructure, Gowda attached a valve knob to one of the pipes; turning the knob mixed the sound from the two audio streams, thus materially and metaphorically bringing together the flows of water and sound.

Gowda explained to me that this was the soundscape of her childhood.[44] She associates this radio program with her father, who avidly listened to it. Gowda wanted to build in a moment of surprise when the audience bent down to listen to the pipes. In much the same way the pipes that bring water to the city dwellers connect them through civic infrastructures, the airwaves too create their own immaterial infrastructures, connecting disparate people, and bringing them into a sense of shared community. The sounds emanating through the pipes take the audience "some place" not here, to a different time that evokes the slower rhythms of childhood. The words wrap around the listener producing a sense of tactile immediacy conveyed through sound. The sensuous remediations take the audience by surprise—catching us off guard, piercing the film of habituation that insulates us from a sense of secular wonder. The third dimension of the installation consisted of four large windows where each was covered with translight film and transformed into a ready-made light box that typically carries advertisements and are mounted in public spaces such as bus stands. Gowda's translight backdrops were blank and did not carry any advertisement. Moreover, the blank surface was deliberately slashed, and through the crevices one could glimpse the fluorescent lights that would have illumined the advertisement. Through the fissures in the material, we glimpse a complex, layered, and highly mediated image and observe how the "society of the spectacle" is produced.

By bringing together land and water, sound and light, consumer advertising and traditional *vaastu-shastras*, Gowda excavates a hetero-temporal, layered, and porous city, crisscrossed with class aspirations, development programs, and traditional geographies. None of these media is pure, each is remediated: sometimes sound waves pass like water, and *vaastu* coexists with faux marble. These three dimensions: water, land, and travel—plumbing pipes, that are disgorged and carry sound waves, light boxes that signal the empty spaces for advertisements, and the faux walls that evoke lineaments of property purchase bring together various material and metaphoric dimensions of urban living in contemporary Bangalore. By estranging each, Gowda insists that we pay renewed attention to them. In each of these triptychs, Gowda brings to light the infrastructures of urban living that connect and disconnect us through material and social relations.

Figure 5. Sheela Gowda, *Darkroom*, 2006. Courtesy of the artist and GALLERYSKE.

Darkroom

Darkroom is a large-scale sculptural installation composed of metal tar drums, used by roadmakers to build Bangalore's highways.[45] The metal drums are arranged in a manner that evokes the gravitas of classical colonnades and cites the grandeur of colonial architecture. While colonnades generally served the purpose of intimidating and deterring unwanted visitors, Gowda's metallic drums, aglow with a bronzed oxidation, draws its viewers in. Despite the harshness we associate with these industrial construction materials—lead plumbing pipes, asphalt, plastic sheeting, metal barrels—under Gowda's tenacious care, the corrosive material reveals its warmth, its pliancy, even its solace. As Gowda puts it, "What I want to say should not weigh like concrete, but be elusive."[46] Its elusiveness resists hermeneutic authority or interpretive closure. Rather than proffering a singular meaning, the sculpture solicits the viewer and draws us into its world of sensuous dimensionality.

Gowda's artwork registers the precarious labor and life of construction workers in the metropolis. Migrant construction laborers work under conditions of dire precarity: they seldom make legally mandated minimum wages; they work long hours, live and work in fairly risky conditions, grapple with job insecurity, and face health hazards. Writing of predatory real estate practices in Bangalore, Llerena Guiu Searle observes, "These perilous landscapes, this hard work, and this deprivation fuel real estate sector profits, which, contrary to industry rhetoric, trickle up, not down."[47]

Sheela Gowda's *Darkroom* reminds us that migrant workers reassemble tar drums to provide shelter for themselves. In many cases, the drums offer refuge to the workers to sleep in while they construct the roads. The drums are recycled, the lid is given to the watchman who sells it, the base goes to somebody else, the sheets are taken to a factory where they are turned into a shiny metal to make masonry tools. Gowda selects tar drums that are not too damaged: to produce these sheets they first remove the lid and the base, and then cut open the cylinder. She gets the tar residue burnt off by the crew's burner. To flatten the sheets, she puts them under the road roller. The metal tar drums, no doubt, function to hold tar, so witnessing the empty tar drums itself suggests a prior process of emptying out, of vacating, of turning inside-out.

The road, in the modernist imagination, connotes national progress and state development. In liberalized India, the road also conveys a sense of global futurity, while indexing personal evocations of adventure and freedom. Gowda's work brings attention to the tar drums as material that provides shelter through the resources for the road. The materiality of the tar drums brings together notions of dwelling and travel, of refuge and risk, of shelter and exposure. As Gowda puts it, "This work is basically a house. I want viewers to get down on their knees to enter it and then to emerge inside a dark room that does not easily reveal its dimensions."[48] Once inside, the viewer must relinquish the comfort and security of vision. Plunged into darkness, the viewer is required to crawl in a prone position along a low ceiling to pass through the passage that leads her to the main portion of the house. Gowda choreographs gestural moves that critically reflect the way pilgrims at Yogamaya or Kali Khoh temple in Uttar Pradesh, in the vicinity of the famed Vindhyavasini temple, get down on their hands and knees to crawl through a dark passage to emerge through an opening to the holy shrine of Goddess Kali, where the supplicant gains darshan from the divine goddess.[49]

Gowda's critical mimesis of the migrant laborer's home does not present itself as an anthropological curiosity. Rather Gowda insists that we lose our sense of bearings, get down on our knees, symbolically prostrate ourselves before emerging into the space of habitation. Losing our sense of mastery and control, we yield to the new demands made on us by this space, in order to renew our understanding of a migrant tar house not as abject and precarious, but as a place of creativity and imagination. One emerges into the house of the laborer not as a confident and imperious consumer but through an embodied act of submission, crawling on one's hands and knees. Here too Gowda insists on the art of yielding as a prerequisite to a new understanding.

Once inside the viewer can stand up again, even raise her head and behold numerous "stars" twinkle down on her through tiny pinpricked holes punctured into the ceiling of the metal roof. From the compactness of the dark room, the gesture of lifting one's head opens out the space to the immense night sky. Much like a compressed gas chamber that then explodes to enable

one to feel a sense of sudden release and expansiveness, the third space momentarily allows the viewer to break beyond the social determination of her position and repositions the body in terms of social class and cosmic scale. But even as the glimmering night sky summons the viewer to experience herself as embedded within a grand planetary design, this is no innocent scene of the eco-sublime. The tactility of the asphalt carpet under the feet of the audience tethers her to the material and reminds her audience that the night sky is just another punctured tar sheet that offers the promise while also exposing the limits of an eco-sublime.

Experiencing this space requires an encounter between body and architecture that takes three distinct turns: first, acknowledge the mock power of the imposing frontal colonnade; then, through an act of physical subservience, crawl through the middle passage; and finally emerge into an otherworldly arena, a sublime space marked not by control but by submission—the darkroom that yields its secrets "if we allow ourselves to be taken in."[50] Allowing oneself to be "taken in" requires the ability to release our sense of control, our panic, our stereotype, even our pity. Release carries ethical implications as it enjoins us to surrender our control and our hold over others.

Darkroom invites us to see the habitation of a roadmaker not as despairing and abject—it insists that we mold our body, lose our footing, rearrange our balance so we experience the dwelling also as a site of imagination—a darkroom where, as Gowda puts it, "the image materializes." The darkroom is the space for remediation where the film must pass through the touch of water in order to turn into image.

In *Darkroom*, Gowda choreographs the viewer's body and insists that she enter into a new embodied engagement with the artwork that reconfigures her ethical and social engagement to the roadmaker as well. "We both look to the skies," says Sheela Gowda about the manual labors of roadmaking and artmaking. As Gowda puts it, "I have a working relationship with a team of road makers . . . because road making is a seasonal activity which cannot happen after rainy spells."[51] Roadmakers consult the monsoon calendar to calculate when they should lay tar on the roads so the tar can dry before the rains. Much like a farmer who plants and harvests the crops according to weather patterns, roadmakers also cognize that roadmaking must understand and accommodate seasonal changes. Looking to the sky grants nature the power to guide us, rather than looking at the sky where the viewer continues to exert control over what is surveyed. In looking *to* the sky, rather than looking at the sky, the roadmaker and the artist, like the farmer, locate their activity within larger ecological patterns and environmental conditions. Through a simple gesture of looking to the sky, Gowda reminds us that we may need to rescale the ambitions of the human body to exert absolute control and dominion over all that it surveys and appreciate its place as one node in a larger network of human and nonhuman relations. Her sculptural installation choreographs the viewer's body, dehabituating it and inserting it

into new proximities with other lifeworlds, and rescaling its self-importance within the larger cosmos.

Darkroom offers the audience a chance to look to the sky to recalibrate and rescale the human within the larger constellation of a planetary imagination. In looking *to* the skies, rather than looking *at* the sky, *Darkroom* insists that the viewer participate in the installation not as a consuming viewer but as a supplicant. *Darkroom* invites the viewer to partake in the embodied act of seeking counsel from the environment, from the elements that are bigger than her. *Darkroom* is an invitation to look to the sky, for this is what we all share—all living beings, whether roadmaker, artist, or viewer.

The relational aesthetics of this piece choreographs the gestures between the migrant laborer, the artist, and the viewer to approach an agonistic social field riven with frictions of privilege and inequality, provocation and conciliation, stereotype and panic. But Gowda also choreographs encounters between human and nonhuman bodies. The materials that Gowda uses in her artworks range from durable metal tar drums to fragile incense ash to the multivalent symbolic and sensuous evocations of cow dung. These pliable yet resilient materials modify their form while still retaining their material essence. The assemblage Gowda composes bring human bodies into nonhierarchical encounters with material substances imbued not only with symbolic associations but also with their recalcitrant materiality. Mapping new topologies between the self and the world, the affective experience of encountering these artworks open up and unfold the insulated self into new orientations toward the world.

Krishnaraj Chonat: Gated Communities and the Phantom of Globality

Bangalore-based visual and performance artist Krishnaraj Chonat's recent body of work offers an opportunity to "study up" and examine the culture of power and affluence rather than the dispossession of the subaltern. His artworks critique Bangalore's frenzied aspirations to remake itself into a world-class city. In his social sculptures, installations, and live art, Chonat illuminates the panic that divides social classes within the city. Through humor, irony, and a spare aesthetic economy, Chonat comments on elite panic and the subsequent insulation of the wealthy from human and nonhuman contaminations of the city. Because the image of panic is generally associated with hysterical masses or fleeing crowds, it can become difficult to reveal how elite panic operates in urban spaces. Elite panic circulates in the city as an overreaction, a heightened and disproportionate sense of alarm and insecurity that leads to excessive and sometimes imprudent efforts to secure safety.

Chonat points to a looming social crisis as "terrible architecture" pervades the city, "concrete and glass, Corinthian columns and suffocating Roman

pillars co-existing along with bizarre vaastu requirements, of theme-based living complexes that offer anything from Balinese gates to Venetian villas to French windows in east-facing Californian houses, to ugly uninspiring government buildings and secretariats reminding us even today of medieval relationships between the ruler and the ruled."[52] According to Chonat, the "fever-inducing aesthetics" of urban beautification programs assault the sensory habitus of citizens such that "the common citizen feels held against a wall in front of a firing squad."[53] Chonat's strong rhetoric translates into a ghostly aesthetic where the structural violence of evictions, enclosures, and property development emerges in a haunted and sterile register.

In the wake of liberalization, property developers have cultivated a range of new consumers, which includes nonresident Indians, multinational companies, and the Indian information technology industry. As a result, real estate prices have soared making property affordable only to the wealthy. While developers profit from the skyrocketing prices of property, construction workers are paid abysmally low wages.[54] The pristine gated communities within Bangalore City consist of palm-lined boulevards, tennis courts, swimming pools, restaurants, clubs in enclaves named to evoke global destinations such as Palo Alto, California. Residents within these communities stroll within its protected precincts as if they were far removed from the dirt, contagion, and disease of the city. The increased securitization at these gated communities demonstrate the growing erosion of confidence in the ability of the state to protect its citizens and a concurrent amplification of anxiety and sense of threat at the hands of the urban nonelite.

Although there have been relatively scant instances of violent crime inflicted on the rich, the measures taken to insulate and protect the wealthy from the poor far exceed any documented crimes. The conflation of poverty with criminality feeds urban elite panic that seeks out gated communities. Yet as a recent case in Noida, a New Delhi suburb, demonstrates, elite enclave dwellers also threaten working-class bodies. Take the case of thirty-year-old Zohra Bibi, a part-time maid, who worked at Mahaguna Moderne, a plush residential colony.[55] When Bibi went missing on July 13, 2017, her husband, Abdul Sattar, who lived just three hundred meters away in the neighboring informal settlement, panicked. He gathered his neighbors and went to the residential complex, overpowered security, and went inside. The police had to intervene, and Bibi was found, unharmed, in the residential colony, where she had been hiding after being attacked by her employers.

Following this incident, tensions escalated between the residents of Mahaguna Moderne and the dwellers of the informal settlement beyond the complex. The predominantly Bengali Muslim workforce, including many of the construction workers who had built this apartment complex, protested that they were locked out of the residential community and were pejoratively referred to as "illegal immigrants." To retaliate, Noida authorities claimed that the informal settlements were encroaching on private property, cut off

their electricity and water supply, and demolished makeshift tea stalls and shops selling fruit and vegetables that lined the main road from Mahaguna Moderne.

This case brought to the surface the daily indignities that domestic workers had suffered at the hands of their employers and security personnel in gated communities. These humiliations include daily frisking to check for theft, minimal leave, not being able to sit on designated benches or even walk on pavements, not allowed to use toilets that they clean. Moreover, with no infrastructural support—no water, electricity, housing, toilets, or education— the panic and precarity that exacerbates conflicts between the urban poor and their wealthy neighbors will continue to grow apace. Unfortunately, this case is far from uncommon. The 4.2 million domestic workers in India have little legal recourse to prevent exploitation at the hands of their employers.

The anxieties of the elite city dwellers converge not only on the threatening infiltration of the unruly working classes within their pristine gated enclaves but also on the rampant public health issues, such as dengue, bird flu, and most recently, COVID-19, that have risen apace in rapidly globalizing Bangalore. What are the consequences of elites' panic and their subsequent attempts to insulate themselves from a dense network of other human and nonhuman entanglements?

Chonat's artworks capture the deterritorialized modes of habitation among the elite, who inhabit the city as if it were an elsewhere. His works pointedly take up the mushrooming of elite enclaves and gated communities in the city's outskirts: Venetian bungalows, palm-lined Californian boulevards that offer simulacral "global" lifestyles to the wealthy, propertied classes are all up for critical scrutiny here. The discourse of globality, in the context of neoliberal urbanism in India, produces citizen-consumers who inhabit subject positions that exist in tension with their wider social and material contexts. The spectacular fashioning of consumer desire generates vertiginous disjunctures between the production of globality and the disruptive material challenges it introduces into the lives of city dwellers.

In *Private Sky* (SKE Gallery, 2006), Chonat creates an installation comprising a chalk white palatial bungalow with a two-car garage. The bungalow is perched precariously atop a leafless dead tree, whose bare wide branches reach outward and upward to the sky.[56] The dead white tree in turn is held within a white pot. The tree that holds the bungalow does not grow unconstrained; rather the limited dimensions of the pot have choked off the life of the tree. When roots cannot grow deeper, trees become unstable. In addition, pollution restricts the trees' intake of water and metabolism and causes leaves to fall early. Infrastructural endeavors such as laying utility lines or covering tree roots with cement further exacerbates the problem and chokes off the tree's nutrient supply.

The dead tree is stuffed into a pot that can barely contain its size, and the very lack of fit between the pot and the tree suggests the shortage of oxygen,

the suffocation that chokes the tree. The house is perched precariously on top of the tree, implying that the house has displaced the tree. Indeed, property development within the city has required the decimation of its tree cover. Bangalore, once called "the garden city" for its beautiful flowering trees, has witnessed extensive deforestation in order to make place for more buildings.[57] The blanched whiteness of the installation reflects a ghostly sterility pointing to the ways that predatory real estate capital sucks the very life out of the trees. In addition, the pristine whiteness evokes the ghosted labor that helped construct the house. The unsullied whiteness suggests a deathly beauty that draws on the ghosted manual labor and the depleted natural soil to erect the otherworldly pallid installation. A large, theatrical full moon made of fur adds a touch of lunacy and hauntedness to the scene.

In this scenario of deathly pallor, the only live being is a black, oversized mosquito that sits menacingly at the edge of the installation, watching this spectral scene of ruins. Chonat here wryly inserts the mosquito as a reminder that no amount of insulation can safeguard the elite city dweller from the bite of a mosquito, the bearer of the life-threatening dengue disease. In a different installation he returns to the mosquito, the world's deadliest animal, which took the life of a mighty local king. Chonat suggests that even the most powerful person can die from a mosquito bite and is not immune to the sting of a menacing mosquito. In this way, Chonat inserts the nonhuman as an overlooked but inexorable local agent in the history and futurity of the city. In Chonat's words,

> This work directly refers to a Venetian Housing colony with east-facing Californian houses and villas that has come up in Yelahanka on a lake bed filled up for this very purpose. I have fond memories of this lake where I spent many weekends doing sketches as an art student. It is a mosquito-infested area and I was struck by the possibility of a Venetian colony with mosquitoes: perhaps the only harsh reminder of how fantastical dreams of living in beautifully distant [constructed] lands can be enjoyed with closed eyes until it is all shattered by a tiny winged local![58]

The installation is housed in a room with walls of mirrors that replicate the image and offers up for view a dizzying proliferation of identical houses. Not only are the houses identical, but it appears that the inhabitants too must be interpellated by a political and economic rationality that privileges identical signs of success: the villa, the two-car garage, the transplantation of a "global" life that barely touches the mosquito-infested grounds of the third world city. It is a little disconcerting, then, when the mirror recruits the viewer into this image. The viewer not only finds herself implicated within this ashen graveyard of elite property homes; she also finds herself reproduced as standardized and replicable versions, gazing at identical pallid dream houses. By

Figure 6. Krishnaraj Chonat, *Private Sky*, 2007. Courtesy of the artist and GALLERYSKE.

using mirrors to replicate innumerable such tableaus, Chonat inserts human bodies as only one node in a dense network of other human and nonhuman relations.

Using a kaleidoscopic visual montage to displace the centrality of the person, Chonat brings together house, tree, mosquito, and viewer into an unsettling assemblage. As the viewer moves across the room, the resultant mobile mosaic of human and nonhuman, image and texture, light and mirror, shimmers and alters scale and perspective. In constellating a political ecology of human and nonhuman entanglements, the composition warns against anthropocentric hubris that disregards the vital life force of nonhuman beings. Chonat offsets human self-interest and its inexorable appetite for consumption by recalcitrant and uncanny urban remainders: the choked tree and the menacing mosquito. The title of the piece, *Private Sky*, warns against the increasing privatization of all commons in the neoliberal city. Even the sky, expansive and universal, is parceled out and privatized.

Private Sky oscillates between the textural materiality of the sculpture and the replicable image in the mirror, offering ways of cognition that enable the viewer to attend to the play of thing and image. The precarity of the bungalow reveals a lack of foundations to the earth, an insufficient rootedness in the soil, and suggests the very superficial and disconnected ways the elite in gated communities dwell in the city. Specifically targeting property development, Chonat's piece comments on the ironies of selling deterritorialized

fantasies to home buyers. The desire to own Venetian bungalows and Californian ranch houses requires an active disavowal of the immediate environs and material realities one inhabits, most stubbornly captured in the figure of the menacing black mosquito. These homes imaginatively transplant the homeowners in gated communities to first world locations, justifying and reinforcing elite panic about the human and nonhuman world that threateningly encroaches on their insulated property. Given the centrality of property development both to the visual landscape of the city and to the rising urban anxiety about the escalation of rents and land value, Gowda and Chonat grapple with circulations of panic and allow us to consider how spatial arrangements ameliorate or exacerbate the social frictions produced by these urban affects.

Shantamani Muddaiah: Charcoal and the Debris of Home

Sculptural artist Shantamani Muddaiah uses ephemeral natural materials, such as charcoal and paper, in her paintings, sculptures, and installations. A resident of Bangalore, Muddaiah trained at MSU Baroda and subsequently at the Glasgow School of Art. Muddaiah's artwork primarily takes up the degradation of manual labor and the neglect of informal economies in the valorization of e-commerce in the high-tech city. In 1995 she departed from her signature repertoire and used wood charcoal to create a life-size sculpture of a pregnant woman titled *Home*, a response to the ethnic violence that erupted in Bangalore in the wake of the demolition of the Babri mosque.

The demolition of the Babri Masjid in Ayodhya, a holy site for both Hindus and Muslims, in December 1992 was not a singular and bounded event.[59] It was preceded by months of preparation and performance and was followed by violent repercussions beyond the disputed site. The Rath Yatra, or chariot procession, galvanized scores of young men from the Bajrang Dal, or "Hanuman's Troops," the youth wing of the family of right-wing organizations of the Rashtriya Swayam Sevak (RSS). The procession commenced in September 1990 and traversed the breadth of the nation, from Somnath in Gujarat to Ayodhya in Uttar Pradesh, covering approximately ten thousand kilometers (over six thousand miles) in eight states over thirty-five days. The vehicle itself, a Toyota van, was adorned in a manner to suggest the chariot of Arjuna and Krishna in Hindu mythology and strongly evoked the televised epics that had garnered enormous national attention.

The procession exemplified the deployment of performance and symbolic iconography in the affective constitution of community identity. The tactical manipulation of politics-based emotion—particularly anger and resentment—unleashed populist energy and resonated beyond the temporal and spatial trajectory of the Rath Yatra. The visceral and affective reverberations released by the Rath Yatra rippled throughout the nation and beyond.

Among the southern states, Karnataka witnessed the immediate effects of this violence in districts and towns that had already experienced ethnic flares in the wake of the Rath Yatra.[60] In a number of small towns and cities in Karnataka, including Ramanagram, Channapatna. Kolar, Davangere, Tumkur, and Mysore, Ramjyoti processions that had been timed to coincide with the Dasara festivities were canceled. The processions attracted huge numbers of Hindus and were deliberately routed through predominantly Muslim areas and in front of mosques to incite ethnic tensions.

On October 2, 1994, the government of Karnataka introduced a ten-minute news bulletin in Urdu, which was broadcast on the national channel Doordarshan immediately after the Kannada news section. This insertion of an Urdu-language news bulletin incensed the linguistic nationalists in Bangalore, and a group of three hundred protestors from various pro-Kannada organizations gathered to protest what they saw as the increasing devaluation of Kannada language and the appeasement toward minorities for electoral gains. Muslim minorities in Bangalore spoke Kannada fluently so the claim by the centrist Congress government that the Urdu bulletin was inserted so minorities could learn about social programs was widely dismissed as devious and unconvincing. However, the linguistic agitation took a violent turn when people began to torch vehicles, damage property, and kill people. The protests against the Urdu news bulletin spiraled out into a religiously politicized one.[61] Sixty-three Muslim houses were destroyed. The violence claimed twenty-five lives according to official sources, while unofficial estimates put the death toll at forty and in some cases as high as one hundred. Things came under control one week later.

In the wake of this violent incident, artist C. F. John coordinated a creative response. A group of young artists including Raghavendra Rao, Ravisankar Rao, Amaresh U Bijjal, Ramesh Chandra, Shantamani, Nandakishore, and Tripura Kashyap visited the affected localities and interviewed the victims and survivors of this violence. They spent several weeks with the affected communities on Mysore Road and in Bapujinagar colony, witnessing and participating at a very personal level. Drawing on the material and affective resources of their research, they created artworks that were then presented in an exhibition of installations and performance.

The show, titled *Silence of Furies and Sorrows—Pages of a Burning City*, was held in Venkatappa Art Gallery in Bangalore. Artists wanted to respond to the growing ethnic tensions and religious intolerance in their cosmopolitan city. The artist and curator Suresh Jayaram describes this installation thus: "The violence in our city in recent times motivated a group of artists to find forms to express the agony as well as the inherent hope of a people subjected to the brutality of communalist and fundamentalist forces. The riots left the city with many raw wounds. The dead were reduced to numbers in the media. Some were compensated. Many stories remained unheard. The fire was extinguished and we were left with smouldering ashes and ravaged

hearts recounting losses of limbs and loved ones."[62] Artist Yusuf Arakkal observes:

> It is heartening to note that these young artists have very effectively achieved a fusion of artistic demands with the compulsions of social responsibilities, without compromising the aesthetic possibilities of such creative exercise. At the first glance it is the aesthetic possibilities that are explored using various materials ranging from torn clothes, mud steel wires, bricks, tinpans and coal which attracts one's attention. Yet, it slowly involves the viewer into the complexities of the messages about the tragic events that reduces human beings into pitiable non-entities.[63]

Both Suresh Jayaram and Yusuf Arakkal have been instrumental in providing mentorship and guidance to younger artists in the city. Their description of the riots that reduced the Muslim other into "numbers" or "pitiable non-entities" augurs the way the contemporary right-wing political milieu has routinized religious violence and normalized the "thingification" of Muslims.[64] The exhibition was a landmark event that politicized Bangalore artists but also began a move toward more experimental artistic forms.

For the exhibition, Shantamani Muddaiah created a sculpture called *Home*, a life-size figure of a pregnant woman mounted on a 30×60×30-inch pedestal. Composed of wood charcoal with cotton rag pulp, the figure of the pregnant woman simultaneously connotes the fullness of life, and also the cinders of death. Charcoal allowed Muddaiah to capture both the residue of destruction and the fragility of creative expression. A transitory material, charcoal signifies both destruction as well as the liminal process before turning to ash; it signifies both death and the disintegration of death. In her words, "Charcoal is the last stage before ashes. Just before turning to dust, the wood of the tree still bears the imprint of the plant, as a trace memory. Through oxidation by fire it continues interacting with the world one last time before consuming itself into flames."[65] Charcoal, then, is "vibrant matter" that mediates between life and death.[66]

Materials are significant to Muddaiah and charcoal carries deep associations to modern urban life. The development of large-scale manufacturing, mines, factories owe their existence to the rise of coal made possible by the use of steam power to access seams of carbon deep underground.[67] For Muddaiah, charcoal signifies waste and carbonization of environment. The rhetoric of development and progress has unleashed in the city a battery of economic, spatial, and social transformations that have had disastrous environmental consequences. Muddaiah laments, "With all these big dreams and extensive processes, we are not only carbonizing the physical environment, we are also undoing all that we have built and understood for thousands of years."[68] Charcoal has other associations as well—it is

Figure 7. Shantamani Muddaiah,
Home, 2008. Photograph by
Mallikarjun Katakol. Courtesy of
the artist.

used in rituals with a strong reminder of the fragility and transformation of life.

Muddaiah's first association of charcoal was the burnt-down house of the woman, a victim of communal attacks in Bangalore in 1994 in the wake of the demolition of the Babri mosque. Muddaiah recalls, "I started using charcoal as a material after I had the startling firsthand experience of meeting a pregnant woman who had lost everything and everyone in her family during the communal riots. Her dwelling was completely burnt down and not one person attempted to help her. As I left in the evening, the last sight I saw was her standing alone against the sunset, her burnt house in shambles around her, slowly fading away into the darkness as I walked away."[69] In and through the making of *Home*, Muddaiah returns to the pregnant woman she walked away from, pointing to how "performance remains" beyond the inescapable liveness of panic. She sculpts the life-size figure of this pregnant woman in charcoal, a material that conveys the fragility of her encounter with the woman; the merest touch could disintegrate the solidity of the sculpture. Her incinerated pregnant body simultaneously holds the promise of life

and the impossibility of that promise, the residue of coal and the negation of life.

Muddaiah's title, *Home*, not only refers to its negation—the incinerated residence, or even to the womb, that home where the unborn baby resides—but also speaks to silence itself as a final refuge. In order for the statue to be at home again, she must be released from the bondage of this silence. The sculpture confronts the viewer with an intractable stubbornness that solicits her attention. The viewer faces this image composed of cinders, so firm, yet one that will crumble on the slightest touch. The sculpture issues a formidable challenge: "Will you, viewer, walk away like the artist did? Like the artist, will you walk away to bear me in your memory?" What does this walking away entail? Muddaiah's *Home* inscribes on the viewer what she only dimly cognizes of her lived historical relation to the traumatic events of her time.

Muddaiah's sculpture offers a precocious mode of witnessing: the viewer approaches this sculpture not through an intellectual response or conceptual hermeneutic frameworks but through a momentary shudder that registers the shock of the unintelligible, through a sensuous reverberation with the structural vulnerability of the minority. The relational dynamic that the sculpture sets into motion facilitates an unspoken petition to bear witness. The sculpture solicits from the viewer a responsibility derived from a relational dynamic between the witness and the victim, and it thereby avows the sense of routinized panic experienced by members of minority communities. In crafting this precarious sculpture, Muddaiah literalizes the ways panic seizes its object. Panic here moves from ambient anxiety to a viscous affect that, as agent, seizes the woman and transforms her into a thing, figuratively petrifying her.

By transferring the materiality of the charred home onto the bodily surface of the pregnant woman, Muddaiah coalesces ruination and vitality, death and birth onto a single figure, which holds the glimmer of life in the smoking debris. Panic arrests the free-floating "liquid fear" that circulates in urban spaces of minority subjects, radically annihilating temporal horizons beyond the urgency of the inescapable "now." In its uncovered state, the sculpture evokes a sense of exposure, vulnerability, and powerlessness. A testament to survival, the figure also exudes the sense of desperation aroused by panic—the desperation to survive even when all around her lies smoldering in the ruins of ethnic violence.

Unsettling the question of settlement, these artists draw out the lineaments for an ethics of property. Surekha illustrates the haunted scene of evictions in palimpsestic drawings that convey property and home as nonfungible, affective sites, literally portraying the skin and skein of spatial struggles. Sheela Gowda takes us through multiple scenes of dwelling, the smoking remains of settlements, the makeshift sanctuary of migrant laborers, the aspirational homes of middle-class tenants. Krishnaraj Chonat demonstrates that property is as much aspiration as materiality; it partakes in a sign system that

metonymically signals the social status of its owner while also belonging in a dense network of human and nonhuman entanglements. Shantamani Muddaiah depicts an extreme image of unhomeliness, the uncanny image she recollects of a pregnant woman. While Gowda displays scenes of ruination in burnt down informal settlements, Chonat reveals elite panic of the unruliness that lurks outside, and Muddaiah explores the routinized panic that minorities endure in their perpetual unhomeliness in the nation.

By simultaneously attending to urban aspirations of building "world-class" cities across the global South, and their ensuing civic and psychic effects, these artists make vivid that affective politics is not an incidental by-product but, rather, the galvanizing undercurrent in the life of cities. These artists take on very different demographics to think through questions of dwelling and dispossession. Together they foreground the panic and precarity of dwelling: its deterritorialized fantasy foundations, its exposure, its susceptibility to violence. In approaching the question of property through the prism of panic: the panic of the dispossessed or the migrant worker, the panic of the elite, and the panic of the minority, these artists draw our attention to the structural precarity of urban dwellings and to how panic reconfigures social relations in the liberalized city.

Chapter 2

✦

Cosmopolitan Aspirations
and the Call Center Worker

The discourse of "the world-class city" permeates the designs and agendas of urban planners and policy-makers; it also suffuses the imaginaries of residents in these cities. City dwellers inhabit, negotiate, and contest these pervasive discourses, and their attendant material effects, that aspire to remake their cities in the image of foreign destinations, such as Dubai, Shanghai, or Singapore. Concurrent to the spatial transformations are the changes in the citizens themselves. Urban dwellers aspire to remake themselves in the idealized and ubiquitous images of the "good life" that circulate in the public sphere and are beamed through advertising and media imagery.

Bangalore, in the southern state of Karnataka, formerly described via monikers such as "pensioner's paradise" and "garden city," which evoke images of rest and retreat after the frenzy and tumult of life's work, now grows at a pace so rapid that it eludes our conceptual grasp of it.[1] The city of Bangalore holds together two irreconcilable worlds, popularly referred to as Cantonment and City. According to Janaki Nair, Bangalore's history is "a tale of two cities": a western part, referred to quite simply as City, which dates back to at least five centuries, and the eastern part, or Cantonment, which is no more than two centuries old. In 1868 the area called Cantonment was officially designated a Civil and Military Station, an independent area under the control of the British Raj, with swathes of parkland separating it from the City, and all facilities particularly developed to serve the British troops. In 1949 Bangalore City and Cantonment were brought together under a single municipal administration, but as Nair points out, "in many ways, Bangalore continues as a divided city, and brings to life some old divisions between its eastern and western parts."[2] By the early twentieth century, the Cantonment and City seemed like two different worlds, each with its own markets, railway stations, hospitals, schools; the city thrived as a commercial entity, while the cultural and economic realities of the British military shaped social life in the Cantonment. A. N. Murthy Rao describes the difference between the Cantonment and the City thus: "In addition to the strange appearance of a foreign environment, Cantonment was also beautiful. The spaciousness, wealth of

colour, peace, restfulness and beauty: none of this belonged to us, it was pro-
duced by the unconscious alienated labour of our people for the foreigners. If
we could forget this, we might enjoy it, but not even for a moment's interac-
tion with the English allowed you to forget this fact."[3] No doubt the spatial
segregations of the city served to reinforce social antagonisms and perpetuate
the interests of colonial authorities, which then endured in the postcolonial
period to retain vestiges of class, caste, and language privilege. Today the
city is the capital of the southern state of Karnataka, where two-thirds of the
population of 6 million speaks Kannada. "Bangalore," the Anglicized version
of Bengaluru, was adopted after the British took over the ancient kingdom of
Mysore in 1831. In August 2007 the city was officially renamed Bengaluru,
the name that Kannada-speakers use.[4] The name change provoked heated
arguments: proponents of the name change argued that Kannada-speakers
have always referred to the city as Bengaluru, elites claimed that the name
change would affect the city's ascent to global power and its modern capital-
ist aspirations, and still others argued that the change was an effort to erase
colonial history. In the rapidly burgeoning city, narratives of the past are as
unstable as predictions for the future.

From an earlier somnolent rhythm of life this city has transformed into the
high-technology capital of the global South with a dizzying velocity of trans-
national traffic in capital, media, information, commodities, and people. A
coveted site for enterprise investment, Bangalore has taken significant strides
in industries of information technology, biotechnology, pharmaceuticals, and
manufacturing. One of the fastest-growing wealth bases in the Asia Pacific,
with a population of over 12 million in 2020 (its population has more than
doubled in the last twenty years), Bangalore offers an exemplary paradigm
to analyze the transformation of citizen-subjects in the wake of transnational
circulations of capital, consumer desires, and mediascapes within Asian
world-class cities.

Bangalore's reputation as a scientific capital of India can be traced back to
the early decades in post-Independence India. During his visit to the city in
1962, Prime Minister Jawaharlal Nehru, a champion of scientific modernity
in India, described Bangalore not as an edenic paradise of recuperation but,
rather, as the prototype for the future. He declared, "Most of the old cities
represent the past of India. They represent history, whereas your city repre-
sents the future we are trying to mould."[5] India's first public sector enterprise,
Indian Telephone Industries, was established in Bangalore in 1948; other
key public sector undertakings established in Bangalore included Hindustan
Aeronautics Limited, Hindustan Machine Tools, Bharat Electronics Limited,
Bharat Heavy Electricals Limited, Indian Telephone Industries, and Bharat
Earth Movers Limited. The city has consistently received a significant por-
tion of the central government's financial and infrastructural investment in
science and technology. The setting up of a wide range of public sector R&D
institutes, such as Central Power Research Institute, Indian Institute of Astro

Physics, Indian Space Research Organization, and the National Center for Biological Sciences, among others, consolidated the image of Bangalore as a premier destination for research and enterprise. The establishment of educational institutions such Indian Institute of Science and the first engineering college in the princely state of Mysore, University Visvesvaraya College of Engineering, also contributed to the making of Bangalore as the high-technology capital of India. As the promise of the technology capital of India, Bangalore embodied the nation's futurity.

The liberalization of the Indian economy projected Bangalore as India's "Silicon Valley." Bangalore is home to numerous information technology (IT) companies, including the Indian giants Infosys and Wipro and multinationals such as Hewlett-Packard, IBM, SAP, and Cisco. In addition to the many multinational companies that have moved back-office operations to Bangalore, the biotechnology industry has also found its home in the city. The establishment of the Indian Institute of Information Technology Bangalore in the early 1990s further supported the emerging technology talent in the city. Jointly undertaken by India and Singapore, the creation of an International Technology Park in Whitefield, Bangalore, in 1994 set up the conditions for the formation and proliferation of numerous IT companies in the area. Bangalore is a thriving global IT hub, with about 0.9 million direct and 2.7 million indirect employees.

Following the liberalization of the Indian economy, Bangalore has witnessed striking changes in the economic, spatial, social, and cultural arenas. Needless to say, the expansion and proliferation of these industries have transformed the spatial and social physiognomy of the city. The industries have attracted not only skilled NRIs, or Non-Resident Indians, who are fast returning to work in the IT and biotechnology industries; it has also drawn a large population from smaller towns (Karnataka, Manipur, Bihar) to work in the IT-enabled service industries, especially outsourced business-processing industries. The heterogeneous profile of migrant labor in the city thus includes an assortment of workers, with different skill sets, from different parts of the world, the country, and the state.

In addition to the shifting demographic profile in the city, Bangalore has also witnessed rapid infrastructural collapse. The breakdown of infrastructure is evident in the city's inability to contend with the increasing problems of traffic, pollution, water shortage, and overcrowding. The infrastructural dysfunction is accompanied by a dizzying escalation in the cost of living: real estate prices have shot up an average sixfold in the past ten years, and prices of goods, services, and transportation have risen too. Compounded with an increase in costs of living, Bangalore's emergence as India's high-tech city has produced a sense of resentment among different constituents in the city, including the erstwhile elite, regional nationalists, the Hindu Right, and activists working in areas as diverse as environment, gender, and law, among others. The mixture of ethnic and class diversity has

created ripples of tension throughout the city, with not infrequent incidents of violence.

Despite the representation of Bangalore as Silicon Valley, Bangalore's formal economy depends on a variety of industrial sectors, including aerospace and ground transport, automated and nonautomated export-driven textile production, and an electronics sector. Further, the labyrinthine and burgeoning informal economy, which supports and facilitates the industrial sectors reveals a picture far removed from the sterile glass and chrome buildings; here the inexorable mark of poverty reveals the underbelly of the world city. While gaining an international reputation as India's high-tech capital, Bangalore is a repository that holds multiple urban imaginaries that range from garment industries to flower markets, from *karaga* festivals to *Ashura juloos* processions, from multinational industries to the multiple informal economies that service the needs of various urban constituencies in the city. As James Heitzman puts it, "Perhaps it is here, in the grotesque distancing of the information economy and the gated urban enclave from the barefoot boys cleaning dishes behind the tea stalls, that we see the mark of the global, and the resemblance of Bangalore to other world cities."[6]

Driving down to Whitefield, a small suburb on the southeastern outskirts of Bangalore, was an uncanny experience. The bustling thoroughfare was busy with cars, auto-rickshaws, buses, motorcycles, and cycles thronging the streets. Flanked on either side of the road were tons of businesses, restaurants, rows of small shops, internet cafes, apartment complexes, a handful of luxury hotels, and residential enclaves all crammed together. Bangalore impressed its visitors with gleaming spectacularity: sprawling campuses called "IT parks" were home to flashy glass and chrome offices of leading technology companies such as Microsoft, SAP, and Accenture.

Whitefield was named for D. S. White, the founder of the Eurasian and Anglo-Indian Association in Mysore.[7] After successfully petitioning the Maharaja of Mysore on behalf of the association, White was granted nearly four thousand acres of land. White imagined a utopic paradise for Anglo-Indian residents where they would collectively create a self-sustaining farming community, where residents would work together toward a common purpose without any private ownership of property.[8] In 1889 Whitefield contained twenty-five families and in 1894 the association transferred its rights of occupancy to them.

I recalled my last journey to Whitefield, some twenty years earlier, to visit the renowned ashram (temple) of Sai Baba. The leafy winding roads, lined with flowering jacaranda trees covered by purple-blue blooms, were quieter then. More a simulacral version of the Silicon Valley of my current residence in the Bay Area in California than the Bangalore of my youth, Whitefield palimpsestically held together contradictory urban imaginaries that grated against each other. There were no trees on that stretch anymore: the vivid jacarandas had been chopped down to make way for wider roads.

If the glass and chrome buildings in Whitefield left me wondering whether I was in Silicon Valley, Singapore, or Bangalore, my bewilderment heightened when I entered the "hyperreal" world of the call center industry.[9] The pristine and sterile milieu itself seemed to promise a sense of crisp efficiency that inspired confidence and marked a shift from parochial work cultures of bureaucracy, hierarchy, and centralization. While the first world feel of the environs exuded a sense of India having arrived on the global stage, the salaries for the call center employees are dramatically lower in India. This highlights the contradictory discourses around outsourcing that, for Indian nationalists, evokes rhetorics about superior Indian technology skills on the one hand, and for Americans deprived of their jobs, sentiments regarding cheap third world labor. For example, if an employee in the US is paid an annual income of $22,000–32,000 (hourly wage between $10 and $15 per hour), her counterpart in India will make roughly $5,000 per year (about $2 per hour). This considerable difference in salary needs to be adjusted against the "fully loaded cost" to company per employee, which encompasses the costs of operation (mandated insurance; health care, leave, and disability benefits; retirement programs; and other benefits paid to the employee); infrastructure (e.g., building and materials); costs of training and retraining employees; bandwidth and communication; security and transportation; and so on. Even after accounting for these costs, net savings for the company to move operations to India are substantial (for example, in the range of 60–70 percent per employee), providing the impetus for outsourcing. However, India is fast becoming less attractive than locations in China, Eastern Europe, and Philippines, which provide even greater margins for savings.

After waiting at the security desk and putting on an ID badge supplied to visitors, I was escorted upstairs to see the executives, the voice and diction trainers, and finally the call center employees, who were seated in rows, with headsets on, a flickering computer screen in front, and a telephone beside them. The open, flexible, and flat spatial plan reflected the organizational rhetorics around equality, autonomy, and informality within the workspace. These employees were managed not via their superiors' supervision but through internalized models of self-management, a corporate governmentality that exerted internal pressures to conform their performance with managerial expectations.

One of the executives invited me to pick up the telephone and listen in on the conversations. The conversations I listened to were fairly banal: the "agents" (as call center employees are called) conducted surveys with British customers on the other side of the telephone. The executive informed me that his brief was to ensure that customers stayed on the line. This was confirmed in the telephone exchange I witnessed: A young, urbane man conversed in a clipped British accent with a British woman who hung up on him within seconds. While he was probably familiar with such a scenario, the agent, somewhat embarrassed, feigned surprise. Although aware of my presence,

he did not meet my gaze. While working in a call center was initially considered trendy, and attracted English-speaking urbane youth from middle-class and upper-caste backgrounds, the profession soon lost its appeal for the elite classes, and subsequently drew scores of lower-caste and lower-middle-class migrant youth.

When I asked the chief operations officer and the trainers what they thought about the practice of impersonation in call center industries they were quick to point out that impersonation was getting more attention in the media than warranted. Some of these representations border on caricature, they argued. Many call centers had given up the practice of impersonation. The trainer I spoke with offered six- to eight-week training programs that included "accent neutralization," voice and diction, and information on American sports, weather, and political and popular cultural scenarios. This, he assured me, was not to perpetuate any deceptions on the American public but to facilitate smooth "small talk" between Indian employees and their American customers.

In her insightful essay on the entrepreneurial subjectivities of Indian call center employees, Purnima Mankekar details the biopolitical ramifications of retraining bodily practices during employee training sessions.

> Being American involves not just talking like an "American" but also learning to inhabit an American body and learning anew how to move through space like an American: agents are taught to use deodorants, how to enter and leave elevators ("while entering an elevator they should first wait for those inside to come out and then enter—they shouldn't rush in as if they are boarding a Delhi bus") how to stand in the hallways ("they should not stand with one foot against the wall") and last but not least, how to use western style toilets. Although most of them probably watch (or used to watch) imported television shows and Hollywood films in their leisure, they now mine these media as crucial sources of how to become American.[10]

This demonstrates how emergent subjectivities of call center workers are "forged," evoking the double sense of making and faking, through struggles for mobility through space and class positioning.

Drawing on the work of Arlie Hochschild and "deep acting techniques" in the production of an "authentic" professional persona, Sonali Sathaye examines the role of soft skills training in the formation of the ideal IT worker in Bangalore. Through sustained training in interpersonal and communication management techniques, service workers are coached to refashion their conduct, comportment, and appearance in ways that maximize their efficiency at work. In her words, soft skills training "is a niche that seems here to stay, given the drive to individualize—which has meant, ironically, to standardize—the worker in and around the modern corporation. In such a situation, an

industry that holds out the promise of turning out legions of uniformly moti-vated, dynamic, self-starters becomes an obvious, imperative necessity."[11]

Enriching these studies, Savitha Babu considers workshops that build con-fidence in "lower caste" employees working in the invisibly caste marked workplace. Her analysis of personality development programs conducted by social justice activists in Bangalore draws attention to the pedagogical value of "confidence" workshops for Dalit subjects. These workshops draw on a rich political and cultural history of anti-caste resistance and offer opportuni-ties to "learn confidence." Babu makes vivid that the critiques of personality development programs in neoliberal India do not adequately capture the multidimensional effects of such programs that counter the shaming prac-tices within educational institutions where students of "lower caste" status are devalued as "quota" rather than "merit" students.[12] Indeed, analyses of caste often remain obscured within discussions of contemporary capitalism in India where the pervasive effects of caste continue to benefit certain actors over others through promoting networks, resources, and other forms of social advantage. David Mosse demonstrates that the invisibility of caste in the economic realm of contemporary capitalism serves to protect the unmarked privilege of upper castes through recourse to such putatively objective measures as merit, which continues to perpetuate conditions of unfair com-petition. He explores caste as resource, as both capital and connections that continue to privilege upper castes in ways that mask the salience of caste as an economic vector of power.[13]

While the previous chapter considered the dark side of aspiration and how it manifests in urban panic around property and precarity, here I examine more privileged aspirations to global cosmopolitanism. The aesthetic prac-tices of high-technology workers craft new models of subjecthood that aspire to class mobility. The call center agents I interviewed confirmed this sense of aspirational self-fashioning as a stepping-stone to the next stage in a cor-porate career. The workers referred to their jobs as interim positions before they moved on to something better, more lucrative, more permanent. While the pay was good, there was little potential for career growth, they claimed. Some insisted that it was the glamour of the call centers that drew them. In the words of one employee, "You're talking with a complete stranger from a part of the world you've only seen in movies. There's a sense of connection."[14] Another employee remarked, "Our call center does work for really big global brands. We get a feel of what it's like to be working abroad by working for a big, multinational firm."[15] These comments elucidate how imaginaries of "the global lifestyle" shape the aspirational subjectivities of urban youth workers in India's high-tech industry.

While some employees might romanticize their jobs as offering a mode of travel through telephone conversations, others evinced more pragmatic concerns. One of the employees told me: "I'm much more worried about how I will get home at night than if someone in the States believes I am from

Texas or not."[16] In the words of another employee, "What I mostly think about is how I don't have a social life any more, how I can't hang out with friends because we work from 4 p.m. to 3 a.m. . . . and of course I really miss my sleep."[17] In addition, the racist invective from some customers when the agents' faltering American accent aroused suspicions unnerved many call center employees, who were eager to move to a less abusive work situation. Neither do these responses remain static over time. For instance, in a 2007 interview conducted by *Time* magazine, employees spoke candidly of the demise of the call center dream: "Earlier it was considered cool to work at a call center," said Nishant Thakur, nineteen, "that died out quite quickly." Another employee, Vishal Lathwal, nineteen, corroborated, "If you work at a call center today people will think you don't have anything else to do or were a bad student."[18]

These divergent and contradictory responses not only heterogenize otherwise simplistic and uniform representations of the call center youth as enamored of the West, but they also remind us of the lure and limits of consumer fantasies in the fashioning of emergent citizen-consumers in urban India. More importantly, these variable perceptions of the call center industry among youth in neoliberal India remind us of the importance of conceiving of cosmopolitan encounters not only through categories of national difference but also of intracultural differences of class, caste, gender, and regional diversity, subject to rhizomatic vicissitudes in the rapidly shifting techno-finance-media-scapes of urban India.

The discourse of globality, in the context of neoliberal urbanism in India, produces citizen-consumers who inhabit, through consumer choices and active fantasies, subject positions that exist in tension with the wider social and material contexts within which they are situated. The pervasive fashioning of consumer desire generates vertiginous disjunctures between on the one hand the production of globality and on the other the disruptive material challenges it introduces into the lives of city dwellers. Lata Mani, feminist cultural critic, argues that globalization mandates a "phantom discourse" to mediate the disruptive effects that are produced in its wake. "This phantom discourse," she argues, "does not merely disarticulate the real relations between neoliberal globalisation and the material realities it enters, transforms, or destroys. It also offers a mode of affiliation for its chief beneficiaries who are required to feel global in conditions that are a far cry from what that term supposedly denotes."[19] Mani's argument provokes us to move beyond the binaries of virtuality and materiality, which dominate critiques of technology and mediascapes in late modern capitalism. Considering the lives of the call center workers offers important insights into how the disjunctures between fantasy and lived experience, discourse and embodiment are negotiated, contested, and inhabited through impersonation.

Although I am considering impersonation, I am not interested in role-playing within traditional Indian artistic and cultural practices, which has

a long history within the subcontinent. Rather, I am interested in the social, cultural, and political implications of impersonation within work cultures situated in highly asymmetrical, intercultural, racialized economies of empire and power. The rich body of work in the context of colonial encounters by intellectuals such as Frantz Fanon, Roberto Fernández Retamar, Homi Bhabha, V. S. Naipaul, Derek Walcott, among others, considers the multivalent associations of mimicry in the production of a (gendered, elite) colonial subjectivity as violated authenticity, as weapon of resistance, as a register for the ambivalence of colonial discourse, as an index of nothingness, as a defiant act of imagination. The question of mimicry has also been debated within the field of South Asian subaltern studies where critics such as Ranajit Guha, Partha Chatterjee, and Dipesh Chakraborty have imaginatively responded to the charges of postcolonial nationalism as derivative discourse. The historical context of the multiple valences of mimicry is also important to bear in mind while considering how the neoliberal regimes of global capital harness this "flexibility" to facilitate multinational corporate agendas.

Does mimicry, in this context, produce a psychically damaged, schizoid colonial subject or create a "flexible" subject, capable of negotiating a dissembling doubleness, a way of inhabiting two worlds simultaneously? To understand practices of corporate impersonation we need to bear in mind the geopolitical history through which mimicry has long been deployed, to repressive and subversive effects, to negotiate the psychic neurosis and disjunctural doubleness of colonial and postcolonial subjectivities.

The call center employees, the bilingual natives, are in many ways the offspring of Thomas Babington Macaulay, British colonial administrator who was instrumental in the introduction of English as a medium of instruction in schools in colonial India.[20] The large English-speaking population made India an attractive location to outsource low-end information technology functions in the early 1990s. The shift to digitization produced new regimes of labor that provided back-office functions for industries that included telecommunications, cable, education, travel, and retail, among others. The digital regimes of labor enabled Indian companies to provide a range of services: survey, market research, account management, data management and processing, mortgage services, credit bureau services, travel and hospitality services, health care, white pages directory services, data conversion, imaging, indexing services, data entry, digitization, and management services, and so on. The transmittance of large quantities of data across territorial boundaries ensures new modes of "labor arbitrage," a form of cost-cutting where a company outsources labor and pays one labor pool in a different geography less than it would another labor pool in its own country for accomplishing the same work.[21]

Practices of impersonation are not disembodied but occur at a complex conjuncture in which material city, global capital, neoliberal state, urban cultural production, social relations, and spatial alignments intersect and

shape one another. Considering the material ways in which global capital enters into, disrupts, and rearranges a complex terrain of cultural, social, and political practices reminds us that even "cyber coolies," as they are disparagingly referred to, are located somewhere, must negotiate traffic, readjust their bodies clocks to serve customers halfway across the globe, contend with the unrelenting tedium of their jobs (they take roughly five hundred to seven hundred calls a night). Situating the affective labor of call center employees within their material contexts enables us to ponder the consequences of discourses that negate the concrete, material embeddedness of transnational labor.

The theater artists I consider in this chapter frame corporate practices of impersonation critically and mine the call center industry as a repository of data about urban aspiration. Examining a range of performances produced in Bangalore, Berlin, Kolkata, London, Los Angeles, Mumbai, New York City, and San Francisco reveal how these performances wrestle with divergent ethical dilemmas. While the critique of Euro-American corporate exploitation of third world labor structures the cosmopolitan encounters in both *Alladeen* and *Call Cutta in a Box*, *John and Jane* and *Dancing on Glass* evince different concerns: in the latter works, self-management and intracultural differences rather than intercultural encounters shape the volatile and asymmetrical encounters. Further, these latter productions complicate binaries such as self/other, consumer/producer, pleasure/labor, and economy/culture by exposing the precarity of the aspiring subject under neoliberal regimes of subjection. In the latter accounts, the psychic terrain of the agent is mediated by racialized fantasies, class aspiration, consumer desire, and new erotic tensions that emerge during their "nights of labor."

Have the virtual intimacies generated by new media and market technologies simultaneously ushered in a cosmopolitan connectivity? How, in this moment of neoliberal globalization, do we imagine the lives of others? This question propels the imaginations of call center employees, who aspire to upward mobility, to an "unbound seriality" of entrepreneurial youth.[22] What utopic gestures do we glimpse from portrayals of cross-cultural contact in the age of the copy? What social and cultural displacements are made vivid if we take into account, rather than disavow, the material circumstances in which these encounters are embedded? By considering the intersection of consumer fantasy, urban aspiration, and neoliberal state, this chapter tracks the affinities between economic globalization and cultural cosmopolitanism.

The virtual intimacies on display enable us to probe the multiple mediations that underpin taxonomies of identity and difference, culture and capital within the discursive frameworks of neoliberal globalization. The four works I consider dramatize cosmopolitan encounters between differently situated consumers and laborers: *Alladeen*, a collaborative venture by New York–based Builders Association and British-based experimental group motiroti; *Call Cutta in a Box*, produced by Berlin-based Rimini Protokoll; *John and*

Jane, an experimental documentary by Mumbai-based Ashim Ahluwalia; and *Dancing on Glass,* written by Bangalore playwright Ram Ganesh Kamatham. These works are not only produced through global artistic and financial alliances; they also take as their subject transnational circuits of production and consumption, labor and leisure.

Alladeen and "Global Souls"

I watched motiroti and Builders Association's collaborative Obie-winning production of *Alladeen* at the REDCAT (Roy and Edna Disney / Cal Arts Theatre) in Los Angeles in March 2004. The award-winning UK-based arts organization motiroti was founded in 1991 and is well known for their experimental and thought-provoking productions. As artists who themselves straddle multiple national imaginations, including Trinidad, Pakistan, India, and the United Kingdom, motiroti explores asymmetrical relations of power that shape competing imaginations of place. The group's declared artistic policy aims "to make art projects that transform space, and the meaning of space" as well as "to make art projects in the context of and with the intent of progressing current thinking about race, sexuality and gender."[23] Through their creative work, the Black British duo, Keith Khan and Ali Zaidi, bring diverse communities into cosmopolitan conversations that attenuate national and regional differences. Their dramatic performances probe ideas of home, travel, and community activism in performance events that include food, films, popular culture, and urban cultural practices.

Founded in 1994 and directed by Marianne Weems, Builders Association is a New York–based experimental performance company that, like motiroti, innovatively combines stage, screen, video, sound, and architectural design to perform stories from our contemporary world. Their Obie Award–winning work includes experimental productions such as *Xtravaganza* (2000) and *Continuous City* (2008). In *Alladeen,* the artistic collaboration between Builders Association and motiroti produced a mesmerizing experimental work that takes up questions of virtual identities and transnational impersonation within the call center industry.

Alladeen is composed of three media interfaces: the multimedia stage production, a website that features research on call center industry, and a music video. Social media offer the magical carpet to travel to other places, simultaneously distant and intimate. *Alladeen* juxtaposes electronic music, innovative video imagery, and live performance to explore postmodern travelers' tales. Built in two dimensions, the set straddles a wide screen that rises to reveal the sterile and hyperefficient interior of the call center. Various images are projected on the back wall that merge into each other, carpets morph into highways, and abstract Islamic art morphs into images of American popular culture, thus reiterating the power of transformations evoked in the title of the play.

The performance dramatizes, through sound, spectacle, video, and new media, the crisscrossing of global flows between various metropoles located in the global North and South. The project focuses on the international call center industry in Bangalore, where Indian operators train to pass as Americans and in the process make visible a network of consumerism, aspirations, and cultural collisions. Using Aladdin's story of transformation as inspiration, this retelling maps a transnational drama of desire and mimicry. As Builders Association states on its website, "*Alladeen* explores how we function as 'global souls' caught up in circuits of technology, and how our voices and images travel from one culture to another."[24] It is this notion of disembodied "global souls" that I want to draw attention to here.

The collaborative "triptych" production of Alladeen enacts a tale of three cities—New York, London, and Bangalore—that are not only the key sites of transaction in a global outsourcing industry but also provide the source material for the transnational production of the performance. Displaying the tenacious relationship between capital and empire, this triangulation exposes American corporate hegemony as both continuity and rupture of British imperial history in India. The triangulation of Bangalore between London and New York juxtaposes the older memory of a somnolent colonial Bangalore with the frenetic rhythms of a city pervaded by global flows of European and American late capitalism. The specter of British imperial history hovers over this scenario and lends it a sense of historical depth by reminding us that, despite the presentist rhetorics, globalization partakes in a much deeper history of transnational capital and empire. Joining British colonial history with the extension of empire to the United States, the multimedia show suggests that imperialism did not end with formal decolonization. Rather, imperialism is intrinsic to capitalism. Tracing the circuits of global capital between New York, Bangalore, and London, the show demonstrates how contemporary imperialism derives from the capitalist exploitation of some countries by others.

The production insists on using the Arabic pronunciation, Alladeen, instead of Aladdin, in order to de-Orientalize and reappropriate the medieval Arabic folk character. In addition, its critical mimesis of Orientalism with its evocations of flying carpets, genies, and so on offers the backdrop against which fantasy and materiality collide in the call center industry. The production emphasizes Aladdinian shape-shifting and mutability, a theme that is captured not only in the substance of the folktale but also in the obscure origins of this story told by a Syrian to a Frenchman about a Chinese character. This mutable global cosmopolitanism is contrasted to territorialized, sedentarist, and bounded notions of local identity.[25]

The narrative tracks the pedagogical and cultural training of four call center aspirants. The scenic space is composed of several fragments that include a split stage, actors stationed in front of computer screens, a large-screen backdrop depicting more images that mutate into one another: these include

footage of "real" call center employees from Bangalore and images from American popular culture, such as the TV series *Friends* (1994–2004). The training and work sessions of the call center employees in Bangalore are at the heart of this play. The four actors are seated downstage and the images projected on a movie screen upstage. We witness the pedagogical inculcation of Bangalore employees seated in swivel chairs by an officious white American instructor, and an Indian supervisor, eager to purge their diction of any native influences. The depiction of pedagogical indoctrination is juxtaposed with clips from a video called "How to Neuter the Mother Tongue," where the supervisor Sharu Jose instructs her students on how to speak in Standard American English. The segment illustrates how multiple media of instruction, from classroom teaching to American sitcoms, *mediate* the subjects of the call center industry.[26]

Language training within call center agencies focus not only on retraining speech patterns that require dropping Indian regional inflections but also on acquiring facility and ease with spoken "global English." *Alladeen*'s focus on "accent neutralization" within call center industries raises an important question: For capital to be flexible, does it need to neutralize culture? Does culture get in the way of capital? The "global English" that renders agents placeless is a variant of metropolitan American English without regional markers. A sleight of hand conflates "American" with "global," forcing us to reformulate the question: What is the culture of capital? The efficiency of economic performance lies in the uninterrupted flow of global communication, which necessitates the indoctrination of a replicable, standardized set of practices and procedures that efface all traces of contextual contamination. This pedagogical indoctrination into American tongues, lifestyles, and pop-cultural references becomes an important part of the training of call center employees.

Carol Upadhya explores the role of international management theory within outsourcing industries to study the ways corporate training programs encourage employees to mold themselves to fit a management-approved personality type.[27] She points out that Indian software engineers are expected to fashion themselves to an acceptable "global" (read American) corporate type, while ironically these very corporations extol the values of individuality and self-reliance within the workplace. Global cultural industries deploy "culture" in myriad ways to manage frictions that may interfere with smooth financial transactions.

Alladeen illustrates how the employees take on American names and identities derived from American television's famous sit-com *Friends*. Identification, in this scenario, is tethered to a neoliberal rationality where corporate surveillance is internalized into techniques of self-management. In the words of the *New York Times* critic Margo Jefferson, "We see the Asian faces of Tanya and Aman morph into the white faces of Phoebe and Joey, answering the questions and complaints of unsuspecting American callers. The callers

could be us. The callers are us. And the speakers are us, too, now. They have learned to be."[28] But who is the "us" of a transnational *New York Times* readership? What (racialized, territorialized, classed) horizontal fraternity is invoked here? According to this account, the "speaker" from overseas triggers the dissolution of racial, ethnic, and religious differences and enables the coming together of divergent Americans into a unified imagined community. But what kind of cosmopolitanism is predicated on the melting away of differences into the unmarked, normative whiteness of the American consumer?

The phantasmatic character of these transformations is reiterated through the scenic design: images from Hollywood and Bollywood movies alternate; blue globes turn in the workspace, and green lamps float through black space, heightening the sense of fantasy. In addition, the screen projections of maps, video footage of "real" call center employees from Bangalore, and images from *Friends* meld and morph into each other. These transformations exemplify the ways in which employees are interpellated by deterritorialized discourses on globality. Through a process that simultaneously disavows the material dimensions of their labor and also actively encourages them to imagine, if not identify with, the lifestyles of the racialized, urbane American middle class, impersonation becomes a "worlding practice" whereby call center agents take up and perpetuate the vision of a world-class city.[29]

The telephonic exchange between American consumer and Indian employee impersonating an American identity offers a crucial moment to consider both the racialization of imagined cosmopolitan identities in India as well as the territorial claims and articulations of citizen entitlements in the United States. Call center employees engaging in a sort of "neocolonial mimicry" play right into the desire of global capitalists for a reformed, recognizable "other" as a subject of difference that is in Bhabha's formulation, "almost the same" (i.e., can do the same work) "but not quite / not white" (i.e., gets a fraction of the pay).[30] If, for Bhabha, "the gaze" offered the possibility of subversive rearticulation where colonial surveillance is returned in the displacing gaze of the colonized, in the context of the call center industry the "vocal mimicry" plays on the ambivalence of contemporary capitalism that turns call center employee's mimicry of American identity into the "menace" of outsourcing American jobs to the "third world." The morphing faces, the vocal mimicry signal the menace of labor arbitrage in how highly mobile capital detaches entitlements from territorialized claims of citizenship and reattaches them to the neoliberal market.

While *Alladeen* successfully explores the coimbrication of neocolonial mimicry and racialized performativity in the production of neoliberal, transnational citizen-consumers, it reproduces the effects of deterritorialized discourses on globality. In his essay on *Alladeen* within the context of a performative matrix, Jon McKenzie asks, "Does this cultural performance reinscribe the normative forces of globalization, or is it transgressive, transforming and unsettling them? Or might it be both?"[31] While McKenzie

suggests that the play simultaneously reinscribes and challenges normative discourses of globalization, Jennifer Parker-Starbuck observes in her review of the play, "Although these attempts at cultural passing are theatrically entertaining, the crucial underlying issues of colonialism and corporate capitalism that drive these erasures could have been more critically unpacked in terms of the content of the piece. . . . Unfortunately, the interrogation of such facts was not fully present in the production, giving way instead to a 'let's all be Friends' glossing over the questions of political economic structures."[32] If *Alladeen* participates in the compulsive deterritorializing of globalization, it also perpetuates a utopic fallacy of cosmopolitan connection. In order to understand why *Alladeen*, a play that sets out to critique exploitative transnational labor practices, provokes such ambivalence among its viewers we need to look beyond the stage and onto the wider representational regimes of subjection under neoliberal capital.

Although *Alladeen* attends to the asymmetrical relations of power that undergird cosmopolitan encounters, the play reifies differences between callers and speakers, us and them. By rendering the caller invisible (and hence Jefferson's universal "us"), while simultaneously provincializing "the other" as mimic native, *Alladeen* reinscribes the binary colonial logics of identity and power, of black skin and white mask, that, as Fanon passionately argued, produces "the other" only through a crushing objecthood.

While *Alladeen* depicts the ways call center agents imagine the lives of "others" through a retraining of speech and corporal and cultural sensibilities, it stops short of drawing the privileged and invisible spectator into the circuit of transnational labor. While for the call center employee fantasy, identification, and impersonation are crucial technologies for the cultivation of a "flexible" self, the means through which to aspire to a better life, for the spectator, the native is unidentifiable, abject, nothing like the self. The comforting colonial certitudes of master/native consolidate the "Western subject's" self-image and structures his gaze. The call center employee signifies everything that the Western subject is not; the viewer, in short, disidentifies with the native mimic. *Alladeen* invests the spectator with power and anonymity, as he sniggers at the hapless attempts of "third world" workers to impersonate him. The disintegrating mutation of the derivative "other" onstage becomes the occasion to reinforce the binaries of us/them, first world / third world, and consumer/laborer and augment the stability, desirability, and authenticity of the self. In this way, *Alladeen* reinscribes the (neo)colonial gaze that witnesses the decomposition of the native mimic.

The Cosmo-utopia of *Call Cutta in a Box*

Rimini Protokoll, a German/Swiss theater collective that consists of directors Daniel Wetzel, Stefan Kaegi, and Helgard Haug, created two performance

pieces that explored the staged encounter between consumer and laborer within the corporatist framework of the call center industry. Rimini Protokoll's performance piece *Call Cutta in a Box* reimagines their earlier work *Call Cutta Mobile Phone Theatre* (2005), which staged a transnational performance encounter between Kolkata and Berlin. *Mobile Phone Theatre* uses the labor of the employees of a Kolkata-based call center agency. Cast by Rimini Protokoll as performers, these call center employees spatially orient tourists in Berlin through their role as sedentarized yet cyber-mobile expert tour guides. What ensues is a choreography where, via "virtual migration," the sedentary Kolkatan leads travelers through the streets of Berlin and Kolkata while also initiating a (rehearsed) "spontaneous" cosmopolitan conversation.[33] For one audience member, Tina Bastajian, the dramatization incorporates the fuzziness inherent in GPS technologies and "allows for diversions to emerge, and sometimes more successfully than others, takes us off course, where routine can become epiphany, discovered together in real time."[34]

According to the director, Wetzel, the walking tour project, while generative, disabled an engaged dialogue between two people located across the globe. To conduct a "real" conversation while simultaneously attempting to find your spatial bearings proved too challenging. Wetzel further observes, "Also technically the connection was just not so good—it was too fragile and noisy. We asked ourselves what would happen if we reduced the complications and offered the option to really talk."[35] Thus emerged their second call center performance piece, *Call Cutta in a Box*.

In *Call Cutta in a Box*, Rimini Protokoll moves the mobile phone theater within the precincts of a closed room, where the solitary audience member now engages in a one-on-one transnational telephone conversation with a call center employee in Kolkata. For the project, Rimini Protokoll contracted the services of Descon Limited, a software call center in Kolkata that provided them with fifteen workstations and free technical and maintenance services. Each performance is thus a joint venture between Rimini Protokoll and Descon Limited, a company located in Salt Lake City, a satellite township and IT hub built on a reclaimed saltwater lake.

Meanwhile, at precisely this time, the trajectory of neoliberal aspirations in the region was seriously challenged by the poorest and most disenfranchised people in the region, where Left governments promoted rapid urbanization of the city's peripheries. From 2006 to 2008, when *Call Cutta in a Box* was playing, Kolkata was rocked by serious challenges to its neoliberal ambitions. Some of the most marginalized sections in Bengal, local peasants and sharecroppers, fiercely confronted the emerging neoliberal policies in the region. Two events reshaped the electoral politics in West Bengal: first, the collusive politics of state and private capital led the Left government to seize land from peasants and provide massive subsides to Tata Motors to set up the factory of the world's cheapest car, Nano, at Singur, a site on the edge of Kolkata.

Second, the Left government's plans to cordon off village land into a profitable Special Economic Zone (SEZ) at Nandigram, a village in West Bengal sparked a peasant uprising, which was met with extreme police reprisals.[36] The exposure of its imperialist designs, in its bid to make the poorest sections of its society finance the aspirations of the country's middle classes, discredited the Left government as a champion for social justice.

Call Cutta in a Box cordons off the artistic project from the concurrent rhizomatic political shifts in Kolkata. In Rimini Protokoll's aesthetically bounded performance, the audience/customer enters into a room where a phone rings; she picks it up and begins her conversation with the call center agent.[37] The cosmopolitan encounter is enacted through discrete scenes: the agent offers her customer a cup of tea to provide "the Indian touch." Immediately, an electronic boiler automatically switches on, and the customer enjoys the tea. More "synchronized surprises" follow that demonstrate the increasingly algocratic organization of social relations in the transnational marketplace.

The conversations in *Call Cutta in a Box* range from strained intimacy ("Can you feel the distance between us?" asks the female agent; the male customer responds, "You are very far but your voice is very near") to overt flirtation ("I am very alone. Come here," says the male customer to the female agent; later he tells her, "You can marry me") to deeper engagements ("What is a big mistake that you have made in your life?" asks the agent; the customer replies, "I've learned something from all my 'mistakes,' so I wouldn't call them mistakes, just experiences that brought new understanding") to sentimental experiences (one customer begins to weep as she hears the agent sing a Hindi song; she explains, "Sometimes you don't need to understand the words to get the feeling").

The agents steer the conversation by asking fairly direct and personal questions: "Are you lonely? Do you have a boyfriend? Are you healthy?" to more probing ones: "Are you satisfied with your life?" Reminders of cultural difference punctuate the exchange: the agents insert the topic of reincarnation, sing Indian songs, share pictures of their domestic help, serve *chutki* (Indian peppermint), display the map of Kolkata and a picture of the generic glass and chrome Descon building where they are located, and conclude by presenting a kitschy altar of Kali, the Hindu goddess, which the customers discover in a drawer while they are taken on an imaginary ride through the city of Kolkata. The scene of mutual revelation closes the intercontinental phone play: agent and customer gaze at each other's faces on their computer screens, promise to stay in touch, and bid farewell.

Rimini Protokoll is critical of the ways that global capital, seeking a higher rate of return, enters into, and disrupts the lifeworlds of laborers. So their cosmo-utopic project attempts to redress the dehumanizing effacement of identity of call center employees. The DVD documentation of the film I viewed demonstrates heterogeneous conversations that take place between

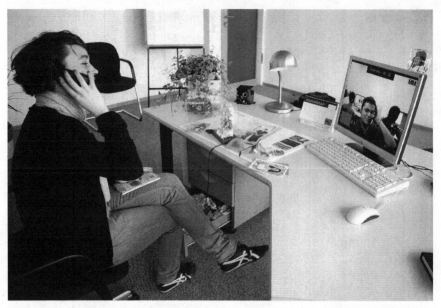

Figure 8. Rimini Protokoll / Hebbel Am Ufer (HAU), *Call Cutta in a Box*, Berlin, 2008.
Copyright © Barbara Braun / MuTphoto.

agent and customer, but the cheery agents follow the script to ensure the predetermined turns in the conversation.

Call Cutta in a Box programs a series of surprises into the dialogue that manifests the significance of code in enabling transnational commerce. Revealing the power of programming codes in the organization of transnational labor, A. Aneesh advocates algocracy, where authority is embedded in the technology of the code itself, thus rendering obsolete older hierarchies.[38] Programming and coding are intrinsic to the emerging transnational labor regimes, he argues: through optimal algorithms that mediate code and capital, programming codes organize transnational labor. For example, "the fields on a computer screen can be coded to allow only certain kinds of texts or digits. Software templates provide existing channels that guide action in precise ways. This guidance suggests that authority does not need legitimacy in the same sense, because either there are no alternative routes to the permissible ones or the permissible routes are themselves programmed."[39] The rule of the algorithm presages a new neoliberal governmentality.

The universality of abstract programming code mirrors the social discourses of liberal cosmopolitan connections. While structured as a transnational conversation to give insight into the life of the call center agent, the intercontinental play ends up reifying cultural difference. The "global friends" discourse assembled from the drama of cosmo-utopic "connectivity"

not only effaces the constitutive asymmetry that undergirds these global conversations but also obscures the mutual participation of consumers and laborers in reinforcing capitalist hegemony. Miya Yoshida argues, "For the audience, *Call Cutta* is a participatory art project that they enter out of a private interest, and in their leisure time, while for the agents, it is a 'job' by which they support their lives."[40] While the encounter between the audience and the employee can be read through the binaries of pleasure and work, leisure and labor, consumption and production, such polarities disallow a larger consideration of how recreation itself is central to the "re-creation" of labor power. *Call Cutta in a Box* demonstrates the dialectical relationship between leisure and labor that mutually fuel the engine of global capitalism.

In an interview with Barbara Van Lindt, Rimini Protokoll director Daniel Wetzel acknowledges how pedagogical indoctrination into Euro-American cultural practices and representations facilitates the smooth functioning of business. He notes, "[The] theatre of service hides the reality of globalization . . . but this theatre of service also forces the Indian performer to hide his identity."[41] Here Wetzel evinces an anxiety that corporate globalization requires practices of subterfuge to facilitate the smooth uninterrupted global flow of service/capital. The theater performance of Rimini Protokoll's *Call Cutta in a Box* redresses the damage caused by such mediations by enabling the consumer to glimpse "the Indian" behind their American persona. Wetzel laments the "absolute lack of communication from person to person" in the "vast ocean of business-related talking all around the globe, occurring all the time." *Call Cutta*, then, offers an opportunity for a conversation between two people "who don't know each other, who are literally situated in different worlds, without any business-related reasons, and trying to just get a glimpse of who and where and what the other one might be. . . . The play offers you an opportunity to talk to subjects on the backstage of the globalization process."[42]

Call Cutta's ingenious transnational conversation moved from the *Mobile Phone* theater version to the one "in a box," and allows the audience member to enter into scripted spontaneity with agents to "just talk." But does the promise of a "real connection" deliver? Is it possible to access the presence of "the Indian," behind the European persona, without recourse to more mediation? Does *Call Cutta* invoke "culture" in ways that reflect the cultural stereotyping in management ideologies? Do outsourcing companies reify "cultural difference" while simultaneously celebrating that very difference as indicative of an egalitarian, progressive, multicultural, global industry?

If the call center industry provides an intensified glimpse into the performance of roles in the everyday life of the corporate workplace, does having an Indian affirm her Indianness put an end to role-playing? Or is she now, in *Call Cutta in a Box*, playing the Indian? The persona constitutes the very idea of the person. The cosmopolitan encounters discussed above reify cultural difference into an unchanging and a priori fact of identity. The interface

between global capital and cultural identity in *Call Cutta in a Box* reveals how "culture" itself is commoditized, subjecting it to novel forms of capitalist control.

John and Jane: Copies in the Age of Capital

Ashim Ahluwalia's *John and Jane* poignantly depicts urban actors in the call center industry in Mumbai, a city at once home to cosmopolitan aspirations, regional and religious nationalism, and the fantasy-generating Hindi cinema industry. Though Mumbai is held hostage by homegrown and terrorist violence, the city's urban planners and politicians yearn to remake it in the image of Shanghai. While *Alladeen* and *Call Cutta* attempt to bridge the distance between the putative West and East, first world and third world, laborers and consumers, Indian urban planners look to Singapore-Dubai-Shanghai for inspiration and emulation rather than the erstwhile triad of New York–London-Berlin. In the "Asian century," Asian cities offer the mimetic models through which Indian cities imagine their participation in world-city projects.

If *Alladeen* and *Call Cutta in a Box* demonstrate the utopic potential for cosmopolitan contact in the global marketplace of the copy, then Ashim Ahluwalia's experimental documentary, *John and Jane*, depicts the increasing isolation in the life of call center agents. Shot in 35 mm images, the film explores the dystopic ramifications of the psychic and social disjunctures produced in the lives of call center workers. By deterritorializing its viewers through its unsettling sonic score, unstable visuals, and uncanny narrative, *John and Jane* takes the viewer on a dark tour of the fantasy lives of its protagonists. Ahluwalia sets the story of his six agents against the frenetic rhythms and flickering nightscape of Mumbai, city of cinematic fantasies, the cosmopolitan nerve of the nation. Set against the frenzied rhythms of neoliberal Mumbai, *John and Jane* tracks the ways the six call center agents step into its field of vision. How are these agents interpellated through the pervasive spectacular consumerism in neoliberal Mumbai? How do their consumer practices index the aspirations that project them as cosmopolitan world-class citizens? The economic aspiration to globality comes at the cost of disrupting and denying the rhythms of their temporal clocks, social lives, and personal identifications. The film progressively depicts how consumer fantasies produce, through embodied practices, new habitations of selfhood in the neoliberal marketplace.

The ominous soundtrack in the film, created by Masta Juicy, heightens the disquieting sense of the uncanny. By sonically disallowing any harmonizing closures, the tense, pulsing electronic soundtrack reinforces the way the film unsettles its viewers. The precarity of this world is delivered aesthetically through the film's visuals and soundtrack. What fantasies keep its dwellers awake through the night? These are no nights of the proletarians: Ahluwalia

depicts the frictions between the material everyday and the consumer desire that buoys up fantasy lives. The tiny, claustrophobic tenement-style homes the agents live in are a far cry from the pristine sterility of the air-conditioned offices where they work through the night. The generic, replicable place-lessness of the spotless offices is punctured only by occasional reminders of manual labor: in the corridors, a sweeper polishes the floor, and a *tiffin-wala* brings food to the employees.

Ashim Ahluwalia, an experimental filmmaker and the founder of Future East pictures, lives and works in Mumbai. *John and Jane* is his second film, following *Thin Air*, the award-winning documentary that follows the lives of three magicians against the backdrop of contemporary Mumbai. *John and Jane* received several awards, including the Best Film Award and Dialogue Prize from the European Media Art Festival; the Winner of Jury Award from the VC Filmfest; an Honourable Mention from the Maysles Brothers Award; and Best Nonfiction Film from the National Film Award. Described by Ahluwalia as "part observational documentary and part science-fiction," *John and Jane* follows the stories of six call center agents who answer American 1-800 numbers in a Mumbai call center, Fourth Dimension. The double life of the call center employees triggered Ahluwalia's desire to make this film. In the words of the filmmaker, "For me, the idea of virtual 'call agents' with fake identities seemed like science fiction. Who were these Indians that became 'Americans' at night? . . . What we discovered while making this film was incredible—characters who had a hard time separating the real from the virtual."[43]

The trope of the replica propels the filmic narrative and is established in the opening shots where flickering lights of Mumbai's nightscape illuminate mannequins in a display window. The double life of the call center agent is presented through three dyads, three versions of John and Jane. In the film, the call center organizes its laborers into pairs, and Ahluwalia traces the stories of six characters. Traversing the spectrum of subject positions, Ahluwalia's narrative begins with agents most tethered to the material everyday and depicts increasingly abstruse accounts and concludes with a story with only the faintest grip on reality. The story moves from the concrete sensuous-ness of the everyday life of the characters to deterritorialized depictions of the agents' double life. As Ahluwalia describes it, "In the film, there are three sets of John and Jane—who appear in order of their team's ranking. In that sense, the film documents the transition from Indian (worst sales ranking) to American (highest sales)."[44]

The narrative of the six agents is punctuated by scenes of pedagogical training: first a Caucasian American and then an Indian American train call center aspirants to speak "neutralized English" and impart data on the values of the average John Doe, which include individualism, achievement, success, privacy, progress, and the pursuit of happiness. If the repetitive rehearsals of rhyming couplets to neutralize accents infantilizes the adult trainees, the

cultural education disparages India. Leafing through mail-order catalogues, the instructor not only kindles the consumer appetites of her trainees, she simultaneously derides products available in India: "Do we get towels looking like this in India? No. Do we have this much variety in India? No." Insidiously indoctrinating the trainees into the cultural, social, and economic superiority of American consumerism, these scenes demonstrate the subtle ways that corporations entrench new aspirations and inculcate consumer desire within the trainees.

The first agent, Glen, while derisive and critical of his job, continues to labor through its grueling worknight in the hope that it will eventually pave the way for him to model for fashion giants such as Gucci and Cavalli. Smoking joints, drinking at local pubs, and ranting to his friend about his "disgust" for his job enables Glen to endure its repulsive, degrading inanity. Humor is a key tactic of subversion and survival: Glen narrates how when a customer complained of the noises his new rotisserie makes, Glen quips, "Maybe you put a live chicken in there?" But even his sense of humor cannot defuse the increasing dehumanization that Glen experiences in this job. "Am I talking to an answering machine?" berates one caller. "No, sir," Glen replies curtly, "We're some fucking human beings here." Intermittently Glen resists, then yields to, the algocratic programming of his embodied nightly labor.

Training dancers in decrepit rooms, applying mascara on his fellow dancers, shopping at glitzy, high-end stores enable Sidney, a queer dancer (Jane, in this dyad), to sustain himself from the dreary monotony of his job. Unlike Glen, though, we can already begin to see how the precarity of the job, the constant surveillance and insecurity generated by the performance matrix begins to erode Sidney's self-confidence: "They record your calls, and they grade you. If the call was bad, you lose your incentives for the whole month." The exasperation of working through the unrelenting tedium and stress of his job generates a feeling of inferiority. "I'm stupid," he says, "because an inner feeling within me says: No, you can do better." Glen and Sydney sharply criticize, even despise their jobs, but stick with it because they believe in its promise of cosmopolitan mobility. They hope that it will provide them with the means to escape the stultifying oppressiveness of their tawdry, provincial lives and will bring them closer to their aspirations of being a fashion model and a dancer.

The next dyad we are introduced to is Osmond and Nikki Cooper. If, for Glen, the insidious demands of capitalist labor are indoctrinated into workers through embodied practices that tame and train them into answering machines, for Osmond these bodily habits are precisely what enables him to cultivate a "principled" lifestyle. Osmond retrains his personality, through carefully cultivated habits, to move from his earlier slovenly lifestyle to a brisk, corporatized one, or, as he puts it, from "a negative to a positive." As Osmond prepares himself an English breakfast in his tenement style one-room home, we glimpse the images that adorn his walls: a house in a

gated community, an Aprilia motorcycle, images of celebrity role models—all indexing the cosmocratic lifestyle he yearns for. He surrounds himself with schedules that account for every minute of his day, along with self-help books. He even sleeps to the incessant reverberation of the tape-recorded mantra that repeats, on a loop: "Now I am wealthy, now I am wealthy . . ." A careful retraining of embodied practices facilitates the fashioning of an entrepreneurial subjectivity: "Now when I'm talking about business, there's more to it than products," explains Osmond, "Like, for example, my breath. A small thing like my breath can turn people away. My business teaches me to improve upon those things." Through the embodied cultivation of an entrepreneurial habitus, Osmond lives the American dream in India. "Only in America can I become a billionaire," he muses, connecting his material aspirations to cosmopolitan mobility and travel.

If becoming a billionaire is the telos of Osmond's aspirations, in Nikki Cooper we find more altruistic and sentimental desires. Nikki's sense of compassion is not restricted to her callers; she inherits a rickety lodge from her aunt, where she lives and which she rents out to her friends. When she is not working, Nikki attends "spirituality" classes, where we see her gently swaying to New Age–type devotional music. Nikki persuades herself that her role in the call center is not merely to sell products to customers but, more importantly, to assuage the gloom of lonely Americans. Nikki attempts to alleviate some of their imagined isolation by persuading elderly Americans to buy cheaper phone plans that will reconnect them with friends and family. "No one calls me. I call no one. That's just fine. I'm satisfied with it just like it is," admits one caller. But her missionary desire to rescue these abandoned souls makes her try harder to sell cheaper calling cards: "You want to do so much for others. It's love, and giving. It's so beautiful," she insists.

Nikki's yearning for a family and a home is especially acute when set against the teeming, hectic nightscape of Mumbai. For both Osmond and Nikki, orphans without the nurture of parents, call centers become their home. While she yearns for the security and plenitude that she imagines a family can provide, she is content that she has found a surrogate family in the call center. Likewise, for Osmond, Amway is his mother, for just as a mother "builds you up," so too does Amway.

Nicholas and Naomi are the last in the series of dyads. For Nicholas, working at a cell center firm promises not just to transform his exterior habits but to rearrange his inner sense of self. The call center offers the ground for courtship and conjugality. He meets, falls in love with, and marries a fellow call center worker. The call center also promises to transform him from a Hindi-speaking Mumbaikar to an urbane, sophisticated American: "I was a person who used to speak in Hindi, but then English started coming into me, where I would always like to speak in English. . . . It was kind of an American feeling that I started having. . . . I don't want to be an Indian any more." This is no scene of accent neutralization; rather, language is the means

through which to register the acquisition of a new value system and escape the "vernacular" provincialism of Hindi to English, the language of the global elite.

The most extreme segment is the final one: Naomi, a young woman whose racialized fantasy to be not just American, but specifically a blond American, leaves her with only a blurred and indistinct grasp on her immediate surroundings. Speaking through a sleep-deprived haze, Naomi giggles, "I'm totally, naturally blond. I'm looking for an ideal guy. Blonds get attracted to blonds. That's very natural, of course." If in her waking hours she fantasizes in color, then as she sleeps, she dreams in numbers: "I'm doing data entry. My fingers move in my sleep," she murmurs: "I dream of numbers." Unable to break the programmed reflexes of her embodied nightly labor, Naomi attempts to reclaim some control over her body through her consumer practices. But labor and leisure coexist in an inescapable loop. Naomi languidly wanders through spaces of consumption: she tries on skin-lightening makeup at shopping malls, and keeps an eye out for blond men at nightclubs. In the racialized scenarios that play out in her head, we see a case of the other threatening to engulf the self. The film ends on this dystopic, posthumanist note.

Ahluwalia etches out these nights of labor against the maniacal, pulsating canvas of the Mumbai nightscape, which glitters between the rush and flow of incessant traffic and petrified images of dummies in window displays. Social ties wane as their nightly labor and daily sleep shift their temporal clock, leaving them increasingly more isolated. We watch the agents as they navigate their day in a slightly dazed manner, and we see the increasing hold that cosmopolitan aspirations, fueled by consumer fantasies, have over their everyday lives. Ahluwalia insightfully demonstrates the continuous feedback loop between labor and leisure, production and consumption, that structures the everynight life of the agents. By revealing the precarity and tenuousness of their hold on their material social worlds, Ahluwalia demonstrates how global capital subsumes and erodes affective social relations under its hegemonic logic.

As in Pirandello's classic play, the six characters here are abandoned by their author and play predetermined roles within an algocratic imaginary with little scope for individual agency. As they shuttle between actor and character, person and persona, the dichotomy between the two begins to dissolve. Ahluwalia exposes the varying ways that agents challenge, criticize, imbibe, inhabit, surrender to their fictions. But like Pirandello, Ahluwalia also insists that theirs is a play-within-a-play. The role-playing is not limited to their worknights: Ahluwalia exposes a range of habituated performances of globality, urbanity, gender, charity, class, caste, and race. There is no "authentic" agent who dons an inauthentic mask; Ahluwalia's six characters flicker between given and imagined roles, even as they resist and yield to the algocratic programming of their bodies and their dreams.

Cosmopolitanism from Below: *Dancing on Glass*

Ram Ganesh Kamatham's *Dancing on Glass* (2004) moves the focus from disembodied practices of global impersonation to a consideration of the very real temporal, embodied disorientations experienced by call center workers. The title, *Dancing on Glass*, reinforces this point by calling attention to the material, mortal body, simultaneously in rapture and in pain. An emerging playwright of English theater from the city of Bangalore, Ram Ganesh Kamatham wrote his first play, *Square Root of Minus One*, in 2002. Since then he has written fifteen plays and directed seven. His creative work deals with neoliberal urbanism, mythology and history, and urban youth, among other issues. Kamatham's trilogy of city plays comprises *Dancing on Glass*, *Creeper*, and *Bust*.

I watched *Dancing on Glass*, directed by Preetam Koilpillai, well known for his experimental productions, in July 2004 in Bangalore, four months after having seen *Alladeen*. I subsequently watched another production of *Dancing on Glass* directed by Vidhu Singh of Rasanova in San Francisco's CounterPulse theater in October 2010. The divergent audience responses to these two productions of *Dancing on Glass* were instructive. The Bangalore production drew a fairly homogeneous crowd of trendy, urbane, English-speaking theatergoing youth to the intimate auditorium of the Alliance Française in Bangalore. The encouraging cheers during the show from the audience in the extended the sensuous fellow-feeling and camaraderie beyond the stage. Breaking the diegetic verisimilitude by interrupting the aesthetic distance between actors and audience made the viewing experience itself intimate, friendly, and convivial.

The San Francisco production drew a much more eclectic crowd composed of Indian software professionals, San Franciscan theatergoers, and nostalgic diasporic Indians. The divergent responses during the talk-back discussion at the San Francisco production ranged from comments that addressed actors as native informants on all things Indian to vociferous objections to the "call girl" portrayal of Indian womanhood in the play.

Dancing on Glass tracks the life of Megha, aka Megan, a young, confident call center employee who gradually descends into a vortex of depression and gloom. In addition to the repetitive tedium of her job and the racist and sexist abuse she encounters over the telephone, she contends with the challenges of working through the night. In the words of Megha, "Slept at five in the morning, it's now four in the afternoon. Open my window, I'll get blazing sunlight. Started sleeping this way, now I've done a full three-sixty. Is there anything that isn't flipped completely upside down around here?"[45] The nocturnal working hours produce resultant ailments: she develops a skin disorder from lack of exposure to the sun; her hormones act up because of her irregular sleep patterns. The temporal disruptions produced by the nightly demands of labor not only created physical ailments but also deprived employees of

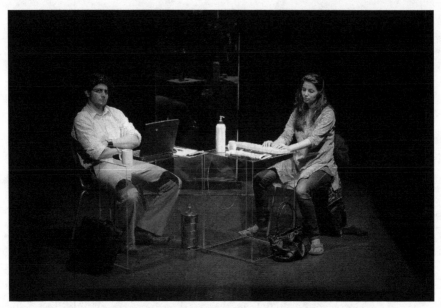

Figure 9. Amisha Upadhyaya as Megha and Amit Sharma as Shankar in Vidhu Singh production of R. G. Kamatham's *Dancing on Glass*. CounterPulse, San Francisco, 2010. Photograph by Michael Rauner.

everyday sociality and plunged them into quarantined work-lives. *Dancing on Glass* exemplifies how somatic rhythms of the call center workers are disordered as employees work nightly to service American and European customers.

Compounded with sleep deprivation, the training manual Megha is expected to memorize brings her to the edge of her nerves. An unapologetic repository of racist and Orientalist clichés, the manual infuriates Megha as she memorizes the disparities between India and USA:

> "Resources: The differences and similarities between India and USA. India—Scarcer resources. USA—More abundant resources. India— Mismanagement of resources. USA—Resources better managed. USA resources . . . oil, natural gas, coal. India resources . . . Rich in spices, cloth and textiles, artefacts . . . and people." She stops reading. "People! Yes there are one billion of us fuckwits. And when you walk down M.G. Road there are elephants, Bengal tigers and fakirs who do the Great Indian Rope trick for just under a dollar."

Vocalizing her frustration, Megha constantly exceeds the proper place of the idealized Indian middle-class woman in urban India. Yet she is not invulnerable to the increasingly widespread sexualization and harassment women

experience in public spaces. For example, Megha narrates a fairly routine incident that occurs in the city: "So I fall and some ten fuckers come running from all goddamn directions and surround me. One fucker lifts me up, like . . . like this . . . *(gestures)* The guy is supposed to help me up and instead he's feeling me up. And the remaining nine bastards stand around watching. I told them all to fuck off, got on my bike and got out of there."

Dancing on Glass makes vivid the intracultural tensions where cosmopolitan images and ideas are contested, seized on, and challenged by actors situated along identity vectors of region, class, and caste. Kamatham portrays how acute conflicts between culture, caste and class are mediated through women's bodies. When transnational encounters are displaced onto intracultural scenes of material aspiration and cultural belonging, they generate unstable and volatile fields of social power.

Consider this case: on December 13, 2005, roughly a year and half after *Dancing on Glass* premiered in Bangalore, Prathibha Murthy, a twenty-four-year-old call center employee, was kidnapped, raped, and killed by the company-hired cab driver.[46] The incident exposed the precarious conditions of labor that undergird the professional aspirations of Bangalore's young call center workers and punctured a hole in the gleaming facade of Brand Bangalore. For critics of the high-tech boom in Bangalore, this case reinforced patriarchal commonsense about women's place being within the home, the dangers of the urban nightscape, and the threats awaiting "call-girls," the epithet disparagingly used to refer to women workers in the business process outsourcing (BPO) industry.[47] The incident gives pause to anodyne and deterritorialized representations of the call center industry that dwell on impersonation and cosmopolitan "connection" between people located in widely divergent cultures and societies.

In addition, a spate of attacks on "Westernized" middle- and upper-middle-class Indian women in Mangalore and Bangalore in early 2009 and 2012 by members of Ram Sene, a Hindutva right-wing group, is a case in point.[48] Middle-class women were targeted for wearing "Western clothes," drinking or smoking in public, and even speaking English. Many of these attacks were perpetrated in the name of a nostalgic invocation of traditional "Indian culture." Such restorative nostalgic visions hark back to an imagined past where women knew their spatial and sexual bounds.

The trope of the middle-class, upper-caste woman embodying Indian culture is threatened by the rapidly proliferating images of global consumption—women as consumers and women to consume. While violence becomes the way to discipline unruly middle-class women who've strayed from the ideal, this material violence has a symbolic dimension and traffics in the erotic excitement of not only asserting masculine authority over wayward women but also savoring the transgression of intimacy through touch (even if violent) with "Westernized" middle-class, and frequently upper-caste, women. In addition, it reveals the frustrations of shifting channels of power and oppression:

"independent women" with greater purchasing power are perceived as emasculating to lower-class men, who redress their economic emasculation by asserting their masculine power. Working-class women are routinely violated, but it hardly makes the news. Acts of violence index the gendering of authority and reveal a growing sense of masculine anxiety about managing a world that rapidly eludes its control. The rage that frequently erupts on the streets manifests the disconnect between an imagined utopia of neoliberal globality and the dystopic material realities that engulf the everyday life of the citizen. The heterogeneous social terrain in Bangalore belies easy classifications of class wars expressed through culture or even its converse: culture wars expressed through class. But questions of culture, caste, and class are paramount in thinking about the ongoing gendered conflicts in the city.

Dancing on Glass pivots around the disjuncture between liberty and liberalization. As Joanna Slater puts it in the *Wall Street Journal,*

> For many young people, especially women, call-center work means money, independence and an informal environment where they can wear and say what they like. Along with training in American accents and geography, India's legions of call-center employees are absorbing new ideas about family, material possessions and romance. . . . In a culture where women rarely wear shorts or skirts above the knee, the work itself was an eye-opener. . . . Sometimes, it is all too much for a generation that still decries public kissing.[49]

While Slater does not exactly invoke the civilizing mission of the call center industry in India, her argument suggests that having flooded the Indian market with images, commodities, lifestyles, and fantasies, liberalization has ushered in liberty. The conflation of liberalization and liberty is unsurprisingly played out on the body of the woman.

Dancing on Glass opens with a conversation between Megha, aka Megan, and a hostile American customer on the other end. The customer demands to know her real identity, and then hurls a stream of invectives at her for taking his job. The opening immediately sets the context of social and economic anxieties about the flight of American jobs to India and China, among other places.[50] Consider, to begin with, the following exchange between Megha and her American customer over the telephone:

> VOICE-OVER: You're not Megan. You're Jamila or Sushma or something, right?
> MEGHA: Dan, I'm here to help you with any problems you have with your account. I'm just doing my job. And I'm here to . . .
> VOICE-OVER: Naw, bitch. You're doing my job. Sitting in front of a computer, and takin' calls. That's my job. That's what I feed my family with, yeah? And you took it away.

The rage and panic in the voice of the American man on the other end of the phone signals that it is not merely his job that the faceless Indian woman has usurped but also, more importantly, his entitlements as an American citizen, his American dream, his very sense of self. If his role in the global economy is usurped by a faceless woman halfway across the world, then what is he left with? Indeed, who is he? The loss of his role as a knowledge worker produces a crisis in his understanding of himself, and unsettles the very coherence of his sense of self.

The proliferation of call centers in cheaper, "third world" locations indexes the disarticulation of entitlements from citizenship and reconnects them instead to cheaper labor with the requisite technological savvy and cross-cultural skills. As Aihwa Ong reminds us, "In this digitalized network, not only cognitive skills are being floated away. Also arbitraged is some notion of American masculinity tied to technical know-how, as low-cost and high-quality versions can also be found offshore. . . . Territorialized citizenship is being fragmented by transnational logics of exchange, accumulation, and disenfranchisement."[51] These are not factory jobs but more jobs in coveted high-tech industries that mark cognitive skill and expertise, a domain that characterizes American identity and exceptionalism.

The linguistic violence in the play registers the sense of aggression among city dwellers who have to deal with the increasing demands of their jobs along with the decreasing quality of life, scant leisure time with friends and family, and poor infrastructural support. Megha's lover, Pradeep, dies as a result of overwork: he stays beyond his night shift to repair a systems break-down at work, and then, on his way home, hurtles to his death when his motorcycle crashes into a road divider.

The death of her lover, Pradeep, a fellow call center employee, precipitates Megha's descent into despair. On his way home from "the graveyard shift," a telling epithet for night labor, Pradeep, sleep-deprived and disoriented, crashes to his death after he falls asleep while riding his motorcycle. In a state of shock, Megha turns to Pradeep's roommate, Shankar, a small-town migrant hopelessly infatuated with her. The play explores the class and gendered tensions within the city between lower-middle-class male migrants and their more "liberal" and urbane middle-class female counterparts. *Dancing on Glass* charts the gradual prohibitions of freedoms as the protagonist loses her sense of sexual, social, and personal freedom.

Megha's reticence about her lover's demise alarms her friends, coworkers, and Pradeep's family. When Shankar chides her for not showing up for her lover's funeral, she retorts:

> SHANKAR: How could you stay away?
> MEGHA *(shrugs)*: I didn't feel like coming . . . This is a bit sudden. My
> schedule is all messed up.
> SHANKAR: We're all a bit shaken . . .

MEGHA: Yeah. This is all quite inconvenient.
SHANKAR: What's wrong with you?
MEGHA: Nothing. This is just . . . you know.
SHANKAR: Inconvenient?
MEGHA: I mean you're here, when you're supposed to be at work.
 And I should be sleeping.

Kamatham stretches the limits of neoliberal rationalities of expediency, convenience, and opportunity. The portrayal of Megha leaves ambiguous whether she is simply unable to grieve, caught within her role as the foul-mouthed, fiercely independent young woman of urban India, or if grief can ignite a fresh set of romantic opportunities.

In *Dancing on Glass*, cosmopolitan encounters furnish fields of desire that exacerbate intracultural conflicts. The final scene in the play in the 2004 production closes on the sexual intimacy between Shankar and Megha. While the actors onstage mutually engage in consensual foreplay, an ominous screen appears backstage and reveals the same actors, on film, struggling in a violent sexual encounter. Here, we see Megha struggle against Shankar. The disturbing close of the play leaves the audience wondering what to make of the final double take. Does the virtual represent the real, sexual fantasies that are repressed in live encounters? By concluding on this ominous double take, a cheery and predictable scene of foreplay, juxtaposed against an onscreen sinister and menacing one, Kamatham unsettles his audience. By estranging us from habituated scenes of courtship, Kamatham insists on the subtle and insidious sexual violence that structures gender relations in liberalizing India.

In an interview, the playwright Ram Ganesh Kamatham told me his motivation for writing the play was to offer a micropolitical look at the disruptions that global capital has produced in individual lives. In his words,

> With a macro-global perspective and its accompanying liberal humanist rhetoric, real issues are often glossed over, and these real issues are seen directly around us—infrastructure unable to cope with an exploding population, a spate of new physical/mental disorders that our healthcare is not yet equipped to deal with, a massive attack on our sense of identity and culture. . . . This play takes the micro-local or 'on ground' position, experiencing the trauma of this change in an immediate way via a human relationship that struggles to cope with this drastic lifestyle change, emotional alienation and fragmented identity.[52]

Dancing on Glass imagines cosmopolitanism from below: by remapping conceptual geographies of first world / third world, consumers/laborers, Kamatham depicts characters who inhabit multiple positions and negotiate shifting channels of power and precarity.

By moving away from the binary of nationalism/cosmopolitanism, this chapter forwards neoliberal cities as crucial cosmopolitan contact zones that offer important insights into the vexed problem of how to live with cultural difference. The city is crisscrossed by complex global dynamics of commodities, images, people, capital, technology, and desires that destabilize the certitudes offered by older geopolitical binaries. While the call center agents engage in conversations between Bombay and the US or Bangalore and the UK, the city planners also dream of creating simulacral Shanghais and Singapores. These new mappings of space and desire elude the secure binaries of modernist categories.

In order to rethink hegemonic frameworks for global encounters, we need to move beyond entrenched conceptual binaries of West/East, first world / third world, consumption/labor to renewed and dispersed mappings of the first world in the third world and vice versa, of inextricable loops of consumption and production, of rhizomatic shifts of culture, class, and gender in the volatile and unstable fields of power and desire. Tracing the cultural life of aspiration requires us to attend to the profusion of consumer fantasies and cosmopolitan desires, and the chafing frictions between these urban dreamscapes and the material realities on the ground. Returning to the material particular facilitates thinking of cultural difference from the ground up, rather than offering, as the cosmopolitan "global souls" do, a deterritorialized "view from nowhere." Cosmopolitanism from below allows us to move from a disembodied discourse of placeless, replicable, uniform workers in a generic globalized economy to a consideration of the lived contradictions and nonfungible particularity of virtual labor in late capitalism.

Chapter 3

✦

Aspiring to Queer Globality

From Shame to Self-Assertion

Sunil Gupta's photographic series *Mr. Malhotra's Party* opened at Bangalore's Tasveer Gallery's Face Up Exhibition in July 2009.[1] As in the title, "Face up," the twelve photographs primarily depict images of elite, attractive youth, standing confidently against the dynamic background of a city in flux. The frontal aesthetic of the photographs sets each subject in "Mr. Malhotra's party" at the very center of the image, looking straight into the eye of the beholder. Sunil Gupta describes the title thus: "Gay nights at local clubs in Delhi are always sign-posted as private parties in a fictitious person's name to get around Section 377. . . . Part of the aim of 'Mr. Malhotra's Party' series is that they are slightly confrontational; they are looking back at you. They're not afraid. That's very important."[2] Shot in 2007, these photographs impart a strikingly different mood from earlier pictures Gupta had taken in 1980s, in which the subjects either turn their backs to the camera or look away or have their faces in the shadows. "Earlier, I had to persuade people (to pose), now people are asking me (if they can pose)," says Gupta.[3] Dispersing the private "gay" party onto the streets of New Delhi queers the unthinking heteronormativity of public space. Their audacious presence interrupts the quotidian rhythms of heteronormative public life and announces proliferating nonnormative sexualities and the fluidity of sexual identifications. As the resolute center against a vortex of activity, these photos claim the public streets as arena for the confident and assertive display of nonnormative sexual identities.

This chapter tracks the affective shift in same-sex politics from shame, stigma, and humiliation to pride and self-assertion through a conjunctural analysis that explores the intersections between global capital, public health discourses, and consumer fantasy in the production of alternative sexual subjectivities. By looking at the centrality of performance in the constitution of queer selfhoods, we can trace shifting representations from labile alternative sexual practices and an enforced "performance" of heterosexuality to an increasingly confident assertion of sexual difference. As an enactment of

social categories, performance offers the modality through which to conceal an alternative sexual identity. By mobilizing conceptions of truth and false-hood encoded within discourses of the closet, queer activists challenge this coercive performance of heterosexuality that reifies and confirms a dominant, heteronormative social order. Thus "confession," facing up, and publicly claiming your sexual identity marks the refashioning of queer selfhoods in the shadow of neoliberal urbanism.

This analysis of elite queer performance situates the consolidation and rationalization of sexuality within the context of transnational frameworks of development. AIDS activism in conjunction with rights discourses draws desire into the pragmatics of sexual health so that sexuality emerges as a rei-fied and positivist category. Thus, careful attention to the particular spatial contexts within which "queerness" is lived, embodied, contested, or rejected redresses accounts of a coherent, universal "global gay" identity and offers a multidimensional understanding of "queerness" in its global itineraries.[4]

Using theater as a site of inquiry, I explore the emergence of queer self-hoods in the shadow of liberalized urbanism. Theater, as a social, expressive practice, lies at the intersection of discourse and embodiment, so provides a particularly fecund site to consider the emergence of queer selfhoods. I consider some of Mahesh Dattani's plays as a point of entry to consider the political and affective shift in representations of same-sex desire from tropes of shame and concealment to an emergent rights discourse for sexual minorities in urban India. A close reading of some of his plays reveals the intersection of liberal rhetorics of rights and freedom of choice, and neolib-eral public cultures of consumption.[5] In conclusion, I turn to performances by nonelite transgender performers: specifically, the transgender activist per-formers A. Revathi and Living Smile Vidya, and the theater group Panmai. Their performances of self-narratives disclose their journey from stigmatized nonelite trans performers who experience shame and humiliation to confi-dent assertions of sexual and caste identity. Before turning to the ways these social categories of gender and sexuality are enacted and interrupted onstage, I offer a brief historical survey of the theater landscape in the city.

Poetics and Politics of Performance

The itineraries of modern theater in Karnataka suggest that playwrights evinced a cosmopolitan horizon in their plays. While late nineteenth-century and early twentieth-century Kannada theater drew from Sanskrit classics such as Kalidasa's *Abhijñānaśākuntala*, playwrights such as B. M. Srikan-taiah (1884–1946), referred to as the "Father of modern Kannada literature," heralded the Navodaya movement, which called for a new cultural awaken-ing in Kannada literature. Sami Venkatodiri (1898–1934) also drew from Greek, British, and European playwrights such as Shakespeare, Molière, and

Goldsmith. More explicit social commentaries were undertaken in the works of T. P. Kailasam (1884–1946) and Adya Rangacharya (1904–1985). These playwrights deployed biting comedy to grapple with prevalent social issues such as caste and gender violence, which acquired a macabre humor in the works of D. R. Bendre (1896–1983). The dramatic corpus of playwrights G. B. Joshi, Chandrashekhar Kambar, and P. Lankesh infused the sensibilities of the Navya (modernist) literary movement into their theater. The Navya movement, initiated by Gopalakrishna Adiga and V. K. Gokak, and influenced by the political philosophy of Ram Manohar Lohia, eschewed the Romanticism of the Navodaya School and conveyed their disillusionment and critique of the failed promise of Independence. While U. R. Ananthamurthy's novel *Samskara* (1966), which critiques Brahmanical orthodoxy and gender repression, provides a watershed moment in this new cultural turn, prominent playwrights also responded to the prevalent social ferment through a range of aesthetic means; for example, Girish Karnad and Chandrashekhar Kambar deploy history and mythology, and blend folk and modern idioms to address a range of social, caste, and gender issues. Veteran actor and director B. Jayashree, the granddaughter of Gubbi Veeranna, founded Spandana in 1973 and directed a range of plays that draw on Kannada folk forms, such as *bayalaata*. Furthermore, the influence of artist-intellectuals such as Shivaram Karanth and K. V. Subanna on the aesthetic and social imaginary of theatermakers in Karnataka should not be underestimated. Theater institutes such as Ninasam, founded by K. V. Subanna in 1949 exerts a strong influence on theater practice in the region. More recently, Adishakti founded in 1981 by the late Veenapani Chawla in Pondicherry, has attracted scores of youth from neighboring cities who have taken advantage of its workshops and training sessions to develop theater skills.

The Navya literary movement, criticized for overintellectualism, abstraction, and for losing touch with the everyday political struggles of ordinary people, was challenged by powerful emergent writers including poet Siddalingaiah, B. Krishnappa, and D. R. Nagaraj, among others. Advocating Dalit rights, these writers promoted a new progressive cultural movement referred to as Bandaya, or protest literary movement, which displaced the centrality of Navya movement. The resistance to democratic repression during the Emergency (1975–1977) saw more overt politicization of Bangalore theater, which had hitherto drawn on Sanskrit drama, Western classics, and folk theater for inspiration. In 1975, theater director Prasanna founded Samudaya, the first radical theater movement in Bangalore, which expressly used theater to speak to social and political injustice. Associated with luminaries such as directors B. V. Karanth, M. C. Anand, Laxmi Chandrashekar, poet Siddalingaiah, and playwright Krishnaswamy, Samudaya took on a range of topical issues, such as atrocities on Dalit laborers (*Belchi*), the murder of a Dalit youth in Shimoga (*Pathre Sangappa*), informal settlement and slum dwellings (*Paatu Ondu* [Lesson 1] and *Paatu Yeradu* [Lesson 2]), the deaths of mine

workers in Dhanbad in 1975, factory strikes in Bangalore (*Struggle*), bonded labor (*Jeethadahatti*), and custodial killings (*Bharata Darshana*), among others. Blurring art and life, these performances cast the workers themselves in the dramas about their life thus bringing a different dimension to contemporary celebrations of delegated performances. H. S. Shiva Prakash, associated with Bandaya movement, draws on folktales and mythology to critique Brahmanical oppression through nonsecular imaginaries.

English-language theater has a long history in India and has seen continued growth and vitality in the postcolonial period. The first Indian English play dates back to Krishna Mohan Banerjee's *The Persecuted or Dramatic Scenes Illustrative of the Present State of Hindoo Society in Calcutta* (1831). After that, pre-Independence India boasted many other playwrights, such as Michael Madhusudan Dutt, Sri Aurobindo, Harindranath Chattopadhaya, A. S. P. Ayyar, P. A. Krishnaswany, T. P. Kailasam, and Bharati Sarabhai. Postcolonial playwrights include Asif Currimbhoy, Nissim Ezekiel, Ram Ganesh Kamatham, Abhishek Majumdar, Dina Mehta, Cyrus Mistry, Manjula Padmanabhan, Gieve Patel, Girish Karnad, Poile Sengupta, Pratap Sharma, and Salmin Sheriff. Theater practitioners in Bangalore actively took up social and political issues in post-Independence India. English-language theater thrives in the city and has featured classics, adaptations, and new plays. The Bangalore Little Theatre, founded in 1960, has produced over two hundred plays in English. The city has also seen the flourishing of many other groups that stage English-language productions, including the Artistes' Repertory Theater, cofounded by Arundhati Raja and Jagdish Raja. In 2011 the Rajas founded Jagriti, a theater space located in Whitefield that hosts productions from companies within India and abroad. While often charged with elitism and inauthenticity, English-language drama in India has proven to be innovative, dynamic, and self-reflective, often commenting on social issues of the day and bringing insight and complexity to their audiences.

Today the proliferation of theater groups in the city has fostered theater that ranges widely in style, content, and languages. The extraordinary interest in theater among youth in particular is striking. Ranga Shankara, a theater space founded by Arundhati Nag after the demise of Kannada actor Shankar Nag, showcases performances by mostly anyone with the ability to pay the nominal fees for renting the Ranga Shankara theater. This democratization of theater practice greatly invigorated performance activity in the city, while also highlighting the emergent entrepreneurial sensibilities in the city.

Sexual Epistemologies

In order to understand the affective and cultural shift from shame to self-assertion in queer politics, it is important to situate these dramas within their wider representational regimes. Juridical and public health discourses have

reshaped the discursive terrain around same-sex desire and practices in urban India. On July 2, 2009, the Delhi High Court declared that Section 377 of the Indian Penal Code (IPC), 1860, that criminalized "carnal intercourse against the order of nature" should be read down to exclude consensual sex between adults in private.[6] The Union of India, represented by the Ministry of Home Affairs and the Ministry of Health and Family Welfare, were at odds with each other. While the former argued against the petition on grounds of "public morality," the latter confirmed the petitioner's claim that Section 377 drove homosexuals underground, making it more difficult to reach and serve homosexual carriers of HIV infection. In their judgment, Chief Justice Ajit Prakash Shah and Justice S. Muralidhar challenged the constitutional validity of Section 377 on the grounds that constitutional morality must be upheld and that pervasive public censure of homosexuality does not justify the repressions of the fundamental rights guaranteed under Articles 14, 15, and 21.[7]

This verdict was the result of an eight-year struggle that began in September 2001, when Naz Foundation India filed a Public Interest Litigation to challenge Section 377 of the IPC in the Delhi High Court.[8] Naz argued that Section 377 criminalized same-sex relations irrespective of the consent of the people involved, and thereby proved to be one of the most significant barriers in effective HIV/AIDS interventions with sexual minorities. Referring to the 1860 colonial law as hateful, Sujatha Rao, the chief of National Aids Control Organization, affirms that this law is "not acceptable" and abolishing it is "fundamental" to the nation's AIDS fight.[9] The Ministry of Health and Family Welfare echoed Naz's argument that the draconian colonial law perpetuated and aggravated the AIDS epidemic, thus establishing a causal relationship between decriminalizing same-sex practices and the management of AIDS in India.[10] The competing moralisms in the arguments for and against the repeal of Section 377 are captured in the petitioners claim that all citizens should be protected from HIV infection, thus reframing and defusing potentially explosive moral condemnation of "carnal intercourse" into a subject that addresses questions of disease and health. In 2013 the Supreme Court held that amending or repealing Section 377 should be determined by Parliament, not the judiciary, and so overturned the Delhi High Court verdict. In 2017, the Supreme Court ruled that the Right to Privacy was a fundamental right, and as sexual orientation is a fundamental right to privacy, the rights of LGBT persons are constitutionally protected.[11] On September 6, 2018, the Supreme Court ruled unanimously in *Navtej Singh Johar v. Union of India* that Section 377 was unconstitutional and decriminalized homosexuality and ruled that consensual sexual conduct between adults of the same sex is not a crime.

AIDS and the medical and social institutions that surround it play a crucial role in the globalization of same-sex identity politics and the emergence of queer selfhoods in India.[12] In his work on the convergence of AIDS and emergent same-sex activism, Lawrence Cohen demonstrates the intersection

of transnationalism, development politics, and same-sex identities in the circulation of global developmental capital, which marks out a domain of "AIDS cosmopolitanism."[13] Likewise, Kavita Misra argues: "The AIDS crisis in India has produced a community of expertise, a set of transnationally mobile individuals and groups, many of whom are situated in the realm of the non-governmental."[14] The prevalence of donor agencies associated with AIDS that bring money to Indian medical services has not only decisively shaped the knowledge and expertise about the disease and the quality of treatment for AIDS but has also percolated into the ways sexual identity politics have reshaped the affective and rhetorical dimensions of alternative sexual practices in India.

Naz Foundation of India is not alone in its war against AIDS in India. The liberalization of the Indian economy in 1991 not only boosted the entry of multinational corporations and direct foreign investment in the corporate sector but also propelled the proliferation of a variety of transnational nongovernmental organizations, several of which focused on AIDS-related services. Bangalore city alone has over five hundred centers working in the area of AIDS awareness.

Bangalore contains kaleidoscopic urban imaginaries, composed of many, often irreconcilable fragments of social life. To map a unilinear account of the city's sexual politics subsumes the diverse, contradictory alternative sexual practices into a totalizing narrative that reduces the multiplicity of the city's sexual geography. By sharpening developmentalist arguments about progress and globality (often conflated) in order to buttress their argument for the repeal of IPC Section 377, queer activists unwittingly play on the state's anxiety to attract foreign investment. For example, Vinay Chandran, executive director of Swabhava Trust, an NGO that works toward LGBT rights, observes that the call center industry has contributed to slackening some of the public censure toward same-sex practices. "Since BPO employees deal with western customers, they have to be familiar with their cultural realities like gay marriages. This has helped remove the stigma of homosexuality," says Chandran.[15] Queer activism in the city tactically deploys neoliberal rhetorics surrounding the city's imminent globality and imagined futurity.

Building on analytic philosopher J. L. Austin's recuperation of the performative speech act, and Jacques Derrida's insistence on the citationality that undergird and enable these performatives, Judith Butler elaborates her theory of gender performativity.[16] While redressing criticisms of voluntarism, free will, and agency that represent gender as choice or role that is donned and doffed at will, Butler clarifies the coercive and enforced nature of gender performativity. Using Foucauldian ideas of subjectivation to argue against liberal humanist accounts of resistant, sovereign, a priori subjects, Butler demonstrates how social subjection becomes the ground for the emergence of sexual subjecthood. As Butler elucidates, "There is no 'one' who takes on a gender norm. On the contrary, this citation of a gender norm is necessary

in order to qualify as 'one,' to become a viable 'one,' where subject-formation is dependent on the prior operation of legitimating gender norms."[17] For Butler, then, the liberal (and neoliberal) language of "choice" is unsuited to understanding how subjects are produced through "compulsory repetition of prior and subjectivating norms . . . which are also the resources from which resistance, subversion, displacement are forged."[18] It is in the gap between the citation of norms and its embodied iteration that it becomes possible to, wittingly or unwittingly, queer, dislodge, or displace the stability of the normative. While holding on to the idea of the performative as the iterative enactment of social categories, in this analysis "performance" also offers us a mode of enquiry, an epistemological framework, a means of knowledge.

Shifting Contours of Queer Performance

Mahesh Dattani, author of over fourteen plays, four screenplays, and two radio plays, was born in Bangalore in 1958. A Sahitya Akademi Award–winning playwright, he currently resides in Mumbai. The question of minority subjecthood frames much of his work: for example, *Tara* and *Dance Like a Man* explore questions of gender and familial politics in relation to disability and artistic embodiment, while *Final Solutions* grapples with the crisis of secularism in the wake of the demolition of the Babri mosque in 1992. Through an intersectional treatment of marginality and politics, minority subjecthood offers the lens through which he examines same-sex desire in his plays.

Mahesh Dattani has been pivotal to the growing stature and visibility of Indian English theater within India and abroad. When Dattani was challenged at a seminar in Mysore in 1994 for not writing in his own language, he responded, "I do." The questioner argued that his subject matter, homosexuality in India, was foreign to Indian culture, just like the English language. This exchange reveals the widespread notion that conceives of same-sex desire and English language as inauthentic and alien to the social milieu in India.[19]

Dattani first broached the topic of alternative sexual practices in his play *Bravely Fought the Queen* in 1991.[20] The play revolves around two sisters, Alka and Lalitha, married to two brothers, Nitin and Jatin Trivedi, who live in twin houses adjacent to each other. The women are housebound and take turns caring for Baa, their ailing mother-in-law. Alka and Nitin are childless because her husband is a closet homosexual (and a former lover of her brother Praful). Lalitha, on the other hand, has a disabled daughter suffering from cerebral palsy, a consequence of Jatin's domestic violence toward her when she was pregnant with the baby. The plot unfolds through the eyes of another couple, the pseudo-audience figures, Sridhar (an employee in Trivedi's failing advertising agency) and his wife Lalitha, who are drawn into the incestuous dysfunctions of the Trivedi household, in a manner reminiscent of Edward Albee's *Who's Afraid of Virginia Woolf?*

The play evokes the "ob-scene," literally takes place offstage, by the powerful absent presence of several characters that include Daksha (the disabled daughter of Jatin and Lalitha), Kanhaiya, the mysterious cook, Praful (Alka and Lalitha's brother and Nitin's former lover), the beggar woman, and the auto-rickshaw driver. The persistence presence of these absent characters reveals how private and clandestine fantasies are molded by the throbbing world outside.

This bifurcation of inside/outside is reinforced scenically; the stage is divided into gendered precincts of inner and outer, private and public worlds. The "ob-scene" keeps hidden that which is hideous, while powerfully shaping the action onstage.[21] In Dattani's dark play, all characters are flawed and inhabit a world of shame and duplicity. The spatial precincts of inside/outside get mapped onto psychic selves, and hypocrisy, predicated on the incongruence between what one is inside and on the outside, becomes the primary mode of negotiating the double standards of a patriarchal, heteronormative society. This unsettling disjuncture—the inability to be on the outside what you are inside—is a recurrent theme that runs through his subsequent plays as well.

The pervasive imagery of disguise and disclosure reinforces the idea of dissemblance; the masked ball and the mudpack, a rejuvenating herbal facial mask, emphasize the tropes of concealment and revelation at the heart of this play. The "queen" in the play's title not only evokes the image of the homosexual queen but also shuttles between transgressive historical figures, such as the gender-blurring Jhansi ki Rani (the queen who fights bravely like a man), and the class-troubling Naina Devi (the queen who sings *thumris* like a *tawaif*, or prostitute). The theme of performance is reinforced when Alka insists on playing the queen and Lalitha opts to play the prostitute in the upcoming masked ball. As Michael Walling says in his director's note on the London production of the play: "This is a play about performance, and uses the theatre to demonstrate how, in a world of hypocrisy, acting becomes a way of life. Paradoxically it is only by the overt performance of the theatre that such acting can be exposed for what it is."[22] Walling's comments urge us to think of performance not only as a bounded event, an aesthetic object of knowledge, but also as a way of being-in-the-world, a means of negotiating the double standards of a patriarchal, heteronormative society. Performance thus offers an important modality for characters to negotiate their sexual subjectivities in a stifling and conformist society.

In addition, the recurrent metaphor of the bonsai that Lalitha gifts to the Trivedis connotes the stuntedness of the characters caught in this oppressive, dysfunctional home. *Bravely Fought the Queen* portrays the home and the private, immured against the reach of the state, as rife with repressions and cruelties: Baa and Lalitha are victims of gender violence at the hands of their husbands. Furthermore, the parental home is not imagined nostalgically and provides no sanctuary: Alka recalls how Praful burns her hair

Figure 10. Siddiqua Akhtar as Dolly and Suchitra Malik as Lalitha in Border Crossings'
1996 production of *Bravely Fought the Queen* by Mahesh Dattani, directed by Michael
Walling, at the Leicester Haymarket Theatre.

when he suspects that she might be promiscuous. The play mounts a cri-
tique of "home" imagined as a safe haven from the turbulence of the world.
It also preempts the limits of contemporary legal arguments that mobilize
the concept of privacy as an inalienable right that animates arguments for
decriminalizing homosexuality.

Bravely Fought the Queen reveals the coimbrication of gendered and sex-
ual violence toward women and sexual minorities. The play suggests that
Baa has always been aware of her son's sexual proclivities but that knowl-
edge circulates as the unspoken secret between her and the couple, even as
Baa conveniently displaces her fury and frustration against her son on to
her daughter-in-law. Here we see that the coherence and stability of Baa's
"home" is predicated on a series of exclusions and denials.

In their seminal essay "What's Home Got to Do with It?," Biddy Mar-
tin and Chandra Mohanty unsettle the certitudes that configure home as
a place of shelter and refuge. Using Minnie Bruce Pratt's autobiographical
narrative *Identity: Skin Blood Heart* as a point of departure, Mohanty and
Martin demonstrate how stable and secure ideas of selfhood are predicated

on a range of exclusions inherent in the bounded and constricting notions of home. Martin and Mohanty explore "the tension between desire for home, for synchrony, for sameness, and the realization of the repressions and violence that make home, harmony, sameness imaginable, and that enforce it."[23] The abjection of sexual difference within Baa's home reveals the homophobic anxiety to repress sexual differences and force individuals into self-identical and normative categories in order to perpetuate the fiction of familial identity. Only when such illusions about the sanctity of home are transgressed and shattered is the self opened to the world, a world made invisible and threatening by the security of home.

Dattani launches a critique against the pervasive heterosexism that dogs political imaginaries, whether within the private microcosm of the family or larger public realm of the nation. As a recalcitrant specter, the silent "subaltern" haunts the middle-class consciousness of the characters. In *Bravely Fought the Queen*, the auto-rickshaw driver, Kanhaiya, and the cook hover between body and specter. The ways their sexuality is evoked even as their bodies are effaced reveals new mappings of desire and sexuality that lie outside the heterosexist protocols of middle-class society. In Dattani's theater, the body of the working-class man provides the ground on which the urban elite queer stages his drama for authentic sexual selfhood.

In his radio play *Do the Needful*, performed on BBC Radio 4 in 1997, Dattani returns to the theme of the repressions of the heterosexual contract in a lighter vein. The narrative shuttles between two cities—Bangalore and Mumbai—and evokes the soundscapes of both urban spaces. Here Bangalore-based Gowdas attempt to arrange a suitable matrimonial alliance for their errant daughter, the feisty Lata, by compromising regional particularities in order to find her a suitable groom. The boy in question is Mumbai-based Alpesh Patel, a divorced, closeted gay man whose parents insist that he remarry. Charting a developmentalist teleology, the play represents the elders in the family as the source of tradition and orthodoxy, while the younger generation are depicted as urbane, liberal, and possessing a dexterity with which to navigate contradictory social norms and personal desires.

Do the Needful offers a liberal critique of the custom of arranged marriage to make a case for the importance of individual choice in selecting one's life partner. But the idea of "choice" slides between liberal formulations of individual autonomy against social constraints and neoliberal notions of the free market. Consider, for example, Lata's counsel to herself: "I remembered you with your Nike cap. Just do it! Just do it. Leave!"[24] This exhortation to "just do it" exposes the conflation of liberal and neoliberal rhetorics of "freedom" that traffics between the self and the market, and promotes "choice" not only between commodities but also between marriage, sexual partner, and orientation as the key signifier of personal freedom.

The parents exchange photographs of the couple before proceeding with a formal visit to further explore the potential alliance. The photograph features

as a recurring trope in Dattani's subsequent plays as well, but here, in a radio play, it circulates in a manner that displaces the centrality of the eye to the ear. Likewise, the sight-centric metaphors of invisibility, coming out, and disclosure recenter the seeing ear as the source of knowledge.

At the play's conclusion, Lata and Alpesh arrive at a curious compromise to "do the needful" and get married. Under the cover of the legal institution of marriage, Lata and Alpesh resolve to pursue their own "choice": Lata will maintain her relationship with the married Muslim Kashmiri lover, Salim, and Alpesh will pursue "the Maali," Lata's gardener, with whom he enters into a sexual relationship. *Do the Needful* dramatizes the liberal conflict between individual autonomy and social constraint by exposing marriage as the telos of middle-class Indian society.

While marriage offers a cover for the illicit passions of the protagonists who transgress religious and sexual boundaries, *Do the Needful* suggests that these liberal characters continue to perpetuate feudal views about their domestic workers. The *maali* (gardener) figures merely as a foil to depict Alpesh's sexual appetite. "Will you bring the Maali as your dowry?" Alpesh asks Lata, cheekily. No doubt this moment indexes an ironic self-reflexivity on the part of the elite queers, but Dattani reveals the ways working-class characters circulate as commodified, fetish objects for the sexual pleasure of elite queers.[25] The figure of the *maali*, simultaneously spectral and sexual, haunts the elite urbane dramas of the neoliberal queers.

Dattani's next full-length play, *On a Muggy Night in Mumbai* (1998), takes on the question of same-sex desire in a much more confrontational manner. Set against the Mumbai skyline, the set design reveals the private space of Kamlesh's apartment, in addition to recesses and folds that suggest "the inner thoughts of the characters."[26] Here, too, the noise of weddings suffuses the public and private soundscapes of the characters. Dattani returns to a critique of the heterosexual contract of marriage and juxtaposes it with the homosexual contract of silence. Kamlesh, the protagonist, invites his gay friends over to his place and, amid the din of wedding revelry that emanates from the apartment below, insists that his friends solemnly vow to keep his relationship with his former lover and his sister's current fiancé, Prakash/Ed, a secret.

Sharad, his friend and former partner, assures him, "As far as we are concerned, Prakash doesn't even exist. It is the opposite of a marriage—the whole world acknowledges two people who enter a union pact, so they have to stick by that. Now all of us refuse to acknowledge the existence of your relationship with Prakash, so you have to abide by that. He does not exist for you."[27] Here the heterosexual contract is turned on its head, as his gay friends publicly pledge to deny, rather than affirm, his relationship with his former lover.

Redressing monolithic and undifferentiated representations of queer subjects, *On a Muggy Night in Mumbai* heterogenizes the gay community by

etching out multiple ways of inhabiting alternative sexual subjectivities. In addition, the play explores various ways of negotiating gay identity in a country that criminalizes men having sex with men (or MSMs, as they are frequently called). One character, Bunny, a beloved television star, recommends camouflage as the way to navigate gay sexuality in a homophobic society: "Camouflage! Even animals do it. Blend with the surroundings. They can't find you. You politically correct gays deny yourself the basic animal instinct of camouflage." Sharad, the flamboyant queen, rejoins: "Give me maquillage! Lots of rouge and glitters! Let the world know that you exist. Honey, if you flaunt it, you've got it!" Exhausted from the constant shuttling between disguise and display, Kamlesh yearns for his sexual identity to be public but banal: "I don't want camouflage and I don't want glitters. I don't want to flaunt or hide anything."[28] This exchange reveals the centrality of shame in the constitution of queer selfhoods. Does shame cause one to lead a double life, must one defiantly exhibit and enjoy one's shamelessness, or does one domesticate the shame and assimilatively enfold queer selves within a heteronormative imaginary?

On a Muggy Night in Mumbai makes a strong case against the double lives that gay people in India are forced to lead. In chastising Prakash's self-loathing, Kamlesh implores: "It can work out fine between us if you had some pride in yourself! Please! Don't turn your back on yourself. You are wrenching your soul from your body!"[29] The gay man, according to this notion, is represented as a split subject trying to reconcile his outside with his inside, his body with his soul. Kiran, Kamlesh's sister, reiterates this view when she insists: "You will be lonelier if you tried to be anything else other than who you are."[30] The traumatic inability to reconcile the private with public selves is reiterated in Bunny's closing speech:

> The man whom my wife loves does not exist. I have denied a lot of things. The only people who know me—the real me—are present here in this room. And you all hate me for being such a hypocrite . . . I have tried to survive. In both worlds. And it seems I do not exist in either . . . I deny them in public, but I want their love in private. I have never told anyone in so many words what I am telling you now—I am a gay man. Everyone believes me to be the model middle-class Indian man. I was chosen for the part in the serial because I fit into common perceptions of what a family man ought to look like. I believed in it myself. I lied—to myself first. And I continue to lie to millions of people every week on Thursday nights.[31]

For Kamlesh, Bunny, and Kiran, shame interlines the split between an inside/outside, private/public; the fragmented psychic topography can only be reconciled when the boundary separating the two selves is dissolved.

In her book *Touching Feeling: Affect, Pedagogy, Performativity*, Eve Sedgwick explores the role of shame in the constitution of subjecthood. She writes, "Shame turns itself skin side out; shame and pride, shame and dignity, shame and self-display, shame and exhibitionism are different interlinings of the same glove. Shame, it might finally be said, transformational shame, is performance. I mean theatrical performance. Performance interlines shame as more than just its result or a way of warding it off, though importantly it is those things. Shame is the affect that mantles the threshold between introversion and extroversion, between absorption and theatricality, between performativity and—performativity."[32] Eve Sedgwick and Adam Frank's anthology on the work of Silvan Tomkins has offered an important entry point for scholars working in the area of affect theory generally, and shame in particular.[33] Tomkins contends that we locate shame at the intersection of the body and sociality. Shame reveals itself corporeally as it courses through our body and erupts as the blush on our skin, the askance gaze, the twisted posture. He writes, "The self lives in the face, and within the face the self burns brightest in the eyes."[34] Shame is the affective terrain on which the queer self is fragmented and ruptured into an inside and outside. But shame is also a profoundly social affect: and this excessive, uncontainable corporeal affect is produced by one's vulnerability to those who judge and condemn one.[35]

Witnessing how shame can unravel its subject can elicit an ethical response in the audience: the theater, then, offers a crucial site for the empathetic identification for those shamed. As Tomkins writes, "The human being is capable through empathy and identification of living through others and therefore of being shamed by what happens to others. To the extent to which the individual invests his affect in other human beings, in institutions, and in the world around him, he is vulnerable to the vicarious experience of shame."[36] Watching a character experience shame may touch and viscerally affect an audience member. Shame reveals our sense of openness, our vulnerability to being impacted by others.

Emmanuel Levinas powerfully probes the relationship between shame and exposure, and the concomitant feeling of being unable to escape one's body. For Levinas, the intensity of shame derives from a sense of radical exposure of that which was meant to be kept hidden, and the consequent sense of conflict and estrangement within the self that simultaneously acknowledges but also rejects the exposed self. The inability to identify with this exposed being, now foreign and repugnant to us, exacerbates the interlining between the inner and outer facets of the self. Shame draws together a primal scene of exposure and contempt, nakedness and censure, vulnerability and disgrace. Levinas writes, "The necessity of fleeing, in order to hide oneself, is put in check by the impossibility of fleeing oneself. What appears in shame is thus precisely the fact of being riveted to oneself, the radical impossibility of fleeing oneself to hide from oneself, the unalterably binding presence of the I to itself."[37] Unable to make others unsee our exposedness, shame triggers a

process of the self forsaking itself. An inescapably bodily affect, shame deepens the crimson blush, makes our skin crawl, instigates a repudiation of the very body that betrays our sense of private and inner sanctuary.

If liberal formulations are predicated on a particular understanding of the self that attempts to reconcile the disjuncture between inner and outer selves and worlds, in order to live openly as a queer person, Sharad inverts such a topography of the self. Sharad believes that sexual identity is not hidden and concealed within the body but worn and performed on the surface of the body. In his view, the inner essence is produced through comportment, dress, manner; Sharad epitomizes the idea that gender and sexuality, whether heterosexual or homosexual, is a performance par excellence. Being a heterosexual male, he demonstrates, is an act of consummate performance: "All it needs is a little practice. I have begun my lessons. Don't sit with your legs crossed. Keep them wide apart. And make sure you occupy lots of room. It's all about occupying space baby. The walk. Walk as if you have a cricket bat between your legs. And thrust your hand forward when you meet people . . . And the speech. Watch the speech. No fluttery vowels. Not 'it's so-o-o hot in here.' But 'It's HOT! It's fucking HOT!' "[38] Toxic heterosexual masculinity is thus the effect of a compulsory, iterative performance of gender and sexual identity. These representations of gay identity destabilize monolithic portrayals of queer self-identification and selfhoods.

Dattani continues to disclose the class privileges of the queer elites by shining a light on the ways marginalized and disenfranchised subaltern subjects haunt the peripheries of queer becomings. *On a Muggy Night in Mumbai* opens with a quick scene where Kamlesh has just finished having sex with the security guard. Kamlesh asks him whether he enjoys the sex or does it only for the money. The security guard dithers, unsure how to respond to the question. Kamlesh, without waiting for his response, abruptly dismisses him. The security guard returns at the end of the play and cautions the revelers: "Aap log apna kaam sari duniya ko batana chahte hain kya? . . . Aap yeh sab khullam khulla kyon karte hain?" (Do you want to tell the whole world about your business? Why do you do this so openly?).[39] The guard retrieves the incriminating photograph of Kamlesh and Prakash in an intimate, sexual embrace from the apartment below. The photograph resurfaces in the play, not as the object whose exchange consolidates marriage, as in *Do the Needful*, but, rather, as the image, which threatens to dissolve marriage. It is the revelation of this image that finally brings Kiran to the truth of the fiction of her ongoing courtship to Prakash. For the raucous elites, the guard is merely the messenger. Curiously, he takes on the incongruous voice of the wider, heteronormative society. His words of censure appear almost as a dub, an odd disjuncture keeps his words divorced from his acts.[40] Unlike the wedding revelers, it is not the immorality of gay sexuality that troubles the guard but, instead, their seeming indiscretion and the publicity of their queerness. He hands the photograph back to Kamlesh and disappears from

the play. The brief but insistent voices of working-class characters interrupt elite queer dramas that often only use them as sexual objects rather than as sexual subjects.

The spectral presence of nonelite, working-class men who have sex with men in Dattani's theater evokes the image of *kothis*. Broadly designated as effeminate men who have a feminine sense of self, *kothis* typically enact "passive" sexual roles. Dattani provides glimpses into the ways the working-class body is sexualized for the consumption of elite homosexual appetites. Lawrence Cohen observes that for many elite Anglophone men,

> the object of desire of a typical middle-class or elite man who likes men is an ordinary working-class or service-class man, by definition not gay given his linguistic and class position. These men form a group of sexually available types in the understanding and experience of elites, from "masseurs" passed among friends or found near Andheri train station at night to "drivers" and "Maharajs" (Brahman cooks, frequently from Rajasthan) to other "vernac queens" who are awed by the language and privilege of gays who must be protected from their tricks.[41]

NGOs label such working-class men *kothis*, which, as a consequence of AIDS prevention research and intervention with MSM, is quickly consolidated into a seemingly "self-evident" category.

According to Shivananda Khan, the founder of Naz, the *kothi/panthi* binarism maps far more effectively onto the practice and body politics of most men who have sex with men or *hijras* (men who undergo voluntary castration and penectomy and wear female clothing) than does "gay" or the too-vague MSM category itself.[42] Lawrence Cohen, on the other hand, demonstrates the ways that AIDS cosmopolitanism ossifies "kothi-panthi framework" as a social fact of "Indian culture."[43] In a similar vein, Paul Boyce explains that the *kothis* have been targeted by AIDS activism because they are seen as especially vulnerable to fall prey to disease given that they may be less well informed about protection, and since they are typically associated with the receptive role in anal sexual intercourse.[44] Examining Dattani's theater, however, enables us to study up and consider how nonelite and working-class men who have sex with men are variously erased, elided, and made into the ground for the enactment of elite queer dramas.

If *On a Muggy Night in Mumbai* demonstrates the ways the urban, middle-class body recoils in shame from its own sexual fantasies and practices, *Seven Steps around the Fire* explores the "shamelessness" of the hijras. Hijras believe that their surgical castration is a ritual offering of their penis to the Goddess Bedhraj Mata and their emasculation precipitates the attainment of divine power, which ironically endows them with the power to confer fertility on newlyweds or newborn children. Hijras are well known for the

important ritual role they play in maintaining the heterosexual contract: they bless couples at weddings, childbirth, and other events that reinforce conjugal heteronormativity.

According to Chandrika, a migrant hijra from rural Karnataka now working as an activist with Sangama, an NGO committed to the rights of hijras and sexual minorities in Bangalore, while many hijras aspire to a life of chastity and piety, most of them routinely engage in sex work.[45] In addition, Chandrika recounted to me that Bangalore has a reputation of tolerance toward sexual minorities in general and hijras in particular. In fact, Vividha, another NGO that works closely with transgender communities organized two cultural festivals that showcased hijra performances called Hijra Habba between 2002 and 2003. Hijra Habba abruptly came to an end with the suicide of their chief organizer, Famila. "Now it has become Queer Habba," remarked Chandrika wryly. The first Karnataka Queer Habba, held in Bangalore in June 2009, followed along the lines of the Queer Pride festival that began in 2008. The Queer festivals include a series of events such as Pride parades, queer sporting events, film screenings, theater, storytelling events, and so on. Chandrika, remarked that while she was open to building solidarities across sexual minorities, she could never think of herself as "queer," a term that was, in her mind, infused with class privilege.

While the hijra's unruly disregard for middle-class decorum provokes anxiety in her audience, this hardly shields them from physical and emotional brutality; *Seven Steps* underscores the clandestine and institutional violence that hijras are often made to endure.[46] The image of the incriminating photograph returns in *Seven Steps around the Fire*. The photograph in question is a Polaroid shot of Mr. Sharma's son Subbu with his betrothed, Kamla, a hijra, whom he secretly weds. Mr. Sharma, an important political personality in the city, arranges to have Kamla murdered, but the existence of the photograph continues to agitate him. He eventually manages to procure the photo but not before losing his son, Subbu, to suicide.

Here again, as the title suggests, marriage offers the ground on which to launch a critique of heterosexuality as invisible norm in Indian society. As the play opens, the sounds of Hindu marriage *shlokas* (rites) swell in the auditorium, and we see a beautiful woman, Kamla, in bridal dress. But as the light steadily increases we observe that Kamla is enveloped in flames, an image that visually evokes the dowry deaths prevalent in India. This figure in flames reiterates the themes of everyday and spectacular violence in marriages and propels the plot forward. The story revolves around Uma Rao, a sociology PhD student and the wife of the chief superintendent, and her attempt to uncover the grisly details of the murder trail that leads back to the city's powerful elite. Her sleuthing leads her to Anarkali, another hijra, falsely arrested for Kamla's murder.

As in *On a Muggy Night in Mumbai*, *Seven Steps* portrays the bonds of care and nurture in marginalized communities. Dattani's directions suggest

that Uma enters into the hijras' quarters to see them "combing each other's hair and going about their routine. The camaraderie is very much evident."[47] "They are sisters," asserts Champa, the head hijra, therefore it is unthinkable that Anarkali would murder Kamla.[48] Champa is at pains to clarify that the bonds between them are stronger than filiative bonds and etches out an alternative community. Shouting after Uma, for whom hijras slide from abnormal sexuality to criminality, Champa exclaims: "You don't know how much we loved her. You will not understand. I loved her more than you can love your daughter! You don't know."[49]

These bonds of nurture are at odds with Uma's own marital relationship, which is fraught with unequal sexual and power dynamics. But while portraying the care and affection in the hijra community, Dattani is also careful not to romanticize it, and etches out some of the petty jealousies and cutthroat competitiveness that pervade these relationships.

The play concludes with Uma's voice-over:

> They knew. Anarkali, Champa and all the hijra people knew who was behind the killing of Kamla. They have no voice. The case was hushed up and was not even reported in the newspapers. Champa was right. The police made no arrests. Subbu's suicide was written off as an accident. The photograph was destroyed. So were the lives of two young people . . . but Anarkali's blessings remain with me. *(touching the locket)* I could not tell her that I did not want her blessings for a child. All I want is what they want . . . to move on. To love. To live.[50]

Uma remains fixed in spotlight, and the hijras move into the shadows on the periphery. Her final speech reveals how institutional homophobia has been normalized in society. "They have no voice," says Uma in her final speech. But the play reveals that although the subaltern speaks, she cannot and will not be heard. It is important to stress here the difference between the urban, middle-class gay man who imposes silence on himself in response to the pervasive bourgeois norms of sexual propriety and the outspoken hijra, who despite her flamboyant performance of gender liminality will not be heard.

Uma recognizes this, and her final words reveal her own restlessness with bourgeois heteronormative assumptions about what constitutes a life worth living: "I could not tell her that I did not want her blessings for a child. All I want is what they want . . . to move on."[51] Dattani suggests that for Uma, the blessing was not to secure any of the unspoken privileges of heteronormative life. Rather it was to give Uma the courage to "move on" from a stifling marriage, toward a life that is not entirely determined by sanctioned social mores that consolidate the fiction of the normativity of marriage.

If Dattani's elite queer charts a movement from shameful, furtive, tentative same-sex sexual desires to an increasingly brazen sexuality that simultaneously reifies sexuality as rationalized fact, the hijra flamboyantly turns

bourgeois propriety and its bête noire, shame, on its head. Hijras publicly display their sexuality as a performance full of outrageousness, brazen humor, and immodesty. As Gayatri Reddy puts it, "Hijras serve as potential repositories of shamelessness, and by exposing that by which they are construed as shameless, they serve as purveyors of this stigma to the public. Given their perception as *besarm* (without shame) and knowing their potential to invoke shame in others, people are afraid of provoking them. . . . Hijras . . . use this knowledge to their advantage, threatening to lift their saris if their demands are not met."[52] Hijra performances exceed conventions of passing; their specific gestural practices such as hand-clapping and lifting their petticoats to expose their lack of genitals, do not reinforce gender norms by a hyperbolic performance of femininity; rather, such practices explicitly play on their gender liminality.[53]

If *Seven Steps* illustrates how sexual subjects are interpellated by the law, the police, and other institutions of the modern state, then Dattani's next play, *Night Queen* (1998), demonstrates the liberties proffered by anonymous sex. *Night Queen* is a short play that returns to the topic of gay sexuality and the double lives that many gay men are forced to lead. Here, again, echoing the plot of *Bravely Fought the Queen*, the prospective groom of Raghu's sister, Ash, of ambiguous sexual preference, is picked up by Raghu for an evening of casual sex.

Dattani reveals the potential for implicit violence among progressive and "out" gay men, where the inability to declare your sexual identity is met with intense contempt. Consider, for example, the following exchange between the two men:

> RAGHU: So. You see who you are. Don't you?
> ASH *(turning away from him)*: That is not all!
> RAGHU: There are more dreams?
> ASH: Nightmares! Living ones. Real, not fantasy! Don't you want to hear them too?
> RAGHU: No. All I wanted you to do was admit you are gay. You may go now.[54]

Raghu's desperate desire for Ash to unequivocally admit to a singular and fixed sexual identity reveals some of the unease around sexual ambiguity, and implicit coercions and stridency of progressivist politics. The shrill determinism, solidity, and empiricism in the later plays explore how fluid, labile, tenuous same-sex desire ossify into positivist, taxonomical categories. In a move that unwittingly reveals the violence laced in these demands to "confess, or else," we begin to see how sexual desires are increasingly capitulating to the incontrovertible language of empiricism: "Say it—you are gay!" The violence with which Raghu attacks Ash for not confessing his gay identity is instructive. Consider, for example, the following exchange:

> RAGHU: Oh yes! You are ugly. And you will be uglier. Pretending to
> love her—
> ASH: I do.
> RAGHU *(ignoring him)*: Pretending that she turns you on. That you
> are in love with her. That everything will be alright after mar-
> riage. Such pretense! And when you sleep with her, you will be
> groaning extra loud with pleasure, shutting your eyes, thinking
> of your snake god or whatever, and penetrating her with those
> images in your mind. Pretending, pretending all the fucking way!
> That's really shitty ugly! And in case you can't make those won-
> derful fountains erupt, she will look at you, questioning you. And
> you will be ugly enough to lead her to believe that she isn't good
> enough. That she doesn't satisfy you. You will watch her being
> filled with self doubt. And you will give your ugly sympathy to
> her. You will say to her it's alright, you still love her. And she will
> be grateful to you! That's ugly! See that! See all that and tell me if
> that isn't ugly.
> ASH: No! That won't happen! I know it won't!
> RAGHU *(drowning him)*: That is not ugly, that is simply repulsive.
> Hideous! To think it won't happen. You stink![55]

Raghu's verbal violence reveals his agitation around sexual ambiguity. Unable to entertain sexual ambiguity, and the possibility that desire may be equivo-cal, he sharply denies the fluidity, uncertainty, and incipience of mobile sexual desires. In so doing, he reveals that his own position mirrors and refracts intolerant heterosexist society. Dattani's plays chronicle the affective and performative transformation in same-sex politics in urban India over the past few decades. The pressure to "confess, or else" naturalizes a particular confessional mode of inhabiting queer selfhoods, which ossifies labile sexual desires into an accepted grid of same-sex sexual subject positions.

The emergence of a confrontational mode of expressive same-sex poli-tics thus derives from a transnational network that includes AIDS activism, queer pride parades, and queer film festivals, in addition to the increased visibility of homosexuality in the media and in public culture at large. The confrontational mode of same-sex politics must be located within liberal dis-courses of individual choice and minority rights, and aspirational discourses of "progressivism," and market-driven globality. This particular argument rehearses Western developmental narratives that track the liberation of the subject from stultifying tradition to an increasingly liberated modern gay subjectivity. Emergent discourses of elite gay rights in urban India invoke an ethnocentric cosmopolitanism, one that reduces the heterogeneity of sexual practices and subject positions into a Eurocentric model of LGBT politics and enforces "confession" as the modality to arrive at authentic sexual selfhoods.

Nonelite Trans Performance and Remaking the Self

The very act of writing an autobiography from a Dalit perspective radiates audaciousness; it constitutes an affront to caste heteropatriarchy. First used by B. R. Ambedkar, political theorist, lawyer, and the key draftsman of the Indian constitution, the term "Dalit" means "broken" or "crushed." The term designated persons formerly referred to as untouchables, or *avarnas*, those without caste in the Hindu caste system. Untouchability was abolished in 1950, but despite laws, Dalits still face widespread discrimination and routine harassment and violence. By insisting that the lower-class/-caste transgender has a story worth telling, this radical act of writing an autobiography, an act of public intimacy exposes both the particular story of an individual and the larger story of structural violence against marginalized communities. The acts of self-narration by stigmatized trans persons, through prose and performance, reveal the complicity of upper-caste/-class, hetero-patriarchal society in the perpetuation of physical and psychic violence toward these marginalized communities.

The memoirs of trans women performers, A. Revathi and Living Smile Vidya complicate the homogeneous discourse of queer activism in India. Vidya refers to transgenders as "the Dalits of the Dalits, the most oppressed women among women—they enjoy no equality, no freedom, no fraternity. They continue to lead a wretched life, devoid of pride and dignity."[56] Both writers describe activism emerging from NGO spaces as fraught with class and caste disparities. A. Revathi discusses the thorny interpersonal terrain she navigated while employed at an NGO working for the rights of sexual minorities, while Vidya recounts her disenchantment with NGOs and her attempts to stay away from them. As Vidya puts it, "I was unhappy with the way most of these bodies functioned. My objection to their work was directed at their excessive focus on HIV/AIDS awareness, while their main objectives should be the general welfare of transgenders, the redressal of their grievances, providing them job opportunities and economic freedom overall. No Indian NGO had fought to liberate *tirunangais* from begging and sex work. What kind of rehabilitation was it to tell them 'go on being sex workers but do it safely?'"[57] Vidya points out the conundrum within sex-positive activist communities that work hard to destigmatize sex work. For her, it is critical that one recognize that while legalizing and destigmatizing sex work is crucial, these occupations are not without sexual abuse and violence that require vigilance and attention. In the eagerness to recuperate sex work from the stigma that surrounds it, Vidya cautions that activists can sometimes ignore the very reals harms that continue to pervade these sexual encounters.

In these memoirs, neither author identifies herself as "queer"—each specifically details her distress at the disjuncture between self-perception as women and outer corporeal masculine form. They describe themselves as *pottai, aravani, kothi,* or *tirunangai,* terms that are resonant with their local milieu and

contexts for self-perception. In one conversation, Revathi reveals her surprise that there may be others like her. She takes aside her urban mentor, Famila, and asks her of the English-speaking activists in Sangama, "Are these people like us?" to which Famila responds definitively, "No, they are gay."[58]

The variegated and complex mobile flows of nonnormative desires abrade against homogenizing accounts that retain the transcultural validity of Western sexual epistemologies. Rather than gloss over the frictions in these class and caste formations to present a harmonizing and undifferentiated vision of a unified queer activist ethics, it is important to recover the contradictions and tensions, to present an agonistic account of the politics of nonnormative sexualities in India.

A. Revathi is a trans woman activist who worked in Bangalore-based NGO Sangama and subsequently turned to theater as a platform for social justice. She is also the author of three memoirs. In *The Truth about Me: A Hijra Life Story*, she details her transformation from Doraiswamy, born in a small village in Salem, to Revathi, a vocal and compassionate trans advocate and performer.[59] As the youngest son, she received a lot of attention from her family but became increasingly aware of the incongruence of her sexual and gender identity.

Growing up in the village in Namakkal taluk in Salem, caste norms pervaded Revathi's social life. She recalls an incident when her mother berated her for sharing a snack with a Dalit child she was playing with. "You must not accept food from that child. It will pollute you!" When she protested, her mother scolded, "If you accept food from Chakkili children, God will poke your eyes out."[60] Revathi herself belonged to the Gounder caste, which she describes as upper-caste. The Gounder community frequently had antagonistic relationships with the Arundhathiars, derogatively referred to as Chakkili. However, the Gounders, classified as a Forward Caste at the time of Indian Independence, was reclassified as a Backward Caste in 1975. Caste identities are not necessarily fixed; they can be mobilized and manipulated to receive state benefits.

Revathi depicts her escape from her home to the urban metropolises of Delhi, Mumbai, and then Bangalore. She describes harrowing scenes of physical and sexual assault, at the hands of clients, strangers, and policemen. She portrays a precarious existence and depicts the ways she navigates her challenges: a romantic relationship with her supervisor, the suicide of her mentee, and the death of her guru. Her second memoir focuses on her career trajectory: *A Life in Trans Activism* describes Revathi's journey as an activist in an NGO and her turn to theater and writing as avenues for self-expression and social justice. In a chapter titled "Life as Performance," Revathi writes movingly about the experience of watching a dramatized Kannada version of her first memoir called *Badaku Bayalu*. The play, directed by D. M. Ganesh in 2013, was performed at Ninasam in Heggodu in Karnataka. She writes,

I was stunned when I saw the performance of the play finally. I had taken four years to write my story. And yet how could they so marvelously recreate the story of my life in just one and a half hours? . . . I was choked with emotion. My body was shaking. I wanted to scream loudly. . . . While watching the play, tears welled up in my eyes. I relived the multiple traumas in my life—harassment by family, friends, society and police. At the end of the play, I was overwhelmed by emotions I had buried away inside me. In a sense I felt more pain when I saw the difficult scenes of my life than I had felt when they were happening to me in reality.[61]

Why did watching the scenes of her life play out onstage overwhelm Revathi in a way that directly experiencing these traumatic events did not? Via mimetic representation, Revathi processes her own life story without reflexive defense mechanisms. The performance provides a transitory sanctuary, a refuge where she can bear witness to her own life, narrativized and made coherent. She is caught off guard, without immediate recourse to her usual strategies of psychic management. The live performance for Revathi plays out as a record of her own life story.[62]

Drawing on the scholarship of Adriana Cavarero, Udaya Kumar probes the inherent exteriority within accounts of self-narration. The aspiration to appear as subject in the narrative of another, reveals a yearning to perceive oneself as both subject and object in the story. Kumar argues, "A focus on exteriority may help us see autobiographical utterances as performances. . . . We need to consider the inner world itself as inscribed on the surface of things, as produced through actions and utterances in a field of mutual exposure and unevenly shared visibility."[63] For Revathi, the opportunity to see her life's story embodied and enacted by another fully exteriorizes those abjected dimensions of her self that she had hitherto repressed.

Perhaps the moment of recognition occurs when Revathi sees herself in another's body possessing an integrity and abundance that her experience of stigma had consistently denied her.[64] The simultaneous distance and intimacy of the scene unfolding before her offers Revathi an opportunity for profound witnessing, where she views the scene without internalized defense mechanisms and coping strategies. Witnessing this narrative in which she overcomes the odds, she is overcome. The cathartic moment provides a ritual and therapeutic purgation. She weeps for herself unconstrainedly, like she has never wept for herself before.

Performance studies scholars have cautioned us against conflating liveness with immediacy—the live moment is always already heterogeneous and plural, mediated through memory, expectations, and multiple associations. In order to grasp the significance of the traumatic missed encounter, the live moment requires renarrativization in a temporal ordering of events.[65] It is

through this renarrativization that Revathi is able to grasp the full force of what she has lived through.

So moved was Revathi by this performance that it ignited in her a desire to use theater as a tool for social awareness. She was weary of the politics in NGO spaces and hopeful that art could initiate social change in ways that activism could not. She approached the director and requested if she could perform in the play. Ganesh agreed, and Revathi subsequently trained at Ninasam for two months. As she prepared for the role, she tried her hand at acting despite the director's counsel to "just be yourself." Having negotiated the disjuncture between her inner gender identity and outer gender performance, a discrepant performance, Revathi was accustomed to navigating the threshold between authenticity and performance.[66] The dramatization of her life story simultaneously stages the transformation of the trans woman from a "what" to a "who." If activism enables trans persons to demand recognition and equal rights for the "what" of their shared identity, performance allows them to narrate their own unique story and disclose the who, the unique person enduring the narrative.

I Am Vidya: A Transgender's Journey is the autobiography of Living Smile Vidya, a Dalit transwoman, performer, writer, poet, and artist from Trichy, Tamil Nadu. Her autobiography details her trajectory from a boy in Puttur in Tamil Nadu to a trans female performer and activist. In her memoir, Vidya narrates her life's journey from being the only son born to impoverished Dalit parents to her metamorphosis into a trans woman. She details her struggles of shuttling between a personal sense of feminine identity and masculine form. She narrates her childhood experiences of being privileged in her family for being the only boy, born after two girls, and her grief at her mother's sudden death when she was still too young to grasp the acuteness of her grief.

Even as Vidya narrates the excessive discipline in her home, she also shares her father's desperation to use education as a means of self-refashioning and class aspiration to find a way out of their caste status. Growing up in Puttur in Tamil Nadu, Vidya's father worked as a sweeper. She details the struggles her father faced as a Dalit man, frantic to raise their standard of living, and her painful memories of him applying fervently for an electricity connection for the street they lived on. In her words, "His dreams, desires and ambitions all centered on his son of the future."[67] Even as their surroundings were modernized, still they were "poor as ever."[68] She writes, "The pain and awareness of their oppression on the basis of their caste haunted my parents all their lives. Their intense yearning for a son must have sprung from their desperate hope that he would change the course of their abject existence."[69]

Living Smile Vidya details the paternal pressure and extreme focus on her academic success. But soon her father's unreasonable demands and expectations of academic success began to take its toll on their relationship. "There was, building up inside me, an anger; a kind of antagonism toward my father.

My innermost thoughts and nature filled with anxiety and fears, I was finding it increasingly difficult to focus on my studies."[70] The very self-assurance that she had enjoyed as being the only boy in the family enabled her to turn the confidence into a resource for resistance.

In college she gravitated toward theater, joined an NGO where she met, "people like me who went around in male garb but were women in spirit and urges—known as kothis."[71] She details her travels, first to Chennai, then to Pune, her *nirvan* surgery (trans surgery), her transformation into a *tirunangai*, the distressing turn to begging, her return to visit her family, and her dogged pursuit of gainful employment. Vidya writes of her joy doing theater, the community and deep friendships she cultivated in the theater. She writes with excitement about meeting, via her professor and mentor, Mu Ramaswami, other luminaries she admired such as playwright, Murughabhupati. When she meets her theater friends in her new form as a woman, she recalls, "the dam burst and tears flowed down my cheeks at this demonstration of love and affection from my friends, which came as a balm to the emotional wounds I had accrued since my return from Pune."[72] Throughout her account, theater is a space of refuge for Vidya, a role-playing place where she can temporarily exit her corporeal constraints and inhabit alternative worlds.

Vidya recounts her experience of working on staging the life story of Agitator Comrade Periyar, the Dalit activist. The formative experience of participating in a play about Periyar, the father of the Self Respect movement, may well have impressed on Vidya the power of self-assertion. Erode Venkatappa Ramasamy, better known as Periyar, was a social activist who launched the Self Respect movement or *Suyamariyadai Iyakkam* in 1925. His focus was on obliterating the deeply entrenched and dehumanizing Hindu practice of caste discrimination. Periyar critiqued not only Brahmins but also the casteism of non-Brahmins toward Dalits. He was convinced that casteism could never be vanquished without the simultaneous destruction of the practices and beliefs of Hinduism.[73] He pointed to caste endogamy as a scourge to be overcome through encouragement of intercaste marriages. Along with other Dalit activists, such as B. R. Ambedkar and Jyotirao Phule, Periyar was troubled by the policing of female sexuality as a means to maintain caste purity. Vidya provided audiovisual support for the final performance, which included voice-overs and visuals of Periyar. They traveled with this show and did over forty shows over the next two years.

Today Living Smile Vidya is well known as a performer and activist. Her theater group, Panmai, which she cofounded in 2014, consists of trans performers: Angel Glady and Gee Imaan Semmalar. Angel Glady is a Bahujan transwoman from Tamil Nadu, Gee Imaan Semmalar is a *savarna* (upper-caste) trans activist from Kerala.

Panmai means "diversity" and is the first theater group in India that is exclusively founded, led, and managed by trans people. Panmai has performed in a variety of spaces from auditoria in Chennai, Bangalore, and other

Figure 11. Living Smile Vidya, Gee Semmalar, and Angel Glady in Panmai's *Colour of Trans 2.0*, Chennai, 2015. Photograph by Apar Rajeev.

cities in India to college campuses in the United States. Operating on the basis of crowd sourcing and donation, Panmai envisions a cultural platform for transgender and other oppressed sections to express themselves creatively. Panmai Theatre also performs for children in hospitals, including shows such as *Red Nose Clown* and *Hospital Clown*.

Their debut play, *Colour of Trans 2.0*, a multilingual show in English, Tamil, and Malayalam, explicitly engages with questions of caste patriarchy and its violent repercussions on trans persons. Delineating a confessional style of performance, Trans 2.0 offers a live document of experiences of humiliation and disempowerment. *Colour of Trans 2.0* unfolds as a series of seven autobiographical vignettes that captures multiple notions of purity and pollution that Dalit trans subjects navigate in their everyday lives. The non-linear and episodic narrative presents subjects who are unfinished, in media res, and identities that are processual rather than self-evident and given. To further augment this, videos are interspersed along with the vignettes and provide brief glimpses of police brutality, sexuality, and desire, alongside a range of performance techniques from cabaret to monologues and clowning. These media techniques further accentuate the multiple televisual and cultural discourses through which selfhoods emerge.[74]

The vignettes provide glimpses into the stigmas and struggles trans people negotiate on a daily basis, and how these humiliations impact their

relationships at home and in society. Each scene recalls foundational memo-
ries of home and exclusion: Living Smile Vidya's violent memories of her
father and his exacting academic demands on her reveal not just an intem-
perate and patriarchal figure but also the fragile and precarious aspirations
of an impoverished Dalit man who sees academic success as the only hope to
move out of caste poverty and humiliation. Gee Imaan Semmalar details the
love and pain he experiences when he watches his single mother grapple with
social stigma and the emotional and physical labor of single parenthood;
Angel Glady details her emergence from familial and social rejection.

For the actors in *Color of Trans 2.0*, self-performance becomes a way of
stitching together a self in the presence of an audience. Adriana Cavarero
reminds us, "*Who* each one is, is revealed to others when he or she acts in their
presence in an interactive theater where each is at the same time *actor and
spectator*."[75] The performance of self demands that audiences attend to these
particular life stories in a way that retroactively returns a sense of dignity that
was denied to these actors offstage. Viewing these narratives, audiences are
made aware of their complicity in the routine humiliations perpetrated on non-
elite transgender persons. If Glady documents her struggles with simply finding
a place to stay, Semmalar details how even intimate romantic relationships are
not free from judgment. Though these stories are wrenching, they are narrated
through a lighthearted playfulness and convey the resilience of the actors as
they grapple with quotidian discrimination. Bringing an intersectional analysis
of caste patriarchy, Dalit stigma, trans shame, these accounts vividly demon-
strate the inextricability of violence, caste, and sexuality in the subcontinent.

Panmai is distinct from other trans/queer performers in their avowal of
caste patriarchy as a significant channel of oppression. Living Smile Vidya
equates trans occupations to those prescribed by caste norms: begging and
sex work are the predominant occupations for trans women. In her mem-
oir, Vidya delineates her struggles in gaining employment, her inability to
even procure a voter ID or ration card. She offers a granular understand-
ing of the challenges of begging, "For the first fifteen days of my begging
career, my extreme diffidence made it difficult for me to put my hand out in
supplication—especially for alms. Shame, fear, ego, my education, memo-
ries of awards and rewards and God knows what else made me pull back
every time I tried."[76] Often the only "respectable" occupations for trans peo-
ple are in NGO organizations, but here too a casteist hierarchy is in place:
upper-caste personnel occupy executive and administrative positions, while
lower-caste workers and Dalits perform menial tasks.

While the greater prominence of LGBTQ rights activism has conferred
some visibility and respectability from progressive quarters, the nonelite
trans activists are critical of the invisible caste and class structuring of much
of the elite queer activism in the country. For this reason, they highlight the
structural violence of caste patriarchy at the root of misogyny, caste violence,
and homophobia in India. Gee Sammelar astutely points out,

The rejection of endogamous reproductive function by trans peo-
ple means an abdication of the reproduction of caste relations and
labour force making us lesser citizens of the Brahmin empire/Indian
nation state. I opened my heart and mind to the possibilities of creat-
ing families outside of heteropatriarchy and caste endogamy after I
started living among trans communities. Trans communities have a
familial system in which sisterhood across caste is possible and often
practiced. There are, of course, caste practices and differences among
trans communities, however the collective experience of being dis-
owned by families, structural exclusions in employment, education
and housing create at the very minimum, the possibility of a strong
sense of belonging and "consciousness of kind." I have seen trans
women raise orphaned babies into strong, beautiful people.[77]

Moving away from the status rituals that pervade the social life of caste, with
brutal norms and severe sanctions that codify gestures, behaviors, and rela-
tions, the very act of self-representation in writing and onstage constitutes a
radical departure. Panmai's *The Colour of Trans 2.0* makes clear the necessity
for strong unequivocal assertion of identity, rights, and equality. The cultural
shift in expressing an assertive sexual identity offers Panmai an aspirational
politics that is bold, unapologetic, and confident, an affective shift that has
been forged through experiences of humiliation, shame, and stigma. Yet given
that Panmai and the autobiographies all stage self-narratives, these perform-
ers also transgress identity politics by providing us with stories that allow us
to see the fullness and multidimensionality of their selfhood—by exposing
the "who" in addition to the "what."

We have discussed how the liberalization of the Indian economy impacts
the affective terrain of queer lives in India, precipitating transformations
from discourses of shame to aspirational rhetorics of equal rights. Anupama
Rao has brilliantly detailed the ways that colonial and postcolonial activ-
ism transforms stigmatized "untouchables" into Dalit citizens. "Dalit," she
reminds us, means "crushed"; yet this social suffering forms the bedrock
for the assertion and articulation for the demand of recognition and the
consequent emergence of an assertive political subject.[78] Focusing on perlo-
cutionary speech acts, Judith Butler examines linguistic agency that enables
language to stay alive and supple and to dodge and dislodge the fixing and
incarcerating force of illocutionary speech. A word like "Dalit" in this con-
text acquires a nimble and malleable chain of resignifications eluding capture
through illocutionary legal fiat. The dense historicity conveyed in "Dalit"
carries a layered sense of discursive performativity. In much the same way
that the negativity inherent in the word "queer" was seized and détourned
to assert an uncompromising defiance, so too Dalit politics resignified nega-
tive identity within the caste structure and imbued it with a spirited political
program.

The confessional performances of Revathi and Panmai reveal the intersection of caste discourses of humiliation and queer experiences of shame. Goffman reminds us that stigmatized persons approach every encounter with "normals" not knowing whether others will recognize them as the whole person they experience themselves to be. Confessional performance becomes an arena where stigmatized persons can claim and display a full and multidimensional subjectivity. The opportunity to display the coherence, plenitude, and even abundance of the self in a public space provides stigmatized persons relief at being witnessed in their full humanity.

While Goffman's discussions on stigma typically take the individual sufferer as its starting point, studies of humiliation of Dalits underscore the structural dimensions of affective domination. Here humiliation constitutes a "structure of feeling," with profound material and psychic reverberations, and entails a systematic strategy of domination.[79] Drawing on Cornel West, V. Geetha describes this sense of humiliation as an "ontological wounding." These acts that humiliate, she argues, require making the wounded body bear witness against itself, which wounds the being at its constitutive core. She eloquently asserts, "Forced to live out of a body that is its own ruin, the Dalit suffers a state of permanent dissociation. . . . This sense of alienation from her body and its productive worth is further accentuated by iterative acts of humiliation which separate the Dalit from her fellow beings in an everyday existential sense."[80]

V. Geetha powerfully alerts us to the ways in which the iterative and repetitive wounding constitutes a form of structural violence. However, performance theorists remind us that while repetition may enable discourses to accrue power it can initiate a process by which they lose their power. Restaging their experiences of humiliation in the presence of a witnessing audience provides Panmai an opportunity to repeat but resignify primal scenes of trauma.

This chapter has traced the shifting affective terrain of same-sex politics in the wake of economic reforms in liberalized India. Using Mahesh Dattani's plays about queer desire as a point of departure, I have explored how global institutions such as NGOs intersect with public health and legal discourses and desiring bodies on the ground to produce new assertions of selfhood and provide new horizontal, cosmopolitan imaginaries of sexual identity. Exposing the heterogeneity of the field of same-sex desire, the chapter turns to performances of self-narration in the works of trans female artivists Revathi and Living Smile Vidya to consider how shame, humiliation, and stigma derive from intersectional experiences of caste, class, rural, and sexual marginalization. These intersectional performances of caste and transgender desire move beyond homogeneous elitist models of "global queer" identities. The performances discussed here exemplify how vulnerable queer subjects not only survive but also thrive in contexts of precarity. These queer artivists epitomize the resilience, spirit, and temerity required to move through heteropatriarchal worlds while playfully rejecting its normative categories.

Chapter 4

Libidinal Urbanism

Narcissism in the Noir City

The previous chapters sketch out scenes of aspiration and how a range of subjects from property owners to call center workers and queer activists strive toward cosmopolitan ideoscapes within the shifting economic and social horizons of liberalized India. We consider how aspiration splinters and fragments as it grapples with alarming disjunctures between the promise of capital and its material effects on the ground. The dreamscapes generate their own discontents, triggering a range of strategies of psychic management such as nostalgia, panic, shame, and defiance to grapple with vertiginous urban transformations. In this chapter, we turn to an artist who offers a counter-narrative to imaginaries of urban striving. In her photo performance series *Phantom Lady* (1996–1998, 2012), Pushpamala N. stages scenes of noir narcissism, which with their overtones of self-indulgent languor offset prevailing discourses of aspiration, toil, and the performance principle. Pushpamala N. deploys the noir form to convey urban precarity. The mood of suspense and drama that lurks in the photographs reveals the dark underbelly of the booming metropolis. Plumbing its protean, nonunitary, and aporetic dimensions, Pushpamala N. deploys narcissism from within and unsettles its prevalent meanings. The photo performance series spatializes narcissism and uncovers the libidinal life of the city.

The first series, *Phantom Lady or Kismet* (1996–1998), depicts a night in the life of a dreamer, one who finds a home in a railway station. Stationed in a place of transit, the dreamer takes flight on the wings of mediatized fantasy. Her fantasy, drawn as much from the stock images and clichés of Hindi melodrama as from American noir, shuttles between noir and action and recovers a libidinal urbanism that eludes the administered world of the planned city. In the second series, *Return of the Phantom Lady* (2012), made sixteen years later, the Phantom Lady rescues a young orphaned schoolgirl from Mumbai's land mafia.[1] Here the labyrinthine interiors and dark corridors and passageways of the first series give way to the harsher, iridescent, exposed city. *Return* maps out the topography of Mumbai through a narrative that homes in on

the scandal of property and the criminality of the land mafia. Pushpamala N. depicts the eponymous protagonist across several contested sites within the cosmopolitan metropolis of Mumbai and magnifies the noir dimensions of its nonlegal, shadowy urbanism.

Pushpamala N. is a Bangalore-based performance artist who draws on cinematic archetypes and deploys fantasy to register narcissistic resistance to discourses of aspiration. Pushpamala N. uses photography, video, live art, and sculpture to create artworks such as *Sunehre Sapne* (1998), *Dard-e-Dil* (2002), and *"Native Women of South India"* (2004), in which she appears as auteur and protagonist. Her ironic, subversive artworks use sharp humor to drive a wedge between popular and high art, between original and copy, genuine and counterfeit, and challenges the unifying coherences of both bourgeois artistic modernism and "authentic folk" tradition. She started her career as a sculptor and moved to performance photography in the transforming political, economic, and social ferment of the 1990s. Several artists in India radically reshaped their art practice in the wake of the demolition of Babri mosque in 1992 and the rapid ascendancy of the Hindu Right in the public sphere. Pushpamala N. heightens the pleasure of delicious cinematic fantasy through the genre of photo romance. According to Pushpamala N., "The photo-romance is a photographic narrative in the style of a comic strip usually published serially in magazines, with real actors playing the roles of the characters."[2] By plumbing the genre of photo-romance, Pushpamala N. broke new ground in Indian art that had primarily reserved photography as a medium for documentary truth-telling.

Pushpamala N.'s photo performance is situated in a long legacy of feminist and political performance art making in India. Indian Hungarian painter Amrita Sher Gill began exploring ideas of artist as subject and object in her self-portraits as early as the 1930s. Her self-portraits were sensuous yet enigmatic, eschewing the spiritual reworking of mythologies in the Bengal School as well as the corporeal realism of Raja Ravi Varma. Following on her heels, artists like Nilima Sheikh, Arpita Singh, and Anjolie Ela Menon took up feminist concerns in their artworks that explored the gamut of themes that ranged from spectacular political violence to routine discriminations. Experimental artists such as Nalini Malani play with media such as video, film, and projected animation to develop multilayered narratives about conflict between nations, communities, and within homes. Malani also curated the first-ever exhibition of Indian women artists in Delhi in 1985. Moving away from the figurative style of painting that exemplified the painters of the Baroda School, Anita Dube and other members of the Indian Radical Painters and Sculptors Association rejected bourgeois sensibilities of artmaking in India and turned to an idiom that was avowedly radical and political. Rummana Hussain's work engaged performance art more directly as she reflected on the precariousness of Muslim minority subjects in the wake of the demolition of the Babri mosque. In performance art pieces such as *Is It What You Think?*

Hussain also engaged with her own relationship with her surgically altered body as a cancer patient. More recently, several Indian artists have blurred the boundaries between visual and performance art—contemporary artists such as Ayisha Abraham, Smitha Cariappa, Nikhil Chopra, Subodh Gupta, Jitish Kallat, Amar Kanwar, Ravikumar Kashi, Sonia Khurana, Umesh Madanahalli, Babu Eswar Prasad, Maya Rao, and Inder Salim, among others, have turned to performance and art to capture the vicissitudes of urban transformations. While a student at M. S. Baroda, Pushpamala N. was influenced by the Narrative painting movement, especially that of Bhupen Khakhar of the Baroda group, who combined an ironic, subversive, and mischievous self-consciousness in his self-portraits, where he photographed himself as a James Bond–type hero, a toothpaste model, and Mr. Universe.

In the Phantom Lady series, Pushpamala N.'s noir aesthetic, her play with darkness and death, suspense and suspicion, portend a sense of social anxiety. The Phantom Lady's travels and travails through the informal city reveal not disorganized and chaotic scenes that are beyond the law but, instead, complex networks of clandestine operations and organizations. The networks she sketches out in her photographs parallel the networks in the burgeoning city, their sprawling, rhizomatic formations bely the unifying coherences of the planned city. Through her use of shadow and color, seduction and intrigue, labyrinths and caverns, Pushpamala N. uncovers the sensuous and imagistic hyperstimuli of the urban sensorium. She portrays fugitive nightscapes generated through the promiscuous intermingling of performance, photography, and cinema. Pushpamala N. captures the heightened sense of risk and the resultant perception of threat that is magnified through media urbanism. The noir mise-en-scène evokes the diffuse, dispersed, and unanchored sense of fear—its subjects and objects are easily recognizable characters from cinema—but still, the menace lurks libidinally across the space itself, pervasive yet unidentifiable.

Indian social theorists Neera Chandhoke and Ashis Nandy discuss the emergence of narcissism as a predominant mood in neoliberal India, increasingly entrenched not only within individuals and communities but also within modes of neoliberal governmentality.[3] The transformation in the economic horizon from socialist inspired economy to a newly liberalized one not only created conditions for public-private partnerships, but also encouraged and nurtured indirect techniques for "governing" individuals without taking responsibility for them. The emergent neoliberal political rationality both ruptured existing systems of social and political life and brought forth a productive force, giving rise to new subjects, conducts, relations, and worlds. The transformation in forms of state welfarism did not map onto a loss of regulation of the citizens. Rather, rhetorics of self-reliance reorganized and restructured government techniques. Encouraged to be responsible for their own action, individuals imbibed practices of self-discipline and aspired to turn themselves into enterprising subjects. The liberalization of the Indian

economy precipitated a range of discursive shifts from controlled expenditure to immodest extravagance, from privation to plenty, from self-restraint to self-indulgence, from frugality to excess, and from social service to narcissism.

Reworking Narcissism: The Uses of an Idea

How might a consideration of narcissism enable us to think about emergent rhetorics of self-reliance in neoliberal India? In the era of social media, the millennials came of age with selfies and Facebook, MySpace and *Indian Idol*. Described by Jean Twenge as "Generation Me," the millennials, according to her, are even more self-absorbed than their narcissistic counterparts in the 1970s, a period characterized by Tom Wolfe as the "Me Decade" and indicted by Christopher Lasch who lamented its "culture of narcissism."[4] These critics mourn the loss of civic ties, the social bonds of community that are displaced in the increasing focus on the narcissistic self. More recently, Marshall McLuhan and Bruce Powers argued that narcissism was "the fastest developing social disease of the peoples of the West."[5] In *Virtually You* Elias Aboujaoude states that the internet exacerbates narcissism by curating our "e-personality," enabling us to act with exaggerated confidence, sexiness, and charisma, offering avatars that remake the self.[6] The proliferation of Facebook selfies and Twitter memes reveals an excessive preoccupation with the presentation, performance, and management of self and a concomitant weakening of bonds of social connection.

Primarily associated with a culture of vanity and self-absorption, narcissism is popularly conceived as a condition where private feeling engulfs one's entire affective world. In such a view, the very idea of a public, located outside oneself, recedes from the horizon. From traditional psychoanalysis to art history, women in particular have long been charged with narcissism, of feminine self-absorption with their own alterity. Dislodging masculinist traditions of feminine portraiture, feminist performance artists turned to their own bodies as canvas and dissolved the binary between subjects and objects of art. Amelia Jones has pointed out that these feminist performance artists "unhinge the gendered opposition structuring conventional models of art production and interpretation (female object versus male/acting subject.)"[7] Oscillating between persons and things, these artists recuperate narcissism as an aesthetic style to disorder the dichotomies of painter and portrait, self and other, subject and object. Turning representations of feminine narcissism on its head, feminist artists have pondered what it might mean for women artists to own narcissism in their artwork as an aesthetic style.

Several feminist critics have reconceptualized narcissism as an enabling force.[8] Kaja Silverman argues that "female narcissism may represent a form of resistance to the positive Oedipal complex, with its inheritance of self-contempt and loathing."[9] Ann Pellegrini explores the "unsettling possibilities

of female narcissism for theory and for politics."[10] But can narcissism signal something beyond a culture of self-absorption and entitlement? Can it serve as libidinal and erotic intervention in an environment increasingly organized and rationalized under "the performance principle," which ensures self-surveillance of workers and their competitive economic performances?

Like "narcotic," "narcissism" derives from the Greek *narke*, which denotes sleep or stupor, and this etymology provides a fecund analytical category for capturing the aesthetic, psychic, and social dynamics of self-absorption and mutuality in neoliberal India. Different versions of the Greek myth proffer varying accounts of Narcissus, a Greek hunter, who fell in love with his own beauty when he gazed on his reflection in the waters of a spring. In part 3 of Ovid's *Metamorphoses*, Narcissus pines away. In other versions of the myth, he kills himself; a flower that bears his name springs up where he dies. According to a variation of this tale, Narcissus sees his beloved dead twin sister in his own watery reflection and reaches down to caress her, ignoring the voices deterring him, until their faces meet and he drowns.[11]

In Freud's conceptualization, narcissism connotes a sense of original cathexis, which "includes everything" but gradually "detaches from itself the external world."[12] He suggests that the ego-feeling we are aware of now is only "a shrunken vestige of a far more extensive feeling—a feeling which embraced the universe and expressed an inseparable connection of the ego with the external world."[13] Primary narcissism, in Freud, imagines a limitless extension and oneness with the universe, an oceanic feeling.

The clinical profile of the narcissist draws on and departs from Freud's discussions of narcissism as libidinal investment of the ego accompanied by megalomaniacal fantasies.[14] Increasingly, narcissism came to signify the pathology of exaggerated self-love accompanied by depreciation of others who are incorporated into the narcissist's imaginary as foils to reflect one's own superiority. Behind a surface charm, however, lurks a ruthless indifference. Nonetheless, according to psychoanalysts one's inflated sense of self is an overcompensation for an underlying sense of inferiority, insecurity, depletion, inauthenticity, and depression. For this reason, the narcissist turns others into "selfobjects," to use a term coined by Heinz Kohut, to deny their independence in reality or fantasy and incorporate them into one's own self-conception and use them as mirrors to provide the approval needed to maintain feelings of value.

Several critics denounced this popular conception of narcissism that focused on egocentric self-absorption and a subsequent retreat from public life. In his book *The Culture of Narcissism*, Lasch laments that "self-absorption defines the moral climate of contemporary society."[15] For him, narcissism is "a disposition to see the world as a mirror, more particularly as a projection of one's own fears and desires—not because it makes people grasping and self-assertive but because it makes them weak and dependent."[16] Foregrounding the centrality of performance in the cultivation of narcissism, Lasch writes,

"All of us, actors and spectators alike, live surrounded by mirrors. In them, we seek reassurance of our capacity to captivate or impress others, anxiously searching out blemishes that might detract from the appearance we intend to project."[17] However, as Imogen Tyler reminds us, more recent invocations of Lasch's theories on narcissism ignore his "nostalgic idealization of a lost patriarchal culture," which is built on antifeminist and avowedly white-centric analyses.[18] According to social psychologists, narcissism has only exacerbated in the crucible of neoliberalism in the five decades since Lasch first made his searing indictment of postindustrial societies.[19]

Narcissism receives its most liberatory and radical rereading in the work of Frankfurt School theorist Herbert Marcuse. Rather than dismissing narcissism as solipsistic self-absorption, Marcuse recovers its subversive dimensions. He recuperates narcissism and examines its interplay both in the psychic domains of private feeling and the social torsions of political economy. According to Marcuse, postindustrial societies are increasingly governed by "the performance principle," which he describes as the logic of an acquisitive and antagonistic society in the process of constant expansion.[20] As he puts it, "The organization of sexuality reflects the basic features of the performance principle and its organization of society. . . . Under the rule of the performance principle, body and mind are made into instruments of alienated labor; they can function as such instruments only if they renounce the freedom of the libidinal subject-object which the human organism primarily is and desires."[21] Under the performance principle, various libidinal desires are reorganized and unified to direct toward the opposite sex and establish genital sexuality as normative; this moves the libido to one part of the body, freeing up the rest of the body to be used as an instrument of labor. Under the order of the performance principle, civilization progresses as "organized domination" and congeals into a system of objective administration. Marcuse describes the performance principle as the gradual rationalization of domination: individuals increasingly perform pregiven roles that alienate them from their labor and their fellow workers. With the perpetual negation of the pleasure principle and the constant denial of gratification,

> libido is diverted for socially useful performances in which the individual works for himself only insofar as he works for the apparatus, engaged in activities that mostly do not coincide with his own faculties and desires. In normal development, the individual lives his repression "freely" as his own life: he desires what he is supposed to desire; his gratifications are profitable to him and to others; he is reasonably and often even exuberantly happy. This happiness, which takes place part-time during the few hours of leisure . . . enables him to continue his performance, which in turn perpetuates his labor and that of the others. His erotic performance is brought in line with his societal performance.[22]

Marcuse identifies sexuality as a crucial realm in which the performance principle demonstrates its capacity for the control and domination of the pleasure principle. He writes, "Under the performance principle, various libidinal desires are reorganized and unified to direct towards the opposite sex and establish genital sexuality as normative, this moves the libido to one part of the body freeing up the rest of the body to be used as an instrument of labor."[23] Marcuse draws on the concept of narcissism to recover a nonrepressive civilization, one that provides a different way of being in the world, and proffers fresh mappings between person and place. Against the image of the overreaching Prometheus, the archetypal hero of "the performance principle," who symbolizes toil, productivity, and progress through repression, he forwards counterheroes: Orpheus, whose voice sings rather than commands, and Narcissus, who dies but metamorphoses into a flower that bears his name. Connoting joy and repose, song and sleep, Marcuse's Narcissus recovers a nonrepressive erotic attitude toward the world, a libidinal disposition that recuperates an undifferentiated libido prior to the division into ego and external objects.

However, the laborer remains masculine, and "the beauty of the woman and the happiness she promises are fatal in the work-world of civilization."[24] What might it mean to reconfigure the narcissistic performer as female? Drawing on Marcuse's conception of narcissism, could Pushpamala N.'s Phantom Lady be imagined as the Narcissus of neoliberal India, a symbol of an alternative protagonist, one who symbolizes a playful refusal of a culture of aspiration, urban striving, and exertion? Can the Phantom Lady provide an image of an extension rather than a constraining deflection of the libido? Could the oceanic extension serve as a new libidinal cathexis of the objective world and remap the relations between self and world, citizen and city?

Pushpamala N. disarticulates the image of the liberal *Homo oeconomicus*, an isolated, rational, freely choosing, self-interested individual, and proposes instead a gender-troubling Narcissus, one whose nightly surrender to the world of mediated fantasy inscribes her as limit to the performance principle. Like Narcissus at the watery scene, unaware that the permeable and wavering image he gazes on is his own, the Phantom Lady shuttles between solipsism and sociality. Oblivious of the contours of a boundaried self, she absorbs both the environment and the double into herself. The Phantom Lady's libidinal encounters dilate and amplify her sense of self, illuminating the sociability of the solitary figure.

Noir Narcissism

In her *Phantom Lady or Kismet* series, shot in 1996–1998, Pushpamala N. deploys the noir form to navigate the pervasive sense of suspicion and anxiety in the urban nightscape. The photographs dramatize an atmosphere of

disquiet by bringing together bodies and environments in ways that envelope the viewer with a sense of cinematic surplus. The formal elements of the photographs emphasize darkness, play with light and shadow, and capture low-angle shots, deploying a series of strategies that suffuse the images with an atmosphere of suspicion and anxiety, themes that are reinforced in the narrative. Darkness, writes Zygmunt Bauman, is "the natural habitat of uncertainty—and so of fear."[25] The images, shot by photographer Meenal Aggarwal, make vivid Bauman's claim that fear is one of the characteristic affects that pervades our time. The noir depictions of the shadowy, nonlegal city subvert the confident and dazzling rhetorics of, on the one hand, the Nehruvian planned city and, on the other, postliberalized "India Shining."

Depicting Mumbai as fugitive and kinetic, the Phantom Lady's escapades display an underlying sense of unease, precarity, and anxiety vivified through her competing use of noir and action genres through the medium of photography. Via the dark visceral undercurrents of the nonlegal city, we glimpse violent fantasies sublimated into cinematic archetypes that structure nightlife in the city. As a gender-troubling heroic pirate, the Phantom Lady sets out to rescue her more feminized doubles (the Vamp in the first series and a schoolgirl in the second) from the city's vices. The Phantom Lady embodies the quintessential outlaw; like the popular culture sources she cites, such as Zorro, Robinhood, Phantom, Don, and of course Hunterwali, she rescues persecuted subjects from the villainy of the city's tyrants.[26] While in the first series, the Vamp is mysteriously murdered, in the second series, the Phantom Lady rescues the schoolgirl and escapes with her into an infinite and radiant horizon.

By darkening the lights on "India Shining," Pushpamala N.'s noir aesthetic conveys the social anxieties of the city, its restless disquiet, its enigmatic atmosphere, its ambiance of criminality and subterfuge. Gyan Prakash describes noir urbanism as "the uncanny alchemy between dark representations and the urban experience"; in Pushpamala N.'s photographs this noir urbanism turns the familiar unfamiliar—the city of planning and order gives way to the unsettling environments of inscrutable anxieties.[27] The sense of anxiety plays on the fragility of urban life where the assurances of state support and institutional bulwarks against risk have receded in the increasingly privatized scenarios of neoliberal capitalism. The growing privatization of the commons and the concomitant rise in rhetorics of self-reliance and individual responsibility produces an anxious self—at once self-regarding and self-escaping.

In the *Phantom Lady* series Pushpamala N. cites the 1930s stunt artist of Bombay cinema, Fearless Nadia, as inspiration and intertext for her photoromance series. Fearless Nadia was formerly a circus trainer and stage actress; her muscular strength, derived from years of training in horse-riding, dance, and circus, made her at once powerful and feminine, a heady combination that the Wadia brothers believed could break into the male-dominated genre of stunt films. The film *Hunterwali*, made in 1935 by Homi Wadia, broke the

mold of feminine representation on the Indian screen. The film depicts blond-haired, blue-eyed Australian actress Mary Evans, better known as Fearless Nadia, as Princess Madhuri, aka Hunterwali. *Hunterwali*, a portmanteau word composed of an English word suggesting "whip" and the Urdu *wali* (woman), translates to *Woman with a Whip*, a title that drew sharp criticism for its hybridity. The film was a huge success: it ran for twenty-five weeks and made record earnings for the year. Perhaps the fact that she was clearly not of Indian origin helped audiences to accept her as a powerful woman, literally out of her place.

Directed by Fearless Nadia's future husband, Homi Wadia, the plot revolved around an Indian princess who dons a mask and rescues disempowered subalterns from their oppressors. Fearless Nadia exploded onto the Hindi cinema screen at a historical moment when debates raged on between Indian nationalist reformers and British colonizers regarding women's emancipation in India. Pushpamala N. is well aware of the ambivalent desires that the figure of a white woman as rescuer conjures in the Indian cultural imaginary.[28] By reworking the trope of the Hunterwali, Pushpamala N. shows that the unruly woman, the subject of moral panics, returns as a figure of crisis and acquires a new intensity in a moment of rapid social change.

The highly saturated visual fields of urban public culture in liberalized India derive its energy from multiple, conflicting images of gender and sexuality. *Phantom Lady or Kismet* oscillates between pre-Independence action cinema and its racialized fantasies and anxious discourses around globalization and female sexuality. Pushpamala N.'s ironic reenactment recovers pleasure, fantasy, and masquerade through the figure of the excessive Hunterwali. In impersonating Hunterwali, she both reveals and sets off a chain of surrogation—Mary Evans as Fearless Nadia as Indian princess as Hunterwali as a female Robinhood who is then appropriated to set into motion, via photography another set of substitutions of artist as actress, brown woman masquerading as white woman passing as brown woman. In the cut between passing and masquerade, between the cinematic narrative and photographic punctum, Pushpamala N. activates the libidinal economies of media urbanism in India.

The heterogeneous discourses on sexuality shift from ordered representations of unthreatening, controlled, reproductive femininity within the planned city to a viral and proliferating media sensorium that deforms the unity and coherence of the middle-class, upper-caste urban family, the moral nerve of the nation.[29] For instance, the fiery protests against Miss World contest that were held in Bangalore City in 1996 (the same year as the *Phantom Lady or Kismet* series) dramatically foregrounded questions regarding the importation of Western values and the commodification of women. At the same time that the new "liberalized" Indian woman was programmatically trained and reshaped to export out into beauty pageants and fashion industries, there was a simultaneous explosion of family dramas on the big screens

that anxiously reinforced conservative hierarchies within the extended family. Television channels offered a variety of serials that shifted representation of socially conscientious, thrifty women who anchored the values of the middle-class Indian family to portrayals of desiring women. These images offered a range of sexual subject positions for women that depicted them as sympathetic characters but also bold as well as financially and intellectually independent. Not only fictional programs on television serials, but also the proliferating talk shows on television discussed questions of sexuality openly, with surprising candor and boldness. The advertising industries portrayed women as both objects of desire and powerfully desiring subjects. Advertising campaigns for products such as Kamasutra returned sex from the imperatives of family planning and procreation of earlier advertisements to elite depictions of heterosexual pleasure. The beauty pageants and family dramas, whether figured as "global" or "authentic," channeled a controlled, strategic, and reproductive sexuality toward the tasks of nation-building, either as an ambassador for the newly liberalized nation or by providing new heirs for the nation.

Sex became ever more detached from the welfarist planning imperative and instead cathected to the programmed pleasures of the liberalized economy. Fueled by heterogeneous magnetic fields of consumer desire, these depictions remained by and large heteronormative. The figure of the woman was now not simply a metaphor for reproducing the nation but also a metonym for consuming desirable commodities. In such a discursive and visual field, a film like Deepa Mehta's *Fire*, also in 1996, depicted a lesbian relationship between two sisters in law within an extended family in a Delhi middle-class, upper-caste home and provoked violent protests. The social forms that emerged in the wake of economic liberalization troubled the imperatives of the planned city, which mapped a particular order on social and sexual lives of its citizens. Situating Pushpamala N.'s images of erotically powerful and desiring women—the unruly Phantom Lady and the unproductively sexual Vamp—allows us to see the extent to which she draws on and détourns discourses of sexuality in liberalized India.

Phantom Lady or Kismet (1996–1998) is a set of twenty-four black-and-white photographic prints that depict the Phantom Lady and her doppelganger, The Vamp, in a series of perilous encounters within the noir city. In the words of Pushpamala N., "Phantom Lady is also about modern day Bombay—the Great Metropolis of the Indian imagination, the city of dreams and of infinite opportunity, with its rich and poor, its underworld, its film and theatre and its grandiose colonial architecture, pictured time and again in countless films, art works and literature. The locations chosen for the shoot are some iconic sites of the history of the city."[30] Through a range of mise-en-scènes, Pushpamala N. sketches out the story of doubles, the Phantom Lady and the Vamp. The series begins and ends in a railway station, setting into play a series of oppositions between stasis and movement,

waiting and arrival, ordinary infrastructures and otherworldly characters. The photographs trace a narrative arc that leads the Phantom Lady from the railway station to urban Parsi cafes, to a colonial mansion where she encounters the Vamp, who rescues her from criminals who in turn murder the Vamp. Fleeing from the pursuit of the murderous criminals, the final images show the Phantom Lady back in the railway station. The viewer is left wondering if the scenes of intrigue, suspense, crime, and anxiety were purely the products of her feverish imagination or if they had indeed transpired. *Phantom Lady* reimagines the action heroine, Hunterwali, and frames her within a noir aesthetic, sets her against labyrinthine spaces, dark alleyways, deserted urban streets within Mumbai city.

Pushpamala N. acknowledges the enduring cosmopolitanism in the aesthetic styles of Mumbai. She traces the cultural influence of the Parsis, tenth-century Zoroastrian immigrants from Persia, both through the making of films such as *Hunterwali* and through the distinctive architectural style embodied in the Bombay Gothic style of Kekee Manzil, the century-old mansion of the Gandhy family, where some of the images are shot. Several images were also shot in Brabourne Restaurant, an Iranian café owned by Rasheed Irani, who also served as a film critic for the *Times of India* newspaper, and entertained film crew in his restaurant. Irani's cafés were open to all segments of society and were frequented by the working classes, especially those who worked in the textile industry. Iranians also trace their roots to Zoroastrians, but are more recent transplants in Mumbai. Overall, the images convey the cosmopolitan confluence of colonial architecture, Irani's cafes, Parsi interiors and mansions, and Marathi theaters, all of which contribute to the layered and palimpsestic cultural influences in the city. Likewise, the atmospheric images of the Phantom Lady and her feminized double, the Vamp, trace the contours of the libidinal city.

The opening photograph is an image of a deserted railway station: an empty bench at night, with curved, intricate armrests, is aglow in the warm light of a streetlamp mounted atop a tall pole just beyond the photographic frame. Beyond the empty bench stands the shadowy figure of the Phantom Lady, draped in a heavy, dark cape, the light falling on her black hat with a light feather plume, which shrouds the mask she wears on her face. Her erect figure, parallel to the tall light poles, stands beside a small, mysterious, suitcase-like box. In the darkness, the piercing lights in the distance appear detached from the poles and hover as if they were animate luminous entities suspended in midair. The snaking railway line glimmers in the glow of streetlights; the bright glare of an approaching train punctures the limpid darkness. Almost in silhouette, the Phantom Lady appears otherworldly and enigmatic.

As I mentioned earlier, this series begins and ends in a railway station, an exemplary spatial and symbolic institution, which represents a space of journeys, of comings and goings, of travel and traffic. In this series, the railway

Figure 12. Pushpamala N., *Phantom Lady or Kismet*, Mumbai, 1996–1998. Courtesy of the artist.

station, typically characterized by the rush and throng of social energy, is disconcertingly vacant and bereft of human community. The Phantom Lady appears to be waiting for the night train. But she barely casts a glance in the direction of the approaching train. She seems only vaguely aware of the screeching train hurtling toward her. What in this ominous deserted railway station so transfixes her attention that she hardly perceives the clattering train? She does not board the train to any destination; rather, the station appears to be her home. She is a resident of a transit center, stuck in precisely the place that symbolizes traffic and movement. The interplay between her static body and the moving train, frozen in the snapshot, synchronizes the rhythms of waiting and arrival that sets the tone for the photo series.

The Phantom Lady's daydreaming at the railway station, her actions in dreams, her stasis in the place of movement and traffic suggest a sensuous inertia, a useless, unproductive affect that militates against prevailing and ubiquitous incitements to urban aspiration. The daydream, Bachelard reminds us, transports the dreamer outside the immediate environs to a world that bears the mark of infinity. The daydream is the quintessential space of elsewhere. As he puts it, "As soon as we are motionless we are elsewhere; we are dreaming in a world that is immense. Indeed, immensity is the movement of motionless man. It is one of the dynamic characteristics of quiet daydreaming."[31] The withdrawal into fantasy, and subsequent narcotic apathy insists on tracing out the libidinal contours of the city, accessible through

a mediatized imagination. The narcissism in the *Phantom Lady* series keeps in motion a narrative of the self—a cyclical structure of dilation and exploits, of noir and action, that resituates the self as an actor and supplies a fiction of agency in an economic and social environment of increasing precarity. The inactivity registers a resistance against urban striving, the relentless profit-driven instrumental action that the rest of the world seems to be caught up in.

Through the dialectic of stillness and movement, Pushpamala N.'s "action stills" demonstrate a restless stasis. The photos in *Phantom Lady or Kismet* shuttle between sumptuous darkness and heroic exploits, between the nervous waiting at lonely benches to the lurching midair action. Consider, for instance, the image that shows the Phantom Lady in midair, jumping from the balcony of Kekee Manzil, the Bombay Gothic mansion of the Gandhy family. Her free fall in her dark cape and outlandish costume stands in stark contrast to the erect pillars, the curved balcony, the imposing carvings that convey the grandeur and stability of the colonial architecture in the background. The incongruity of this figure against the stateliness and high seriousness of colonial architecture undercuts some urban nostalgia surrounding the changing cityscapes of contemporary India. Pushpamala N. stages tableaus of intrigue that juxtapose noir urbanism with an ironic sense of ludic machismo of action movies. The abrasion between the genres of noir and action produces an erotic tension, chafing back and forth between the feline seduction of noir and the macho jerkiness of action cinema, between the delay and dilation of noir to the spasmodic lurches of action cinema.

The Phantom Lady acknowledges its twin forebears of cinema and photography, each of which further multiplies into action melodrama and film noir, on the one hand, and street and glamour photography, on the other. Citing cinema via photography, Pushpamala N. gestures toward the remediation of what Ravi Sundaram calls "pirate modernity."[32] Dispersing and destabilizing the fixities of the planned city, the Phantom Lady introduces her viewers to proliferating shadows and viral cultures of the noir city. The modernist binaries of the administered, planned city and its stable supports give way to vertiginous circulation of players that disorder neat divisions between seller and buyer, producer and consumer, and expose a chiasmic and libidinal economy.

The series introduces us to the Phantom Lady's sensuous doppelganger, the Vamp. The character Pushpamala N. refers to as the Vamp, the noir's femme fatale, is an iconic figure in Hindi cinema—one who embodies the unruly sexual license held in check by the planned city. Film scholar Ranjani Mazumdar has reminded us that in the changing configurations of desire, sexuality, and spectatorship in a consumer-driven, mass-mediated public sphere, the figure of the vamp coalesced onto the erotically powerful character of the female protagonist. In liberalized India, the increasingly sexualized heroine displaces the vamp in erotic dance sequences. Mazumdar observes, "The vamp was the outsider, distinct from the iconic woman of the nation. While the heroine

was the site of virtue and 'Indianness,' the vamp's body suggested excess, out of control desire, and vices induced by 'Western' license. . . . With the vamp came the invention of the Indian 'cabaret,' a spectacle of vice and abandon allegedly of Western origin, in which the vamp danced provocatively in front of the audience."[33] A consummate figure of gratuitous, unproductive expenditure, of inertia and idleness, Pushpamala N.'s sumptuous Vamp is the exemplary Narcissus—in love with herself, rejecting the overreaching Promethean imperatives of toil and industry.

In one photograph, we see the Vamp in an elegant pose, reclining on a dark, curved divan, her face half-lit, her vacant gaze askance. The soft white mohair fur of a handheld fan rests just below her exposed bare shoulders and contrasts with the dark, heavy silk brocade gathered at her feet, near which are placed two pale cushions shimmering in heavy opalescent silk. She holds a slender, long cigarette, her palms cupped as if holding an orb of darkness. On an intricately carved wooden side table stand a decanter and a wine glass filled to the brim. Looming over the image and cast on the wall behind her is the shadow of a latticed windowpane and an ominous, magnified, hatted figure. The image evokes a range of oppositions: dark and light, male and female, erect and supine, immaterial and fleshly. Composed of sensuous materiality and insubstantial shadows, sumptuous decadence and threatening darkness, supine vulnerability and immaterial menace, the ambivalence of the encounter conveys noir glamour.

In several of the photographs in the *Phantom Lady or Kismet* series, the characters strike a pose that simultaneously cites and exceeds the gestus of cinematic archetypes. While the poses convey prototypical and clichéd images from Mumbai cinema, the stillness of the photograph also imbues them with something more enigmatic. Craig Owens reminds us that the "'rhetoric of the pose' is such that it presents oneself to the gaze of the Other as if one were already frozen, immobilized—that is, already a picture."[34] Drawing on the popular myth of the Medusa, Owens returns to the moment in which Medusa freezes into a pose on seeing her reflection. Despite the stereotypical associations of the object of the gaze with passivity, Owens forwards the pose as radical action. Striking a pose forces the gaze to surrender: "Confronted with a pose, the gaze itself is immobilized, brought to a standstill . . . to strike a pose is to pose a threat."[35] Consider, for instance, the image of the reclining Vamp: like Medusa, in her luxuriant pose the Vamp petrifies and immobilizes him until he appears ensnared in a latticed shadowy pattern.

Another photograph that captures the combination of languid self-absorption and looming peril further accentuates the atmospheric drama in the series: the Vamp gazes into a mirror, adjusting a headpiece, her sharp elbows elevated to form a dancer-like body pose. We see the Vamp in profile, and her face is reflected in the mirrors across her, and beside her. Like Narcissus, she, too, appears enamored of her own beauty, her erotic self-absorption amplified in multiple mirrors. Festooned by a brightly glowing

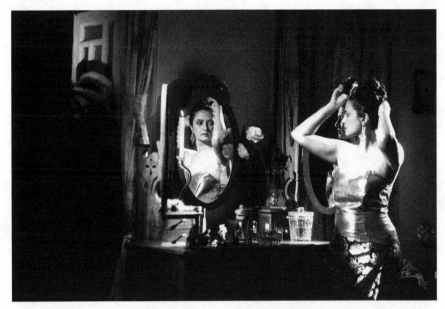

Figure 13. Pushpamala N., *Phantom Lady or Kismet*, Mumbai, 1996–1998. Courtesy of the artist.

candle on one side of the mirror and a vase of two slender roses on the other, the image accumulates all the stock clichés of a romantic rendezvous. Yet there is no one else here except, in the far left, a menacing hooded figure. The Phantom Lady, recognizable only by her eye patch, lurks in the shadows. On the wall on the far right is a photograph of two figures, possibly an image of the doubles together. The photograph on the wall appears from a different era, and unlike the proliferating shadows and doubles of the *Phantom Lady* series, seems to afford some stable referents and legible signposts of the nuclear family. The narcissistic figures in the series, on the other hand, reject the repressive instrumentality of procreative sexuality and offer images that disconcert the social programs of the planned city and its heterosexist imaginaries of the nuclear family.

The pose is evoked again in another photograph of the Vamp caught in a frozen dance gesture in a bright and busy room—marked by festivity, drink, and dance. In an Ibsenian moment, she resembles Nora from *A Doll's House*, as if she were dancing for her very life. Positioned in the center of the room, with various guests gazing on at her from different angles, her head is turned away from us, her slender frame caught between the two large fans. She looks like a butterfly as her onlookers take in and enjoy the spectacle. In each of these scenes, the "rhetoric of the pose" works to intercept some of the cinematic clichés that Pushpamala N. invokes in her photo series, and it evokes a more ambivalent response.

If in noir the glamorous femme fatale is merely a clue to a deeper puzzle that the male detective must excavate and assemble, Pushpamala N. queers the noir genre. In her photographic series the glamorous Vamp may "echo" the Phantom Lady herself, may be a feverish projection of a mediatized imagination, may be her paramour or her lost twin. The secure modernist relationship between subject and object, probing detective and exposed woman is transferred onto a narcissistic terrain of substitutions, proxies, and echoes. She is not merely a fantasy screen behind which lie clues to the detective's probe. In one image, the Vamp gazes at the Phantom Lady, who sits in a chair, her back to us, her hands bound and tied in a rope behind her. Across her and standing astride a sunlit doorway, the Vamp gazes at the bound Phantom Lady, a slender cigarette between her fingers. The play between oppositions continues in this image: the heavy materiality of the wood door is juxtaposed with the Vamp's almost ethereal presence at the door. Her enigmatic expression suggests bemusement or boredom. Nothing in her demeanor implies that she is in the least surprised by finding the Phantom Lady in a restrained and immobilized state. Composed of light and shadow, of slender cigarettes and twining ropes, the narcissistic scene resembles a sadomasochistic fantasy, where the self is both subject and object of desire, at once acting and acted on.

The libidinal fantasies are not repressed within deep recesses of the unconscious but pulse along the labyrinthine coil and skein of the urban night. Pushpamala N. critically re-cites the figure of the probing detective: the febrile fantasies of the sleepless Phantom Lady also simultaneously unsettle the heterosexist "planned city" of forcible sterilization and family planning.[36] The pulsions for incestuous hunger, for same-sex desire, for illicit pleasures keep the Phantom Lady dreaming and waiting. The libidinal relations between the Phantom Lady and her double reveal a desire that is inassimilable into heterosexist bourgeois society. It is excessive, unruly, and threatens to disorder the principles of parsimony and thrift that the planned city thrives on.

Pushpamala N. opens up the dyadic scenes of narcissistic pleasure and intrigue to include what appear like documentary scenes of the city. The environs for some of these photographs are set in *dhabas*, alleyways, and dark corridors, where we glimpse the laboring underclasses of Mumbai. Consider, for instance, a pair of images of flight and pursuit: in the first one, the Phantom Lady strides into a dark, rain-drenched wide street. Streetlights puncture the fluid darkness of the night and are reflected in the gleaming wet tar roads. Presumably, she walks fast, as indicated by the blurry edges of her hood. Beneath the eye mask, her face appears anxious. The road is deserted, and a few feet behind her is a man in a dark suit and hat, pursuing her.

The drama of pursuit is heightened in the next image: the photo depicts the Phantom Lady in what appears to be the open corridor of a government office building. She stands against a tall square pillar, in black velvet shorts and tasseled black boots, within a short barricaded area that holds plants. Her hat and feathered plume cast an eerily magnified shadow behind her.

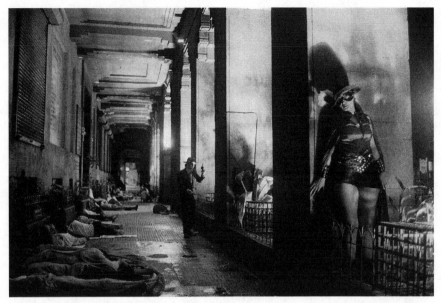

Figure 14. Pushpamala N., *Phantom Lady or Kismet*, Mumbai, 1996–1998. Courtesy of the artist.

The suited pursuer strikes a dramatic pose, gun in raised hand, and follows close behind. He walks stealthily along labyrinthine corridors, where on the cold, hard, tiled floor, in deep and unsuspecting sleep, lie rows and rows of laboring migrant workers.

The recalcitrant presence of the sleeping laborers interrupts the fantasy of the Phantom Lady. As remainder and supplement, the urban precariat abrades against the noir fantasies of staged conflict. The gentle nonchalance of their sleeping poses, some exposed, others draped in a thin cotton sheet, starkly contrasts with the stiff and staged poses of the Phantom Lady and her pursuer. Very few of the sleeping figures' faces are exposed. Either cut off by the photographic frame or turned away from the camera, the laborers play an ambivalent role in this fantasy scenario. Neither backdrop nor cosmetic addition, this eruption of the real into the staged scenes of noir fantasy adds an unexpected affective charge into the photograph. The disquieting collision of documentary and noir forms within the photograph allows us to glimpse the underbelly of "India Shining," the rows of sleeping masses who, tired after a long day's work of informal labor, sleep in the corridors of office buildings.

In the final two images, we return full circle. The Phantom Lady is back in the railway station. Apparently forlorn and tired, she slouches and droops on a wooden bench that appears slanted as if veering away from the hurtling train rushing past. The electric light pole that illumines the Phantom Lady stands erect behind her, its light source cut off from the frame. A network of

myriad lamps and pipes and lines provide the infrastructural backdrop. The blurriness of the train in the image conveys its speed. There is not another soul in the station. The photograph exudes a strange melancholy. The figure of the Phantom Lady appears enervated, even a bit defeated. She holds the furry white fan of the dead Vamp, a strange ghostly thing, illumined in the night.

The next photograph registers the progress of time. Appearing to repli-cate the previous image, the photo is identical except for a few details: night has turned to day, the train has disappeared, the lights are no longer gleam-ing. The Phantom Lady sits on the same slightly askew damp bench in what appears to be the early hours of the morning. The station is bereft, save for the panoply of grids, poles, railway tracks, bridges, wires, signals, lights, and lines that crisscross the skyline behind her. One wonders: Did she fall asleep? Was this a dream? Is she dead? Her head appears a little higher and we dis-cern more of her face. She still clutches the Vamp's fan in her hand as if in an effort to hold on to some material memory of her. The suitcase has switched sides. A few wet puddles in front of her catch and refract her image in tiny fragments. The horizontal landscape photograph itself seems to sit upright, in portrait form, formally suggesting that the time of slumber and repose is now past. The dreary and bleak realism of the damp morning intimates that it is time to rise from slumber to the vertical world of labor. Writing of this image, film historian, Madhava Prasad says, "It's the end of the line for her, I cannot help thinking, and already the cityscape has turned her into a picturesque reminder of a happy dream, someone who might go on returning to that seat for the rest of her life, her story buried within herself, while the living world whirls past her, avoiding her fading figure."[37] What comes full circle is also the end of the line. Something about the spent force of fitful fantasies and narcissistic self-absorption seems to fade away in the unforgiving light of day. The image conveys fatigue and suggests the narcotic power of anesthetizing mass culture fantasies.

In Pushpamala N.'s urban metropolis, narcissism emerges at the intersec-tion of psychic life and social history. The noir framework gestures toward the melancholic loss of a Nehruvian dreamworld, which promised urban development in tandem with social welfare. But it does so through a criti-cal irony, which simultaneously mourns and mocks the passing of an entire dreamworld.

As we have explored earlier in this book, the rapid changes following India's liberalization affected not merely spatial or social landscapes of urban life; they reshaped the very dreams of the citizens. The incessant barrage of images and commodities in the mediascapes of the city generated insistent fantasies that fuel aspirations for a better life. The ideological and institutional shift to *economic* self-reliance in the newly independent nation in the 1950s trans-formed to discourses and policies of *individual* self-reliance in the liberalized society of the 1990s. The liberalization of the Indian economy placed a new rhetorical focus on individual self-reliance and self-empowerment. Thomas

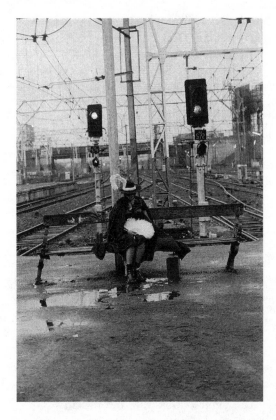

Figure 15. Pushpamala N.,
Phantom Lady or Kismet, Mumbai,
1996–1998. Courtesy of the artist.

Lemke describes how neoliberal policies shift obligations for social welfare into a matter of personal responsibility, "The strategy of rendering individual subjects 'responsible' (and also collectives, such as families, associations, etc.) entails shifting the responsibility for social risks such as illness, unemployment, poverty, etc., and for life in society into the domain for which the individual is responsible and transforming it into a problem of 'self-care.' "[38] The *Phantom Lady* series captures the consequent sense of ontological insecurity in the context of the transformation of social relations and increased rhetorics of self-reliance within the neoliberal city.[39] Embracing, rather than rejecting, narcissism enables Pushpamala N. to generate new mappings of self and city and provide alternative arrangements of desire and sociality.

The Return of the Phantom Lady

If the cyclical structure of the first series suggests not linear progress but a looping back, this recursivity is reflected in the title of the second series, *The Return of the Phantom Lady*. Made sixteen years later, *Return* conjures

up the revenant, the restless phantom who revisits to avenge injustice, and maps a spatial history of Mumbai through a narrative of crime and suspense. Shot by photographer Clay Kelton, the dark shadowy worlds captured in the first series are thrown into a riot of Technicolor in the second. According to Pushpamala N., *Return* is in the same film noir style but in gorgeous color "recalling the rich baroque tones of movie halls, the peeling interiors of dingy offices and slums, and the acid tones of cheap crime thriller covers, the drama unfolds as the city is mapped through the contested sites of its historical film theatres, new glass faced office blocks and shanty businesses, with layers of cinematic references."[40] Saturated by vivid, acidic colors, the images evoke the pungent colors in *Nighthawks*, Edward Hopper's painting of an American diner, which was inspired by the artist's nighttime strolls through Manhattan. Pushpamala N.'s images draw on the warm hues and color palette of Hopper's painting to convey an atmosphere of sensuous libidinal urbanism.

If in her first series, the site-specific locations of Parsi cafés, colonial buildings, and nighttime streets and railway stations celebrate the cosmopolitanism of Mumbai, her second series zooms in on the threat to dwellings and lifeworlds in the context of property disputes in contemporary Mumbai. Pushpamala N. situates her mise-en-scène in a range of contentious sites: in an Old Drive-In Theatre in Bandra; in Maker Maxity, Bandra; an Old Office on PM Road; in Bharatmata Theatre in Lalbagh; in Dharavi Kumbharwada; and in Gorai Fishing Village. Each judiciously selected site is embroiled in a legal battle over land scams, Special Economic Zones (SEZs), evictions, and "redevelopment projects," all pressing urban issues that Pushpamala N. makes vivid in her artwork. The exploits of the Phantom Lady thread together a series of contested sites through a narrative of criminal and fugitive intimacies in the city. Through the narrative journey of the protagonist, we glimpse nonlegal squatters colonies, new unauthorized neighborhoods, informal settlements, neighborhood mills and factories, small shops. *Return* exposes the precarity and unruliness of the nonlegal city, its vulnerability, resilience, and creativity. Pushpamala N.'s *Return* sketches out the unruly domains of nonlegal practices, recovering disorder as both libidinal and affective engagements with the city.

In *Return* the Phantom Lady rescues a pubescent schoolgirl from the clutches of Mumbai's land mafia, who murder her father. The narrative charts the adventures of the Phantom Lady and the schoolgirl as they escape the corporate office where her father is murdered, navigate a demolished drive-in theater in Bandra, seek refuge in a potters' village in Kumbharwada in Dharavi, hide out in Bharatmata Theatre in Lalbaugh, continue through Gorai Fishing Village, and finally escape via ferry to the other side of Mumbai. *Return* traverses liminal corridors and sites threatened with seizure from their dwellers and converted into high investment capital.

A chilling opening image reveals a school-uniformed, prepubescent girl, roughly eleven years old, in what appears to be the interior corridors of a

shiny corporate office at night. Sitting crouched on her knees beside a gleaming wall, she looks nervous, her hands clasped together as if in anticipation, or perhaps, in prayer. Her reflection is multiplied both on the gleaming Formica wall beside her, the faux marble floors, and the glass wall across her. A single shaft of light enters from a slightly ajar door and illumines the bald head and a hand of a dead man lying, face down, prone, in front of her. The man is her father, recently murdered by the land mafia in the city. The white-feathered plume of the Phantom Lady is caught in silhouette, composing a triangulated image of the scene. The schoolgirl, her shadow, and the corpse are reflected in an adjacent mirror. Beyond her is a window where one glimpses the rush of nighttime traffic. Through its darkness and sterility, its shadows and reflections, the photograph evokes an atmosphere of anxiety, which is heightened by our sense that this is a scene of crime.

In the next images, we observe interior spaces that shuttle between gleaming corporate workplaces and desultory government offices. A shot composed of shadows and warm colors illuminates the profile of the Phantom Lady crouching toward a wooden desk, with a telephone and a few colorful folders. The room appears to be a rudimentary government office—with banks of dusty steel filing cabinets on the side. An ominous shadow of a ceiling fan hovers over the image. The room has no windows and no visible doors. The ensuing claustrophobia evoked by the absence of a sense of outside accentuates the sense of mounting disquiet.

The images move from the claustrophobic interiors of corporate and government office spaces to the bright outdoors of the Old Drive-In Theatre at the Bandra-Kurla complex, a contested site marked for demolition and redevelopment plan.[41] In the flat, bright, stagey image, the Phantom Lady holds a gun in one hand, and with the other she leads the schoolgirl briskly away from a band of gangsters, wearing bandannas and vests and standing in macho poses, presumably chasing them after the murder of her father. Close behind her and in histrionic poses recalling gangster characters from the Hindi cinema world, the thugs point their guns at them. The low-angle shot magnifies the Phantom Lady's power as she confidently moves through the place, securely holding the hand of the schoolgirl, whose worried expression and slightly hunched posture conveys an agitated nervousness to flee from the simultaneously menacing and ludic figures in the background. The textured surface of the ridged, grooved, and corrugated ceiling that looms over the characters adds a material dimension to the cinematic image. The sheer staginess of this image undercuts the mood of anxiety in the previous photographs and adds an ironic and mischievous sense of hyperbole to the cinematic scenes.

Capturing this scenario from a different perspective, the next photograph reinforces the cinematic reference and the ironic hyperbole. The cinemascopic image shows the three thugs, the Phantom Lady, and the schoolgirl all in a straight line and in silhouette. Each actor's histrionic pose conveys a parodic

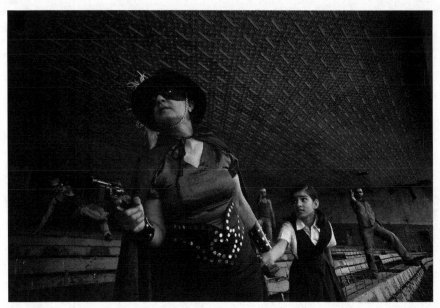

Figure 16. Pushpamala N., *The Return of the Phantom Lady (Sinful City)*, Mumbai, 2012.
Courtesy of the artist.

overstatement of Hindi gangster cinema. The scene is shot from the darkened interiors of the seating pavilion of stadium as if the gangster scenario were part of a cinematic fantasy. The backdrop behind the actors reveals a few bright yellow heavy construction vehicles and laborers overseeing the building activities. In the distance, beyond the construction site, tower several gleaming glass and chrome high-rises.

Several images of hide-and-seek follow: in one image, the Phantom Lady furtively gazes at three "pirate figures" hatching a scheme. In another photograph, reminiscent of the iconic image from Chaplin's *The Kid*, which shows Chaplin and a little boy stare out from behind a wall with an incredulous expression, we see the Phantom Lady and the schoolgirl peer out from behind tall plastic sheets that covers ghostly human-shaped projectors and office furniture. Even banal everyday objects such as plastic covers acquire a haunted, ghostly quality.

The next images present the duo in Dharavi, the location of the Oscar-winning *Slumdog Millionaire* and also reputed to be "the biggest slum in Asia." More than sixty years ago, Dharavi began as a village in the marshlands and grew, with no government support, to become an economic miracle, exporting crafts and manufactured goods to places as far away as Sweden. Spread over 540 acres of land and encompassing around seventy thousand households, Dharavi was first established around 1910, when so-called lower

caste workers (in leather, pottery, fishing) sought out spaces to work: Tamils opened tanneries; Uttar Pradesh migrants worked in textiles; the Kumbhars came from Gujarat to establish a potters' colony. Founded in 1912, Kumbharwada (Potter's Land) is one of the oldest colonies in Mumbai. With the help of the Mumbai trader's communities and the British government, 13.5 acres of land was leased out to the community of potters for a period of ninety-nine years.

Pushpamala N.'s images focus on the potters' colony in Dharavi Kumbharwada, the world's largest pottery market. One photograph shows the Phantom Lady and the schoolgirl walking away from the smoky rubble of cement and clay, precariously weaving through the maze of beautifully crafted pots and artisanal things. The white plume on the Phantom Lady's hat appears like another tuft of smoke, its soft and evanescent spectrality in contrast to the durable materiality of the rows of gently sloping earthen pots. The schoolgirl is barely discernible beneath the misty clouds of concrete smoke. Barely a specter, we sense her presence beside, almost behind, the Phantom Lady. The vapory, smoking rubble, the earthen warmth of the crafted pots, and the two spectral figures lend an air of wistfulness and nostalgia to this scene in Kumbharwada, stereotyped through mediascapes of squalor and ruin.

In a close-up photograph in Kumbharwada, we see a potter at work flanked on either side by the Phantom Lady and the schoolgirl. His craftsmanship is made vivid as he adjusts the potter's wheel, his face tense and almost reflexively flinching away from the Phantom Lady, who appears to be disclosing something to him. The tension between being and acting is hard to miss—the Phantom Lady and the schoolgirl are in character even as the potter appears to be a somewhat reluctant recruit. The eruptions of the real in these stage-managed images convey the elusive and unfulfilled desires for cross-class and cross-caste connections. This close-up photograph reveals an aspiration for proximity, the desire, at least fleetingly, to bridge social worlds. Yet even though the effort to provide a visual riposte to caste hierarchies and gendered distance is laudable, the intimacy appears forced.

The photograph of the potter in his workspace offers a glimpse of his craftsmanship. He squats on the ground, his right hand shaped into a fist atop the rotating potter's wheel. His hand acts as a fulcrum and firmly clasps the spinning wheel, giving it a sense of stability. The two fugitives are shielded in a dark, almost womb-like basement; the schoolgirl places her crossed arm and lays her head on the Phantom Lady, who throws a protective arm around her in a nonchalant gesture of maternal affection. Rather than provide patronizing, top-down images of the victimhood, misery, and squalor of the "slumdogs," Pushpamala N. trains her lens on creativity, resourcefulness, and community within these precarious informal settlements.

The next set of images turns to another contentious site, the historical Bharatmata Theatre, originally built for Mumbai's millworkers.[42] Recently, an eviction notice from the owners, National Textile Mills, threatened to

bring down the seventy-five-year-old theater. Bharatmata Theatre served as the venue for tamasha performances, a popular Marathi folk theater form that brought together the laboring communities in Mumbai's mills for evenings of entertainment. Pushpamala N. recalls the protests outside this theater, during the photo shoot that tried to stall the "redevelopment" agendas of the neo-liberal state.[43] In the images, Pushpamala N. attends to the projections and materialities of the cinematic city. One low-angle close-up photograph shows the Phantom Lady in the projection room, her hand opening the projection box, while her face is turned toward the viewer. The image suggests that perhaps a bomb is hidden in the projection box. The subsequent photograph shows her inside the projection room, dismantling and possibly defusing the bomb. In an interview, Pushpamala N. explained to me that sites like the Bharatmata Theatre have often been threatened with arson attacks—an easy way for illegal real estate developers to thwart legal regulations that prevent taking possession of such historical properties. Setting fire to such places of historical value solves the problem of legal rigmaroles and quickly enables them to take possession of highly coveted real estate properties. By encountering the things of the media, its images and rhythms, its screening spaces, its technologies, Pushpamala N. evokes an urban sensorium saturated with the risks and tactilities of cinema.

Turning from the tactile materiality of projection rooms and film reels to the cinematic image, the filmic referent continues in the next photographs, where we see real bodies rub up against cinematic ones. In one photograph, the contoured Phantom Lady is juxtaposed against a large flat-screen projection of working-class laborers from the film *Natrang*, which was screening there at the time of her shoot. Another photograph shows Sonali Kulkarnee, sensual Marathi actress, in a *laavani* pose, while in the corner of the image a tiny Phantom Lady figure lies prostrate on the movie theater's floor. The Phantom Lady's two-dimensional image against the flat projections both includes and excludes her within the cinematic imaginary—yearning for a fullness with the image yet in a state of perpetual alienation from it.

Another photographic mise-en-scène unfolds in the deserted movie theater: the backlit plume of the Phantom Lady's hat adds a touch of shimmering drama as her silhouette stands directly across the aisle from a remote figure in the distance. We discern a hatted man, framed against the red curtains in the doorway. Deep red curtains, blue-green walls, saffron-bordered ceilings, and whirling ceiling fans saturate the cinematically overdetermined scene. Citing the controversies over Bharatmata and using Natrang as a point of entry, Pushpamala N. excavates a different history of cinema viewership, performance, community, and labor in Mumbai.[44]

Depicting the Phantom Lady in the historical theater allows us to see both the imagistic consumption and the material production of cinematic fantasies. The material grappling with things of the media recalls Ravi Sundaram's description of the media-saturated urban sensorium, where proliferation

combines with a media sensorium to create a "dynamic urban loop that pushes the city to the brink in the 1990s."[45] It returns us from the image-dominated culture of late capitalism to the tactility of media urbanism, of the pungent crumbling reels of film and metal projectors. The Phantom Lady not only navigates a world marked by the clichéd, fictive narratives of popular cinema but also brings into the urban field of vision the vast and proliferating materialities of media urbanism.

Pushpamala N. illustrates that the affective economies of media urbanism are a primal and primary sensuous mode of experiencing India's expanding metropolises. Here media urbanism refers not only to image production and circulation, and the material things of the media, but also the fantasies and dreamworlds they generate. This mediated fantasy structures our kinetic engagements with the city—its sights and sounds, its smells and textures—trigger repertoires of an urban sensorium that mediates its citizen-subjects.

Pushpamala N.'s final contested site is Gorai Fishing Village, where she stages scenes of capture and escape. The region was targeted as prime property for redevelopment as a tourist destination, and Mumbai Metropolitan Region Area Development Authority had proposed to earmark it as an SEZ. As a result, the fishermen, mostly Adivasis, who lived on the property and had no title documents to claim ownership of the land, were threatened to become destitute. About ninety-five hectares of land around the Dharavi Bhet area is a bay and is the mainstay of the fisherfolk and the Adivasi community. This falls under the Coastal Regulation Zone. About twenty-five hundred hectares of the total land in the Dharavi Bhet is a heavy mangrove forest ecosystem that is important to sustain environmental balance. Destroying mangrove land to create a cement and concrete jungle will harm the environment considerably. While coastal smuggling was big business in preliberalized India, current illegal scandals revolve around real estate mafias looking to evict working-class and marginalized dwellers in order to turn a quick buck in the economic boom of redevelopment projects. Pushpamala N. sets her performances against the backdrop of this contested site.

In one photograph, set against the sea, a muscular hoodlum, dressed in a black vest and blue jeans, grabs the schoolgirl from behind, cups her face as he twists it toward him. His other hand points a gun to her head. She looks stricken as her hands attempt to unclasp his grip on her. The Phantom Lady takes a bold step toward him. The cinematic drama unfolds against the seascape, indiscernible in the sinister darkness. A solitary boat, ethereal and pale, floats in the distance. The implicit violence in the scene gives way in the final two images that portray the escape of the Phantom Lady and the schoolgirl. In the penultimate image, a boat cuts through the waters of the sea and transports them to a safer place. The courageous expression on the face of the Phantom Lady is aglow in a warm amber light as she holds the schoolgirl securely in a snug embrace. The schoolgirl seems to burrow herself in maternal warmth, her head resting on the Phantom Lady's arm, and their pointed

Figure 17. Pushpamala N., *The Return of the Phantom Lady (Sinful City)*, Mumbai, 2012. Courtesy of the artist.

knees softly touching. The bow leads the boat into gently lapping waters, the breaking of dawn rendering it a subtle shade of blue. The lighting, the colors, the gestures, and the ensuing atmosphere imbue the scene with a soft maternal tenderness. The realm of a watery and oceanic narcissism itself promises a release from the land disputes and territorial scuffles that precede this scene.

The final low-angle photograph captures the Phantom Lady and the schoolgirl together, in silhouette, against the vast expanse of a prismatic sunlit sky. Dotted with innumerable, shimmering, dispersed clouds against a pale blue sky with gilded streaks, the photograph augurs a glorious dawn. The panoramic photograph captures the Phantom Lady and schoolgirl somewhat obliquely, as if we are encouraged to stride with them as they move onward to another destination. Their erect and confident postures appear undaunted from the fretfulness of prior events. The vast and largely vacant landscape offers a sense of expansiveness and release from the bustle and tumult of urban life. They appear ensconced by the grandeur of the sky and sea, their new habitat. The image glows with iridescent promise.

The two series have certain elements in common: identifiable archetypal tropes, mirror images, psychological oppositions, a noir aesthetic sketched out in black-and-white or Technicolor, a chase sequence, crime, sexual threat. In *Return* Pushpamala N. brings vivid and saturated colors of modernist art and combines her neo-noir style with the vitality of gangster cinema, of

pulsating rhythms of Hindi movie songs, of detective fiction. The threat that previously lurked in the shadows now explodes full-blooded onto the screen. *Return* sets each shot in a contested site—against the drama of a clichéd plot of a melodramatic Hindi film with noir overtones, Pushpamala N. introduces the nonlegal city not merely as backdrop or container of social dramas but as a libidinal performer. In addition to the formal differences between the two series, the change in protagonists and sequence is also significant. Whereas the first series narrates a cyclical drama, the journey undertaken in the second series moves in a linear narrative from enclosure to escape, from the stultifying corporate and government interiors to an expansive beyond. While the first series presents us with the Vamp—an image of excess and waste—the second offers the figure of the innocent schoolgirl, who represents a sense of potential value, a repository of human capital, and by comparison solicits the viewer's sense of protectiveness.

We move then narratively from unproductive narcissism to maternal narcissism, from a circular temporal structure to a linear one, from queer failure to maternal triumph, from a refusal of teleology to the topos of what Lee Edelman describes as "reproductive futurism" as political horizon.[46] While the first one shows a momentary reverie at the railway station, amplifying and exploring the heterogeneity of the now, its aporetic narcissism, its non-unitary contours, the second centers on the schoolgirl as a trope of futural promise. While Pushpamala N.'s first series ends on a note of exhaustion and failure, of stasis and apathetic resignation, the second closes on a hopeful note, with an image of a newly conceived Mother India and her adopted daughter striding toward a luminous horizon.

Pushpamala N. uncovers the libidinal contours of the nonlegal city and captures the "noir" dimensions of urban precarity. The libidinal erotics of the city's noir underbelly displace the rationalist classic morphology of the planned city. Evoking a noir atmosphere, the images convey the pervasive sense of anxiety, suspicion, and fear in the wake of radical economic transformations that produce extreme precarity for underprivileged citizens of the city. Through cinematic archetypes, Pushpamala N. reveals the libidinal enmeshment of person and place, which produces eruptions within the real. By placing extraordinary figures into contested environments, the images reconfigure reified social arrangements of power, capital, and dispossession into new relational movements. The emergent rhetorics of self-reliance and individual responsibility induce a renewed narcissism, one that libidinally generates an oceanic civic philia. This narcissism enables Pushpamala N. to map new topographies of city and citizen and stage scenes of urban desire, anxiety, and survival that simultaneously enfold the self and disperse it into the city.

Chapter 5

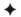

Wasted

Consumer Desire and Its Detritus

In his short single-channel video *The Brief Ascension of Marian Hussain* (2005; 2'23"), renowned Indian artist Vivan Sundaram displays a lively mound of trash. Structured on the concept of a loop, the central image is a three-meter-high artistically arranged heap of trash consisting of plastic scraps of diverse colors. After every ten seconds a human body is seen higher up in the pile, until a lithe adolescent boy, perhaps a ragpicker, emerges from within this garbage heap. The viewer discerns a boy sleeping on a yellow foam mattress perched precariously on top of this makeshift structure, which morphs into what appears to be a mountain of refuse. The actor, Marian Hussain, is slim, bare-chested, and clad in faded denim jeans. He stretches out and then lurches into the air in an elegant, almost balletic leap, a motion resembling the grace and power of a superhero. The looping of the video is such that it disallows any complete ascension as the film returns him to the garbage in which he is enmeshed. The living, heaving mound of trash engulfs and then ejects the boy, and as the video loop repeats the circular motions, the boy continues to both surmount and return to the mound of trash.

Despite its brevity, Sundaram's single-channel video allows the viewer to glimpse the entanglements between want and waste, commodity aspiration and trash, wasted things and wasted people. The imbrication of Marian Hussain in the waste, his emergence and reincorporation in trash, delineates the ways certain human lives are consigned to the realm of waste. Despite the critique against consumer capitalism and its practices of accumulation and disposal, the emergence of the waste picker in the iterable gestus of a superhero figure inserts a sense of the verve, vitality, and resilience of those who rise from and return to garbage. Grating against the indoctrinated blindness of middle-class consumers to the trash they generate, the flickering specter of the waste picker appears and disappears, a stubborn reminder of the acute precarity of waste pickers.

Vivan Sundaram, one of India's pioneers of installation art, actively shaped aesthetic and cultural dialogues around social and political transformations

in India. Sundaram was a founding member of SAHMAT, a collective of artists and activists formed in the wake of the assassination of street theater activist Safdar Hashmi in 1989. He was also central to changing paradigms in Indian visual art through his participation in events like the Kasauli workshop in 1976. The relationship between urban growth and garbage has preoccupied Vivan Sundaram for several years. His works, such as *Great Indian Bazaar* (Second Johannesburg Biennale, 1997: Okwui Enwezor's "Trade Routes: History and Geography") and *living-it-out-in-delhi* (Rabindra Bhavan Galleries of the Lalit Kala Akademi, 2005), and the exhibition of the multidimensional work *Trash* in New York, for example, bring to the fore recycled materials and their entanglements with consumer capitalism, economies of surplus and consequent waste, and the shifting conditions of labor in liberalized India.

Sundaram's installation *12 Bed Ward* (2005) captures, in a haunting way, his engagement with urban detritus and emergent economies of value and waste. Unlike *The Brief Ascension of Marian Hussain*, there is no animation here, no heaving matter, no momentary flight. The stillness and gravitas of *12 Bed Ward*, a large, dormitory-size installation, uncovers an alternative arrangement of affect and desire. The viewer enters a gray, sterile, solemn ward with twelve metal beds, six on either side of a wide aisle. Across the aisle at the end of the room stands an unoccupied metal chair, remote, austere, and magisterial, erect in its capacity to preside over and surveil the horizontal beds. Each bed holds the worn-out soles of discarded shoes, arranged in neat, assorted patterns on each bed. The soles, some solitary, others nestled in pairs, are tautly stitched together with black thread and fitted to the frame of an iron bed. They are then suspended horizontally on the bed frame to provide an illusory sense of a ravaged mattress composed of worn-out soles, suspended in midair. A low-hanging exposed light bulb illumines each bed, casting a filigreed pattern of looming shadows of immobilized spectral footprints. The play of naked light and ominous shadows, the exposure and display of innards, the recuperated soles of ravaged shoes, the haunting silence and stillness of this installation induces an atmosphere of sinister foreboding.

Each sole tells its own unique story: the impress, the wear, the height of the heel offer a sense of the shoes' ghosted owner. Some facing the viewer, others looking down, these soles convey the many unexpected journeys undertaken by the owners. They also reveal the soles' multiple lives, from street-side repair to disaggregation, recycling, decomposition, and restoration. The installation stages the ghosted encounters between hands and feet, the arduous care with which the manual laborers deftly separate sole from shoe for the informal recycling economy.

For a visceral understanding of the embodied labor of recycling outworn shoes, let us turn to the description provided by Vinay Gidwani, urban theorist and geographer, as he describes his journey to one of the makeshift sheds where salvaged shoes are recycled:

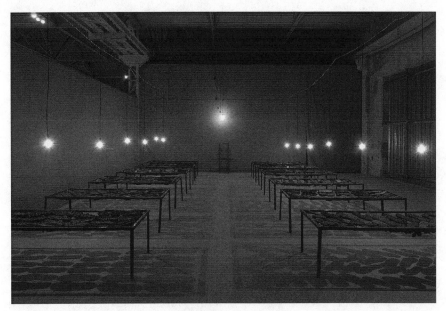

Figure 18. Vivan Sundaram, *12 Bed Ward*. Kiran Nadar Museum of Art, New Delhi, 2005. Courtesy of the artist.

Stretched on the floor in these makeshift sheds you were apt to find rectangular open ovens with grills, and arrayed in zigzag pattern along these ovens young women (occasionally men) placing sandals, slippers, and sneakers on the hot grills. As the soles heat up, along with the adhesive that binds them to the body of the footwear, plumes of noxious grey smoke waft into the air. The smoke catches the back of the throat, so acrid that it's difficult to suppress a staccato of coughing. "Dioxins," my colleague murmurs. The women, who have no safety gear at hand, merely cover their noses with a *chunni* or *pallu*. When I ask, "Doesn't it burn your throat?" they stare at us incredulously, both startled and bemused by the obviousness of the question. "Of course it does," one of the women answers with a shrug. "What can we do?" . . . As the glue loosens the women grasp the sneaker with a *chimta* and peel its sole off with a pair of pliers. One of them tells us that they remove anywhere from 100 to 150 kilograms of PVC soles daily.[1]

The *12 Bed Ward* installation and Vinay Gidwani's ethnography offer two scenes of "salvage capitalism." Both scenes sensuously evoke the precarity of recyclers. At first glance, Gidwani's account is at odds with the clean precision of Vivan Sundaram's installation, its geometric lines, and the sterility of

the institutional setting. Affectively, though, this scene summons something of the mood described by Gidwani. Its very meticulousness ironically evokes a range of messy and anarchic intensities. This installation brings together the uncanny atmosphere of an empty institutional ward, the menacing power that exudes from the solitary chair, the bleakness and sense of vulnerable exposure of the salvaged soles that resemble bare entrails, organs, and viscera obscenely on display. The spare aesthetic register at work here, so distinct from the earlier piece, offers no reprieve, no uplift, and only exposes the grave aftermath of consumer capitalism.

Commenting on Sundaram's work, art historian Chaitanya Sambrani reminds us that the history of urbanity is linked to the archaeology of trash. Trash is the logical telos of consumer society and its ethos of planned obsolescence.[2] Saloni Mathur echoes this theme, reminding us that garbage signifies the end point of a consumer society, which not only conveys mounting consumer appetite but also underscores how such appetites produce precarity within certain sections of society.[3] Sundaram's powerful installation of exposed soles in *12 Bed Ward* and the recalcitrant figure of Marian Hussain in the video loop bring together what Sambrani refers to as "subversive economy of reuse and salvage" and what Mathur describes as "necessary strategies of survival within capitalism." The "death-like chamber" of *12 Bed Ward* is really more like a purgatory, a temporary and liminal space where salvaged soles are given new life and enter into new circuits of value. Focusing on the infrapolitics of the informal economy of the recyclers, these critics foreground the innovative ways recyclers turn the trash of the wealthy into the means of renewal and livelihood. The presence of the soles in this art installation as well as in his multidimensional *Trash* not only underscores the vision and talent of Vivan Sundaram but also alludes to the creativity, skill, and craftsmanship of the recycler.

This chapter explores both the ways humans make waste and the ways waste makes humans. How does the performativity of waste, its repertoire of iterative practices, delineate which subjects are included and which excluded from the category of "the human?" How does the itinerary of the discarded object from middle-class consumers' home to the recycler's shop tell us something about the ways trash demarcates who counts as human? How does the sociality of trash begin to define the boundaries of the human? No doubt the story of growth and garbage, consumer desire and detritus, draws on pioneering anticapitalist critiques of rapidly globalizing cities. Performance studies contributes to this conversation by looking at how iterative practices consolidate categories of human and waste. How do toxic substances exert power over our health while shaping our social relations, entrenching social inequality, and consolidating often casteist or racist ideas of which lives are valued? How does the cultural performance of waste delineate self and other, inside and outside, private and public?[4] How are these new subject positions solidified through the performative iteration of waste labor? How do waste

and an association with nonhuman waste render certain subjects less than human? Simultaneously, how does the proper classification, recycling, and disposing of waste render others as environmental subjects, whether bourgeois environmentalists or eco-activists?

India's recyclers, like Marian Hussain in Sundaram's video loop, tell the dark stories of "India Shining." The stories of the garbage pickers Sunil, Kalu, and Abdul, eloquently captured in Katherine Boo's Pulitzer Prize–winning nonfiction book *Behind the Beautiful Forevers*, allow us to glimpse the aspirations and despairs that guide the lives of waste pickers like Marian Hussain.[5] Sunil, Kalu, and Abdul, along with a host of other lively characters, live in Annawadi, a murky informal settlement that houses three thousand residents on swampy reclaimed land bordering a sewage cesspool, behind the international airport and the glitzy luxury hotels in Mumbai. In the shadowy squalor of the glittering metropolis, Sunil and Abdul scrape by and make a living as garbage pickers. Living, in this slum, is an improvisational art form that demonstrates a dexterous capacity to dodge adversity: "In Annawadi, fortunes derived not just from what people did, or how well they did it, but from the accidents and catastrophes they avoided. A decent life was the train that hadn't hit you, the slumlord you hadn't offended, the malaria you hadn't caught."[6] This sprawling urban slum is home to a range of characters who exhibit audacity, resilience, humor, and vitality but are not immune to the crushing opportunism, corruption, and injustice they navigate daily.

In David Hare's dramatic adaptation of Boo's account, the figure of Abdul, whose growing ethical probity is set against that of Sunil, whose risk-taking is fueled by the promise of the good life in neoliberal Mumbai.[7] Both Abdul and Sunil are made acutely aware of the looming violence around them at the hands of local gangsters, corrupt police, jealous neighbors, and local politicians. The relentless production of fantasies of good life in neoliberal India brings images of wealth and success tantalizingly close to its urban underclass. For the waste pickers, however, these fantasies do not deliver; rather, they exacerbate the sense of acute deprivation in the midst of proliferating mediascapes of affluence and growing mountains of urban detritus.

Since it requires minimal training, prior knowledge, or capital investment, waste picking is a widespread occupation performed by multitudes of impoverished, dispossessed, and desperate Indian citizens. According to the Solid Waste Management Rules Association, a waste picker is formally defined as "a person or groups of persons informally engaged in collection and recovery of reusable and recyclable solid waste from the source of waste generation . . . for sale to recyclers directly or through intermediaries to earn their livelihood."[8] Rough estimates put the figure of India's waste pickers at 3.5 million people in 2011. The waste pickers in India include a vast array of workers who labor in a range of waste practices, from sewage to scavenging to recycling to electronic waste. The figure of the *kabaadiwala*, an itinerant and resourceful door-to-door buyer of unwanted goods, is entrenched in the

imaginary of those who grew up in preliberalized India. The increasing pressure to privatize waste management through technocratic solutions threatens to eclipse such professions, with the looming risk that professions deemed informal will soon be rendered illegal.

Marian Hussain, the ragpicker in the video, is associated with the NGO Chintan Environmental Action and Research Group and apprenticed with the artist Vivan Sundaram. Chintan has made important interventions in finding ways to empower those engaged in recycling and to create awareness about reducing consumption and educate middle and upper classes on better waste management techniques.[9] India's thriving NGO sectors, of which Chintan is a shining example, are crucial players that coordinate recycling in cities and work with waste pickers not only to manage India's growing garbage problem but also to empower the urban underclass and give them a life of "greater dignity."[10] Vivan Sundaram works closely with Chintan and his artworks make vivid the afterlife of commodity capitalism, while simultaneously acknowledging the important work that the impoverished recyclers perform in imagining sustainable urban futures.

Economic liberalization greatly increased the sheer volume of commodities, and hence of waste generated by the nation. According to Assa Doron and Robin Jeffrey, the average American created 150 times more waste each year than the average Indian. While US produced around 250 million metric tons of waste per year, India generated 65 million tons. (Other estimates put India's waste at 5.31 million metric tons per year.)[11] But given its population density (1,157 people per square mile), the problem is especially urgent in India.[12] However, waste has a much longer history in India and has performed important cultural work in shaping ideas of what constitutes Indianness.

Prior to liberalization, India's cultural values of frugality and customs of reuse ensured a check on practices of consumption and disposal. Indian nationalist leaders like Mohandas K. Gandhi and Jawaharlal Nehru converged on hygiene as crucial economic and moral signifier of the nation's modernity. Both Gandhi and Nehru extolled the virtues of prudence and frugality.[13] More recently, Prime Minister Narendra Modi promised to deliver a Swacch Bharat (Clean India) by the 150th birth anniversary of Gandhi in October 2019. For the occasion, a theme park in New Delhi titled "Waste to Wonder" assembled replica versions of the seven wonders of the world. Made from waste products, artists created waste monuments that announce India as an environmentally progressive nation. While Gandhi and Nehru focused on everyday practices of renunciation and frugality in the constitution of the self, Modi's investment in monumentality and the iconography of progress converges on environmentalism as a trendy platform for self-aggrandizement.[14] Stitching together developmental, civic, and moral discourses, Modi's campaign to clean India appeals to what Amita Baviskar refers to as "bourgeois environmentalism," while simultaneously appealing to overseas Indians and middle-class citizens.

Wasted Humans

No account of growth and garbage in India is complete without an understanding of the ways that waste pickers themselves begin to be identified not only with trash but also as trash. The association with trash metonymically transfers to the personhood of waste pickers: like the materials they work with, they are regarded as trash. Some of India's most precarious citizens, waste pickers routinely navigate economic exploitation, criminal justice system, social discrimination, poor sanitation, ill health, and hazardous working conditions. The recyclers, and others who work with and in waste, constitute the very bottom of India's hierarchical society.

Waste pickers frequently belong to the Dalit community, formerly classified as "untouchables." As I mentioned in chapter 3, although untouchability has been illegal since the Indian Constitution's abolition of untouchability in 1950, prejudice against Dalit communities pervades Indian society and continues to stigmatize these populations. Other communities working with waste include lower-caste people, impoverished Muslims, and India's religious minorities. Some travel to cities as displaced landless migrants in the wake of agrarian crises. These communities often live in informal settlements adjacent to mounds of rubbish, akin to the one depicted in Sundaram's video. For caste Hindus, trash is not only an economic signifier of want and waste; it also bears cultural associations, as it is linked with ritual pollution, and waste pickers blur the boundaries between persons and things.

At first glance, the treatment meted out to India's urban underclass exemplifies what Foucault refers to as the processes through which liberal governmentality "makes live, and lets die."[15] Identifying a historical rupture in the seventeenth century in modes of governmentality, this new technology of biopower rearticulates absolute sovereign power, which derived from the ancient legal apparatus of Roman law to "let live and make die." Biopolitics, in Foucault's words, is "a power bent on generating forces, making them grow, and ordering them, rather than one dedicated to impeding them, making them submit, or destroying them."[16] Foucault describes biopolitics as "a new technology of power" that "exists at a different level, on a different scale, and has a different bearing, and makes use of very different instruments." The apparatuses of biopower train their eyes not on determining which subjects die but on administering and fostering worthy lives. More than a disciplinary mechanism, biopolitics acts as a control apparatus exerted over a population as a whole or, as "a global mass."[17] Biopower now augments a management strategy through the disciplinary emphasis on the individual body, with a focus on populations as a whole.

If "making live" is a central tenet of liberal governmentality, how do we understand Foucault's conception of "letting die"? Which lives are worth fostering and which are devoid of "value"? How are the markers of privilege, wealth, race, and sex inscribed onto bodies, and how do these conceptions

of value circulate within a global economy of biopolitics? Who profits and who bears the costs from the regulation and improvement of life processes in a transnational frame? Which lives have value, and which are disposable?

Lawrence Summers, former vice president and chief economist of the World Bank, succinctly captures the disposability of those humans who inhabit the global South. In his controversial leaked memo from 1991, Summers recommends that more electronic waste be dumped into the LDCs (Least Developed Countries.) The memo states, "A given amount of health-impairing pollution should be done in the country with the lowest cost, which will be the country with the lowest wages. . . . I think the economic logic behind dumping a load of toxic waste in the lowest-wage country is impeccable and we should face up to that."[18]

Here Summers advocates that environmental pollution produced in developed countries in the global North should be transferred to poorer countries in the global South, since life expectancy is low in these countries anyway. What he calls his "impeccable logic" clarifies how neoliberal governmentality functions by filtering all actions, decisions, rationales through an economic calculus. According to such an economic calculus, life in the global South is not worth living anyway, so it matters little if the exported toxins add to that deteriorated quality of life.

Summers's characterization of life in the global South follows a logic of "global governmentality" that is no longer limited to the jurisdiction of state power, that is now wielded with impunity by global institutions such as the World Bank and the International Monetary Fund. But is this outsourcing of toxic waste to the global South adequately characterized by Foucault's conception of "letting die"? Or is this a calibrated and measured response derived from rational choice theory? In its casual dismissal of the significance of third world lives, Summers takes a determined position of not simply letting die but actually making die. The rhetoric of free trade and development entrench neocolonial asymmetries of privilege, poverty, and pollution in the transnational economy. Not only are outmoded commodities considered expendable; so are the lives of the racialized laborers from the third world nations.[19]

The wretched populations in the developing world are sharply brought into view through Agamben's conception of "bare life"—disposable populations that can be destroyed with impunity. Drawing on the work of Foucault (biopolitics as management of populations) and Hannah Arendt (*homo laborans*), Agamben describes "bare life" as the "life that cannot be sacrificed but can be killed." Agamben departs from Foucault and asserts that biopolitics is not modern but ancient; the inclusion of bare life in the political realm is the original nucleus of sovereign power.[20]

How can we conceive of the waste pickers as populations not simply allowed to let die, in Foucault's conception, but instead as a population that is actively killed through state processes of willful blindness? The focus on

"willful" rather than "blindness" reinforces the suggestion that these are acts of commission rather than omission. As such, these are scenes of making die rather than letting die. The waste pickers are the populations that Agamben would describe as "*homo sacer*," as those whose killing does not constitute murder and whose death cannot be deemed a sacrifice.

For Zygmunt Bauman, the survival of the modern form of life depends on the dexterity and proficiency of garbage removal. He develops Agamben's idea of *homo sacer* to imagine the wasted human lives of garbage disposers, "the unsung heroes of modernity."[21] He argues that in the modern, secular context, it is precisely the sovereign's capacity to refuse positive laws and deny human rights to the *homo sacer* that legitimizes the sovereign sphere. Urban geographer Vinay Gidwani draws on Agamben and Bauman to argue that the lives of waste pickers in India are "devoid of symbolic, economic, or political value, neither significant in the human realm nor the divine."[22] Pointing to the endemic violence in the Indian state's managerial approach to problems of poverty, Akhil Gupta argues that "extreme poverty should be understood as a direct and culpable form of killing made possible by state policies and practices rather than as an inevitable situation in which the poor are merely 'allowed to die' or 'exposed to death.' "[23] The poor are killed despite their inclusion in projects of national sovereignty and despite their centrality to democratic politics and state legitimacy. While Agamben's conception of the sovereign injunction to "make die," emphasizes the states' productive violence, the binary juxtaposition between sovereign and *homo sacer* is less sustainable where the state is disaggregated and decentralized, and sovereignties are dispersed across a spectrum of political institutions.

These theorists allow us to consider the multiple ways the disaggregated processes and functions of the state sanction violence to actively kill its urban underclass. These acts of killing range from the slow death of illegalizing their professions through the privatization of informal economies of waste management to productive violence of the mismanaged and inefficient bureaucratic systems of delivery to the complicity of corrupt state functionaries in the thriving of a shadowy global outsourcing of hazardous electronic waste. To suggest, per Foucault, that the biopolitical management of populations is concentrated on making live and letting die exonerates the state of its complicity in these routinized acts of taking life.

Transnational Life of Electronic Waste

Driven by rapid urbanization and growing populations, global annual waste is expected to increase over the next thirty years from 2.01 billion tons in 2016 to 3.4 billion tons.[24] In 2016 China imported two-thirds of the world's plastic waste until early 2018, when it refused to take in more, sparking a crisis in the recycling industry. Globally, an estimated 50 million tons of e-waste

are produced annually, with residents of the US and the UK, generating some of the highest rates worldwide: thirty kilograms and twenty-two kilograms per person, respectively.[25] E-waste encompasses a broad and growing range of electronic devices such as household appliances, from refrigerators to air conditioners and washer-dryer units. As costs of these items decrease, replacing these products is more expedient than repairing them.

Nations and corporations in the global North produce millions of tons of toxic waste, which is dumped in poorer nations, especially in Asia. This "toxic colonialism," as environmental activists call it, permits profit making and the creation of low-wage work for many residents of economically desperate communities. The e-waste increases morbidity and mortality; it is linked to high rates of illness and death, along with widespread ecosystem damage. Von Hernandez, a former literature professor from the Philippines and a Greenpeace activist, reminds us that Asia is considered "the dustbin of the world's hazardous waste."[26] Roughly 80 percent of the e-waste that is "recycled" quickly ends up on a container ship bound for an Asian country, where it is dumped and recycled under hazardous conditions. By externalizing the costs of electronic disposal to Asian countries, American and European corporations refuse to account for and contend with real costs of damaging the environment. Connecting poverty to race and pollution, the transnational systems of e-waste dumping reveal the structural and systemic violence of environmental racism.

In his study *Resisting Global Toxics*, David Pellow notes that industrialized nations produce 90 percent of global waste. Each year, roughly 3 million tons of dangerous waste from the United States—the chief source of e-waste—and other industrialized nations cross international borders. And the e-waste problem is one not only of numbers but also of toxic substances.[27] Pellow reminds us that the personal computer is the most visible and harmful component of e-waste.[28] When these components are illegally disposed off and crushed in landfills, the lead is released into the environment, posing hazardous threat and contaminating groundwater; it ravages human health and well-being.[29] In the words of Jim Puckett the executive director of the Seattle-based Basel Action Network, which works to keep toxic waste out of the environment, the global trade in e-waste leaves "the poorer peoples of the world with an untenable choice between poverty and poison."[30]

India generates more than 2 million tons of e-waste of its own, while also importing it from wealthier nations around the world. The arrival of mass television in the 1990s first augured the incipience of the informal e-waste industry, which accelerated after the spread of mobile phones beginning in the twenty-first century. Before economic liberalization in 1991, hazardous waste in India, including chemicals, industrial sludge, and contaminated metals, amounted to a modest 4 million or 5 million metric tons a year. The United States at that time generated 275 million metric tons, while India's hazardous waste in 2015 was estimated at less than 8 million metric tons a year.[31]

The waste pickers in India's informal economy process more than 95 percent of this electronic waste.[32] When waste pickers dismantle and process e-waste without proper precautions, its toxic constituents damage health and in many cases cause respiratory-related deaths in recycling communities. The scientific extraction of valuable metals such as copper, silver, gold, and platinum has driven an underground economy of illegal scavenging for precious metals through waste pickers, who unfortunately have limited understanding of the toxicity and carcinogenic properties of substances such as liquid crystal, lithium, mercury, nickel, polychlorinated biphenyls (PCBs), selenium, arsenic, barium, brominated flameproofing agent, cadmium, chrome, cobalt, copper, and lead, inherent components of electronic equipment. The required techniques for segregating precious metals involve solder-stripping and acid baths, and waste pickers handle these toxic substances without wearing gloves or masks. Moreover, they live in informal settlements that lie adjacent to untreated e-waste dumps and landfills.[33] The vast informal network of players at every node in the electronic waste recycling industry includes various middleman, subcontractors, and contractors. These informal labor networks typically become family affairs, and usually it is women and children who provide the most delicate and often most hazardous task: dismantling circuit boards.[34] Doron describes a predominantly Muslim area near Jama Masjid Bridge Road where one could see locals washing the ash from burned e-waste and using sieves to recover fragments of metal. Such processing was heavily guarded, with policemen standing at the entrance to the slum area on the outskirts of the town where much of this illicit work took place. The role of the police was hard to gauge, but according to one local, there was an arrangement between the police and various parties in the illicit trade. It is difficult to assess the effectiveness of the 1997 Indian Supreme Court ruling that prohibited the import of hazardous waste. This has not deterred the practice of exporting e-waste into India, which continues to thrive through highly corrupt channels.[35] Pellow notes that nations in the global North continue to export e-waste to countries like India, where it enters an illegal underground economy.

The practice of nations in the global North exporting e-waste to poorer nations in the South exemplifies the urban dystopic narrative that Asia's present may be the future of the West. This idea, the central theme of Mike Davis's *Planet of Slums*, suggests the unexamined presumption that the West is the ideal standard for a desirable present and that unless it is more cautious, it may end up looking like a dystopic Asia. While the discourse of modernity consigned the colonials to "the waiting room of history," to be civilized before entering into the bright light of self-rule, here the discourse of urban dystopia also temporally projects a spatial backwardness that the West is being hurled into. As Jennifer Robinson puts it, "The deployment of a dystopic narrative structure in contemporary urban studies rests on the assumption that the urban condition in many places is already dystopic."[36]

This conception of nations in Asia as dumpsters for the obsolete technological products in the global North ties in well to Lawrence Summers's valuation of human lives itself as less worthy in the developing world. How does this transnational political economy of electronic waste reinforce conceptions of what constitutes a valuable life, who counts as a human, and which lives are disposable?

Bangalore-based artists Krishnaraj Chonat and Surekha explicitly take up the question of what Bauman calls "wasted lives" in the urban metropolises of India.[37] By placing at center stage the discarded object of spent desire, the abjected useless thing that ends up in a garbage dump, these artists bring into imaginative focus the highly exclusionary social worlds that are engendered through spatial and social demarcations of hygiene and filth, privilege and poverty, technology and tradition. Examining these works of art reveals the relational dynamics and porous borders between persons and things and allows us to see how commodity capitalism produces a culture of obsolescence, which renders not only commodities but also people as disposable.

Chonat and Surekha's artworks consider the ecological effects of the current urban preoccupations with innovation, speed, and enhancement. How does one represent the deliberate, slow-moving effects of ecological disasters that are often insidious and invisible, not easily revealing their toxic dimensions?[38] What, these artworks demand, are the human, social, ecological consequences of the current valorization of innovation and its consequent cultures of disposal? How do people live with and in waste, and how does a culture of obsolescence render people as waste? What are some creative and critical measures that people take to make something new of these entanglements? Through their turn to refuse, what varied forms of refusal do these artworks register?

By considering the dialectical relationship between progress and debris, as famously captured in Walter Benjamin's notes on Paul Klee's paintings,[39] these artists evoke the ghosts that are occluded in the progressivist discourses of technology and development. Not merely encryptions of ideology or politics, these artworks stir between life and death and uncover a spectral history of innovation and obsolescence in the city. The multiple artistic engagements that I discuss below attempt to recover the buried detritus of rampant high technology in the city today.

Krishnaraj Chonat: Use, Exchange, and the Obsolescence of Values

I return to visual and installation artist Krishnaraj Chonat, whose critical artwork *Private Sky* (2006) we considered in detail in chapter 2. Chonat's artworks capture the dark side of triumphalist discourses of Bangalore as

Figure 19. Krishnaraj
Chonat, *My Hands
Smell of You*, 2010.
Courtesy of the artist
and SKE Gallery.

an emergent world-class city. His work consistently takes up the question of
the effects of unchecked urbanization on habitats, ecologies, and social rela-
tions. Chonat first showed his installation *My Hands Smell of You* (2010)
at SKE Gallery in Bangalore in 2010. On entering the gallery, a shimmering
chandelier-like sculpture dangles from the ceiling. Slivers of light illumine
the glittering sinewy mass that is delicately suspended in midair. On closer
inspection, we discern heaps of scrapped electronic waste: discarded tele-
phones, computer keyboards, and mice dangle from the clouds of embedded
computer monitors.[40] The e-waste hangs like a canopy of blossoms suspended
from a flowering tree. A large mirrored wall catches and duplicates the image.
Caught in the reflection is the viewer herself, both gazing at this scene and
implicated within its system of representation. The shadows of the sculpture
fall on the walls, magnifying and adding a dramatic, dark mood to the instal-
lation. The mass of e-waste hovers over a bed of fragrant red earth. The scene
evokes a Hindu matrimonial bridal bed, fetishized in copious depictions in
Hindi cinema as the culmination of erotic foreplay. To this end, the title of
the piece, *My Hands Smell of You*, reinforces the erotic charge so vividly sug-
gested by the marital bed.

Chonat identifies e-waste as a material residue of the much-touted electronic boom in India's high-tech city, Bangalore. In his words, through this artwork he attempts to elucidate

> a tenuous embrace between the pressures to progress fast in a techno-logical and consumerist fashion resulting in these mountains of waste and a desperate cry for slowing down. To see through a "forest" of wires and "mountains" of waste, to smell the last gasping breath of red earth still exuding fragrance, to see migrating elephants and singing birds that seem to disappear sooner from the "forests of the mind" than in the "wild"; to create an affect through tangible forms and olfactory stimuli that I hope will resonate with the audiences for long, because after all it seems like Art is perhaps our last resort for being human.[41]

Chonat here braids together tropes of slowness and speed, the rhythms of nature and the time of capital.

Chonat's installation, *My Hands Smell of You*, acquires its full elucidation in his reiteration of this piece for the exhibition *Paris-Delhi-Bombay* in the Centre Georges Pompidou in Paris in 2011. In the Pompidou installation, Chonat introduces a performative dimension: the artist gifts a bar of san-dalwood soap and a piece of original artwork to an audience member who in turn donates a piece of electronic waste. This apparently simple exchange of things dramatizes prevalent notions of exchange value and proffers in its place a performative gesture of generosity. By exchanging restorative and creative things for deadly and toxic ones, Chonat exemplifies an ethic of gift-giving that abrades against pervasive neoliberal economic calculus of social relations.

Using e-waste to create "forests of wires" and "mountains of waste," Chonat suggests that the only encounter that urbanites have with nature is mediated through electronic technology. He develops this theme of the alien-ation of urbanites from their natural ecologies in his subsequent work as well. *All Sunsets Are Sunsets*, for example, considers the thoroughly mediated experiences of "nature" that are packaged through media and sold to tour-ists. In *My Hands Smell of You* Chonat evokes a romantic scenario of the wild through his forests, mountains, and red earth, suggesting a generative environment only to invert our horizon of expectation. The corrosive mate-rials in this romantic composition abrade against its erotic theme; the form chafes against the content and reveals not the sensuous union of lovers but, rather, the toxic hierarchies that divide innovation and trash across transna-tional geographies of labor.

The evocation of scent in the title, *My Hands Smell of You*, is particu-larly significant in this context. Suggestive of the fragrance of flowers or the scent of fleshly tangles, smell here almost immediately acquires a sensual

and romantic valence. But a closer engagement with the sculpture thwarts such associations. The erotic fantasies transform into corrosive nightmares. Referring to the smell of electronic waste, Chonat draws our attention to the sensuous handling of toxic waste matter that leaves its metallic odor on the flesh of the third world laborer. Removing usable metals by hand from computers, cell phones, and other discarded electronic objects leaves an acrid stench on the manual laborer's skin.

Chonat's sculpture forces the viewer to consider the highly toxic and risky ways that recyclers scavenge metal parts from electronic waste. The drive to progress at any cost has necessitated not only taking on risky endeavors but also an uncritical celebration of risk-taking *tout court*. Recyclers often have no protective equipment or gear; they breathe in high levels of toxic chemicals, which are then released into the environment. At once tactile and dehumanizing, scavenging to recycle parts leaves the pungent residue of brominated flame retardants, heated lead and tin, which slowly seeps into and contaminates the worker's flesh and lungs. The toxic materials enter the air, if burned, and groundwater, if dumped.

Chonat's artworks bring into imaginative focus the highly exclusionary social worlds that are engendered through spatial and social demarcations of value and waste, of privilege and poverty. For the 2011 *Paris-Delhi-Bombay* exhibition in Paris, Chonat developed his earlier work. By deliberately incorporating a performative dimension, Chonat explores the dialectics of individual agency and systemic environmental racism. He mounted the installation onto a wall he erected in the gallery space, twelve feet high and eighteen feet wide, decorated by e-waste that dangled lengthwise across the wall. The wires, cables, computer mice, and telephones that dangled like heavy pendants of a glittering chandelier are affixed and displayed on one side of the wall. When visitors walk around to the back of the wall, they encounter a different image: here Chonat has mounted a tile-like back wall composed of slabs of burnished sandalwood powder. The doubleness of the sculptural installation is such that one can never glimpse both sides at once. Each of the two modes of sensuous encounter on display precludes the other: an exploitative and dehumanizing remnant on the one wall, and a memento of generosity on the other. The vital materiality that the viewer encounters on either side of the wall reminds her of her own complicity in sustaining or undermining toxic conditions of environmental racism. Chonat's piece suggests that one can either continue to participate in dehumanizing acts of environmental racism or choose to perform gestures of generosity.

The use of sandalwood in the sculpture bears multivalent associations. Declared the "royal tree" by the Sultan of Mysore in 1792, sandalwood is the name of fragrant woods from trees that grow in the postcolonial state of Karnataka. Heavy, yellow, and fine-grained, and unlike many other aromatic woods, the slow-growing sandalwood tree retains its fragrance for decades. Sandalwood also bears religious significance, is thought to have therapeutic

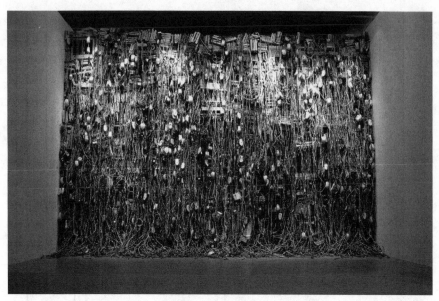

Figure 20. Krishnaraj Chonat, *My Hands Smell of You*, Centre Georges Pompidou. Courtesy of the artist.

properties, and is frequently used in alternative medicine to cool burns, heal rashes, and purify the skin; sandalwood essential oil is used in aromatherapy and Ayurvedic medicine for relieving anxiety. Unfortunately, due to overharvesting in many areas, the sandalwood tree is rapidly disappearing.

By drawing sandalwood, artistic sketches, and e-waste into an assemblage, Chonat's poetic sculpture puts on display the global political economy of environmental racism. Through a consideration of the use-value of e-waste and its apparently incommensurable exchange value through personalized gifts of sandalwood and an original drawing, Chonat makes visible the asymmetries of exchange across geographies of privilege and poverty. Chonat insists that by discarding objects that have not exhausted their use-value, consumers of high-technology gadgets participate in the creation of electronic waste. However, Chonat does not simply lay the blame of the problem of electronic waste on the individual consumer. Chonat's sculpture makes visible how systemic problems such as built-in technological obsolescence that encourage and indeed necessitate consumption are transmuted and simplified into questions of personal responsibility. By offering personalized gifts, Chonat forces the one who discards e-waste to enter into an alternative exchange economy, one predicated not on calculated relations of profit but on an ethical encounter where a creative gift is offered in exchange for a toxic object. The face-to-face immediate exchange between acrid waste and fragrant art, between noxious by-product and creative artifact, shuttles between the deadly electronic waste

Figure 21. Krishnaraj Chonat, *My Hands Smell of You*, Centre Georges Pompidou. Courtesy of the artist.

of the first world and Chonat's creative and imaginative response to systemic practices of risk and endangerment. By offering generative gifts in exchange of toxic objects, Chonat rearranges toxic global hierarchies into a more humane and lateral relationality.

The e-waste dumped from "first world" nations onto the shores of "third world" nations serves as material and concept for Krishnaraj Chonat's critique of the transnational flows of electronic waste. By evoking the sense of smell, Chonat viscerally reminds us of our breath, which connects bodies to environments. But rather than an antagonistic postcolonial riposte, the sculptor approaches the question of structural and systemic environmental injustice perpetuated by the collusion of state and corporations through a performative gesture of generosity.

Chonat choreographs a different register of equality: the ethical exchange of e-waste for artful objects reveals the structured violence within global encounters and a performance of generosity as a response to that violence. By accepting the piece of e-waste and reciprocating with sensuous sandalwood and an original piece of art, the artist enacts a rapprochement through an ethical relationality where the donor is made aware of the ways her everyday actions endanger citizens and life-forms in "third world" nations.

Chonat vividly illustrates the connotations of using soap to clean away the dirt of transnational waste practices. The fragrant soap literally allows

the first world disposer to wash her hands clean from any responsibility in the hazardous circuits of waste transmission. *In My Hands Smell of You*, Chonat captures, via that most ephemeral but enduring of senses, smell, the ways in which the traces of our creative or deadly practices linger on the skin and memory of others. His work seems to suggest that in exchange for the object that will contaminate one's body and pollute one's environment, the giver may offer a memento, a gift that will cleanse the skin and perfume hands. The gesture of generosity here is not elicited to produce any equivalent response in the receiver; it is an absolute and unconditional act of giving. The gifting of sandalwood, with its curative properties, is especially significant: this memento will cleanse burning skin and offer fragrance that evokes the unhurried rhythms of a former Bangalore, redolent of gardens. In offering mementos for the e-waste, the artist sets into motion a different economy of transnational exchange, memory, and sensuousness.

Much like the Tibetan Buddhist practice of *tonglen* meditation, the breathing in of noxious fumes, and breathing out of healing and restorative compassion, binds the gift-giver to the receiver through a radical act of compassionate generosity. Such gift-giving is not an act of charity or philanthropy where one gives in the confidence that one's giving enhances one's stature and does not imperil one's capacity. In the performative gesture of generosity inheres a radical possibility—that the giver may indeed perish from the toxic fumes generated by the recipient. Yet this radical gesture of generosity focuses on confronting the refusal to contemplate the consequences our actions can have on others far removed from us. It forces us to expand our sense of responsibility and awareness beyond ourselves, and confront our self-absorption, consequently awakening our capacity for connection and compassion.

Through his gift of creative objects and his acceptance of the hazardous objects, Chonat enacts a performative generosity—an unconditional act of giving, a generosity that upsets calculations of use and exchange value. In this way, Chonat troubles conceptions of individuals as self-interested, economic actors in a profit-based economy and puts into play a radical and absolute gesture of generosity. Inscribed in the encounter is a pedagogical reminder of the far-reaching consequences of electronic waste. Perhaps this sensuous encounter will trigger a different memory and make one reflect on one's implication in a system of planned obsolescence, and interrupt patterns of consumption and waste that impact other citizens of the world. Chonat's installation insists on a different order of transnational encounter, exchange, and temporality. Chonat promotes an ethics of gift-giving, an act of compassion and generosity.

Surekha and Spectral Obsolescence

We briefly encountered Bangalore-based conceptual artist Surekha's *They had their home here* and *Skin Home* (2008–2009) in the introduction to

chapter 1. Here we return to Surekha's artworks in greater detail. Surekha is a vibrant and dynamic member of Bangalore's public and community arts practice. She is the founding curator of Rangoli Metro Art Center, a public art space initiated by the government of Bangalore. Her civic projects related to public history include *A City in Transit, Making of the Metro I & II, A Letter to Gandhi, My Life Is My Message, Building Bangalore-Archives from MEG, Gandhi in Bangalore, Lines & Beyond, Viewing Landscapes, The World of Puppets,* and *My Indian Life—Megumi Sagakida.* She has coordinated several public interactive projects for the city of Bangalore. Her work, which includes video art, photo performances, sculpture, and installations, addresses feminist and ecological concerns. A minimalist in form and aesthetic, Surekha depicts her subjects with an ironic and often unsettling sense of humor. Her nonnarrative video art is political, not preachy, with a sharp, spare aesthetic economy and conceptual clarity.

Ragi.net Project was part of the *Post Oil City—Bangalore Gardens Reloaded* art exhibition held in Industrial Museum, Bangalore, in February 2013. In this project, Surekha grows *ragi* (finger millet) out of abandoned computer keyboards. Originally grown in Ethiopia and Uganda, finger millet traveled to India around 2000 B.C.E. Today, *ragi* is a widely grown crop, native to Karnataka, which accounts for 64 percent of the total production of *ragi* in India. Ragi is resilient to attack by insects and mold, and its durability, nutritional value, and sturdiness make it a vital crop among poorer farming communities in Karnataka, who enjoy *ragi rotis* and *muddes* (*ragi* balls). However, due to the rampant "development" of Bangalore as India's Information Technology city, many *ragi* fields are seized from farmers and converted to technology parks to service the real estate needs of the IT industry.

For this project, Surekha collaborated with a farmer, Subramani, in Varthur village, an area adjacent to Whitefield, the town where many call centers and IT campuses are located, roughly thirty kilometers from the heart of Bangalore City. The rapacious real estate development in the area displaced villages of Varthur and converted them into IT parks, international schools, and elite residential enclaves. Rather than IT firms springing up on *ragi* farmland, Surekha inverts the process and experiments with *ragi* sprouting on discarded keyboards instead. Along with Subramani, Surekha grows *ragi* in the gaps and holes of the upside-down computer keyboards. For the installation, the rich green *ragi* plant sprouted out from the separated keyboards. Surekha separates out each individual computer key like a miniature cup, with tufts of *ragi* sprouting out of it.

Writing of Surekha's sculpture, Bangalore art critic R. Dhanya notes,

> Here hundreds of computer keys separated from the boards are kept upside down like toy cups; the half an inch hollows holding little servings of brown, globular grains of ragi. Their individual textual symbol is now invisible, creating instead a more democratic picture

Figure 22. Surekha, *Ragi.net*, 2013, Bangalore. Courtesy of the artist.

of millet wielding gathering. In unison they also appear like a topo-
graphical screen shot from Google Earth. . . . Filled with the grains
the keys are like strange mascots of a mixture of farming and technol-
ogy that could be a utopian vision of the future.[42]

Dhanya reads the sculpture as a utopic commingling of farming and technol-
ogy. But Surekha does not braid computer hardware and agriculture into
a harmonious image. Her living/dead sculpture simultaneously displays the
obsolescence of technological products and the obdurate generativity of
organic crops. It signifies the ways technology encroaches on and damages
generative sources of food, energy, and sustenance.

The miniaturized artwork rescales the human viewer, who now looms
over the eco-tech sculpture as an oversized giant with an aerial view of the
disaggregated plots of *ragi*. The choice to separate and parcel out the little
plots of *ragi* offers a God's-eye view of disconnected and individuated plots
of farmland. Through a series of choices—the gigantism of the viewer, the
disaggregation of the plots of *ragi*, and the flowering of *ragi* where discarded
keyboards lie—Surekha reminds the viewer of the social and spatial displace-
ments that have occurred in Bangalore as a result of the growing usurpation
of land for the IT industry. The sculpture forces the viewer to consider the
ecological ramifications of development projects that destroy the ecologies
of farmers in the outskirts of the city. The monstrosity of the human viewer

makes her recognize a life force gone awry, a gigantic anthropocentrism that dominates and controls nature rather than existing in reciprocal harmony with animate ecosystems.

The disaggregation of the unified computer keyboards also points to the social repercussions of isolating farm laborers. The separation of plots of land mimetically reflects the way laborers who toil on discrete plots are increasingly segregated from other farmers, made individually responsible for their own successes and failures. Such personalization of success and failure deflects the onus of poverty and deprivation from systemic factors to more individual ones. These techniques of social control—isolating farmers, enervating trade unionism, and indoctrinating a sense of personal responsibility for poverty—all advance the collusive politics of government and private enterprise that systematically and structurally exploit and dispossess farmers in the high-tech city.

In addition, by disaggregating things that belong together, Surekha reveals how the usurpation of farm lands by high-tech companies fragments the organic interconnectedness of food, land, and community. Surekha exposes the underbelly of the IT industry, an industry that encroaches on and builds its empire on the squandered homes, fields, and livelihoods of farmers and villagers. Literally turning technology on its head, Surekha's sculpture meditates on what David Harvey refers to as "accumulation by dispossession"[43] and considers how the development of technology within India's IT city displaces farmers. Collaborating with a farmer enables Surekha to create a piece that speaks pointedly to the agrarian crisis within the region and its relationship to corporate imperialism.

The multiple effects of India's agrarian crisis include "footloose migration,"[44] the despair-driven exodus from the countryside resulting from the collapse of millions of livelihoods in agriculture and its related occupations.[45] Between 1991 and 2001, over 7 million people for whom cultivation was the main livelihood quit farming: on average, every day close to two thousand people in India abandon farming. In 2011, India's national census, conducted once every decade, recorded nearly 15 million fewer farmers than there were in 1991.[46] Since mid 2020, tens of thousands of farmers have protested the introduction of three new farm laws that seek to liberalize India's agricultural sector, which comprises forty percent of India's workforce. According to the farmers, these laws will remove the minimum price guarantee and the regulated wholesale *mandi* market system, thus exposing farmers to the vagaries of the unregulated free market and intensifying the hold of private companies.

P. Sainath reminds us that farmer suicides are rising even as the number of farmers is shrinking; between 1995 and 2015, the National Crime Records Bureau logged over three hundred thousand farmers' suicides.[47] The report of the National Crime Records Bureau, Accidental Deaths & Suicides in India has drawn a baseline of fifteen thousand farmer suicides each year since 2001, or roughly forty-five farmer suicides every day.

Sainath lists a range of factors that precipitate this agrarian crisis in liberalized India: the increase in cultivation costs; corporate control of seeds, fertilizers, and pesticides; and agricultural credit policies that favor businesses rather than individual farmers. Moreover, public sector banks turn away from farmers, forcing them to borrow from lenders who charge exorbitant interest. That combined with increasing climate uncertainty, unpredictable monsoons, rigged markets, and severe water crisis produce conditions of extreme precarity for farmers.

Akhil Gupta points to the role of aspiration, among impoverished farming communities, to overcome conditions of indebtedness, and perhaps even have a shot at the success and wealth they see unfold around them.[48] The congruence of factors including financialization of farming through seed and input loans, and increased exposure to risk due to global market fluctuations in prices makes farming itself an activity undertaken in a climate of speculation. This "speculative climate" that encourages risk-taking and subsequently produces indebtedness is key to understanding the phenomenon of farmer suicides in India.

Farmer suicides bring to mind what Rob Nixon describes as "the long dyings, the staggered and staggeringly discounted casualties" of environmental change.[49] Here we see a more radical notion of displacement—one that focuses not on the movement of people from their places of belonging but on "the loss of land and resources beneath them, a loss that leaves communities stranded in a place stripped of the very characteristics that made it inhabitable."[50] The event-focused, newsworthy capsules regarding farmer suicides make the effects of the "slow violence" visible in a time-bound, visceral, and affective way.

Surekha's sculpture of the discarded keyboards used to grow *ragi* sprouts forces us to think critically about despair-driven migrations, suicides, and the relationship between the agrarian crisis and the aspiration toward high-tech industry in the city. The *ragi* crop itself is becoming increasingly scarce as *ragi* farmlands are appropriated for purposes of real estate development.

Ragi.net draws out ecocritical themes Surekha has explored in her prior works. For example, in her video installation *Unclaimed and Other Urban Frictions* (2009–2010), Surekha presents four stories that expose the obverse of a constant obsession with innovation, youth, and newness in the city. Here she provides us with succinct portrayals of social abandonment. For the installation, Surekha created walls from discarded computer keyboards with wires dangling listlessly in front of them. In a different room, Surekha lined up stacks of computer monitors in adjacent rows. The films were shown on a large white screen in a separate room. Some of the monitors were arranged so as to create separate little viewing alcoves. The standardized, replicable, objects of electronic waste are neatly arranged: they appear like stacked, packaged, ready-to-sell commodities in an electronic warehouse. This is the environment in which Surekha screens her films that meditate on "economies of abandonment" and technological and human obsolescence in the city.[51]

Unclaimed is a ten-minute experimental documentary that follows Trivi-karma Mahadeva, an undertaker in Bangalore City who for the past four decades has tracked down and buried unclaimed dead bodies in the city. Each day Mahadeva and his sons locate between two to ten unclaimed dead bodies and bury them. The film begins with an almost voyeuristic long shot, as if an inquisitive neighbor were looking, through the thick foliage, at a scene below. The film follows the journey of a dead body in a steel-gray van through the noise and bustle of the city. Draped in a bright blue plastic sheet, the limp dead body reaches its destination, a leafy cemetery ground. Through filmic techniques that play with speed and slowness, noise and sound, Surekha inserts moments of silence within the film itself. In a particularly uncanny shot, Surekha uses a gradual cross-fade of the dead body being deposited into the ground below in a way that dissolves, bit by bit, from a vertical to a horizontal shot. The gradual cross-fade creates a spectral and transient visual illusion of a cross. The silence, the ephemeral cross, the sudden slowing down contribute to a shift in the viewer's attention on to a different affec-tive register in a way that enables her to fleetingly honor the unclaimed dead body. The film changes pace, to slow motion, and the soundtrack gets quiet as the gravedigger excavates the earth to make room for the dead. This sud-den slowness and silence provide the viewer with a few moments to register and appreciate the practices of burial that prepare an anonymous body to be laid down to rest. Surekha plays with rhythm, tempo, and sound to make her viewer pause in the frantic rush of everyday urban life and observe a brief silence to momentarily commemorate the unclaimed dead.

What is the place of an anonymous and unmourned death in a city that is fixated on newness? Intertwining physical and social death, the next two videos, *Romeos and Juliets* and *An Empty Bench* offer competing glimpses of old age, of devaluation, of mounting public and self-perceptions of use-lessness. Surekha's films trace the lived experience of human obsolescence. The films also raise political questions about discriminatory access to public parks. In 2010 the government of Karnataka proposed a move to monitor public parks by requiring visitors to carry ID cards while visiting parks in order to get rid of "unnecessary elements." While several activist groups in the city successfully challenged this "bourgeois environmentalism," Surekha's park couplet, *Romeos and Juliets* and *An Empty Bench*, subtly refer to this debate.[52]

The films intervene into the public arguments that robustly challenged the State's attempt to privatize public commons and thereby encroach on poor citizens' constitutional rights to freely access public spaces. By tapping into middle-class anxieties about their security, public morality, and misuse of parks by "unnecessary elements," the government plan to provide discrimi-natory access to public spaces was of a piece with its attempt to showcase Bangalore as a beautiful garden city, a haven for multinational investment. Surekha's videos obliquely invoke these debates by displaying, on the one

hand, the free and easy access to public parks by an elderly group of middle-class denizens and their laughing clubs; and, on the other, the mysterious disappearance of a beggar woman from a public park.

The eight-minute video *Romeos and Juliets* presents a laughing club consisting of elderly middle-class Bangalore dwellers who meet daily in the early hours of the morning in a public park to laugh. Surekha's experimental documentary traces the activities of Mini Forest Laughter Club in JP Nagar, a suburb in Bangalore. The elderly who join the club are often depressed, feel abandoned by their children, and are lonely for human interaction. These are clearly not the *homo sacer*, or waste pickers, we encountered earlier in the chapter. They are what Zygmunt Bauman would refer to as "collateral casualties" of economic progress.[53] They are surplus populations now rendered redundant or obsolete in the course of economic growth.

Founded by Satyanarayana, the ROMEO club—its name stands for Retired Old Men (and Women) Eating Outside—is composed of primarily upper-caste Hindu elderly men and women. According to its members, the laughing club invokes the third stage, or *ashrama*, of human life, *vanaprastha*, as prescribed in ancient Hindu doctrines. According to this view, human life is imagined as comprising four stages: student, householder, forest dweller, and, finally, one who surrenders or renounces all earthly attachments. Rather than retiring into the forests, however, these elderly retire into public parks and practice what they call *udyanavana prastha*, or the stage of dwelling in parks. Here they "forget about their four walls, and forget about the four people in their lives, and laugh."[54] Yet the implicit caste structuring of this club also reinforces upper-caste privilege, which enables these elderly citizens to move through public commons with an ease and assurance starkly in contrast to the lower-caste status of the beggar woman in the following video.

The parks open up the cloistered world of the elderly citizens beyond the privation of the private and allows them the freedom to commingle with others in public spaces. Affectively, the simulated laughter enables them to move from a sense of isolation and futility to a sense of enforced cheer. Yet the very movement out of their claustrophobic interior dwellings and domestic relationships into the world of the public park provides its own benefits. *Romeos and Juliets* oscillates between silence and peals of laughter as the film shows elderly men and women out in a park laughing while simultaneously engaging in physical exercise, stretches, and contrived poses and gesticulations, which triggers more laughter.

The elderly in the city are consigned to the margins of society. In a culture that rapidly reverses its sense of respect for the elderly and fetishizes youth over age, innovation over experience, the elderly are increasingly made to take responsibility for their own well-being. Laughing clubs are not so different from the wellness programs that are instituted within the corporate workplace, like those in the call centers we encountered earlier in this book. These wellness programs suggest that your well-being is in your own hands:

the laughing clubs illustrate practices of self-preservation in a culture that discards the elderly as obsolete, no longer of any use. Laughter is provoked through enforced outward bodily practices, simulated to "trick" the unhappy mind into believing that it is happy.

This pressure to "perform happiness" enforces cheer not only as desirable attribute but also as a form of moral obligation. The laughing clubs derive their inspiration in no small part from the culture of toxic positivity demanded in the corporate workplace. The relentless pursuit of "the happiness advantage" values cheer for its positive correlation to greater productivity rather than worker well-being. Enforced positivity encourages one to repress genuine feelings of isolation and neglect, disappointment and distress, and denies people the full range of human emotional complexity. Expressing sadness is a sign of weakness, a symptom of failure, and even a form of moral incivility. The pressure to "smile or die" is culturally ubiquitous and is perpetuated through clickbait, "like" buttons and smiley emojis on social media, and wellness workshops conducted by "funsultants" in workplaces. The implicit moratorium on avowing professional and personal challenges, and the encouragement to wear a constant smile denies the challenges, vagaries, and vicissitudes that people navigate in their daily lives.

After exploring practices of well-being, Surekha turns to scenes of despondency. The other park film, *An Empty Bench*, is an eight-minute video that offers a brief glimpse into the life and sudden disappearance of a free-spirited beggar woman, sixty-nine-year-old Padma, who had made a bench in Cubbon Park her home. At once unsentimental and unsettling, the film portrays Padma only through shots of her back, her raspy voice, her weathered, calloused hands, sometimes frantically gesturing, at other times stroking and comforting herself.

Padma, a Tamil beggar woman who landed in Bangalore from Ooty, still yearns to make enough money to return home to Ooty, where she can be "free." While her life is generally "okay," she complains that thieves routinely harass and hurt her and steal her things. The park officials develop a fondness for this garrulous and spirited beggar-woman. After Padma suddenly disappears from the park, the filmmaker's restless shots of the empty park benches, the hordes of tourists and visitors, the cacophony of birds in the park and the traffic outside it, all contribute to an unease about her sudden disappearance. The filmmaker discovers that she is now under the care of a priest in a church in Malleswaram because she was attacked and hurt by someone who possibly evicted her from the park. Her sense of uneasiness in Bangalore is exacerbated by her own feelings of insecurity that as a Tamil she does not quite belong in Bangalore. The film ends on a lingering shot of another elderly old man sitting listlessly on a park bench.

Surekha sketches out Padma's sense of precarity as she tentatively claims the park as a place of rest. The film accentuates her sense of vulnerability and exposure as she attempts to make a public park her refuge. Padma inhabits

a zone of social abandonment, even social death. She exemplifies Agamben's notion of "bare life" or existence in the realm of *zoe*, the form of naked existence reduced to biological functions, beyond the pale of the polis or society. Such life is registered through the withdrawal of the human from social life, demonstrated in an incapacity to recognize someone as a social being. Such a disposable life is completely vulnerable to sovereign injunction and political calculation. Padma, the protagonist in Surekha's film, hovers as a specter, simultaneously invisible and a blight, accommodated in the park but also a vulnerable target.[55] The socially dead are construed as disposable and imagine themselves as having outlived their utility. Figures like Padma, anonymous but not uncommon, are rendered as surplus populations; no longer of use to anyone. Considered a waste human, Padma is the "collateral casualty" of neoliberal globalization.

In Surekha's films, the park becomes the public common, which renews productivity. Parks offer spaces for recreation and simultaneous "re-creation" of labor power. They enable one to escape the confines of domesticity, while also becoming a makeshift home for the poor. As sites that provide leisure and pleasure, rest and companionship, parks offer ways to encounter other citizens, differently positioned by class, caste, ethnicity, religion, and thereby dislodge our stereotypes and dissolve our anxieties about social difference. Parks, as these films suggest, are crucibles for cultivating and practicing democratic values. They are public spaces that offer an antidote to the rush and bustle of urban time, the demands and pressures to work and spend time profitably.

Sudipta Kaviraj illuminates how parks in Calcutta shift from exclusive sanctuaries for the leisurely classes to public commons that derive their character from the increasing economic and social pressures on the city. He points out the correlation between democracy and plebianization, where the poor, hitherto unwelcome from public common, now assert their right to the city. He writes,

> As the pressures on the city grew more intense, the fortresses of the middle class started falling, and being divested of their generally aesthetic functions, the parks opened to the poor. The poor initially moved in with a certain measure of tentativeness. At first, increasingly large numbers of people began to sleep inside the park, thus dividing its day and its night between the upper and the lower classes of users. At night, like the streets, the park turned into a huge space for nightly shelter and sleep; but since most of these people plied jobs requiring an early start, by very early morning, before the middle-class day began, these spaces would be empty again, exactly like the streets, which reverted by morning from collective sleeping places to their normal status as pavements, probably because the sleepers themselves suffered from a vestigial sense that the roads had to be vacated and handed back for their normal function when day began.[56]

The changing social and class physiognomy of the parks encouraged street vendors, beggars, and others to venture into the park. These parks now offered the urban poor a space to meet others and begin to form alternate forms of urban informality.

The heightened panics, intensified by statist surveillance strategies, trigger and exacerbate middle-class insecurities to sanitize public spaces of their messy but rich interactions, and to create uniform and standardized spaces for consumption. Surveillance through ID cards entrenches and consolidates deep class and social divides that pervade Bangalore society today. These struggles to conserve the bourgeois character of parks through aesthetic discourses that combine beauty and hygiene are coded class discourses that attempt to thwart the democratic transformations in the city. Policing these parks through expensive ID cards institutionalizes inequality and dramatically redefines who counts as a citizen, and who, as a piece of rubbish, needs to be thrown out of the public park.

How do parks become sites that authorize some lives while disregarding others? As citizenship in neoliberal India is increasingly intertwined with consumer capitalism, those citizens that are not marketable, are obsolete or have outlived their utility, or are a visual reminder of the city's recalcitrant urban underclass are all deemed as trash. In the neoliberal imaginary, these surplus humans are figured as waste that needs to be discarded.

While all films raise questions about how to deal with the spectrality of spent labor, whether living or dead, middle-class or impoverished, the specific ways these disposable entities are dealt with in the city reveals what Lata Mani calls "our habitual practice of everyday eugenics."[57] The final film, *Re-source* (2009–2010), deals most directly with the question of electronic waste in the city. A six-minute single-channel video, this brief documentary sketches out the activities at Ash Recyclers, jointly run by Syed Hussain and Kumar in Bangalore. A former actor, meat merchant, and "maverick," Hussain applies his skills from meat packaging to computer use: "Just as no part of a goat's body is wasted—its meat, its skin are all used—so too no part of a computer should go to waste." The self-fashioned entrepreneur Hussain argues that his Re-source efforts at salvaging electronic equipment have provided jobs for disenfranchised Muslim women and that, in addition, he donates refurbished computers to disadvantaged schools.[58]

In *Re-source* Surekha demonstrates how discarded computers are carefully dismantled and then refurbished and reanimated into new objects. Fixing older technology using lower-cost parts infuses new life into dead objects and creates new objects. The entrepreneurs at Ash Recyclers repurpose locally sourced, available technology and create new, low-cost technological products with them. By reusing and reimagining these materials, Ash Recyclers provide frugal innovations for developing economies.

By situating these films within the context of the environment of e-waste, Surekha suggests that our technological culture has bequeathed to us a

variety of beings and nonbeings, persons and things, that hover between techne and physis, living and dead, making visible the spectrality of technology. Focusing on the neoliberal value of innovation Surekha illustrates a range of outmoded entities through her film series: the unclaimed dead, the laughing elders, the elderly beggar woman or "unnecessary element," and finally the e-waste, which in the hands of recyclers is transformed into refurbished electronic objects. Treated like obsolescence, the elderly, the beggars, the dead and e-waste acquire spectral valence as entities that have lost their use and are now discarded. By linking the living with the dead, the human with waste, Surekha performatively illumines a culture of utilitarianism that discards all things that have purportedly lost their instrumental value.

The resilience and creativity of the urban underclass are negated as their very presence constitutes an affront to the beautification programs of the city. The artworks by Sundaram, Chonat, and Surekha reveal aspects of neoliberal governmentality that perpetuate violence against these vulnerable populations. The artworks I discuss here exemplify a vivid scenario of waste: here the assemblage of humans, technology, and waste allow us to see how humans are conceived of *as* waste. The particular transnational itineraries of e-waste make clear how some human lives, in the circuits of transnational capitalism, are not simply "allowed to die" but "made to die" and transformed into waste products. Situated at the conjuncture of race, development, and capitalism, the wasted humans we encounter in this chapter from waste pickers to the collateral casualties of economic liberalization are denied their humanity.

Epilogue

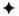

Receptivity and Responsibility in the Neoliberal City

In the 2001 exhibition of his paintings *Tonight at 9 p.m.*, at Gallery Sumukha in Bangalore, artist Ravikumar Kashi turns to a theme that preoccupies his artistic oeuvre: media-fueled consumer desire. Depicted through the coimbricated motifs of cinematic, consumer, and romantic fantasy, the vivid paintings depict images of movie stars, consumer advertising, religious devotees, and other visual cultural signs that saturate mediascapes and public spaces of contemporary Indian cities. One image, serially segmented into three long rectangular panels against a deepening red background, shows iconic Hindi cinema star Shah Rukh Khan in triplicate, wearing a leather jacket and dark glasses, one hand beckoning the viewer toward him. The invitation to proximity is reinforced through the embossed inscription of the word "touch" against the vivid blood-red background. As the eye traverses the painting from left to right, the color deepens until we encounter letters in recessed relief design on the paper: "Keep distance."

By evoking a sense of "close distance," Kashi's painting ironically cites the visual repertoire of consumer images that play on the libidinal frictions between touch and tease, between the eye and the gaze, between the concrete particular and the imagined elsewhere.[1] Advertising imagery works to propel desire through "close distance," which sutures the relationship between desire and vision. The images trace the mimetic constitution of the consuming subject who desires that which the other (in this case, the imagined Western consumer) desires. Kashi suggests that our desires are subliminally informed by a desire for recognition from someone else. Thus, we desire that which is desirable to someone else, and in this manner desires proliferate in an endless relay of recognition and deferral, and in the process instituting within us the otherness of our own desires.

The text, color, and image compose a ludic ensemble that entices and teases the viewer. The word "fun" is scrawled in the upper left corner of the painting. In the background of the middle panel, we discern two stacked identical images of a conventional courtship scene: a man and a woman under two separate beach umbrellas rehearse a staple scene of desire. We spy on the couple outside the domain of work, in an unhurried time, conflating

Figure 23. Ravikumar Kashi, *Keep Distance*, 2001. Photograph by Ranganath Sharma.
Courtesy of the artist.

romance and leisure, while simultaneously advertising new markets for vaca-
tion destinations. Romance itself becomes inseparable from capital as signs
of affluence depict an atmosphere of beachy relaxation, which then pro-
duces appropriately romantic feelings. The apposite mise-en-scène promises
romantic happiness. On top of the right panel we see numerous tiny dark
figures in silhouette of what appear to be soldiers carrying rifles slung over
their shoulder. The intermedial play between cinema, television, and painting
highlights processes of replication within the painting itself as the canvas
captures the proliferating and kinetic array of desires tracked across scenes
of cinema, romance, and war.

Another collaged image in the series, titled *Let Go*, reveals a cutout in the
middle of a large white canvas with numerous embossed figures of seated yogis;
the word "empty" in block letters is embossed on the right. A pencil drawing of
a large hourglass figure is sketched toward the left. The cutout offers a glimpse,
as if from a window, of a black-and-white, almost photographic image of a
man emerging from an ablution in holy waters. Immediately below the figure
of the man is a brightly adorned cluster of flowers that suggests ritual offer-
ings. This assemblage composed of gestural signs, devotional imagery, with
smatterings of lips connoting kisses across the canvas brings together a hetero-
geneous and ironic constellation of signs that convey the ways that religious
practices are instrumentalized to serve a market calculus of self enhancement.

A consummate chronicler of urban affects in the neoliberal city, Ravikumar Kashi is a prominent Bangalore artist and Renaissance man.[2] In *Tonight at 9 p.m.*, Kashi returns to his signature style of combining images and words. His works interweave pop art, televisual imagery, replicated identical images, ticker-tape commentary, and "motivational" text to reveal the deep reaches of capital within the libidinal economies of the city. Together the images produce an affective excess, spurred by an ironic play on speed, high-octane achievement, sexual drive, violence, machismo, and consumption. In his artworks, Kashi turns a sharp eye to the way desires are generated through visual cultures. He depicts a variety of urban desires that draw from vast and proliferating repositories of enchantment that include cinema, tourism, religion, and consumer advertising as resources from which to fashion a new and improved self.

Titles play an important role in Kashi's artistic corpus as they orient viewers toward certain affective states. For example, titles such as *Just Do It*, *Sweet Dreams*, *Go Get It*, *Enjoy*, *Inner Strength*, *Every Face*, and *In Your Reach* steer viewers toward seductive, motivational maxims of urban aspiration that mediates subjects and interpellates citizens as economic consumers. With titles like *Free*, *Fly*, *Secret of Success*, and *Happily Ever After*, bodies are hurled into space. These leaping, balletic, soaring bodies in open spaces convey a sense of expansiveness and freedom, agency, youth, energy, and jouissance. These images ironically suggest that "having a life" is captured through the swirling frenzy of the urban everyday.

Other titles of his exhibitions, such as *Desire* (Vadhera Gallery, Delhi, August 2002), *City without End* (Aicon Gallery, Palo Alto, 2007), and *Any Moment Now* (Air Gallery, London, 2007) reinforce the centrality of time—the immediacy of desire, its teleology of satisfaction, its lurching trajectory toward an object that promises to quell its appetite. Pointing to an alternate temporality from the clock time of industrial modernity that carved up the day into discrete activities of labor and leisure, the new 24/7 workday of neoliberal urbanism chiasmically interweaves labor and leisure so that we are perpetually at work. Play is incorporated into and exists in a feedback loop with work. Caught in this vortex of labor, workers display an enforced positivity that ultimately drains life energy. The tumult of activity is entangled in a cycle of production and consumption so fully integrated that it literally consumes workers, wearing them out and depleting their life force.

The images bring together motifs of leisure, power, sexiness, vigor, and even subversiveness. The imagined carnivalesque release allows for a fantasy of transgression, which after its momentary relief is reorganized and reintegrated into cycles of production. These images provide momentary scenes of fantasy escape from the normative values of the market and offer a sense of freedom, but these rituals, whether of desire or religion, are ultimately enmeshed in market rationalities. The counterfeit images of "the good life" provide sources of aspiration, yearning, and even solace to mass viewers

whose lives are a far cry from the exhilaration and glamour promised in the images. Assuring a sense of temporary release, these consumer images assuage the crushing demands of the 24/7 workday, allowing for recreation, and simultaneous re-creation of labor power. Kashi's images of cinematic and consumer fantasy do not merely replicate what we see around us. By critically miming popular culture's messages, Kashi suggests that these consumer fantasies also provide modes of survival, a brief respite from the unrelenting hardship of life. They offer temporary consolations, offering a momentary suspension from everyday depredations.

How do these tableaus of consumption suffuse everyday fantasies with normative claims? These scenes do not merely mirror what exists in society as social goods. They initiate modes of desire and indoctrination into what one is supposed to desire. Social norms become social goods; consumer advertising serves as pedagogical forms to train and direct desire toward objects that reward conventionality.[3] The vertiginous commodity advertising, with its seductive invitations to consumer fantasies, create the sense of lack, the aching incompleteness within our own lives. Kashi's artworks capture the "cruel optimism," the attachments to notions of the "good life" that are, as Lauren Berlant describes it, an obstacle to our own flourishing.[4] Kashi depicts the contradictions and vagaries of urban aspiration—its hyperstimuli, its perpetual deficiency, its delirious desires, its aching unattainability, its obsolescence.

Brutal Beauty captures the affective life of urban aspiration through a range of artworks that chart the variegated terrain of contemporary capitalism and its dark underbelly. Kashi, along with a host of other artists discussed in this book, delineates the creative and destructive capacities of India's lurch into the liberalized economy. This book tells the story of the transformation of a postcolonial city to a bustling global metropolis. It traces the material, social, and psychic effects of this transformation, and the creative interventions by artists who draw attention to the proliferating social implications of world-class city projects.

Brutal Beauty argues that neoliberalism is an aesthetic project; it is felt most deeply through our changed affective, psychic, and social relations. Aesthetics allow us to attend to the sensuous transformations in the psychic and physical environments of the changed city. Aesthetics foregrounds the work of poiesis, the remaking of the city according to a world-class aesthetic template that simultaneously represses the teeming democratic populations in the city. It also points to the aesthetic refashioning of urban citizens to correspond to their newly changed world. *Brutal Beauty* explores "the neoliberal" not only as mitigation of social programs or the rearticulation of state-market relations but also as a pervasive and inescapable structure of feeling. The affective transformations, captured vividly through artworks, demonstrate how market calculus saturates all aspects of social life. It offers an opportunity to emphasize that "structures of feeling" are not merely ephemeral emotions but also acquire durable social forms.

The question of aesthetics provides a crucial lens through which to understand the spatial aspirations of politicians, real estate entrepreneurs, development sponsors, and urban planners. As the city enlarges and morphs, absorbing periurban territories into its fold, it reconfigures the spatial contours and social dynamics of urban neighborhoods. These spatial transformations impact mobility and livelihoods of its citizens, regulating people's social, professional, and personal lives. Urban renovations reshape spatial arrangements and demarcate spaces separating the wealthy from the urban poor. Informal settlements where the urban poor form a steady pool of service and domestic labor enfold islands of affluence, gated communities with strict surveillance personnel and rules that monitor the coming and going of a steady supply of labor power.

Urban planners advance "aesthetics" as central to the remaking of cities. Making cities beautiful is crucial to the aspiration of remaking urban space in the image of the idealized world-class city. Asher Ghertner refers to this as "rule by aesthetics," which he describes as governmentality that utilizes aesthetics rather than typical instruments of urban planning (e.g., maps, censuses, and surveys) to govern cities.[5] This "aesthetic governmentality" in turn rationalizes brutal measures to make invisible its unsightly elements—that is, its urban underclass. I discuss the implications of this spatial transformation in chapter 1, which examines this aesthetic urban regime by exploring its impact on a range of citizens from evicted dispossessed slum dwellers to privileged gated community denizens.

Brutal Beauty also explores how aesthetics are crucial to the constitution of new aspirational subject positions in contemporary capitalism. It is through new modes of sensorial address, new patterns of behavior, new formations of habitus, that subjectivity is performatively shaped to suit the demands of newly emerging capitalist society. We saw this in chapter 2, where performance becomes the yardstick by which employees are supervised, evaluated, and remunerated as well as a form of aesthetic and emotional labor.

The liberalization of the economy, the global flows of media, commodities, capital, and images, precipitate a proliferating range of urban desires and aspirations, not only for commodities but also for alternate lifestyles and nonnormative sexualities. Chapter 3 addressed the circulation of emergent nonnormative desires in the larger context of globalizing media, NGO activism, and its intersection with existing caste and trans identities in urban India. The emergent political rationality not only ruptured existing systems of social and political life but also brought forth a productive force, giving rise to new publics, subjects, conducts, relations, and worlds. The very forces that can habituate a subject to new modes of being can also produce new sources of understanding and even resistance. The narratives of "city in decline" or the "death of the city" are unable to make sense of this contradictory generative force.

The aesthetics of queer self-making are capacious and go beyond even the focus on bodies and desires. It also paves the way to disperse pleasure across public spaces and libidinize urban environs. In contrast to the principles of performance, striving, and productivity, Narcissus represents a world of self-absorption, indulgence, reverie, and death. Chapter 4 looks at the emergence of narcissism in the context of the obsessive curation and presentation of self in social media, and state and corporate incitements to self-reliance and self-empowerment in public discourses.

Brutal Beauty concludes its analysis by turning to the spent objects of urban desire: trash. Trash embodies not only waste but also value, not only obsolescence but also renewal. What might it mean for us to recognize waste as a source of value rather than consigning it to the realm of the unaesthetic? This final chapter looks at the artworks that have emerged from trash and urges us to think of waste picking itself as a form of aesthetic practice.

The artworks discussed in the preceding chapters make vivid the affective and social transformations in urban imaginaries in the wake of liberalization in India. Artworks cannot be insulated from the currents of urban transformations. The works discussed in this book exist in a dialectical relationship of receptivity and responsibility to the urban environments from which they emerge, suggesting an inextricable connection between arts and social worlds. The tired debates that pit artistic autonomy against social instrumentality derive from Romantic/Utilitarian conceptions of the work of culture. As a result, these debates have calcified feeling and calculation into antinomies.[6] Moving away from stalled debates around the autonomy versus the instrumentality of art, this book traces the political economy of urban affects through artworks. *Brutal Beauty* follows a rich vein of scholarship that has unsettled the dichotomy between feeling/instrumentality and has examined how feelings are part of the calculus to serve normative programs of urban planning.[7]

While discourses of artistic autonomy give ballast to the ideological foundations of the bourgeois liberal humanist subject, turning to a dialectic of receptivity/responsibility moves us away from the insulated and autonomous subject positions of liberal humanism. Instead, we activate a conception of being affected by and affecting social formations. Urban subjects are intersubjectively constituted, porous social beings. The artists I discuss in this book demonstrate a relationship of receptivity and responsibility to the urban environments in which they are enmeshed. Artists are affected by urban forces, and their openness and vulnerability to the world manifests in their artworks that register this affective orientation to the world. Their works give aesthetic form to social confusions, discontinuities, and transformations. Highlighting heteronomous conditions of production, the artworks discussed in this book are likewise porous, open, and receptive to the world that shapes them into being. These artistic responses evince openness and receptivity to the swirling urban transformations, and demonstrate a deep sense of care and responsibility of moving toward horizons of greater social justice.

Brutal Beauty chronicles scenes of urban aspiration and the incitement to aestheticize the self and the city. In doing so, it urges us to attend to the aesthetic dimensions of neoliberalism. It elucidates how urban aspirations take on aesthetic forms in ways that reshape the self and the city. These urban aesthetics unleash brutal forces in overt and insidious ways: they repress the democratic multitudes teeming within the city, deemed unsightly and unwanted. They goad us to desire, accumulate, and discard objects and identities that perpetuate social norms of capitalist and casteist regimes. They entice us to live in ways that actively reinforce fantasies of an imagined elsewhere while simultaneously wearing us down under the relentless pressures of contemporary capitalism. They orient us toward elusive and enigmatic futural horizons, even as we enervate our social institutions, and degrade our material environment. The psychic and social attrition produced by systemic precarity leaves us ever more restless and exhausted, guarded and suspicious. Yet as the artists in this book reveal to us, these new urban forms also generate contradictory and unpredictable effects: they produce new forms of desiring, new modes of solidarities, new sources of pleasure and vitality. Aesthetics are complex and contradictory and may provide, even if only tentatively, the resources for reimagining societies.

Introduction

1. Established in 1867 by John H. Aspinwall, an English trader, Aspinwall House was the erstwhile business premises of Aspinwall & Company Ltd., which traded in pepper, timber, lemongrass oil, ginger, turmeric, and spices, and later in coir, coffee, tea, and rubber. The largest commercial real estate company in India, Delhi Land and Finance Limited, now owns Aspinwall.

2. Sheela Gowda and Christoph Storz, Artists' Statement, Kochi-Muziris Biennale 2012, December 2012.

3. The preeminent novelist Mulk Raj Anand founded the first Triennale-India in 1968; it is still going and is organized by the Lalit Kala Academy in New Delhi. See Nancy Adjania, "Globalism before Globalization: The Ambivalent Fate of Triennale India," in *Western Artists and India: Creative Inspirations in Art and Design*, ed. Shanay Jhaveri (Mumbai: Shoestring, 2013), 168–85.

4. See Ashis Nandy, *Time Warps: Silent and Evasive Pasts in Indian Politics and Religion* (New Brunswick, NJ: Rutgers University Press, 2002). An erstwhile princely state, the Zamorin of Calicut annexed the city prior to the arrival of Portuguese, Dutch, and, finally, British traders on its shores. Kochi's multicultural diversity includes ethnic communities as diverse as Cochin Jews, Eurasian Parangis, Yemeni Arabs, and Syrian Christians, among others. Kochi exemplifies what Diana Taylor refers to as "multilayered sedimentation, a form of vertical density rather than a horizontal sweep." See Diana Taylor, "Performance and/as History," *TDR: The Drama Review* 50, no. 1 (2006): 83.

5. Bose Krishnamachari and Riyas Komu, Concept Statement, Kochi-Muziris Biennale 2012, http://kochimuzirisbiennale.org/concept/.

6. On debates on relational aesthetics and its critics see Nicolas Bourriaud, *Relational Aesthetics*, trans. Simon Pleasance and Fronza Woods with M. Copeland (Dijon: Les presses du réel, 2002); Claire Bishop, "Antagonism and Relational Aesthetics," *October*, no. 110 (October 2004): 51–79; Shannon Jackson, *Social Works: Performing Art, Supporting Publics* (New York: Routledge, 2011); Nestor García Canclini, *Art beyond Itself: Anthropology for Society without a Story Line*, trans. David Frye (Durham, NC: Duke University Press, 2014). On dissensus, see Jacques Rancière, *Dissensus: On Politics and Aesthetics*, ed. and trans. Steven Corcoran (London: Bloomsbury, 2010).

7. *City of Gardens*, directed by me, and adapted by Abhishek Majumdar and me, was produced by Center for Film and Drama and performed at Rangashankara in September 2008.

8. Timothy J. Reiss, "Critical Environments: Cultural Wilderness or Cultural History?," *Canadian Review of Comparative Literature* 10, no. 2 (June 1983): 199; Susan Stewart, *On Longing: Narratives of the Miniature, the Gigantic, the*

Souvenir, the Collection (Baltimore: Johns Hopkins University Press, 1984), 23; Fredric Jameson, "Nostalgia for the Present," *South Atlantic Quarterly* 88, no. 2 (1989): 130.

9. Linda Hutcheon, "Irony, Nostalgia, and Postmodern," in *Methods for the Study of Literature as Cultural Memory*, ed. Raymond Vervliet and Annemarie Estor (Amsterdam: Rodopi, 2000), 206.

10. See Janaki Nair, "Past Perfect: Architecture and Public Life in Bangalore," *Journal of Asian Studies* 61, no. 4 (November 2002): 1205–36, for an excellent account of public space and nostalgia in Bangalore.

11. Svetlana Boym, *The Future of Nostalgia* (New York: Basic Books, 2001), 41.

12. See Amita Baviskar, "The Politics of the City," *Seminar*, no. 516 (August 2002), http://www.india-seminar.com/2002/516/516%20amita%20baviskar.htm.

13. See, for instance, Avijit Mukul Kishore and Rohan Dutt's film on urban planning, *Nostalgia for the Future*, dir. Avijit Mukul Kishore and Rohan Dutt (Mumbai: Film Division of India, 2017), DVD.

14. Nair, "Past Perfect," 1224.

15. See "Attacks on Churches Spread to Bangalore," *Economic Times*, September 21, 2008, https://economictimes.indiatimes.com/news/politics-and-nation/attacks-on-churches-spread-to-bangalore/articleshow/3510304.cms.

16. See Editorial, *The Hindu*, July 25, 1991, https://www.thehindu.com/opinion/editorial/Sparing-the poor/article14504906.ece

17. See Vanita Shastri, "The Politics of Economic Liberalization in India," *Contemporary South Asia* 6, no. 1 (1997).

18. See Agnes Callard, *Aspiration: The Agency of Becoming* (Oxford: Oxford University Press, 2018).

19. See Manuel Castells, *The Rise of the Network Society* (Malden, MA: Blackwell, 1998).

20. According to Saskia Sassen, the global city is the central nervous system for the coordination of processes of production, services, and accumulation on a transnational scale. Saskia Sassen, *The Global City: New York, London, Tokyo* (Princeton, NJ: Princeton University Press, 2001).

21. D. J. Hopkins and Kim Solga, eds., *Performance and the Global City* (London: Palgrave Macmillan, 2013). This project followed their first one, which focused exclusively on global cities in the Western world. See D. J. Hopkins, Shelley Orr, and Kim Solga, eds., *Performance and the City* (Basingstoke, UK: Palgrave Macmillan, 2009).

22. The essays contained in the book, however, offer nuanced critiques of the global city paradigm. See, for example, Susan Bennett's essay "China's Global Performatives," which analyzes Expo 2010 held in Shanghai to explore "the nexus of global corporations, national representation, urban infrastructure, and local experience—all of which function to stimulate and extend an aspirational economy based in city living." Susan Bennett, "China's Global Performatives: 'Better City, Better Life,'" in Hopkins and Solga, *Performance and the Global City*, 93.

23. Mike Davis, *Planet of Slums* (London: Verso, 2006).

24. Gyan Prakash and Kevin Kruse, eds., *The Spaces of the Modern City: Imaginaries, Politics, and Everyday Life* (Princeton, NJ: Princeton University Press, 2008).

25. Gyan Prakash, *Mumbai Fables: A History of an Enchanted City* (Princeton, NJ: Princeton University Press, 2010).

26. Ananya Roy and Aihwa Ong, eds., *Worlding Cities: Asian Experiments and the Art of Being Global* (London: Wiley-Blackwell, 2011).

27. Achille Mbembe and Sarah Nuttall, eds., *Johannesburg: The Elusive Metropolis* (Durham, NC: Duke University Press, 2008).

28. Loren Kruger, *Imagining the Edgy City: Writing, Performing and Building Johannesburg* (New York: Oxford University Press, 2013). She describes Johannesburg as an "edgy city" to convey the literal and figurative contours of the city, a precarious sense of uneasy nervousness and cautious optimism, while also highlighting the extreme contrasts between shopping malls and shanty towns, natives and foreigners, cosmopolitanism and social inequality.

29. Jen Harvie, *Theater and the City* (Basingstoke, UK: Palgrave Macmillan, 2009), 57.

30. SanSan Kwan, *Kinesthetic City: Dance and Movement in Chinese Urban Spaces* (New York: Oxford University Press, 2013).

31. Nicholas Whybrow, introduction to *Performance and the Contemporary City: An Interdisciplinary Reader*, ed. Nicholas Whybrow (London: Palgrave Macmillan, 2010), 6.

32. Ato Quayson, *Oxford Street, Accra: City Life and the Itineraries of Transnationalism* (Durham, NC: Duke University Press, 2014), 21.

33. See Davis, *Planet of Slums.*

34. According to Goffman, "When an individual makes an implicit or explicit claim to be a person of a particular kind, he automatically exerts a moral demand upon the others, obliging them to value and treat him in the manner that persons of his kind have a right to expect." Erving Goffman, *The Presentation of Self in Everyday Life* (Woodstock, NY: Overlook, 1973), 13.

35. Arlie Hochschild takes up Goffman's analysis to examine how performance reshapes not just behavior but also "the heart," by subscribing to normative "feeling rules." Arlie Russell Hochschild, "Emotion Work, Feeling Rules, and Social Structure," *American Journal of Sociology* 85, no. 3 (November 1979).

36. Pierre Bourdieu, *Distinction: A Social Critique of the Judgement of Taste*, trans. Richard Nice (1984; repr., New York: Routledge, 2010). See also Judith Butler, *Gender Trouble: Feminism and the Subversion of Identity* (New York: Routledge, 1990). I draw on Butler's theory in greater detail in chapter 3.

37. Wendy Brown, *Undoing the Demos: Neoliberalism's Stealth Revolution* (New York: Zone Books, 2015), 22.

38. Ibid., 38. Jean and John Comaroff echo Brown's views when they argue, "Neoliberal capitalism displaces political sovereignty with the sovereignty of the market, reduces difference to sameness by recourse to the language of legality, treats government as unnecessary, unless it protects market forces; equates freedom with choice, especially to consume; parses human beings into free-floating labor units, commodities, clients, stakeholders, strangers, their subjectivity distilled into evermore objectified ensembles of interest, entitlements, appetites, desires, purchasing power." See Jean Comaroff and John Comaroff, eds., *Millennial Capitalism and the Culture of Neoliberalism* (Durham, NC: Duke University Press, 2001), 43.

39. See Jamie Peck, *Constructions of Neoliberal Reason* (Oxford: Oxford University Press, 2010).

40. Akhil Gupta, *Red Tape: Bureaucracy, Structural Violence, and Poverty in India* (Durham, NC: Duke University Press, 2012), 278.

41. Tariq Thachil, *Elite Parties, Poor Voters: How Social Services Win Votes in India* (Cambridge: Cambridge University Press, 2014).

42. In the words of Shiv Visvanathan, "Small-town India's sense of aspiration, and its resentment against another leader and family, has propelled Mr. Modi to power once again." Shiv Visvanathan, "What the Thumping Mandate for Modi Means," *The Hindu*, May 24, 2019, https://www.thehindu.com/opinion/op-ed/what-the-thumping-mandate-for-modi-means/article27239218.ece.

43. See Akhil Gupta and K. Sivaramakrishnan, eds., *The State in India after Liberalization: Interdisciplinary Perspectives* (New York: Routledge, 2011). See also Aihwa Ong, who cautions against conceptualizing neoliberalism as a static, rigid, and uniform discourse, which flattens the heterogeneity of economic and social practices that are unleashed in a variety of ways. Aihwa Ong, *Neoliberalism as Exception: Mutations in Citizenship and Sovereignty* (Durham, NC: Duke University Press, 2006).

44. I take my cue from the critiques of neoliberalism developed by David Harvey, *A Brief History of Neoliberalism* (Oxford: Oxford University Press, 2005), 3; Comaroff and Comaroff, *Millennial Capitalism and the Culture of Neoliberalism*; and Wendy Brown, *Edgework: Critical Essays on Knowledge and Politics* (Princeton, NJ: Princeton University Press, 2005).

45. Raymond Williams, *Marxism and Literature* (Oxford: Oxford University Press, 1977), 128–35. As the work of Lauren Berlant and Sara Ahmed have shown us, braiding together political and affective economies enables us to see the operations of "cruel optimism" or the "happiness imperative" in contemporary capitalism. See Lauren Berlant, *Cruel Optimism* (Durham, NC: Duke University Press, 2011); and Sara Ahmed, *The Promise of Happiness* (Durham, NC: Duke University Press, 2010).

46. Richard Florida builds on the conception of human capital as central to economic growth of cities by developing his theory of creative capitalism. He argues that creativity plays a critical function as a driver of innovation and growth within cities. Reinforcing the importance of place and geography, he examines how creative persons drive economic growth and represent a particular type of human capital. Creative capitalism encounters a checkered itinerary in the context of India. Dia Da Costa reminds us how creative industries, in particular art and heritage industries, are mobilized to advance a narrative of development while obscuring ethnic and structural violence against minorities and impoverished populations. Da Costa's research offers an important corrective to sanguine accounts of creative capitalism. Dia Da Costa, *Politicizing Creative Economy: Activism and a Hunger Called Theater* (Urbana: University of Illinois Press, 2016); Richard Florida, *The Rise of the Creative Class* (New York: Basic Books, 2014).

47. As Jonathan Crary trenchantly argues, "A 24/7 environment has the semblance of a social world, but it is actually the non-social model of machinic performance and a suspension of living that does not disclose the human cost required to sustain its effectiveness." Jonathan Crary, *24/7: Late Capitalism and the Ends of Sleep* (London: Verso, 2013), 9.

48. Julie Ren defines an artscape as "a conceptual framing characterized by an urge to unsettle." It is encapsulated in the shared importance of criticality. Julie Ren and Jason Luder, eds., *Art and the City: Worlding the Discussion through a Critical Artscape* (New York: Routledge, 2017), 4.

49. See also Nicholas Ridout, *Passionate Amateurs: Theatre, Communism, and Love* (Ann Arbor: University of Michigan Press, 2013), for a consideration of labor and performance in theater.

50. See Jason Burke, "Indian LGBT Activists Outraged as Supreme Court Reinstates Gay Sex Ban," *The Guardian*, December 11, 2013, http://www.theguardian.com/world/2013/dec/11/india-supreme-court-reinstates-gay-sex-ban.

51. See Naisargi Dave, *Queer Activism in India: A Story in the Anthropology of Ethics* (Durham, NC: Duke University Press, 2012), 16.

52. See Victoria Bernal and Inderpal Grewal, "Introduction: The NGO Form: Feminist Struggles, States, and Neoliberalism," in *Theorizing NGOs: States, Feminisms, and Neoliberalisms*, ed. Victoria Bernal and Inderpal Grewal (Durham, NC: Duke University Press, 2014), 4.

Chapter 1

1. Surekha, "Surekha in Conversation with Abhishek Hazra," PDome.org, accessed August 3, 2020, https://pdome.org/2011/three-fragmented-actions-of-silence/. She adds, "Now of course, my community has more or less adjusted itself and is part of an overall urban framework. However, we still have our village fairs, festivals and a variety of rituals and folk performances. Even though I don't believe in these rituals I find them to be a part of my immediate past, as they give you a glimpse into areas of our lives which we are rapidly forgetting."

2. The "joint ventures" between public and private interests sound an alarming note. Both the government and the High Court have allowed Maverick Holdings and Investments, a proven defaulter, to participate in the Economically Weaker Section Quarters joint venture. This forebodes how the city will increasingly be reshaped by the collusive politics of government and capital.

3. Maverick Holdings has a record of deviating from their contract; they have already defaulted for developing into a grand mall (Garuda Mall) the property that was allotted to them (via another Joint Venture Program) to construct a multilevel parking lot. According to Partho Sarathy Ray, under the PPP model "a government agency, transfers the land to a private player, and the private player is then allowed to use most of the land for commercial purposes as long as it allocates a certain portion of it to some public purpose. Sold by the state as a win-win arrangement for both the public and private entities, in reality it just provides a fig leaf of public purpose to the wholesale transfer of public and commons resources to corporations." Partho Sarathi Ray, "From Nonadanga to Ejipura: The Urban Battleground," *Sanhati*, February 23, 2013, http://sanhati.com/excerpted/6074/.

4. In 1996 the Bruhat Bengaluru Mahanagar Palike (BBMP), Bangalore's municipal body, had built 1,512 houses in Ejipura, specifically marked off for the Economically Weaker Section. The houses collapsed after seven years owing to poor construction. The entire area was subsequently demolished and residents began to live in tin sheds.

5. Sanjay Srivastava, *Entangled Urbanism: Slum, Gated Community, and Shopping Mall in Delhi and Gurgaon* (Delhi: Oxford University Press, 2015), xxxviii.

6. Ananya Roy, "The Blockade of the World-Class City," in Roy and Ong, *Worlding Cities*, 269.

7. The state pretends to be weak while deploying ambiguity and uncertainty as strategic modes to facilitate a "territorialized flexibility." Roy cautions us to remain vigilant to the rhetorics of consent the state deploys: "The making of consent," she warns, "be it through the norms of civility and civic virtue or through the hope of factory jobs—remains central to the project of homegrown neoliberalism and its world-class cities." Ibid., 273.

8. Llerena Guiu Searle, *Landscapes of Accumulation: Real Estate and Neoliberalization in Contemporary India* (Chicago: University of Chicago Press, 2016).

9. Khoj, a not-for-profit international arts organization founded in Delhi in 1997, remains a paradigmatic exemplar for cooperative artmaking in India.

10. Moving away from a position that privileges antistate and anti-institutional art activism as the dominant progressive response, Jackson makes a case for the affirmation of "dynamic lateralized series of supporting actions" that recognizes "heteronomy" as sociopolitical and also aesthetic openness to contingency, to experiments in not being privately self-governing. See Jackson, *Social Works*, 29.

11. In the visual arts world, the move away in late nineteenth century from fleshly corporeality of the academic realist oeuvre of Raja Ravi Varma and toward a "spiritual" national aesthetics propagated by the Bengal School suggests a turning away from the body itself. Such a devaluation of the corporeality of the body coincides with emerging transformations in Bharatanatyam among the Adyar group, which consisted of Annie Besant and Margaret Cousins, among others. Moving away from the bodily and sensual pleasures depicted in the Devadasis' erotic Sadir dance, the Adyar group developed a more sanitized and Brahmanical version of Bharatanatyam, which, like the Bengal School, placed emphasis on disavowing the erotic and accentuating the "spiritual" dimensions of aesthetics. See Janaki Nair, "Drawing a Line: K. Venkatappa and His Publics," *Indian Economic and Social History Review* 35, no. 2 (1998). See also Priya Srinivasan, *Sweating Saris: Indian Dance as Transnational Labor* (Philadelphia: Temple University Press, 2012); Davesh Soneji, *Unfinished Gestures: Devadāsīs, Memory, and Modernity in South Asia* (Chicago: University of Chicago Press, 2012), on Bharatanatyam, Sadir, and Devadasi dance.

12. Nair, "Drawing a Line," 189. See also Shukla Sawant, "Instituting Artists' Collectives: The Bangalore/Bengaluru Experiments with 'Solidarity Economies,'" *Journal of Transcultural Studies* 1 (2012).

13. In the words of Shukla Sawant, "Lacking the pragmatic approach required to build the physical and administrative edifice of an institution through bureaucratic governmental channels, he resorted to a hands-on creative method of building a structure in which the bricks were people and the mortar, a way of thinking." See Sawant, "Instituting Artists' Collectives," 140. Hadapad tried to inculcate in his students the need to step back from the objects they were shaping to consider how the objects asserted their own force. He advised a student, "If you recognize the agency that an artwork enjoys, you will see that it has the power to alter you. The viewers will surprise you with their diverse reactions

and make you wonder, 'Did I make this work?' You will be transformed." K. S. Srinivasa Murthy, "An Uncompromising Artist," *Frontline* 20, no. 25 (December 6–19, 2003), https://frontline.thehindu.com/other/obituary/article30220329.ece.

14. Claire Bishop cautions against disavowing frictions in "relational aesthetics" by pointing out that "the relations set up by relational aesthetics are not intrinsically democratic, as Bourriaud suggests, since they rest too comfortably within an ideal of subjectivity as whole and of community as immanent togetherness." Bishop, "Antagonism and Relational Aesthetics," 67.

15. Bourriaud, *Relational Aesthetics*, 42.

16. The project launched on June 22, 2009, and ran for 414 days. Each of the twenty-three artists in the collective was conceived as a "time-share holder" with seventeen days at their disposal to use the space as they chose. As its website states, "Samuha is about self-reliance and self-promotion. . . . Samuha will remain unfunded—this is its conscious decision. It is meant to be something that is owned in the truest and most basic sense by the participating artists. The artists who are part of Samuha are here because they are willing to contribute monetarily and ideologically to it. Being a self-sustaining and self-reliant initiative is key." The artist, then, needs to be financially solvent in order to participate in this endeavor, which automatically excludes some artists. They also rejected offers of infrastructural support from artist collectives in the city such as Bar1, 1 Shanti Road, and the International Institute for Art, Culture and Democracy in order to maintain their autonomy. We can see here that the conception of autonomy permeates these endeavors in complex and heterogeneous ways, both avowing and exceeding neoliberal rationalities. See Samuha Artists' Collective, http://samuha.wikidot.com/vision.

17. Starting as early as 2004 with *Standing on Fish*, a small project involving engaging the public in art on the street, to working on *Bangalore City Project*, which aimed to explore ways people can connect with the city through cultural practices, Archana Prasad has been exploring the connection between art, community, and city for a while now. She initiated an experimental docu-performative sound and video public intervention project called *CitySignals*.

18. See http://maraa.in.

19. See Pamela Lee on Raqs Media Collective and the collective's contribution to the discourse on "the commons" in *Forgetting the Art World* (Cambridge, MA: MIT Press, 2012).

20. The phrase "active economies of dispossession" belongs to Harvey: see David Harvey, "The 'New' Imperialism: Accumulation by Dispossession," *Actuel Marx* 35, no. 1 (2004).

21. See Margaret Jane Radin, *Reinterpreting Property* (Chicago: University of Chicago Press, 1993).

22. Rebecca Schneider and Nicholas Ridout, "Precarity and Performance: An Introduction," *TDR: The Drama Review* 56, no. 4 (2012): 5.

23. Zygmunt Bauman, *Liquid Fear* (Cambridge, UK: Polity, 2006), 2 (italics in original).

24. Ulrich Beck, *The Risk Society: Towards a New Modernity* (London: Sage, 1992); Brian Massumi, "Fear (The Spectrum Said)," *positions: east asia cultures critique* 13, no. 1 (Spring 2005).

25. Ernst Bloch, *The Principle of Hope*, vol. 1, trans. Neville Plaice, Stephen Plaice, and Paul Knight (Cambridge, MA: MIT Press, 1986).

26. Keith Tester, *Panic* (New York: Routledge, 2013), 9. For a more apocalyptic description see Paul Virilio's discussion of the "siege psychosis" in *City of Panic* (New York: Berg, 2005), 86. See also Alan Blum, "Panic and Fear: On the Phenomenology of Desperation" in *The Sociological Quarterly* 37, no. 4 (Autumn 1996,) pp. 673-98.

27. Sheela Gowda, personal communication with the author, January 2013.

28. Nalini S. Malaviya, "A Conversation with Sheela Gowda: Creative Impulse," *Art Etc.*, April 2011, http://www.artnewsnviews.com/view-article.php?article=a-conversation-with-sheela-gowda&iid=19&articleid=455.

29. The sculptures of ash that we see in *Collateral* also draw from Gowda's earlier work with ash such as *Still*, a fragile work that juxtaposes incense ash residues with watercolors in a single horizontal straight column line. It depicts scenes of landscape, portraiture, and old family photographs, offering a gentle and unobtrusive arrangement of memory, kinship, and the passage of time. Gowda comments, "Like the ash, these watercolors were more or less monochrome. I scanned them, printed them out, and then put them under glass. So they are prints of watercolors of photographs of moments, many generations away from the initial moment of viewing. In this sense, the watercolors, like the ash, contain a trace of time." Quote from press release, September 2006, Bose Pacia, http://www.bosepacia.com/exhibitions/2006-09-14_sheela-gowda/press-release/.

30. See Malaviya, "A Conversation with Sheela Gowda."

31. Sheela Gowda quoted in "Collateral Damage: Indian Artist Sheela Gowda Burns Installation in UK Gallery," *Art Radar*, March 9, 2011, http://artradarjournal.com/2011/03/09/collateral-damage-indian-artist-sheela-gowda-burns-installation-in-uk-gallery/.

32. See Caren Kaplan, "Sensing Distance: The Time and Space of Contemporary War," *Social Text Online*, June 17, 2013, https://socialtextjournal.org/periscope_article/sensing-distance-the-time-and-space-of-contemporary-war/.

33. Caren Kaplan, *Aerial Aftermaths: Wartime from Above* (Durham, NC: Duke University Press, 2018).

34. See Jane Bennett, *Vibrant Matter: A Political Ecology of Things* (Durham, NC: Duke University Press, 2010), 10.

35. Here Gowda cites through sculpture the Indo-Persian miniature tradition. Saloni Mathur writes, "Miniature painting in India, a narrative tradition that encompasses both religious and secular storytelling practices while often blurring the lines between them, was itself a unique confluence of Persian, Indian, and European art when it was established in the sixteenth century during the period of Mughal rule in the subcontinent." See Saloni Mathur, "Diasporic Body Double: The Art of the Singh Twins," *Art Journal* 65, no. 2 (Summer 2006): 23.

36. Sheela Gowda quoted in Trevor Smith, "The Specific Labour of Sheela Gowda," *Afterall: A Journal of Art, Context, and Enquiry*, no. 22 (Autumn/Winter 2009): 40.

37. Ibid.

38. See Erika Langmuir, *The Pan Art Dictionary: 1300–1800* (London: Transatlantic, 1989), 252.

39. See Richard Williams, *The Anxious City: British Urbanism in the Late 20th Century* (Abingdon, UK: Routledge, 2004), 25–53.

40. Srivastava, *Entangled Urbanism*, 117.

41. See Richard Sennett, *The Craftsman* (New Haven, CT: Yale University Press, 2008), 215.

42. In a radio program called *Maneya Mathu*, Murthy used the persona of a villager to present a summary of weekly events. Personal communication with Sheela Gowda, January 2013.

43. As Abhishek Hazra puts it, "Alert to the nuances of colloquial Kannada, the dialects of non-urban Kannada and the conversations that circulate across streets, bazaars, devasthanas, and other contemporary public spaces, Murthy's speech is an interesting hybrid of social critique, political analysis and humorous repartee sustained with a lively performative energy." See Abhishek Hazra, "Someplace," in *In the Shade of the Commons: Towards a Culture of Open Networks*, ed. Lipika Bansal, Paul Keller, and Geert Lovink (Amsterdam: Waag Society, 2006), 83.

44. Sheela Gowda, personal communication with the author, January 2013.

45. Other works by Gowda that cite *Darkroom* include *Kagebangara* (2007), in which Gowda uses tar drums alongside yellow and blue plastic tarpaulins to form an abstract sculpture.

46. Malaviya, "A Conversation with Sheela Gowda."

47. Searle, *Landscapes of Accumulation*, 36–37.

48. Sheela Gowda and Trevor Smith, eds., *Sheela Gowda* (Göttingen, Germany: Steidl, 2007), 134.

49. I am grateful to Debashish Banerji for pointing this out to me.

50. Sheela Gowda, personal communication with the author, January 2013.

51. Ibid.

52. On Chonat, see Jaideep Sen, "Slow and Tell: Interview with Krishnaraj Chonat," *Time Out* (Bangalore), February 2010.

53. Ibid.

54. Llerena Searle writes, "Construction costs are only between 20 and 40% of the total project cost. Building contractors make their profits on the labor component through exploitation of cheap migrant labor." Searle, *Landscapes of Accumulation*, 35.

55. Amrit Dhillon, "Routine Abuse of Delhi's Maids Laid Bare as Class Divide Spills into Violence," *The Guardian*, July 21, 2017, https://www.theguardian.com/global-development/2017/jul/21/routine-abuse-delhi-maids-laid-bare-class-divide-violence-mahagun-moderne-india.

56. This recalls his 2006 painting series *Sunshine in Bangalore*, acrylic on black paper, including *East Facing Californian, Just 12 km from Airport*.

57. The green cover of the city has drastically reduced as a result of road widening, buildings, rail construction, and other megacity projects. The expensive timber is allegedly sold off by corrupt government officials who pocket the huge profits, and so continue to mercilessly destroy the city's trees, which include peepal, sandal, teak, and pongamia, trees with large canopies that provide shade and help reduce pollution. The Karnataka Preservation of Trees Act of 1976 made it mandatory for both local people and civic bodies to get permission from the Karnataka Forest Department before felling trees. But the passage of this act has done little to prevent the large-scale felling of trees. The Forest Department seems to have turned a blind eye toward the BBMP's war on the city's trees.

58. Krishnaraj Chonat, "Bengaluru Artists React to Their City" (interview by Lina Vincent Sunish), *Citizen Matters*, June 13, 2011, http://bengaluru .citizenmatters.in/3086-murali-cheeroth-krishnaraj-chonat-clare-arni-venugopal -smriti-mehra-react-to-their-city-3086.

59. Ayodhya is a holy site for both Hindus and Muslims. Hindus regard it as the mythical birthplace of the Hindu god Rama; Muslims believe that Shea, the grandson of Adam, was buried in a cemetery by the River Sarayu in Ayodhya.

60. See Asghar Ali Engineer, seventy-three people were reported dead in the state, and nineteen died in the city of Bangalore in the immediate aftermath of the Babri demolition. See Asghar Ali Engineer, "Bangalore Violence: Linguistic or Communal?," *Economic and Political Weekly* 29, no. 44 (October 29, 1994).

61. In Engineer's words, "In no time the protest against the Urdu telecast on Doordarshan acquired communal overtones and the presence of the BJP at the scene of disturbances could not be missed." Ibid., 2855.

62. Suresh Jayaram, http://www.cfjohn.in/installations-silenceoffuries.htm.

63. Yusuf Arakkal, https://cfjohn.com/selected-media.

64. Aimé Césaire, *Discourse on Colonialism: A Poetics of Anticolonialism* (New York: Monthly Review Press, 1972), 62.

65. M. Shanthamani, "Frozen Phoenix," http://www.shanthamani.com/frozen _phoenix/.

66. See Jane Bennett, *Vibrant Matter*.

67. See Timothy Mitchell, *Carbon Democracy: Political Power in the Age of Oil* (Brooklyn: Verso, 2011).

68. Shanthamani, "Frozen Phoenix," http://www.shanthamani.com/frozen _phoenix/.

69. Quoted in Myriam Morgenstern, "The Carbon Myth," *Art Etc.*, October 2010, http://www.shanthamani.com/frozen_phoenix/.

Chapter 2

1. On Bangalore, see Solomon Benjamin and R. Bhuvaneswari, "Democracy, Inclusive Governance and Poverty in Bangalore" (working paper for the Program in Urban Governance, Partnership and Poverty, University of Birmingham, 2001); Carol Upadhya and A. R. Vasavi, eds., *In an Outpost of the Global Economy: Work and Workers in India's Information Technology Industry* (New Delhi: Routledge, 2008); Smriti Srinivas, *Landscapes of Urban Memory: The Sacred and the Civic in India's High-Tech City* (Minneapolis: University of Minnesota Press, 2001); Tulasi Srinivas, *The Cow in the Elevator: An Anthropology of Wonder* (Durham, NC: Duke University Press, 2018).

2. Janaki Nair, *The Promise of the Metropolis: Bangalore's Twentieth Century* (New Delhi: Oxford University Press, 2005), 26.

3. Quoted in ibid., 23.

4. Kannada is the native language of Karnataka.

5. Quoted in James Heitzman, *Network City: Planning the Information Society in Bangalore* (New Delhi: Oxford University Press, 2004), 61. See also Balaji Parthasarthy, who writes, "Addressing the Bangalore Municipal Corporation in 1962, Jawaharlal Nehru remarked that 'Bangalore . . . is a picture of India of the future, more specifically because of the science, technology and industries in the public sector here.'" Balaji Parthasarthy, "Envisioning the Future in Bangalore,"

Seminar, no. 612 (August 2010), para. 1, http://www.india-seminar.com/2010 /612/612_balaji_parthasarathy.htm.

6. James Heitzman, "Becoming Silicon Valley," *Seminar*, no. 503 (July 2001), http://www.india-seminar.com/2001/503/503%20james%20heitzman.htm.

7. See Benjamin Lewis Rice, "Whitefield," in *Bengaluru, Bengaluru, Bengaluru: Imaginations and Their Times*, ed. Narendar Pani, Sindhu Radhakrishna, and Kishor G. Bhat (New Delhi: Sage, 2010), 90–92.

8. See Krupa Rajangum, "Once an Anglo-Indian Village, Now an Upmarket Suburb," *Citizen Matters*, March 3, 2010, http://bengaluru.citizenmatters.in /1821-about-whitefield-history-1821.

9. I draw from Baudrillard's discussion of simulacra, hyperreality, and the dominance of the sign in late capitalist modernity. For Baudrillard, the hyperreal is the telos of a world that has displaced the stability of material commodities with the value of self-referential signs. See Jean Baudrillard, "Simulacra and Simulation," in *Jean Baudrillard: Selected Writings*, ed. Mark Poster, trans. Jacques Mourrain (Stanford, CA: Stanford University Press, 2002), 169–87.

10. Purnima Mankekar, "Becoming Entrepreneurial Subjects: Neoliberalism and Media," in *The State in India after Liberalization: Interdisciplinary Perspectives*, ed. Akhil Gupta and K. Sivaramakrishnan (New York: Routledge, 2011), 218.

11. Sonali Sathaye, "The Scientific Imperative to Be Positive: Self-Reliance and Success in the Modern World," in *In an Outpost of the Global Economy: Work and Workers in India's Information Technology Industry*, ed. Carol Upadhya and A. R. Vasavi (New Delhi: Routledge, 2008), 156.

12. Savitha Suresh Babu, "Education for Confidence: Political Education for Recasting Bahujan Student Selves," *South Asia: Journal of South Asian Studies* 43, no. 4 (2020) 741–57.

13. David Mosse, "The Modernity of Caste and the Market Economy," *Modern Asian Studies* 54, no. 4 (Cambridge: Cambridge University Press, 2019): 1225–71.

14. Personal interview, Bangalore, 2008.

15. Personal interview, Whitefield, Bangalore, 2008.

16. Personal interview, Whitefield, Bangalore, 2008.

17. Personal interview, Whitefield, Bangalore, 2008.

18. Sudhin Thanawala, "India's Call-Center Jobs Go Begging," *Time*, October 16, 2007, http://content.time.com/time/business/article/0,8599,1671982,00 .html.

19. Lata Mani, "The Phantom of Globality and the Delirium of Excess," *Economic and Political Weekly* 43, no. 39 (September 27, 2008): 41.

20. Lord Macaulay's famous 1835 Minute on Indian Education advocated English as the medium of instruction in colonial India for the specific purpose of constituting a class of English-speaking Indians who would serve as cultural intermediaries between the British and the Indians, the "bilingual natives," who would facilitate the smooth functioning of empire within India. Justifying his position through a rhetorical invocation of the civilizing mission of empire in India, Macaulay declares, "We must at present do our best to form a class of persons Indian in blood and colour but English in tastes, in opinion, in morals, and in intellect." See T. B. Macaulay, "Minute on Indian Education," in

Postcolonialisms: An Anthology of Cultural Theory and Criticism, ed. Gaurav Desai and Supriya Nair (Oxford: Berg, 2005), 124, 130.

21. See Ong, *Neoliberalism as Exception*, 157; and Purnima Mankekar, *Unsettling India: Affect, Temporality, Transnationality* (Durham, NC: Duke University Press, 2015), 199.

22. See Benedict Anderson on unbound seriality, "Nationalism, Identity, and the World-in-Motion," in *Cosmopolitics: Thinking and Feeling beyond the Nation*, ed. Pheng Cheah (Minneapolis: University of Minnesota Press, 1998), 117–33.

23. See Dorothy Rowe, "Cultural Crossings: Performing Race and Transgender in the Work of Moti Roti," *Art History* 26, no. 3 (June 2003): 456–73.

24. "Alladeen," https://www.thebuildersassociation.org/prod_alladeen_info.html.

25. The story of Aladdin (an Anglicization of the Arabic name Al-ad-Din, Arabic: literally "nobility of the faith") is one of the tales of medieval Arabian origin in *The Book of One Thousand and One Nights* (*Arabian Nights*), and one of the most famous, although it was actually added to the collection by Antoine Galland.

26. I draw on Raymond Williams's insight that mediatization in a dramatized society mediates conceptions of selfhood. This work has been richly developed by Stuart Hall. See Stuart Hall, ed., *Representation: Cultural Representations and Signifying Practices* (London: Sage, 1997). See also Mankekar, "Becoming Entrepreneurial Subjects," for details on the training sessions of call center employees in Gurgaon, India.

27. Carol Upadhya, "Management of Culture and Management through Culture in the Indian Software Outsourcing Industry," in *In an Outpost of the Global Economy: Work and Workers in India's Information Technology Industry*, ed. Carol Upadhya and A. R. Vasavi (New Delhi: Routledge, 2008), 128.

28. Margo Jefferson, "On the Other End of the Phone, Workers Stripped of Their Identities," *New York Times*, December 4, 2003, https://www.nytimes.com/2003/12/04/theater/theater-review-other-end-phone-workers-stripped-their-identities.html.

29. Ananya Roy describes the unstable practices of "worlding" as performances of centering, generating, and harnessing global regimes of value, and the production of regimes of truth. See Ananya Roy, "Postcolonial Urbanism: Speed, Hysteria, Mass Dreams," in Roy and Ong, *Worlding Cities*, 307–35.

30. See Homi Bhabha's classic essay "Of Mimicry and Man," in *Location of Culture* (London: Routledge, 1994), 121–31.

31. Jon McKenzie, "The Performative Matrix: Alladeen and Disorientalism," *Performance Research* 13, no. 2 (2008).

32. Jennifer Parker-Starbuck, "Global Friends: The Builders Association at BAM," *PAJ: A Journal of Performance and Art* 77 (2004).

33. On "virtual migration," see A. Aneesh, *Virtual Migration: The Programming of Globalization* (Durham, NC: Duke University Press, 2006).

34. Tina Bastajian, "Some Musings on Iterations and Encounters—Re: Call Cutta(s)," *Artnodes*, no. 8 (2008). She writes, "This pared down iteration, *In A Box*, does not incorporate many plotlines which are woven into the mobile phone theatre script; merging/diverging aspects from Indian and German history,

the re-visiting of public buildings, monuments, getting lost in the city, etc. Yet I still can only hypothesize how one, or rather how I might encounter *Call Cutta* in urban space via a human simulated GPS, which is operated by so-called mutual trust, located thousands of kilometers away. I still feel that I have not fully experienced the work, as the contingency factor *In A Box* was too controlled, I wanted to experience the disorientations that the mobile phone theatre presumably suggests." Ibid., 4.

35. Daniel Wetzel, "Call It *Call Cutta in a Box*" (interview by Barbara Van Lindt), Rimini Protokoll, January 5, 2008, http://www.rimini-protokoll.de /website/en/text/call-it-call-cutta-in-a-box.

36. While located within national borders, SEZs designate a territory where business and trade laws are different than the rest of the country. The primary motivation to designate areas as SEZs is to instigate economic activity by attracting foreign direct investment. By setting up financial policies that enable companies to produce and trade goods at a lower price, SEZs encourage increased investment, job creation, lower taxation, and other special benefits. But as we can see from the examples at Singur and Nandigram, these SEZs often expropriate and wrest away land from already settled, disempowered communities.

37. This description is built on viewing the DVD of the production *Call Cutta in a Box*; it also draws on the reviews and analyses of Tina Bastajian, among others.

38. Aneesh, *Virtual Migration*, 110–11.

39. Ibid., 110.

40. Quoted in Bastajian, "Some Musings on Iterations and Encounters," 3.

41. Wetzel, "Call It *Call Cutta in a Box*."

42. Ibid. Wetzel further argues, "Theatricality is a process between me and the other while I watch him or her or it—in a state of interruption, fascination, openness. . . . I personally experienced both a strong sense of displacement—just plain difference—and moments of surprising closeness."

43. Ashim Ahluwalia, "Filmmaker's Statement," *John and Jane* press kit (Mumbai: Future East Film, 2005), 5, http://www.john-and-jane.com /JohnAndJanePressKit.pdf.

44. Ibid.

45. Ram Ganesh Kamatham, "Dancing on Glass" (unpublished manuscript).

46. See Ravi Sharma, "Murder Most Foul," *Frontline* 22, no. 27 (2006), for a detailed and probing discussion of the incident.

47. See Reena Patel, *Working the Night Shift: Women in India's Call Center Industry* (Stanford, CA: Stanford University Press, 2010). Through a gendered "mobility-morality" paradigm, Patel considers how discourses regarding morality circumscribe women's mobility. She argues that while enabling some women to expand their mobility, the onus of protecting the body of the middle-class woman inadvertently restricts her mobility.

48. See Seema Chishti, "Mangalore Pub Attack," *Indian Express*, February 13, 2009, http://www.indianexpress.com/news/mangalore-pub-attack/422961/0. For a study of the rise of Shiv Sena in the context of religious violence, masculinity, and Mumbai urbanism, see Thomas Blom Hansen, *Wages of Violence: Naming and Identity in Postcolonial Bombay* (Princeton, NJ: Princeton UP, 2001).

49. Joanna Slater, "Call of the West: For India's Youth, New Money Fuels a Revolution; As Foreign Goods, Jobs Flood the Country, Young People are Spurning Tradition; 'Little Gentleman' Loosens Up," *Wall Street Journal*, January 27, 2004, http://search.proquest.com/docview/398866014?accountid=14026.

50. The US Call Center and Consumer Protection Bill, tabled in the US House of Representatives in December 2011, seeks to make companies that move call center jobs abroad ineligible for all federal grants for the next five years. Introduced by Representatives Tim Bishop and David McKinley, it also aims to put stringent mandates on the operations of call centers. See "India BPO Industry Terms US Call Centre Bill 'Protectionist,'" *Business Standard*, December 22, 2011, http://www.business-standard.com/india/news/india-bpo-industry-terms -us-call-centre-bill-protectionist/459381/.

51. Ong, *Neoliberalism as Exception*, 162, 26.

52. Email interview with Ram Ganesh Kamatham.

Chapter 3

1. The exhibition also featured the work of London photographer Anna Fox. Sunil Gupta, a self-identified gay photographer, lives and works in London and New Delhi as a photographer, writer, and curator. Gupta, an Indian-born Canadian photographer, explores migration, sexuality, health/illness, and urban cityscapes. He has been living with AIDS since 1995. He is well aware of the treacherous terrain of sexual identity politics and specifically clarifies that the subjects in his images are self-identified gay/lesbians. He is aware that this demographic does not speak for the vast, heterogeneous field of alternative sexual practices in India, and he talks about how the HIV infection has connected him to his own "Other": the lower-class *kothis* living in the poorer neighborhoods of Delhi.

2. Sunil Gupta and Anna Fox, *Face Up* (Bengaluru: Tasveer Gallery, 2009), 28.

3. Quoted in Himanshu Bhagat, "They Are Just like Us," livemint.com, July 18, 2009, https://www.livemint.com/Leisure/wL1L4Z4ttpaJQiye2XSN1J/They -are-just-like-us.html.

4. See Dennis Altman, "Global Gaze / Global Gays," *GLQ: A Journal of Lesbian and Gay Studies* 3, no. 4 (1997): 417–36; José Muñoz, *Cruising Utopia: The Then and There of Queer Futurity* (New York: New York University Press, 2009).

5. See David Eng's critique of "queer liberalism" as an incarnation of liberal freedom and progress. David Eng, *The Feeling of Kinship: Queer Liberalism and the Racialization of Intimacy* (Durham, NC: Duke University Press, 2010).

6. Section 377 of the IPC is categorized under the subchapter titled "Of Unnatural Offenses" and reads as follows: "Whoever voluntarily has carnal intercourse against the order of nature with any man, woman, or animal shall be punished with imprisonment for life, or with imprisonment of either description for a term which may extend to ten years, and shall also be liable to fine. Explanation: Penetration is sufficient to constitute the carnal intercourse necessary to the offense described in the section." See V. Venkatesan, "Defining Moment," *Frontline*, July 2009, http:// www.frontline.in/static/html/fl2615/stories/20090731261502900.htm.

7. In the constitution of India, Article 14 provides for equality before the law or equal protection within the territory of India; Article 15 guarantees that no citizen will be discriminated against on the basis of religion, race, caste, sex, place

of birth; Article 21 guarantees that no person shall be deprived of their life or personal liberty except according to the procedure established by law.

8. The Naz Foundation India is an NGO founded in 1994 in New Delhi and works actively in the area of HIV prevention, AIDS activism, and sexual health.

9. See Subir Kole, "Globalizing Queer? AIDS, Homophobia and the Politics of Sexual Identity in India," *Global Health* 3, no. 1 (2007), https://www.ncbi.nlm .nih.gov/pmc/articles/PMC2018684/.

10. See ibid. See also David Gisselquist and Mariette Correa, "How Much Does Heterosexual Commercial Sex Contribute to India's HIV Epidemic?," *International Journal of STD and AIDS* 17, no. 11 (2006). Gisselquist and Correa argue that HIV prevention has targeted sexual practices as the primary means of transmitting HIV infection, while ignoring nonsterile medical injections and other risky blood exposures in health care and cosmetic services, which accounts for an important proportion of HIV infection.

11. For a discussion on the imperfect legal basis of arguments for privacy for legal struggles against Section 377, see Ian Miller's superb "The Home and the World: Privacy in the Fight against India's Anti-sodomy Law" (honors thesis, Honors Program in Ethics and Society, Stanford University, 2019).

12. See Kole, "Globalizing Queer?"

13. Lawrence Cohen, "The Kothi Wars: AIDS Cosmopolitanism and the Morality of Classification," in *Sex in Development: Science, Sexuality, and Morality in Global Perspective*, ed. Vincanne Adams and Stacy Leigh Pigg (Durham, NC: Duke University Press, 2005), 271.

14. Kavita Misra, "Politico-moral Transactions in Indian AIDS Service: Confidentiality, Rights and New Modalities of Governance," *Anthropological Quarterly* 79, no. 1 (2006): 38.

15. Quoted in Varuna Verma, "Love and Let Love," *Telegraph* (Calcutta), March 5, 2006, https://www.telegraphindia.com/culture/style/love-and-let-love /cid/1553141.

16. Jacques Derrida, "Signature Event Context," trans. Samuel Weber, in *Limited Inc.*, ed. Gerald Graff (1972; repr., Evanston, IL: Northwestern University Press, 1988); Judith Butler, *Bodies That Matter: On the Discursive Limits of "Sex"* (New York: Routledge, 1993).

17. Butler, *Bodies That Matter*, 23.

18. Ibid., 231.

19. See Nandi Bhatia, "Provincializing English," in "Globalizing Indian English Drama," special issue, *Postcolonial Text* 10, nos. 3–4 (2015).

20. Besides Dattani's plays, many other cultural productions demonstrate the increasing confidence in asserting same-sex desire. For example, in March 2008 a Kannada theater group called Kriya staged a solo-woman adaptation of Ismat Chughtai's infamous Urdu short story, "The Quilt." Chughtai's story eroticizes the relationship between mistress and servant in a manner that evokes the medieval trope of erotic servitude as the normative lens through which love, romance, and desire are articulated both within and outside the formal slave topos. By the eighteenth century, British colonial jurisprudence criminalized same-sex practices. The solo performance piece, directed and performed by Bhavani Prakash, adapted Chughtai's story to "a contemporary sensibility." However, this meant relinquishing the provincial specificity, the local rootedness of the specific lifeworld in

Chughtai's story. The experimental, avant-garde style of the show expunges contextual nuances of the short story and simultaneously universalizes and privatizes this story. By drawing the story into a universalist, liberal-feminist narrative about the "independence" of female sexuality, and foregrounding solipsistic reflexivity rather than the social relationality of same-sex desire, Kriya overwrites Chughtai's radical depiction of the alternative sexualities that are engendered and enjoyed within female publics of nonliberal communities. "The Quilt" ("Lihaaf"), published in 1941, is Ismat Chughtai's infamous short story about same-sex desire, which was banned, then subsequently cleared of obscenity charges. See my review of the play: "Fabric and Fabrication," *The Hindu*, Bengaluru ed., April 1, 2008, http://www.thehindu.com/todays-paper/tp-features/tp-metroplus/Fabric-and-fabrication/article15377452.ece. See also Indrani Chatterjee, *Gender, Slavery and Law in Colonial India* (New Delhi: Oxford University Press, 2002).

21. I'm using the word "obscene" not only to signify its popular meaning of something profoundly improper but also to evoke its folk etymology: *ob-scaenum* means "that which takes place off-stage."

22. Michael Walling, "A Note on the Play: Director's Note for 'Bravely Fought the Queen,'" in *Mahesh Dattani: Collected Plays* (New Delhi: Penguin, 2000), 230.

23. Chandra Mohanty and Biddy Martin, "What's Home Got to Do with It?," in *Feminism without Borders: Decolonizing Theory, Practicing Solidarity*, ed. Chandra Mohanty (Durham, NC: Duke University Press, 2003), 102.

24. Mahesh Dattani, *Do the Needful* (1997), in *Collected Plays*, vol. 1 (New Delhi: Penguin Books, 2000), 152.

25. Ibid., 156.

26. Mahesh Dattani, *On a Muggy Night in Mumbai* (1998), in *Collected Plays*, 1:49.

27. Ibid., 72.

28. Ibid., 70.

29. Ibid., 93.

30. Ibid., 102.

31. Ibid., 103.

32. Eve Sedgwick, "Shame, Theatricality, and Queer Performativity: Henry James's *The Art of the Novel*," in *Touching Feeling: Affect, Pedagogy. Performativity* (Durham, NC: Duke University Press, 2003), 38.

33. Eve Kosofsky Sedgwick and Adam Frank, eds., *Shame and Its Sisters: A Silvan Tomkins Reader* (Durham, NC: Duke University Press, 1995). As Sedgwick and Frank explain, "Shame, as precarious hyperreflexivity of the surface of the body, can turn one inside out—or outside in" (22).

34. Ibid., 136.

35. See also Elspeth Probyn, *Blush: Faces of Shame* (Minneapolis: University of Minnesota Press, 2005).

36. Sedgwick and Frank, *Shame and Its Sisters*, 160.

37. Emmanuel Levinas, *On Escape: De l'évasion*, trans. Bettina Bergo (Stanford, CA: Stanford University Press, 1982), 64.

38. Dattani, *On a Muggy Night in Mumbai*, 101.

39. Ibid., 105.

40. See Tom Boellerstorff, "Dubbing Culture: Indonesian *Gay* and *Lesbi* Subjectivities and Ethnography in an Already Globalized World," *American*

Ethnologist 30, no. 2 (May 2003). Boellerstorff uses the metaphor of "dubbing" to consider how sexual subjectivities in Indonesia hold competing cultural logics together without resolving them into a unitary whole. I thank Kareem Khubchandani for pointing this out to me.

41. Cohen, "The Kothi Wars," 295.

42. *Kothis* are feminized men attracted to other men. They are typically sexually receptive but, unlike hijras, are not castrated. *Panthis* are typically the masculine insertive partners of hijras and *kothis*.

43. Ibid.

44. Paul Boyce, " 'Conceiving *Kothis*': Men Who Have Sex with Men in India and the Cultural Subject of HIV Prevention," *Medical Anthropology* 26, no. 2 (2007): 192.

45. Personal communication with Chandrika (changed name), June 2010. Sangama was founded in 1999 by Elavarthi Manohar.

46. For example, in 2004, three thousand people gathered for a ten-day hunger rally was held to protest the violent gang rape and police complicity in the abuse of Kokila, a twenty-one-year-old hijra.

47. Mahesh Dattani, *Seven Steps around the Fire* (2004), in *Collected Plays*, vol. 2 (New Delhi: Penguin Books, 2005), 253.

48. Ibid., 256.

49. Ibid., 262. Sandeep Bakshi reminds us, "The notion of the community is key to understanding hijra existence, as it is to many marginalized subcultures, which helps them to belong to a hierarchical frame and survive as a 'parallel society.' " See Sandeep Bakshi, "A Comparative Analysis of Hijras and Drag Queens: The Subversive Possibilities and Limits of Parading Effeminacy and Negotiating Masculinity," *Journal of Homosexuality* 46, nos. 3–4 (2004): 213.

50. Dattani, *Seven Steps around the Fire*, 282.

51. Ibid.

52. Gayatri Reddy, *With Respect to Sex: Negotiating Hijra Identity in South India* (Chicago: University of Chicago Press, 2005), 139.

53. Ibid., 141.

54. Mahesh Dattani, *Night Queen* (1998), in *Yaarana: Gay Writing from India*, ed. Hoshang Merchant (New Delhi: Penguin, 1999), 67.

55. Ibid., 69.

56. Living Smile Vidya, *I Am Vidya: A Transgender's Journey* (New Delhi: Rupa, 2013), 136.

57. Ibid., 123.

58. A. Revathi, *The Truth about Me: A Hijra Life Story*, trans. V. Geetha (New Delhi: Penguin, 2009), 238.

59. Ibid.

60. Ibid., 5.

61. A. Revathi, *A Life in Trans Activism*, trans. Nandini Murali (New Delhi: Zubaan, 2016), 121.

62. Rebecca Schneider brilliantly moves us beyond stalled debates around live and recorded by pointing out how the live can itself be a record, and the body can serve as the recording device. See Rebecca Schneider, *Performing Remains: Art and War in Times of Theatrical Reenactment* (New York: Routledge, 2011).

63. Udaya Kumar, *Writing the First Person: Literature, History, and Autobiography in Modern Kerala* (Ranikhet: Permanent Black and Indian Institute of Advanced Study, Shimla, in association with Ashoka University, 2016), 21.

64. Goffman reminds us of the precariousness of social dynamics for stigmatized persons. The "normal" person, whether heterosexual or upper-caste or both, approaches the stigmatized person in full awareness of their marked status and unsure about how to treat them. For Goffman, this dance around the awareness of a power imbalance constitutes "one of the primal scenes of sociology," a scene of "anxious unanchored interaction." See Erving Goffman, *Stigma: Notes on the Management of Spoiled Identity* (New York: Simon and Schuster, 1963).

65. For a discussion of Ulysses and the narrativization of his story, see Adriana Cavarero, *Relating Narratives: Storytelling and Selfhood* (London: Routledge, 2000), 18.

66. Susan Joe Philip, "Being Revathi," *The Hindu*, April 16, 2018, https://www.thehindu.com/entertainment/theatre/in-a-mono-act-a-revathi-gives-a-moving-account-on-what-it-means-to-be-a-transgender/article23559497.ece.

67. Vidya, *I Am Vidya*, 11.

68. Ibid., 12.

69. Ibid., 10–11.

70. Ibid., 29.

71. Ibid., 47.

72. Ibid., 121.

73. See V. Geetha and S. V. Rajadurai, "Neo-Brahminism: An Intentional Fallacy?," *Economic and Political Weekly* 28, nos. 3–4 (January 16–23, 1993): 129–36.

74. Writing specifically about performance of self-confession in the US, Christopher Grobe reminds us, "Confessional performers don't just chronicle the events of their lives; they also dramatize the tension between their inchoate selves and the media they use to try to capture them. Confessionalism, then, amounts to a living critique of autobiography, which confessionalists understand as something stagnant and one dimensional." See Christopher Grobe, *The Art of Confession: The Performance of Self from Robert Lowell to Reality TV* (New York: New York University Press, 2017), 23.

75. Cavarero, *Relating Narratives*, 22 (italics in original).

76. Vidya, *I Am Vidya*, 92.

77. Gee Imaan Semmalar, "Why Trans Movements in India Must Be Anti-caste," Trans.Cafe, December 21, 2016, http://www.trans.cafe/posts/2016/12/12/why-trans-movements-in-india-must-be-anti-caste.

78. Anupama Rao, *The Caste Question: Dalits and the Politics of Modern India* (Berkeley: University of California Press, 2009).

79. See Bhikhu Parekh, "Logic of Humiliation," in *Humiliation: Claims and Contexts*, ed. Gopal Guru (New Delhi: Oxford University Press, 2009), 32. See also Neera Chandhoke, "Equality *for* What? or, The Troublesome Relation between Egalitarianism and Respect," in *Humiliation: Claims and Contexts*, ed. Gopal Guru (New Delhi: Oxford University Press, 2009), 140–62.

80. V. Geetha, "Bereft of Being: The Humiliations of Untouchability," in *Humiliation: Claims and Contexts*, ed. Gopal Guru (New Delhi: Oxford University Press, 2009), 97–98.

Chapter 4

1. In India, many construction projects, whether government-sponsored roadmaking or privately owned building activities are illegally controlled by powerful, often criminal land mafia within these cities. The mafia usually consists of influential businessmen, building contractors, materials suppliers, corrupt public officials, and politicians.

2. Pushpamala N., "The Phantom Lady Strikes! Adventures of the Artist as a Masked Subaltern Heroine in Bombay," *Thesis Eleven* 113, no. 1 (2012): 169.

3. See Neera Chandhoke, "Memory and Narcissism," *The Hindu* (New Delhi), July 27, 2000, https://www.thehindu.com/thehindu/2000/07/27/stories /05272523.htm; and Ashis Nandy, *Regimes of Narcissism, Regimes of Despair* (New Delhi: Oxford University Press, 2013).

4. Jean M. Twenge, *Generation Me: Why Today's Young Americans Are More Confident, Assertive, Entitled—and More Miserable Than Ever Before* (New York: Free Press, 2006); Tom Wolfe, "The 'Me' Decade and the Third Great Awakening," *New York Magazine*, August 23, 1976; Christopher Lasch, *The Culture of Narcissism: American Life in an Age of Diminishing Expectations* (New York: W. W. Norton, 1979).

5. Marshall McLuhan and Bruce R. Powers, *The Global Village: Transformations in World Life and Media in the 21st Century* (New York: Oxford University Press, 1992), 100.

6. Elias Aboujaoude, *Virtually You: The Dangerous Powers of the E-personality* (New York: W. W. Norton, 2012).

7. Amelia Jones's conception of radical narcissism (in Hannah Wilke's work) is still tied to a notion of the "making subject" and an investment in transcending immanence. See Amelia Jones, *Body Art: Performing the Subject* (Minneapolis: University of Minnesota Press, 1998).

8. See Sidonie Smith and Julia Watson, eds., *Interfaces: Women, Autobiography, Image, Performance* (Ann Arbor: University of Michigan Press, 2002).

9. Kaja Silverman, *The Acoustic Mirror: The Female Voice in Psychoanalysis and Cinema* (Bloomington: Indiana University Press, 1988), 154.

10. Ann Pellegrini, *Performance Anxieties: Staging Psychoanalysis, Staging Race* (New York: Routledge, 1997), 169.

11. As Richard Sennett warns, "The emotional structure of the myth is that, when one cannot distinguish between self and other and treats reality as a projection of self, one is in danger. That danger is caught by the metaphor of Narcissus's death: he leans so close to the water mirror, his sense of outside is so taken up by reflection of himself, that the self disappears; it is destroyed." Richard Sennett, "Narcissism and Modern Culture," *October*, no. 4 (Autumn 1977): 70–79.

12. Sigmund Freud, *Civilization and Its Discontents*, trans. Joan Riviere (Mineola, NY: Dover Thrift, 2016), 4.

13. Ibid., 4.

14. See Jose Brunner, "Eichmann, Arendt, and Freud in Jerusalem: On the Evils of Narcissism and the Pleasures of Thoughtlessness," *History and Memory* 8, no. 2 (Fall–Winter 1996): 61–88.

15. Lasch, *The Culture of Narcissism*, 27. Lasch berates the consciousness movements of the 1970s as offering only self-defeating solutions to real personal and social crises. By encouraging people to invest less in love and friendship,

avoid dependence on others, such movements exacerbate the crisis of personal relationships.

16. Christopher Lasch, *The Minimal Self: Psychic Survival in Troubled Times* (New York: W. W. Norton, 1984), 33.

17. Lasch, *The Culture of Narcissism*, 92.

18. Imogen Tyler, "From 'The Me Decade' to 'The Me Millennium': The Cultural History of Narcissism," *International Journal of Cultural Studies* 10, no. 3 (2007): 354.

19. See Twenge, *Generation Me*; and Jean Twenge and Keith Campbell, *The Narcissism Epidemic: Living in the Age of Entitlement* (New York: Atria, 2009).

20. See Jon McKenzie, "Performance and Global Transference," *TDR: The Drama Review* 45, no. 3 (Fall 2001): 5–7, on the importance of Lyotard and Marcuse to understandings of the normative dimensions of performativity.

21. Herbert Marcuse, *Eros and Civilization: A Philosophical Enquiry into Freud* (Boston: Beacon, 1955), 46.

22. Ibid.

23. Ibid., 5.

24. Ibid., 161.

25. Bauman, *Liquid Fear*, 2.

26. For a detailed discussion of the archetypes in *Phantom Lady or Kismet*, and its echoes in *virangana*, Zorro, and *Phantom* comics in cinema and popular culture, see Pushpamala N., "The Phantom Lady Strikes!"

27. Gyan Prakash, ed., *Noir Urbanisms: Dystopic Images of the Modern City* (Princeton, NJ: Princeton University Press, 2010), 13.

28. Mrinalini Sinha has written persuasively about the impact of Katherine Mayo's *Mother India*, a fierce indictment of Indian patriarchal society, which galvanized women's protests against the racist book and stirred a feminist movement in India. "The woman question" was central to ongoing debates about British imperialism as a civilizing mission. The white woman, in this triangulated drama of empire and sexuality, was perceived both as a thorn in the burgeoning friendship between "native" and British men, and as an impediment to the smooth functioning of empire. Rousing sexual desire in the native men who gazed on her virginal whiteness, yet also accused of sterility on entering the tropics, the colonial woman was sexually overdetermined. See Mrinalini Sinha, *Specters of Mother India: The Global Restructuring of an Empire* (Durham, NC: Duke University Press, 2006).

29. See Purnima Mankekar and Louisa Schein, eds., *Media, Erotics, and Transnational Asia* (Durham, NC: Duke University Press, 2013).

30. Pushpamala N., "The Phantom Lady Strikes!"

31. Gaston Bachelard, "Intimate Immensity," in *Visual Sense: A Cultural Reader*, ed. Elizabeth Edwards and Kaushik Bhaumik (London: Bloomsbury Academic, 2008), 442.

32. Ravi Sundaram, *Pirate Modernity: Delhi's Media Urbanism* (New York: Routledge, 2010), 1.

33. See Ranjani Mazumdar, *Bombay Cinema: An Archive of the City* (Minneapolis: University of Minnesota Press, 2007), 86.

34. Craig Owens, "The Medusa Effect, or, The Specular Ruse," *Art in America* 72 (January 1984): 104.

35. Ibid., 198.

36. See Emma Tarlo, *Unsettling Memories: Narratives of the Emergency in Delhi* (Berkeley: University of California Press, 2003), for a discussion on the mass sterilizations in the wake of Emergency in 1973.

37. Madhava Prasad, "The Last Remake of Indian Modernity?," Critical Collective, accessed August 3, 2020, https://criticalcollective.in/ArtistInner2.aspx?Aid=104&Eid=37.

38. Thomas Lemke, "'The Birth of Biopolitics': Michel Foucault's Lecture at the Collège de France on Neo-liberal Governmentality," *Economy and Society* 30, no. 2 (2001): 201.

39. Anthony Giddens refers to ontological security as "a sense of the reliability of persons and things." Giddens uses the concept of "ontological security" to make vivid the sudden awareness of the vulnerability and precariousness of institutionally naturalized "environments of action." These latter are not as trustworthy as their routinized acceptance in everyday social life would have us believe. See Anthony Giddens, *The Birth of Modernity* (Stanford, CA: Stanford University Press, 1990), 92.

40. See http://www.pushpamala.com/projects/the-return-of-the-phantom-lady-sinful-city-2012-a-photo-romance/, accessed March 4, 2021.

41. First built in 1977, the drive-in theater witnessed a steady decline in audience attendance. The Mumbai Metropolitan Region Development Authority recently approved the redevelopment plan, which includes shopping malls, and a downsized drive-in theater on land owned by the state government.

42. In 2010 a city civil court dismissed an appeal filed by the owners of the Bharatmata Theatre in central Mumbai, challenging the eviction notice issued against them in 2002 by the National Textile Corporation. The theater, which is over seventy years old and shows only Marathi movies, had approached the court in September 2002 appealing against an eviction notice issued by the National Textile Corporation (NTC) the same year. Bharatmata is located on the land owned by NTC in Lalbaug and the corporation has been asking for it back. NTC has been arguing that it had given the land on lease to the theater seventy-two years ago and now wants the theater to move out.

43. Pushpamala N., personal interview, January 2013.

44. The theater is a popular hub for Marathi moviegoers and has screened all of Dada Kondke's films. *Maher chi Saadi* was among the films that witnessed a silver jubilee there.

45. Sundaram, *Pirate Modernity*, 72.

46. Lee Edelman, *No Future: Queer Theory and the Death Drive* (Durham, NC: Duke University Press, 2004), 2. As he puts it, "The child remains the perpetual horizon of every acknowledged politics, the fantasmatic beneficiary of every political intervention" (3).

Chapter 5

1. Vinay Gidwani, "Remaindered Things and Remaindered Lives: Traveling with Delhi's Waste," in *Finding Delhi: Loss and Renewal in the Megacity*, ed. Bharati Chaturvedi (Delhi: Penguin Books, 2009), 44–45.

2. Sambrani comments, "Not only are the materials loaded with their previous lives as consumer disposables in an economy premised on disposability, they

have also been reformatted to match a subservient—and subversive—economy of reuse and salvage." Chaitanya Sambrani, "Tracking Trash: Vivan Sundaram and the Turbulent Core of Modernity," in *Trash* (exhibition catalogue) (Mumbai, India: Chemould Gallery, 2008), 9.

3. Saloni Mathur, "On Vivan Sundaram, *Trash* (2005–8)," in *Critical Landscapes: Art, Space, Politics*, ed. Emily Eliza Scott and Kirsten Swenson (Oakland: University of California Press, 2015), 255.

4. See Dipesh Chakrabarty, "Of Garbage, Modernity, and the Citizen's Gaze," in *Economic and Political Weekly* 27, nos. 10/11 (1992): 541–47.

5. Katherine Boo, *Behind the Beautiful Forevers: Life, Death, and Hope in a Mumbai Undercity* (New York: Random House, 2012).

6. Ibid., xx.

7. David Hare, *Behind the Beautiful Forevers: A Play* (London: Faber and Faber, 2014).

8. Akhileshwari Reddy, "A Law for Waste Pickers," *Down to Earth*, April 12, 2018, https://www.downtoearth.org.in/news/waste/a-law-for-waste-pickers -60103.

9. On their website (accessed May 2, 2019, http://www.chintan-india.org), Chintan reminds us that "most Indian cities are run on the work of the informal sector, which includes the 1% of an average city's population who recycle waste and reduce pressure on the environment. Their work helps clean up our cities by recycling approximately 20% of the waste generated. And yet, recyclers lack formal recognition, equal rights, secure and safe livelihoods and dignity. And as consumption patterns change with a growing economy, their work exposes them to ever higher levels of pollution and dangerous toxins."

10. Chintan critiques how waste pickers are considered subhuman and suggests that their middle-class activism may confer a sense of dignity and personhood on a professional group that is currently denied humanity.

11. See Akhileshwari Reddy, "A Law for Waste Pickers."

12. See Assa Doron and Robin Jeffrey, *Waste of a Nation: Garbage and Growth in India* (Cambridge, MA: Harvard University Press, 2018), 43.

13. Vinay Gidwani, *Capital, Interrupted: Agrarian Development and the Politics of Work in India* (Minneapolis: University of Minnesota Press, 2008), 88.

14. While such spectacular practices may suggest an investment in environment-friendly policies, the turn to brazen authoritarianism is evident in the arrest of Disha Ravi, a twenty-two-year-old climate activist from Bangalore, who, in solidarity with Greta Thunberg, started Fridays for Future India. She was charged with sedition and criminal conspiracy for the crime of producing a toolkit that offers information and suggestions on how to support the ongoing farmers' protests in India.

15. Michel Foucault, *"Society Must Be Defended": Lectures at the Collège de France, 1975–76*, trans. David Macey (New York: Picador, 1997), 247.

16. Michel Foucault, *The History of Sexuality*, vol. 1: *An Introduction*, trans. Robert Hurley (New York: Vintage Books, 1990), 136.

17. Foucault, *"Society Must Be Defended,"* 242.

18. See "Furor on Memo at World Bank," *New York Times*, February 7, 1992, http://www.nytimes.com/1992/02/07/business/furor-on-memo-at-world-bank .html.

19. Summers goes on to forward his impeccable neoliberal logic for the right to pollute the third world thus, "The concern over an agent that causes a one in a million change in the odds of prostrate [*sic*] cancer is obviously going to be much higher in a country where people survive to get prostrate [*sic*] cancer than in a country where under 5 mortality is 200 per thousand." Quoted in Basil Enwegbara, "Toxic Colonialism," *The Tech* (MIT) 121, no. 16 (April 6, 2011), http://tech.mit.edu/V121/N16/col16guest.16c.html.

20. In Agamben's words, "The sovereign sphere is the sphere in which it is permitted to kill without committing homicide and without celebrating the sacrifice, and sacred life—that is, life that may be killed but not sacrificed—is the life that has been captured in this sphere. . . . What is captured in the sovereign ban is a human victim who may be killed but not sacrificed: homo sacer." Giorgio Agamben, *Homo Sacer: Sovereign Power and Bare Life* (Stanford, CA: Stanford University Press, 1995), 83.

21. Zygmunt Bauman, *Wasted Lives: Modernity and Its Outcasts* (Cambridge, UK: Polity, 2003), 28.

22. Vinay Gidwani traces how capital continuously draws its economic vitality and moral sanction from programs to eradicate waste. For Gidwani, waste is "the specter that haunts the modern notion of 'value,' which itself operates in two entangled registers: first, 'value' as the economic coding and logic of wealth in capitalist society . . . ; second, 'value' as a normative or moral template for conduct." Vinay Gidwani, "Waste/Value," in *The Wiley-Blackwell Companion to Economic Geography*, ed. Trevor J. Barnes, Jamie Peck, and Eric Sheppard (Malden, MA: Wiley Blackwell, 2000), 278.

23. Akhil Gupta, *Red Tape*, 5.

24. See Shilpa Kaza, Liza Yao, Perinaz Bhada-Tata, and Frank Van Woerden, *What a Waste 2.0: A Global Snapshot of Solid Waste Management to 2050* (Washington, DC: World Bank Group, 2018), https://openknowledge.worldbank.org/handle/10986/30317.

25. Sean Gallager, "India: The Rising Tide of E-waste," Pulitzer Center, January 16, 2014, https://pulitzercenter.org/reporting/india-rising-tide-e-waste.

26. See David Pellow, "Transnational Alliances and Global Politics: New Geographies of Environmental Justice Struggles," in *In the Nature of Cities: Urban Political Ecology and the Politics of Urban Metabolism*, ed. Nik Heynen, Maria Kaika, and Erik Swyngedouw (New York: Routledge, 2006), 233.

27. Lead, beryllium, mercury, cadmium, volatile organic compounds, and brominated flameproofing agent pose major occupational and environment hazards.

28. About 315 million computers that became obsolete between 1997 and 2004 contained more than 1.2 billion pounds of lead. Pellow, "Transnational Alliances and Global Politics," 187.

29. The lead damages central and peripheral nervous system, blood systems, and kidneys in humans. It accumulates in the environment and has acute toxic effects, especially for children, as lead poisoning causes developmental disorders.

30. Quoted in Pellow, "Transnational Alliances and Global Politics," 191.

31. See Doron and Jeffrey, *Waste of a Nation*, 64. According to them, "A report in 2011 estimated India was dealing with 400,000 metric tons of e-waste a year, with annual growth estimated at 10 to 15%. By 2014, e-waste was estimated at between 1.5 and 1.7 million metric tons" (63).

32. Miles Park, "Electronic Waste Is Recycled in Appalling Conditions in India," *The Conversation*, February 14, 2019, https://theconversation.com /electronic-waste-is-recycled-in-appalling-conditions-in-india-110363.

33. See Dinesh Raj Bandela, "E-waste Day: 82% of India's E-waste Is Personal Devices," *Down to Earth*, October 15, 2018, https://www.downtoearth.org.in /blog/waste/e-waste-day-82-of-india-s-e-waste-is-personal-devices-61880.

34. Doron and Jeffrey interviewed e-waste recyclers in Moradabad in India who described the process of basic dismantling and separation followed by different methods of extraction, which included burning, grinding, washing, and bathing in acid. Doron and Jeffrey, *Waste of a Nation*, 125.

35. K. S. Sudhakar of Toxics Link points out that shipments of electronic waste are mislabeled "metal scrap" to get these illegal substances past the authorities and through loopholes in the Basel Convention. Quoted in Pellow, "Transnational Alliances and Global Politics," 199.

36. Jennifer Robinson, "Living in Dystopia: Past, Present, and Future in Contemporary African Cities," in *Noir Urbanisms: Dystopic Images of the Modern City*, ed. Gyan Prakash (Princeton, NJ: Princeton University Press, 2010), 218–19.

37. Bauman, *Wasted Lives*.

38. See Rob Nixon, *Slow Violence and the Environmentalism of the Poor* (Cambridge, MA: Harvard University Press, 2011).

39. Walter Benjamin, "Theses on the Philosophy of History," in *Illuminations: Essays and Reflections* (New York: Harcourt, Brace, and World, 1968), 257.

40. See Sen, "Slow and Tell."

41. Ibid.

42. R. Dhanya, "Review: Post Oil City—Bangalore Gardens Reloaded," *Art and Deal*, accessed December 8, 2017, http://artanddeal.in/cms/?p=1001.

43. Harvey, "The 'New' Imperialism."

44. P. Sainath describes this as "the desperate search for work driving poorer people in many directions without a clear final destination. Like Oriya migrants driven to work in various regions: some weeks in Raipur, then a couple of months at brick kilns in Andhra Pradesh, then at construction sites in diverse towns in Maharashtra." See P. Sainath, "Census Findings Point to Decade of Rural Distress," *The Hindu* (Mumbai ed.), September 25, 2011, http://www.thehindu .com/opinion/columns/sainath/census-findings-point-to-decade-of-rural-distress /article2484996.ece.

45. The male workforce in agriculture has collapsed in thousands of villages, falling to less than a quarter of all workers. A village or other unit is declared a census town when its population crosses five thousand; when the number of male workers in agriculture falls to less than 25 percent of the total; and where population density is at least four hundred people per square kilometer. Between 1991 and 2001, the number of census towns actually declined, from 1,702 to 1,361. By the 2011 census, they had nearly tripled, to 3,894.

46. P. Sainath, "In India Farmers Face a Terrifying Crisis," *New York Times*, April 13, 2018, https://www.nytimes.com/2018/04/13/opinion/india-farmers-crisis.html.

47. P. Sainath, "In 16 Years, Farm Suicides Cross a Quarter Million," *The Hindu*, October 29, 2011, https://www.thehindu.com/opinion/columns/sainath /In-16-years-farm-suicides-cross-a-quarter-million/article12892373.ece; Sainath, "In India Farmers Face a Terrifying Crisis."

48. Akhil Gupta, "Farming as a Speculative Activity: The Ecological Basis of Farmers' Suicides in India," in *The Routledge Companion to the Environmental Humanities*, ed. Ursula Heise, Jon Christensen, and Michelle Niemann (New York: Routledge, 2017), 185–93.

49. Nixon, *Slow Violence*, 2–3.

50. Ibid., 19.

51. See Elizabeth Povinelli, *Economies of Abandonment: Social Belonging and Endurance in Late Liberalism* (Durham, NC: Duke University Press, 2011).

52. See Amita Baviskar on "bourgeois environmentalism." Baviskar, "The Politics of the City."

53. Bauman, *Wasted Lives*, 39.

54. See Surekha, *Romeos and Juliets*. See http://surekhainfo.com/videos-2/, accessed March 7, 2021.

55. Pointing to zones of abandonment, João Biehl argues that the production of social death alters and reconfigures relations between state and families. As Biehl notes in his moving ethnography, *Vita*, "As citizenship is increasingly articulated in the register of consumer culture, what happens to those persons who are deemed non-market-able?" See João Biehl, *Vita: Life in a Zone of Social Abandonment* (Berkeley: University of California Press, 2005), 21.

56. Sudipta Kaviraj, "Filth and the Public Sphere: Concepts and Practices about Spaces in Calcutta," *Public Culture* 10, no. 1 (Fall 1997): 106.

57. Lata Mani, *SacredSecular: A Contemplative Critique* (New Delhi: Routledge, 2009), 103.

58. "Two-thirds of the world may not have access to the latest smartphone, but local electronic shops are adept at fixing older tech using low-cost parts. Vinay Venkatraman explains his work in 'technology crafts,' through which a mobile phone, a lunchbox and a flashlight can become a digital projector for a village school, or an alarm clock and a mouse can be melded into a medical device for local triage." Surekha, *Re-source* (2009–2010). See http://surekhainfo.com/videos-2/, accessed March 7, 2021.

Epilogue

1. In his ethnography of consumer advertising in India, William Mazzarella develops the concept of "close distance" to make sense of how advertisements libidinally assemble consumer subjectivity. In his words, "The mystique associated with these goods depended on their capacity to serve as physical embodiments of a source of value that was understood to reside *elsewhere*. This elsewhere might in shorthand be called 'the West,' but in fact it was conceived as at once concrete and abstract, as a real place *and* as a mythical location. The de facto magic of the goods was that they provided concrete, *present* evidence of this absent source, as conjured in advertising. Auratic in Walter Benjamin's sense, at hand, tactile, yet transcendentally irradiated, these brands reverberated with what one might call a kind of 'close distance.'" William Mazzarella, *Shoveling Smoke: Advertising and Globalization in Contemporary India* (Durham, NC: Duke University Press, 2003), 256.

2. While Ravikumar Kashi earned his degree at the College of Fine Art in Bangalore, he was immersed in the arts practice methodologies at both the informal, improvisational, and collaborative style of the Ken School of Art and the more

formal state-run Chitra Kala Parishad. After completing his MFA in printmaking from Maharaja Sayajirao University, Baroda, Kashi pursued a master's in English from Mysore University. He is the author of two Kannada books on Indian art, *Anukta* and *Kannele*, for which he received the Karnataka Sahitya Kala Akademi Award in 2015. He subsequently received a fellowship to study papermaking at the School of Glasgow. An experimental and intermedial artist, Kashi has worked with a range of materials including graphics, glass, canvas, and most innovatively with paper. Kashi's oeuvre extends beyond paintings to paper sculptures as well. In works that are made from paper pulp and cotton, banana, straw, Kashi creates artist books, cast in paper to suggest a personal journal. The images within these journals document a series of texts and found images in a stream-of-consciousness style. Kashi procures images from magazines or the internet, and then through chemical process transfers the carbon in the image to his "book." He then transfers the images onto the pulp, then draws and paints over the mold. It is through a highly tactile process that Kashi renders his intermedial artist books, bringing together painting and books to provide a critique of the spectacular consumption practices he sees unfolding in the Indian metropolis today. The book is held on a stand, imbuing it with an almost reverential aura, as if the thing had an agential power of its own. He carries out this intermediatic work for a range of television sets made of pulp, on which he paints images from popular cinema and television dramas. In an iconic sculptural artwork, "Thousand Desires," Kashi creates out of pulp thousand tongues—red, glossy, lascivious—and mounts each one individually on the wall. The 6.5-foot-tall sculpture suggests the rapaciousness of desire but also its material fragility.

3. See Ahmed, *The Promise of Happiness*.

4. Berlant, *Cruel Optimism*.

5. Asher Ghertner, *Rule by Aesthetics: World Class City Making in Delhi* (Oxford: Oxford University Press, 2015).

6. While Kant championed the formation of autonomous subjects, he was concerned about means and ends, or instrumentalist ways of thinking about people or art. Always a champion of purposiveness, Kant urges us to become autonomous in ways that reject instrumentality but embrace purposiveness. Increasingly, though, we have come to conflate purposiveness with instrumentality.

7. I am indebted to Raymond Williams, whose methodology of cultural materialism organizes and animates this book. Other influential scholars working on feelings in the capitalist marketplace include Erving Goffman, Arlie Hochschild, Nigel Thrift, Lauren Berlant, and Sara Ahmed.

Aboujaoude, Elias. *Virtually You: The Dangerous Powers of the E-personality.* New York: W. W. Norton, 2012.

Adjania, Nancy. "Globalism before Globalization: The Ambivalent Fate of Triennale India." In *Western Artists and India: Creative Inspirations in Art and Design,* edited by Shanay Jhaveri, 168–85. Mumbai: Shoestring, 2013.

Agamben, Giorgio. *Homo Sacer: Sovereign Power and Bare Life.* Stanford, CA: Stanford University Press, 1995.

Ahmed, Sara. *The Promise of Happiness.* Durham, NC: Duke University Press, 2010.

Albee, Edward. *Who's Afraid of Virginia Woolf?* New York: Signet, 1983.

Altman, Dennis. "Global Gaze / Global Gays." *GLQ: A Journal of Lesbian and Gay Studies* 3, no. 4 (1997): 417–36.

Anderson, Benedict. "Nationalism, Identity, and the World-in-Motion." In *Cosmopolitics: Thinking and Feeling beyond the Nation,* edited by Pheng Cheah, 117–33. Minneapolis: University of Minnesota Press, 1998.

Aneesh, A. *Virtual Migration: The Programming of Globalization.* Durham, NC: Duke University Press, 2006.

Appiah, Anthony. *In My Father's House.* New York: Oxford University Press, 1992.

Babu, Savitha Suresh. "Education for Confidence: Political Education for Recasting Bahujan Student Selves." *South Asia: Journal of South Asian Studies* 43, no. 4, (2020): 741–57.

Bachelard, Gaston. "Intimate Immensity." In *Visual Sense: A Cultural Reader,* edited by Elizabeth Edwards and Kaushik Bhaumik, 441–45. London: Bloomsbury Academic, 2008.

Bakshi, Sandeep. "A Comparative Analysis of Hijras and Drag Queens: The Subversive Possibilities and Limits of Parading Effeminacy and Negotiating Masculinity." *Journal of Homosexuality* 46, nos. 3–4 (2004): 211–23.

Bandela, Dinesh Raj. "E-waste Day: 82% of India's E-waste Is Personal Devices." *Down to Earth,* October 15, 2018. https://www.downtoearth.org.in/blog /waste/e-waste-day-82-of-india-s-e-waste-is-personal-devices-61880.

Bastajian, Tina. "Some Musings on Iterations and Encounters—Re: Call Cutta(s)." *Artnodes,* no. 8 (2008): 1–7.

Baudrillard, Jean. "Simulacra and Simulation." In *Jean Baudrillard: Selected Writings,* edited by Mark Poster, translated by Jacques Mourrain, 169–87. Stanford, CA: Stanford University Press, 2002.

Bauman, Zygmunt. *Liquid Fear.* Cambridge, UK: Polity, 2006.

———. *Wasted Lives: Modernity and Its Outcasts.* Cambridge, UK: Polity, 2003.

Baviskar, Amita. "The Politics of the City." *Seminar*, no. 516 (August 2002). http://www.india-seminar.com/2002/516/516%20amita%20baviskar.htm.

Beck, Ulrich. *The Risk Society: Towards a New Modernity*. London: Sage, 1992.

Benjamin, Solomon, and R. Bhuvaneswari. "Democracy, Inclusive Governance and Poverty in Bangalore." Working paper for the Program in Urban Governance, Partnership and Poverty, University of Birmingham, 2001.

Benjamin, Walter. "Theses on the Philosophy of History." In *Illuminations: Essays and Reflections*, 253–64. New York: Harcourt, Brace, and World, 1968.

Bennett, Jane. *Vibrant Matter: A Political Ecology of Things*. Durham, NC: Duke University Press, 2010.

Bennett, Susan. "China's Global Performatives: 'Better City, Better Life.'" In *Performance and the Global City*, edited by D. J. Hopkins and Kim Solga, 78–96. London: Palgrave Macmillan, 2013.

Berlant, Lauren. *Cruel Optimism*. Durham, NC: Duke University Press, 2011.

Bernal, Victoria, and Inderpal Grewal. "Introduction: The NGO Form: Feminist Struggles, States, and Neoliberalism." In *Theorizing NGOs: States, Feminisms, and Neoliberalisms*, edited by Victoria Bernal and Inderpal Grewal, 1–18. Durham, NC: Duke University Press, 2014.

Bhabha, Homi. *Location of Culture*. London: Routledge, 1994.

Bhagat, Himanshu. "They Are Just like Us." livemint.com, July 18, 2009. http://www.livemint.com/2009/07/16211415/They-are-just-like-us.html.

Bharucha, Rustom. "Ninasam: A Cultural Alternative." *Economic and Political Weekly* 25, no. 26 (June 1990): 1404–11.

Bhatia, Nandi. "Provincializing English." In "Globalizing Indian English Drama," special issue, *Postcolonial Text* 10, nos. 3–4 (2015): 1–15.

Biehl, João. *Vita: Life in a Zone of Social Abandonment*. Berkeley: University of California Press, 2005.

Bishop, Claire. "Antagonism and Relational Aesthetics." *October*, no. 110 (October 2004): 51–79.

Bloch, Ernst. *The Principle of Hope*. Vol. 1. Translated by Neville Plaice, Stephen Plaice, and Paul Knight. Cambridge, MA: MIT Press, 1986.

Blum, Alan. "Panic and Fear: On the Phenomenology of Desperation." *The Sociological Quarterly* 37, no. 4 (1996): 673–98.

Boellerstorff, Tom. "Dubbing Culture: Indonesian Gay and Lesbi Subjectivities and Ethnography in an Already Globalized World." *American Ethnologist* 30, no. 2 (2003): 225–42.

Boo, Katherine. *Behind the Beautiful Forevers: Life, Death, and Hope in a Mumbai Undercity*. New York: Random House, 2012.

Bourdieu, Pierre. *Distinction: A Social Critique of the Judgement of Taste*. Translated by Richard Nice. 1984. Repr., New York: Routledge, 2010.

Bourriaud, Nicolas. *Relational Aesthetics*. Translated by Simon Pleasance and Fronza Woods with M. Copeland. Dijon: Les presses du réel, 2002.

Boyce, Paul. "'Conceiving Kothis': Men Who Have Sex with Men in India and the Cultural Subject of HIV Prevention." *Medical Anthropology* 26, no. 2 (2007): 175–203.

Boym, Svetlana. *The Future of Nostalgia*. New York: Basic Books, 2001.

Brown, Wendy. *Edgework: Critical Essays on Knowledge and Politics*. Princeton, NJ: Princeton University Press, 2005.

———. *Undoing the Demos: Neoliberalism's Stealth Revolution*. New York: Zone Books, 2015.

Brunner, Jose. "Eichmann, Arendt, and Freud in Jerusalem: On the Evils of Narcissism and the Pleasures of Thoughtlessness." *History and Memory* 8, no. 2 (Fall–Winter 1996): 61–88.

Burke, Jason. "Indian LGBT Activists Outraged as Supreme Court Reinstates Gay Sex Ban." *The Guardian*, December 11, 2013. http://www.theguardian .com/world/2013/dec/11/india-supreme-court-reinstates-gay-sex-ban.

Butler, Judith. *Bodies That Matter: On the Discursive Limits of "Sex."* New York: Routledge, 1993.

———. *Gender Trouble: Feminism and the Subversion of Identity*. New York: Routledge, 1990.

Calhoun, Craig. "The Class-Consciousness of Frequent Travellers: Towards a Critique of Actually Existing Cosmopolitanism." In *Conceiving Cosmopolitanism: Theory, Context, and Practice*, edited by Steven Vertovec and Robin Cohen, 86–109. Oxford: Oxford University Press, 2003.

Callard, Agnes. *Aspiration: The Agency of Becoming*. Oxford: Oxford University Press, 2018.

Canclini, Nestor García. *Art beyond Itself: Anthropology for Society without a Story Line*. Translated by David Frye. Durham, NC: Duke University Press, 2014.

Castells, Manuel. *The Rise of the Network Society*. Malden, MA: Blackwell, 1998.

Cavarero, Adriana. *Relating Narratives: Storytelling and Selfhood*. London: Routledge, 2000.

Césaire, Aimé. *Discourse on Colonialism: A Poetics of Anticolonialism*. New York: Monthly Review Press, 1972.

Chakrabarty, Dipesh. "Of Garbage, Modernity, and the Citizen's Gaze." *Economic and Political Weekly* 27, nos. 10/11 (1992): 541–47.

Chandhoke, Neera. "Equality *for* What? or, The Troublesome Relation between Egalitarianism and Respect." In *Humiliation: Claims and Contexts*, edited by Gopal Guru, 140–62. New Delhi: Oxford University Press, 2009.

———. "Memory and Narcissism." *The Hindu* (New Delhi), July 27, 2000. http://www.thehindu.com/2000/07/27/stories/05272523.htm.

Chatterjee, Indrani. *Gender, Slavery and Law in Colonial India*. New Delhi: Oxford University Press, 2002.

Chishti, Seema. "Mangalore Pub Attack." *Indian Express*, February 13, 2009.

Chonat, Krishnaraj. "Bengaluru Artists React to Their City." Interview by Lina Vincent Sunish. *Citizen Matters*, June 13, 2011. http://bengaluru.citizenmatters .in/3086-murali-cheeroth-krishnaraj-chonat-clare-arni-venugopal-smriti -mehra-react-to-their-city-3086.

———. "My Hands Smell of You." *Galleryske*, accessed December 8, 2017. http:// www.galleryske.com/KrishnarajChonat/myhandssmells/myhandstext.html.

Chughtai, Ismat. *The Quilt and Other Stories*. 3rd ed. Translated by Tahira Naqvi and Syeda S. Hameed. New Delhi: Kali for Women, 1996.

Cohen, Lawrence. "The Kothi Wars: AIDS Cosmopolitanism and the Morality of Classification." In *Sex in Development: Science, Sexuality, and Morality in Global Perspective*, edited by Vincanne Adams and Stacy Leigh Pigg, 269–304. Durham, NC: Duke University Press, 2005.

"Collateral Damage: Indian Artist Sheela Gowda Burns Installation in UK Gallery." *Art Radar*, March 9, 2011. http://artradarjournal.com/2011/03 /09/collateral-damage-indian-artist-sheela-gowda-burns-installation-in-uk -gallery/.

Comaroff, Jean, and John Comaroff, eds. *Millennial Capitalism and the Culture of Neoliberalism*. Durham, NC: Duke University Press, 2001.

Crary, Jonathan. *24/7: Late Capitalism and the Ends of Sleep*. London: Verso, 2013.

Da Costa, Dia. *Politicizing Creative Economy: Activism and a Hunger Called Theater*. Urbana: University of Illinois Press, 2016.

Dattani, Mahesh. *Bravely Fought the Queen*. 1991. In *Collected Plays*.

———. *Collected Plays*. New Delhi: Penguin Books, 2000.

———. *Collected Plays*. Vol. 2. New Delhi: Penguin Books, 2005.

———. *Dance like a Man*. 1989. In *Collected Plays*.

———. *Do the Needful*. 1997. In *Collected Plays*.

———. *Final Solutions*. 1993. In *Collected Plays*.

———. *Night Queen*. *Yaarana: Gay Writing from India*. 1998. Edited by Hoshang Merchant. New Delhi: Penguin, 1999.

———. *On a Muggy Night in Mumbai*. 1998. In *Collected Plays*.

———. *Seven Steps around the Fire*. 2004. In *Collected Plays*, vol. 2.

———. *Tara*. New Delhi: Ravi Dayal, 1990.

Dave, Naisargi. *Queer Activism in India: A Story in the Anthropology of Ethics*. Durham, NC: Duke University Press, 2012.

Davis, Mike. *Planet of Slums*. New York: Verso, 2006.

De, Aditi. "Art: Gestures Speak. An Essay on M. Shanthamani's Art." *Mulled Ink*, 2007. http://mulledink.blogspot.com/2012/04/gestures-speak-essay-on -m-shanthamanis.html.

Derrida, Jacques. "Signature Event Context." Translated by Samuel Weber. In *Limited Inc.*, edited by Gerald Graff. 1972. Repr., Evanston, IL: Northwestern University Press, 1988.

Deshpande, Sudhanva. "'The Inexhaustible Work of Criticism in Action': Street Theatre of the Left." *Seagull Theatre Quarterly*, no. 16 (1997): 2–21.

Dhanya, R. "Review: Post Oil City—Bangalore Gardens Reloaded." *Art and Deal*, accessed December 8, 2017. http://artanddeal.in/cms/?p=1001.

Dhillon, Amrit. "Routine Abuse of Delhi's Maids Laid Bare as Class Divide Spills into Violence." *The Guardian*, July 21, 2017. https://www.theguardian.com /global-development/2017/jul/21/routine-abuse-delhi-maids-laid-bare-class -divide-violence-mahagun-moderne-india.

Doron, Assa, and Robin Jeffrey. *Waste of a Nation: Garbage and Growth in India*. Cambridge, MA: Harvard University Press, 2018.

Edelman, Lee. *No Future: Queer Theory and the Death Drive*. Durham, NC: Duke University Press, 2004.

Eng, David. *The Feeling of Kinship: Queer Liberalism and the Racialization of Intimacy*. Durham, NC: Duke University Press, 2010.

Engineer, Asghar Ali. "Bangalore Violence: Linguistic or Communal?" *Economic and Political Weekly* 29, no. 44 (October 29, 1994): 2854–55, 2858.

Enwegbara, Basil. "Toxic Colonialism." *The Tech* (MIT) 121, no. 16 (April 6, 2011). http://tech.mit.edu/V121/N16/col16guest.16c.html.

Felman, Shoshana. "Education and Crisis, or the Vicissitudes of Teaching." In *Testimony: Crises of Witnessing in Literature, Psychoanalysis, and History*, edited by Shoshana Felman and Dori Laub, 1–56. New York: Routledge, 1992.

Florida, Richard. *The Rise of the Creative Class*. New York: Basic Books, 2014.

Foucault, Michel. *The History of Sexuality*, vol. 1: *An Introduction*. Translated by Robert Hurley. New York: Vintage Books, 1990.

———. *"Society Must Be Defended": Lectures at the Collège de France, 1975–76*. Translated by David Macey. New York: Picador, 1997.

Freud, Sigmund. *Civilization and Its Discontents*. Translated by Joan Riviere. Mineola, NY: Dover Thrift, 2016.

"Furor on Memo at World Bank." *New York Times*, February 7, 1992. http://www.nytimes.com/1992/02/07/business/furor-on-memo-at-world-bank.html.

Gallager, Sean. "India: The Rising Tide of E-waste." Pulitzer Center, January 16, 2014. https://pulitzercenter.org/reporting/india-rising-tide-e-waste.

Geetha, V. "Bereft of Being: The Humiliations of Untouchability." In *Humiliation: Claims and Contexts*, edited by Gopal Guru, 95–107. New Delhi: Oxford University Press, 2009.

Geetha, V., and S. V. Rajadurai. "Neo-Brahminism: An Intentional Fallacy?" *Economic and Political Weekly* 28, nos. 3–4 (January 16–23, 1993): 129–36.

Ghertner, Asher. *Rule by Aesthetics: World Class City Making in Delhi*. Oxford: Oxford University Press, 2015.

Giddens, Anthony. *The Birth of Modernity*. Stanford, CA: Stanford University Press, 1990.

Gidwani, Vinay. *Capital, Interrupted: Agrarian Development and the Politics of Work in India*. Minneapolis: University of Minnesota Press, 2008.

———. "Remaindered Things and Remaindered Lives: Traveling with Delhi's Waste." In *Finding Delhi: Loss and Renewal in the Megacity*, edited by Bharati Chaturvedi, 37–54. Delhi: Penguin Books, 2009.

———. "Waste/Value." In *The Wiley-Blackwell Companion to Economic Geography*, edited by Trevor J. Barnes, Jamie Peck, and Eric Sheppard, 275–88. Malden, MA: Wiley Blackwell, 2000.

Gisselquist, David, and Mariette Correa. "How Much Does Heterosexual Commercial Sex Contribute to India's HIV Epidemic?" *International Journal of STD and AIDS* 17, no. 11 (2006): 736–42.

Goffman, Erving. *The Presentation of Self in Everyday Life*. Woodstock, NY: Overlook, 1973.

———. *Stigma: Notes on the Management of Spoiled Identity*. New York: Simon and Schuster, 1963.

Govindraj, Giraddi. "Nativism in Modern Kannada Drama." *New Quest*, no. 45 (May–June 1984): 163–68.

Gowda, Sheela, and Trevor Smith. *Sheela Gowda*. Göttingen, Germany: Steidl, 2007.

Grobe, Christopher. *The Art of Confession: The Performance of Self from Robert Lowell to Reality TV*. New York: New York University Press, 2017.

Gupta, Akhil. "Farming as a Speculative Activity: The Ecological Basis of Farmers' Suicides in India." In *The Routledge Companion to the Environmental Humanities*, edited by Ursula Heise, Jon Christensen, and Michelle Niemann, 185–93. New York: Routledge, 2017.

———. *Red Tape: Bureaucracy, Structural Violence, and Poverty in India*. Durham, NC: Duke University Press, 2012.

Gupta, Akhil, and K. Sivaramakrishnan, eds. *The State in India after Liberalization: Interdisciplinary Perspectives*. New York: Routledge, 2011.

Hall, Stuart, ed. *Representation: Cultural Representations and Signifying Practices*. London: Sage, 1997.

Hansen, Thomas Blom. *Wages of Violence: Naming and Identity in Postcolonial Bombay*. Princeton, NJ: Princeton University Press, 2001.

Hare, David. *Behind the Beautiful Forevers: A Play*. London: Faber and Faber, 2014.

Harvey, David. *A Brief History of Neoliberalism*. Oxford: Oxford University Press, 2005.

———. "The 'New' Imperialism: Accumulation by Dispossession." *Actuel Marx* 35, no. 1 (2004): 71–90.

Harvie, Jen. *Theater and the City*. Basingstoke, UK: Palgrave Macmillan, 2009.

Hazra, Abhishek. "Someplace." In *In the Shade of the Commons: Towards a Culture of Open Networks*, edited by Lipika Bansal, Paul Keller, and Geert Lovink, 82–83. Amsterdam: Waag Society, 2006.

Heitzman, James. "Becoming Silicon Valley." *Seminar*, no. 503 (2001). http://www.india-seminar.com/2001/503/503%20james%20heitzman.htm.

———. *Network City: Planning the Information Society in Bangalore*. New Delhi: Oxford University Press, 2004.

Hochschild, Arlie Russell. "Emotion Work, Feeling Rules, and Social Structure." *American Journal of Sociology* 85, no. 3 (November 1979): 551–75.

Hopkins, D. J., and Kim Solga, eds. *Performance and the Global City*. London: Palgrave Macmillan, 2013.

Hopkins, D. J., Shelley Orr, and Kim Solga, eds. *Performance and the City*. Basingstoke, UK: Palgrave Macmillan, 2009.

Hutcheon, Linda. "Irony, Nostalgia, and the Postmodern." In *Methods for the Study of Literature as Cultural Memory*, edited by Raymond Vervliet and Annemarie Estor, 189–207. Amsterdam: Rodopi, 2000.

Huyssen, Andreas. "World Cultures, World Cities." In *Other Cities, Other Worlds: Urban Imaginaries in a Globalizing Age*, edited by Andreas Huyssen, 1–24. Durham, NC: Duke University Press, 2008.

"India BPO Industry Terms US Call Centre Bill 'Protectionist.' " *Business Standard*, December 22, 2011. http://www.business-standard.com/india/news/india-bpo-industry-terms-us-call-centre-bill-protectionist/459381/.

Jackson, Shannon. *Social Works: Performing Art, Supporting Publics*. New York: Routledge, 2011.

Jameson, Fredric. "Nostalgia for the Present." *South Atlantic Quarterly* 88, no. 2 (1989): 517–37.

Jefferson, Margo. "On the Other End of the Phone, Workers Stripped of Their Identities." *New York Times*, December 4, 2003. http://theater.nytimes.com/mem/theater/treview.html?html_title=&tols_title=ALLADEEN%20(PLAY)&pdate=20031204&byline=By%20MARGO%20JEFFERSON&id=1077011429052.

Jones, Amelia. *Body Art: Performing the Subject*. Minneapolis: University of Minnesota Press, 1998.

Kamatham, Ram Ganesh. "Dancing on Glass" (unpublished manuscript).

Kaplan, Caren. *Aerial Aftermaths: Wartime from Above.* Durham, NC: Duke University Press, 2018.

———. "Sensing Distance: The Time and Space of Contemporary War." *Social Text Online,* June 17, 2013. https://socialtextjournal.org/periscope_article /sensing-distance-the-time-and-space-of-contemporary-war/.

Kaviraj, Sudipta. "Filth and the Public Sphere: Concepts and Practices about Spaces in Calcutta." *Public Culture* 10, no. 1 (Fall 1997): 83–113.

Kaza, Shilpa, Liza Yao, Perinaz Bhada-Tata, and Frank Van Woerden. *What a Waste 2.0: A Global Snapshot of Solid Waste Management to 2050.* Washington, DC: World Bank Group, 2018. https://openknowledge.worldbank.org /handle/10986/30317.

Khan, Shivananda. "The Kothi Framework." Naz Foundation International, November 2000. www.msmgf.org/documents/Asia/MSMinAsia/KthiBehav .doc.

Kishore, Avijit Mukul, and Rohan Dutt, dirs. *Nostalgia for the Future.* Mumbai: Film Division of India, 2017. DVD.

Kole, Subir. "Globalizing Queer? AIDS, Homophobia and the Politics of Sexual Identity in India." *Global Health* 3, no. 1 (2007). http://www .globalizationandhealth.com/content/3/1/8.

Kralova, Jana. "Why We Need to Find a Cure for Social Death." *The Wire.* Accessed August 2, 2016. http://thewire.in/55427/why-we-need-to-find-a-cure -for-social-death/.

Kruger, Loren. *Imagining the Edgy City: Writing, Performing and Building Johannesburg.* New York: Oxford University Press, 2013.

Kumar, Udaya. *Writing the First Person: Literature, History, and Autobiography in Modern Kerala.* Ranikhet: Permanent Black and Indian Institute of Advanced Study, Shimla, in association with Ashoka University, 2016.

Kurtkoti, K. D., ed. *The Tradition of Kannada Theatre.* Gandhinagar: IBH Prakashana, 1986.

Kwan, SanSan. *Kinesthetic City: Dance and Movement in Chinese Urban Spaces.* New York: Oxford University Press, 2013.

Langmuir, Erika. *The Pan Art Dictionary: 1300–1800.* London: Transatlantic, 1989.

Lasch, Christopher. *The Culture of Narcissism: American Life in an Age of Diminishing Expectations.* New York: W. W. Norton, 1979.

———. *The Minimal Self: Psychic Survival in Troubled Times.* New York: W. W. Norton, 1984.

Laub, Dori. "Bearing Witness, or Vicissitudes of Listening." In *Testimony: Crises of Witnessing in Literature, Psychoanalysis, and History,* edited by Shoshana Felman and Dori Laub, 57–74. New York: Routledge, 1992.

Lee, Pamela. *Forgetting the Art World.* Cambridge, MA: MIT Press, 2012.

Lemke, Thomas. "'The Birth of Biopolitics': Michel Foucault's Lecture at the Collège de France on Neo-liberal Governmentality." *Economy and Society* 30, no. 2 (2001): 190–207.

Levinas, Emmanuel. *On Escape: De l'évasion.* Translated by Bettina Bergo. Stanford, CA: Stanford University Press, 1982.

Macaulay, T. B. "Minute on Indian Education." In *Postcolonialisms: An Anthology of Cultural Theory and Criticism*, edited by Gaurav Desai and Supriva Nair, 121–31. Oxford: Berg, 2005.

Malaviya, Nalini S. "A Conversation with Sheela Gowda: Creative Impulse." *Art Etc.*, April 2011. http://www.artnewsnviews.com/view-article.php?article=a -conversation-with-sheela-gowda&iid=19&articleid=455.

Mani, Lata. "The Phantom of Globality and the Delirium of Excess." *Economic and Political Weekly* 43, no. 39 (September 27, 2008): 41–47.

———. *SacredSecular: A Contemplative Critique*. New Delhi: Routledge, 2009.

Mankekar, Purnima. "Becoming Entrepreneurial Subjects: Neoliberalism and Media." In *The State in India after Liberalization: Interdisciplinary Perspectives*, edited by Akhil Gupta and K. Sivaramakrishnan, 213–22. New York: Routledge, 2011.

———. *Unsettling India: Affect, Temporality, Transnationality*. Durham, NC: Duke University Press, 2015.

Mankekar, Purnima, and Louisa Schein. Introduction to *Media, Erotics, and Transnational Asia*, edited by Purnima Mankekar and Louisa Schein, 1–30. Durham, NC: Duke University Press, 2013.

Marcuse, Herbert. *Eros and Civilization: A Philosophical Inquiry into Freud.* Boston: Beacon, 1955.

Massumi, Brian. "Fear (The Spectrum Said)." *positions: east asia cultures critique* 13, no. 1 (Spring 2005): 31–48.

Mathur, Saloni. "Diasporic Body Double: The Art of the Singh Twins." *Art Journal* 65, no. 2 (Summer 2006): 34–56.

———. *Indian Design: Colonial History and Cultural Display*. Berkeley: University of California Press, 2007.

———. "On Vivan Sundaram, *Trash* (2005–8)." In *Critical Landscapes: Art, Space, Politics*, edited by Emily Eliza Scott and Kirsten Swenson, 254–56. Oakland: University of California Press, 2015.

Mazumdar, Ranjani. *Bombay Cinema: An Archive of the City*. Minneapolis: University of Minnesota Press, 2007.

Mazzarella, William. *Shoveling Smoke: Advertising and Globalization in Contemporary India*. Durham, NC: Duke University Press, 2003.

Mbembe, Achille, and Sarah Nuttall. "Aesthetics of Superfluity." In Mbembe and Nuttall, *Johannesburg*, 37–67.

———. "Democracy as a Community of Life." *The Salon* (Johannesburg) (Vol. 4 2011). http://www.jwtc.org.za/resources/docs/salon-volume-4/1-Salon-Vol -4-Mbembe.pdf, 2.

———, eds. *Johannesburg: The Elusive Metropolis*. Durham, NC: Duke University Press, 2008.

McKenzie, Jon. "Performance and Global Transference." *TDR: The Drama Review* 45, no. 3 (Fall 2001): 5–7.

———. "The Performative Matrix: Alladeen and Disorientalism." *Performance Research* 13, no. 2 (2008): 26–36.

McLuhan, Marshall, and Bruce R. Powers. *The Global Village: Transformations in World Life and Media in the 21st Century*. New York: Oxford University Press, 1992.

Miller, Ian. "The Home and the World: Privacy in the Fight against India's Anti-sodomy Law." Honors thesis, Honors Program in Ethics and Society, Stanford University, 2019.

Misra, Kavita. "Politico-moral Transactions in Indian AIDS Service: Confidentiality, Rights and New Modalities of Governance." *Anthropological Quarterly* 79, no. 1 (2006): 33–74.

Mitchell, Timothy. *Carbon Democracy: Political Power in the Age of Oil*. Brooklyn: Verso, 2011.

Mohanty, Chandra, and Biddy Martin. "What's Home Got to Do with It?" In *Feminism without Borders: Decolonizing Theory, Practicing Solidarity*, edited by Chandra Mohanty, 85–105. Durham, NC: Duke University Press, 2003.

Morgenstern, Myriam. "The Carbon Myth." *Art Etc.*, October 2010. http://www.shanthamani.com/frozen_phoenix/.

Mosse, David. "The Modernity of Caste and the Market Economy." *Modern Asian Studies* 54, no. 4 (2019): 1225–71.

Muñoz, José. *Cruising Utopia: The Then and There of Queer Futurity*. New York: New York University Press, 2009.

Murthy, K. S. Srinivasa. "An Uncompromising Artist." *Frontline* 20, no. 25 (December 6–19, 2003). https://frontline.thehindu.com/other/obituary/article30220329.ece.

Nair, Janaki. "Drawing a Line: K. Venkatappa and His Publics." *Indian Economic and Social History Review* 35, no. 2 (1998): 179–210.

———. "Past Perfect: Architecture and Public Life in Bangalore." *Journal of Asian Studies* 61, no. 4 (November 2002): 1205–36.

———. *The Promise of the Metropolis: Bangalore's Twentieth Century*. New Delhi: Oxford University Press, 2005.

Nandy, Ashis. *Regimes of Narcissism, Regimes of Despair*. New Delhi: Oxford University Press, 2013.

———. *Time Warps: Silent and Evasive Pasts in Indian Politics and Religion*. New Brunswick, NJ: Rutgers University Press, 2002.

Nixon, Rob. *Slow Violence and the Environmentalism of the Poor*. Cambridge, MA: Harvard University Press, 2011.

Ong, Aihwa. *Neoliberalism as Exception: Mutations in Citizenship and Sovereignty*. Durham, NC: Duke University Press, 2006.

Owens, Craig. "The Medusa Effect, or, The Specular Ruse." *Art in America* 72 (January 1984).

Parekh, Bhikhu. "Logic of Humiliation." In *Humiliation: Claims and Contexts*, edited by Gopal Guru, 23–40. New Delhi: Oxford University Press, 2009.

Park, Miles. "Electronic Waste Is Recycled in Appalling Conditions in India." *The Conversation*, February 14, 2019. https://theconversation.com/electronic-waste-is-recycled-in-appalling-conditions-in-india-110363.

Parker-Starbuck, Jennifer. "Global Friends: The Builders Association at BAM." *PAJ: A Journal of Performance and Art* 77 (2004): 96–102.

Parthsarthy, Balaji. "Envisioning the Future in Bangalore." *Seminar*, no. 612 (August 2010). http://www.india-seminar.com/2010/612/612_balaji_parthasarathy.htm.

Patel, Reena. *Working the Night Shift: Women in India's Call Center Industry*. Stanford, CA: Stanford University Press, 2010.

Peck, Jamie. *Constructions of Neoliberal Reason.* Oxford: Oxford University Press, 2010.

Pellegrini, Ann. *Performance Anxieties: Staging Psychoanalysis, Staging Race.* New York: Routledge, 1997.

Pellow, David. "Transnational Alliances and Global Politics: New Geographies of Environmental Justice Struggles." In *In the Nature of Cities: Urban Political Ecology and the Politics of Urban Metabolism,* edited by Nik Heynen, Maria Kaika, and Erik Swyngedouw, 226–44. New York: Routledge, 2006.

Philip, Susan Joe. "Being Revathi." *The Hindu,* April 16, 2018. https://www .thehindu.com/entertainment/theatre/in-a-mono-act-a-revathi-gives-a-moving -account-on-what-it-means-to-be-a-transgender/article23559497.ece.

Povinelli, Elizabeth. *Economies of Abandonment: Social Belonging and Endurance in Late Liberalism.* Durham, NC: Duke University Press, 2011.

Prakash, Gyan. "Introduction: Imagining the Modern City, Darkly." In *Noir Urbanisms: Dystopic Images of the Modern City,* edited by Gyan Prakash, 1–14. Princeton, NJ: Princeton University Press, 2010.

———. *Mumbai Fables: A History of an Enchanted City.* Princeton, NJ: Princeton University Press, 2010.

Prakash, Gyan, and Kevin Kruse, eds. *The Spaces of the Modern City: Imaginaries, Politics, and Everyday Life.* Princeton, NJ: Princeton University Press, 2008.

Prasad, Madhava. "The Last Remake of Indian Modernity?" Critical Collective, accessed August 3, 2020, https://criticalcollective.in/ArtistInner2.aspx?Aid= 104&Eid=37.

Probyn, Elspeth. *Blush: Faces of Shame.* Minneapolis: University of Minnesota Press, 2005.

Pushpamala, N. "The Phantom Lady Strikes! Adventures of the Artist as a Masked Subaltern Heroine in Bombay." *Thesis Eleven* 113, no. 1 (2012): 157–80.

Quayson, Ato. *Oxford Street, Accra: City Life and the Itineraries of Transnationalism.* Durham, NC: Duke University Press, 2014.

Radin, Margaret Jane. *Reinterpreting Property.* Chicago: University of Chicago Press, 1993.

Rajangum, Krupa. "Once an Anglo-Indian Village, Now an Upmarket Suburb." *Citizen Matters,* March 3, 2010. http://bengaluru.citizenmatters.in/1821-about -whitefield-history-1821.

Rancière, Jacques. *Dissensus: On Politics and Aesthetics.* Edited and translated by Steven Corcoran. London: Bloomsbury, 2010.

Rao, Anupama. *The Caste Question: Dalits and the Politics of Modern India.* Berkeley: University of California Press, 2009.

Ray, Partho Sarathi. "From Nonadanga to Ejipura: The Urban Battleground." *Sanhati,* February 23, 2013. http://sanhati.com/excerpted/6074/.

Reddy, Akhileshwari. "A Law for Waste Pickers." *Down to Earth,* April 12, 2018. https://www.downtoearth.org.in/news/waste/a-law-for-waste-pickers-60103.

Reddy, Gayatri. *With Respect to Sex: Negotiating Hijra Identity in South India.* Chicago: University of Chicago Press, 2005.

Reiss, Timothy J. "Critical Environments: Cultural Wilderness or Cultural History?" *Canadian Review of Comparative Literature* 10, no. 2 (June 1983): 192–209.

Ren, Julie, and Jason Luder, eds. *Art and the City: Worlding the Discussion through a Critical Artscape*. New York: Routledge, 2017.

Revathi, A. *A Life in Trans Activism*. Translated by Nandini Murali. New Delhi: Zubaan, 2016.

———. *The Truth about Me: A Hijra Life Story*. Translated by V. Geetha. New Delhi: Penguin, 2009.

Rice, Benjamin Lewis. "Whitefield." In *Bengaluru, Bengaluru, Bengaluru: Imaginations and Their Times*, edited by Narendar Pani, Sindhu Radhakrishna, and Kishor G. Bhat, 90–92. New Delhi: Sage, 2010.

Ridout, Nicholas. *Passionate Amateurs: Theatre, Communism, and Love*. Ann Arbor: University of Michigan Press, 2013.

Robinson, Jennifer. "Living in Dystopia: Past, Present, and Future in Contemporary African Cities." In *Noir Urbanisms: Dystopic Images of the Modern City*, edited by Gyan Prakash, 218–40. Princeton, NJ: Princeton University Press, 2010.

Rowe, Dorothy. "Cultural Crossings: Performing Race and Transgender in the Work of Moti Roti." *Art History* 26, no. 3 (June 2003): 456–73.

Roy, Ananya. "The Blockade of the World-Class City." In Roy and Ong, *Worlding Cities*, 259–78.

———. "Postcolonial Urbanism: Speed, Hysteria, Mass Dreams." In Roy and Ong, *Worlding Cities*, 307–35.

Roy, Ananya, and Aihwa Ong, eds. *Worlding Cities: Asian Experiments and the Art of Being Global*. London: Wiley-Blackwell, 2011.

Said, Edward. *Culture and Imperialism*. New York: Knopf, 1993.

Sainath, P. "Census Findings Point to Decade of Rural Distress." *The Hindu* (Mumbai ed.), September 25, 2011. http://www.thehindu.com/opinion/columns/sainath/census-findings-point-to-decade-of-rural-distress/article2484996.ece.

———. "In India Farmers Face a Terrifying Crisis." *New York Times*, April 13, 2018. https://www.nytimes.com/2018/04/13/opinion/india-farmers-crisis.html.

———. "In 16 Years, Farm Suicides Cross a Quarter Million." *The Hindu*, October 29, 2011. https://www.thehindu.com/opinion/columns/sainath/In-16-years-farm-suicides-cross-a-quarter-million/article12892373.ece.

Sambrani, Chaitanya. "Tracking Trash: Vivan Sundaram and the Turbulent Core of Modernity." In *Trash* (exhibition catalogue). Mumbai, India: Chemould Gallery, 2008.

Sassen, Saskia. "The Global City: Introducing a Concept." *Brown Journal of International Affairs* 11, no. 2 (2005): 27–43.

———. *The Global City: New York, London, Tokyo*. Princeton, NJ: Princeton University Press, 2001.

Sathaye, Sonali. "The Scientific Imperative to Be Positive: Self-Reliance and Success in the Modern World." In *In an Outpost of the Global Economy: Work and Workers in India's Information Technology Industry*, edited by Carol Upadhya and A. R. Vasavi, 136–61. New Delhi: Routledge, 2008.

Sawant, Shukla. "Instituting Artists' Collectives: The Bangalore/Bengaluru Experiments with 'Solidarity Economies.'" *Journal of Transcultural Studies* 1 (2012): 122–49.

Schneider, Rebecca. *Performing Remains: Art and War in Times of Theatrical Reenactment*. New York: Routledge, 2011.

Schneider, Rebecca, and Nicholas Ridout. "Precarity and Performance: An Intro-
duction." *TDR: The Drama Review* 56, no. 4 (2012): 5–9.

Searle, Llerena Guiu. *Landscapes of Accumulation: Real Estate and Neoliberal-
ization in Contemporary India.* Chicago: University of Chicago Press, 2016.

Sedgwick, Eve. "Shame, Theatricality, and Queer Performativity: Henry James's
The Art of the Novel." In *Touching Feeling: Affect, Pedagogy, Performativity*,
35–66. Durham, NC: Duke University Press, 2003.

Sedgwick, Eve Kosofsky, and Adam Frank, eds. *Shame and Its Sisters: A Silvan
Tomkins Reader.* Durham, NC: Duke University Press, 1995.

Semmalar, Gee Imaan. "Why Trans Movements in India Must Be Anti-caste."
Trans.cafe, December 21, 2016. http://www.trans.cafe/posts/2016/12/12/why
-trans-movements-in-india-must-be-anti-caste.

Sen, Jaideep. "Slow and Tell: Interview with Krishnaraj Chonat." *Time Out* (Ban-
galore), February 2010.

Sennett, Richard. *The Craftsman.* New Haven, CT: Yale University Press, 2008.

———. "Narcissism and Modern Culture." *October*, no. 4 (Autumn 1977): 70–79.

Shanthamani, M. "Frozen Phoenix." Accessed August 23, 2017. http://www
.shanthamani.com/frozen_phoenix/.

Sharma, Ravi. "Murder Most Foul." *Frontline* 22, no. 27 (2006).

Shastri, Vanita. "The Politics of Economic Liberalization in India." *Contempo-
rary South Asia* 6, no. 1 (1997): 27–56.

Silverman, Kaja. *The Acoustic Mirror: The Female Voice in Psychoanalysis and
Cinema.* Bloomington: Indiana University Press, 1988.

Sinha, Mrinalini. *Specters of Mother India: The Global Restructuring of an
Empire.* Durham, NC: Duke University Press, 2006.

Slater, Joanna. "Call of the West: For India's Youth, New Money Fuels a Revolu-
tion; As Foreign Goods, Jobs Flood the Country, Young People Are Spurning
Tradition; 'Little Gentleman' Loosens Up." *Wall Street Journal*, January 27,
2004. http://search.proquest.com/docview/398866014?accountid=14026.

Smith, Sidonie, and Julia Watson, eds. *Interfaces: Women, Autobiography, Image,
Performance.* Ann Arbor: University of Michigan Press, 2002.

Smith, Trevor. "The Specific Labour of Sheela Gowda." *Afterall: A Journal of Art,
Context, and Enquiry*, no. 22 (Autumn/Winter 2009): 36–43.

Soneji, Davesh. *Unfinished Gestures: Devadāsīs, Memory, and Modernity in
South Asia.* Chicago: University of Chicago Press, 2012.

"Sparing the Poor" (editorial). *The Hindu*, July 25, 1991. https://www.thehindu
.com/opinion/editorial/Sparing-the poor/article14504906.ece.

Srinivas, Smriti. *Landscapes of Urban Memory: The Sacred and the Civic in
India's High-Tech City.* Minneapolis: University of Minnesota Press, 2001.

Srinivas, Tulasi. *The Cow in the Elevator: An Anthropology of Wonder.* Durham,
NC: Duke University Press, 2018.

Srinivasan, Priya. *Sweating Saris: Indian Dance as Transnational Labor.* Philadel-
phia: Temple University Press, 2012.

Srivastava, Sanjay. *Entangled Urbanism: Slum, Gated Community, and Shopping
Mall in Delhi and Gurgaon.* Delhi: Oxford University Press, 2015.

Stewart, Susan. *On Longing: Narratives of the Miniature, the Gigantic, the Sou-
venir, the Collection.* Baltimore: Johns Hopkins University Press, 1984.

Sundaram, Ravi. *Pirate Modernity: Delhi's Media Urbanism*. New York: Routledge, 2011.

Surekha. "Surekha in Conversation with Abhishek Hazra." PDome.org, accessed August 3, 2020. http://surekha.info/interview-1.

Tarlo, Emma. *Unsettling Memories: Narratives of the Emergency in Delhi*. Berkeley: University of California Press, 2003.

Taylor, Diana. "Performance and/as History." *TDR: The Drama Review* 50, no. 1 (2006): 67–86.

Tester, Keith. *Panic*. New York: Routledge, 2013.

Thachil, Tariq. *Elite Parties, Poor Voters: How Social Services Win Votes in India*. Cambridge: Cambridge University Press, 2014.

Thanawala, Sudhin. "India's Call-Center Jobs Go Begging." *Time*, October 16, 2007. http://www.time.com/time/business/article/0,8599,1671982,00.html.

Thrift, Nigel. *Non-representational Theory: Space, Politics, Affect*. New York: Routledge, 2008.

Twenge, Jean M. *Generation Me: Why Today's Young Americans Are More Confident, Assertive, Entitled—and More Miserable Than Ever Before*. New York: Free Press, 2006.

Twenge, Jean, and Keith Campbell. *The Narcissism Epidemic: Living in the Age of Entitlement*. New York: Atria, 2009.

Tyler, Imogen. "From 'The Me Decade' to 'The Me Millennium': The Cultural History of Narcissism." *International Journal of Cultural Studies* 10, no. 3 (2007): 343–63.

Upadhya, Carol. "Management of Culture and Management through Culture in the Indian Software Outsourcing Industry." In Upadhya and Vasavi, *In an Outpost of the Global Economy*, 101–35.

Upadhya, Carol, and A. R. Vasavi, eds. *In an Outpost of the Global Economy: Work and Workers in India's Information Technology Industry*. New Delhi: Routledge, 2008.

Venkatesan, V. "Defining Moment." *Frontline*, July 2009, 29–32.

Verma, Varuna. "Love and Let Love." *Telegraph* (Calcutta), March 5, 2006. http://www.telegraphindia.com/1060305/asp/look/story_5921550.asp.

Vidya, Living Smile. *I Am Vidya: A Transgender's Journey*. New Delhi: Rupa, 2013.

Virilio, Paul. *City of Panic*. New York: Berg, 2005.

Visvanathan, Shiv. "What the Thumping Mandate for Modi Means." *The Hindu*, May 24, 2019. https://www.thehindu.com/opinion/op-ed/what-the-thumping-mandate-for-modi-means/article27239218.ece.

Walling, Michael. "A Note on the Play: Director's Note for 'Bravely Fought the Queen.'" In *Mahesh Dattani: Collected Plays*, 229–30. New Delhi: Penguin, 2000.

Wetzel, Daniel. "Call It *Call Cutta in a Box*" (interview by Barbara Van Lindt). Rimini Protokoll, January 5, 2008. http://www.rimini-protokoll.de/website/en/text/call-it-call-cutta-in-a-box.

Whybrow, Nicholas. Introduction to *Performance and the Contemporary City: An Interdisciplinary Reader*, edited by Whybrow. London: Palgrave Macmillan, 2010.

Williams, Raymond. *Marxism and Literature.* Oxford: Oxford University Press, 1977.

Williams, Richard. *The Anxious City: British Urbanism in the Late 20th Century.* Abingdon, UK: Routledge, 2004.

Wolfe, Tom. "The 'Me' Decade and the Third Great Awakening." *New York Magazine,* August 23, 1976.

Page numbers in *italic* refer to illustrations.